British Sculpture in the Twentieth Century

Edited by Sandy Nairne and Nicholas Serota

West Bend
Art Museum
Collection

Whitechapel Art Gallery 1981

The exhibition *British Sculpture in the Twentieth Century* has been organised by the Whitechapel Art Gallery and shown in two parts:
Part One: Image and Form 1901-50, 11 September-1 November, 1981
Part Two: Symbol and Imagination 1951-80, 27 November-24 January, 1982

It has been sponsored by:
🛡 The British Petroleum Company Limited
The Henry Moore Foundation

It has been indemnified by HM Government under the terms of the National Heritage Act 1980.

Production of this book has been assisted by:
The Elephant Trust
Sotheby Parke Bernet
The Arts Council of Great Britain

The Whitechapel Art Gallery, an independent charitable trust, is most grateful for the regular financial assistance which it receives from the Arts Council of Great Britain, the Greater London Council, the Inner London Education Authority, the Greater London Arts Association and the London Boroughs of Tower Hamlets and Hackney.

Published by the Trustees of the Whitechapel Art Gallery

Edited by Sandy Nairne and Nicholas Serota
Designed by Paul McAlinden
Production by Mark Francis assisted by Patricia Sweeney and Lucinda Hawkins
Typesetting by Apex Computersetting
Printed in the Netherlands by Lecturis bv, Eindhoven

© Trustees of the Whitechapel Art Gallery 1981

5500 copies printed September 1981
ISBN 0 85488 054 2

Acknowledgements

The realisation of an exhibition containing more than 300 works, covering eighty years of sculpture and the publication of this volume has involved the collaboration of a large number of individuals and institutions. On behalf of the Trustees of the Whitechapel may I thank in particular *The British Petroleum Company Limited* for their generous sponsorship of the exhibition as a whole; *the Henry Moore Foundation* for their generous donation, recognising the heavy transport costs on such an exhibition; *the Elephant Trust,* for a donation which covered the initial research on the exhibition, making the whole project possible; *Sotheby Parke Bernet* for a sponsorship which contributed to the realisation of the book; *the Arts Council of Great Britain* for a special grant towards the production costs of the book; *HM Government* for their help in agreeing to indemnify this exhibition under the terms of the National Heritage Act 1980; *lenders to the exhibition,* for their generosity in lending objects which are fragile or difficult to transport; *Alan Bowness,* Director, and the trustees and staff of the Tate Gallery, especially those in the library and registrars department who assisted from the earliest stages of the preparation of the exhibition; *the Directors and staffs* of those museums and galleries in this country and abroad who responded to our request for information and loans; *Sandy Nairne,* joint selector of the exhibition and editor of the book; *the authors of the book,* who responded with enthusiasm to our invitation to research and write on the subjects of their essays; *Susan Ferleger Brades, Hilary Gresty and Sheena Wagstaff,* who between them compiled the bibliography and biographies published here and undertook a great deal of the other research besides; *Paul McAlinden* and *Richard Hollis* for their work on design of the book and publicity material; *the staff of the Whitechapel Art Gallery,* especially *Bruce McAllister,* who coordinated the installation of the exhibition, *Mark Francis* and *Patricia Sweeney,* who supervised production of the book and printed matter, *Jenni Lomax* and *Martin Rewcastle,* who arranged the educational programmes and the Gallery Administrator, *Loveday Shewell.*

Nicholas Serota, Director

Sandy Nairne and Nicholas Serota: **Foreword.**

A glance at the list of exhibitions and publications at the end of this book will reveal the extent to which both the book and the exhibition are long overdue. They now come at a time when 'the whole culture' of modern sculpture (to adapt Robert Motherwell's statement of 1951 about contemporary painters) is quite suddenly regarded as a legitimate source for British sculptors. At almost no time in the previous seventy five years would one have found the range of approach, subject matter, material and even deliberate reference to the sculpture of the preceding hundred years that has characterised British sculpture during the past five years.

The achievement of a small number of individual British sculptors has been widely recognised and exhibited. Moore, Hepworth, Caro and Long have a place in every history of twentieth century western art. But others, including such major figures as Alfred Gilbert, Jacob Epstein, Henri Gaudier Brzeska, and Eric Gill are much less well known. Furthermore the rare one-person exhibitions that have taken place have never been matched by that presentation of the work of contemporaries which would disclose the full pattern of connections within a period. Nor has it been possible to gain any real sense of the change and continuity which has marked the development of sculpture in Britain through several generations. Sculpture, by its size and weight, is more difficult to exhibit than paintings, and this very ordinary physical constraint is one reason why very few historical survey exhibitions of sculpture have been attempted and why so little sculpture has been included in surveys of particular periods. In general it is encouraging that most sculpture exhibitions have concentrated on new work.

The book and the exhibition are designed to complement each other; to open up an area for discussion rather than to define or limit it. They are both arranged on the basis of themes which we felt were the appropriate means of dealing with the issues and subjects of a particular period, though neither the themes nor the artists discussed in the book or shown in the exhibition were ever intended to correspond exactly. Neither should one expect to be able to trace the career of an individual artist, though for further reference we have devoted a section of the book to brief summaries of the careers, important exhibitions and significant publications or catalogues on more than one hundred sculptors born between 1846 and 1945. Our wish, without in any sense diminishing the achievement of individuals, has been to make visitors and readers more aware of the qualities, subjects and language of sculpture itself.

Dennis Farr:

Jacob Epstein: British Medical Association Building Figures, 1907.

I. The Patronage and Support of Sculptors.

During the past eighty years there has been a shift in the patronage of sculptors away from private individuals and institutions to public bodies, notably government departments, local authorities, and universities. Yet this generalization, once made, needs immediate qualification. There is no steady pattern of change, but rather an ebb and flow between private and public patronage at any given time between 1900 and today, which is also linked to the economic vicissitudes of the period under discussion. It must also be said that this essay is confined to patronage within the United Kingdom, although since 1945 British sculptors have enjoyed increasing inter-national recognition and have had their work bought by many public and private institutions in Europe, the United States, Canada, and Japan.

There is, however, one indisputable watershed which marks a fundamental change in our attitude to state support for the arts in this country. This was the creation, in 1940, of the Council for the Encourage-ment of Music and the Arts (C.E.M.A.), from which grew the Arts Council of Great Britain, founded in 1945 and granted a Royal Charter the following year. Although funded by central government, the 'arm's length' principle of responsibility delegated to Council members and officers with special knowledge of the arts has operated from the start and provides the necessary safeguard against direct political interfer-ence. The Arts Council's role is not solely that of a provider but as a stimulator of patronage, especially in recent years when it has worked in collaboration with local authorities and industrialists to promote specific projects. This has had a directly beneficial effect for sculptors, among others, by encouraging local initiat-ives and jointly-funded commissions which would not otherwise have been forthcoming. It is also important to distinguish not only between the various types of commissions but also to identify what appear to be the criteria set by the clients for a particular work. We must remember that some public buildings were built for private clients, such as the British Medical Associ-ation, who commissioned the sculptural adornment from Jacob Epstein on the recommendation of the architect, Charles Holden. Other commissions were placed by government agencies, such as the Crown Commissioners, acting on expert advice, who were responsible for the Central Criminal Court, Old Bailey (1900-7) with its sculptures by F.W.Pomeroy, and the **Queen Victoria Memorial** (1901-11), where the sculptor, Sir Thomas Brock, and the architect, Sir Aston Webb, worked in collaboration. When the

Governors and Directors of the Bank of England rebuilt Soane's original Bank between 1921-37, they employed Sir Herbert Baker as architect, and Charles Wheeler to provide six giant buttress figures and a bas-relief on the Lothbury Street façade and bronze doors for the entrance hall.

One view of the importance of the private patron at the beginning of the century is provided by M.H.Spielmann, an enthusiastic advocate of the 'New School' of British sculpture. After first sounding a warning about following the French example of a Ministry of Fine Arts, he commented that sculpture in England '. . . remains mainly an affair not of publicly recognised ability, but of polite patronage; so that it is now on the status of poetry and scholarship under Queen Anne – a thing not generally diffused.'[1] He had earlier spoken of the 'radical change' which since 1875 'has come over British sculpture – a change so revolutionary that it has given a new direction to the aims and ambitions of the artist and raised the British school to a height unhoped for, or at least wholly unexpected, thirty years ago.'[2] This view was in complete contrast to Julius Meier-Graefe's damning verdict: 'There is no plastic art in England. The nineteenth century produced but one solitary sculptor, Alfred Stevens, and he has left almost nothing behind him.'[3] In fact, Stevens' great High Renaissance style **Wellington Memorial** in St. Paul's Cathedral was to be completed by John Tweed in 1912, four years after this comment was published. Looking through Spielmann's survey of 1901, one is struck by the abundance of public and private commissions executed by some fifty sculptors over the last quarter of the nineteenth century, and which he illustrates in that volume. Taken in conjunction with the large number of public buildings erected in London alone during the same period and up to 1914, one can gain some idea of the great wealth expended on architec-ture and sculpture by the state and by private individuals and institutions in this country at that time.

Nevertheless, only a fortunate minority could depend on the patronage of a handful of wealthy private patrons and the support of a few sympathetic dealers during the lean years of the 1920s and 1930s. The economic and social upheavals which followed in the wake of the 1914-18 War virtually destroyed the old aristocratic tradition of patronage (although the eight

[1]M.H.Spielmann, **British Sculpture and Sculptors of To-Day**, London 1901, p.7.
[2]Ibid, p.1.
[3]Julius Meier-Graefe, **Modern Art**, II, London 1908, p.194.

mural decorations in St. Stephen's Hall, Westminster, were each paid for by individual Peers of the Realm in 1927), and there were fewer public commissions for monumental sculpture. An important exception to this was the spate of commissions for war memorials after 1918, which will be discussed later. The Royal Academy of Arts provided a shop window for artists through its annual summer exhibitions, and its supremacy was not seriously challenged until the foundation of the New English Art Club in 1886, and by the proliferation of exhibiting societies after 1900. Foremost among these was the London Group, founded in March 1914. Sculptors who made their début at the Royal Academy, like the young Hamo Thornycroft, often caught the eye of a patron. In 1880 Thornycroft's small plaster of **Artemis** was seen at the Academy by the architect, Alfred Waterhouse, who was then engaged in building Eaton Hall for the Duke of Westminster. On his recommendation, the Duke agreed to commission from Thornycroft a life-size marble version which was completed and exhibited two years later and set the sculptor on a highly successful career. Many sculptors who exhibited at the Royal Academy and at the Royal Society of British Sculptors (founded 1904), made a regular practice of showing small maquettes in plaster or, occasionally, in bronze, from which further versions could be cast, often in editions of various sizes, in response to public demand. It was a recognized way of generating a steady income, and the practice is continued today by those sculptors working in traditional materials. Portrait sculptors, including Epstein, also made limited editions of certain subjects, especially famous sitters, to order. It was through the income gained from his portrait busts that Epstein was able to finance those of his monumental works which had not been commissioned.

Sculptors face an economic problem peculiar to their art, which is the high cost of producing the finished artefact. Casting in bronze, aluminium, in precious or semi-precious metals, is expensive; the price of marble, stone and seasoned wood, is high in relation to that of paper, paint, and canvas. Alfred Gilbert's failure to manage the financial side of a major commission like the **Shaftesbury Memorial Fountain** (Eros), compounded by the government's inability to fulfil its promise of cheap bronze cannon for melting down, was the cause of his mounting debts and virtual bankruptcy. This in turn led to exile in Belgium for over twenty years, until he was invited back by King George V to complete the magnificent **Clarence Tomb**

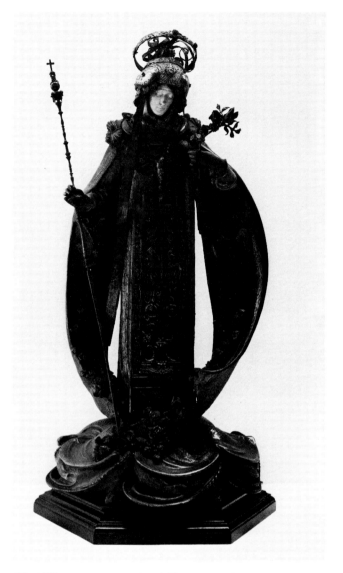

Alfred Gilbert: **The Virgin**, 1894-96. First version of a figure for the Clarence Tomb.

in the Albert Memorial Chapel, Windsor Castle, in 1926. Spielmann also noted a dearth of competent bronze founders in England in the late nineteenth century, as compared with France, where in addition to the famous Parisian founders, Alexis Rudier and Hébrard, there were numerous smaller firms in French provincial cities.[4] A major sculpture commission usually means that a sculptor has to employ studio assistants and rent a large studio. He has to deal with problems of handling and of transporting heavy, bulky objects. The renewed interest in carving, led by Epstein, Eric Gill, Gaudier-Brzeska, Frank Dobson, Henry Moore, Barbara Hepworth, and Alan Durst; and the philosophical 'truth to materials' argument, so

[4]Spielmann, op.cit, p.11, although he does not refer to specific French bronze founders.

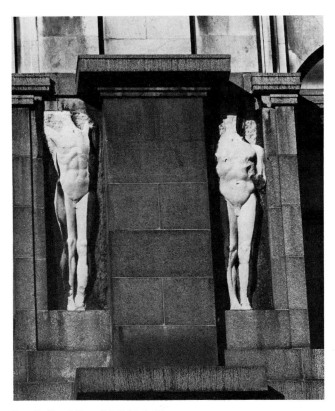

Detail of Jacob Epstein's B.M.A. Figures.

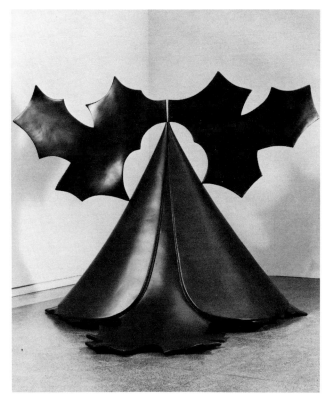

Phillip King: **Genghis Khan**, 1963.

strongly held by the avant-garde sculptors of the 1920s and 1930s, also imposed constraints in what could be used for sculpture. The principle of truth to materials was a way, too, of explaining modern sculpture to an unsympathetic art establishment, and of defending it from the attacks of a hostile public.[5] The advent of a wide range of synthetic materials such as fibreglass, polyurethanes, and caseins – 'plastics'; and the adoption of new industrial techniques like welding and resin finishes to sculpture, changed this 'pure' approach and offered new technical opportunities to sculptors. The emphasis in the 1960s was now on construction rather than carving and the new techniques were also cheaper and thus attractive to the younger generation, who were more predisposed to experiment with modern technological advances. Perhaps one of the most dramatic early manifestations of the new era was Phillip King's purple fibreglass **Genghis Khan** (1963) shown at the third Kassel Documenta in 1964. ◣

Looking back over the period, it is remarkable how many public controversies there were over public sculpture commissions. Epstein was a central target for abuse, especially from the popular press, for over thirty years, and after the uproar caused by his carvings **Night** and **Day** for the London Transport

headquarters at St. James's Park Station in 1929, he was not asked to execute another public commission for twenty years. Henry Moore paid tribute to him, at his death in August 1959, saying: 'He took the brickbats, he took the insults, he faced the howls of derision with which artists since Rembrandt have learned to become familiar. And as far as sculpture in this century is concerned, he took them first.'[6] But Epstein helped the next generation to win acceptance a little more easily for their ideas precisely because he drew the fire of hostile criticism. Moore explained that sculpture, simply because it is three-dimensional, always arouses more violent emotions; it cannot be side-stepped, so to speak. Yet controversy at least made sculpture 'newsworthy' and kept it before the public eye. When Charles Holden, as architect of the British Medical Association building in the Strand, recommended the Council of the B.M.A. to commission Epstein in 1907 to carve eighteen over life-size and mostly nude figures to adorn exterior niches on the second floor, and over forty feet above street level,

[5]Sandy Nairne, **Carved. Modelled. Constructed. Three aspects of British 20th-century sculpture**, Tate Gallery, 1 December 1977 – 23 February 1978.
[6]Philip James (ed.), **Henry Moore on Sculpture**, London, 1966, p.194. First published as an obituary tribute in *The Sunday Times*, 23 August 1959.

THE PATRONAGE AND SUPPORT OF SCULPTORS

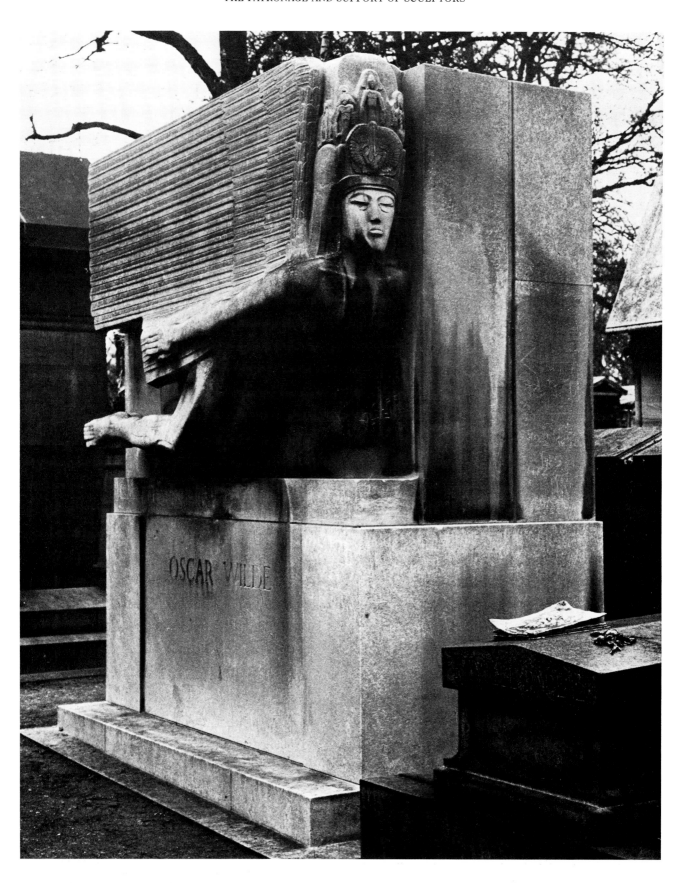

Jacob Epstein: **Tomb of Oscar Wilde**, 1911-13.

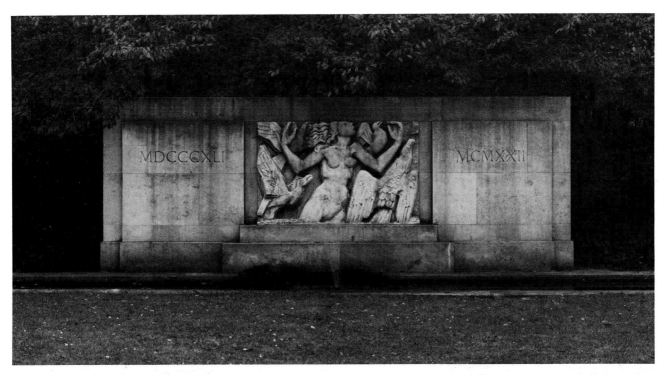

Jacob Epstein: **W.H. Hudson Memorial**, (Rima) 1925.

he could not have foreseen the virulent outcry that ensued even before the hoardings had been removed. A letter from Sir Charles Holmes to *The Times* described the sculptures as 'in the grave, heroic mood of pre-Pheidian Greece.'[7] This austere mood was commented on by Laurence Binyon, Charles Ricketts, Charles Shannon, and Sir Martin Conway, all of whom rebutted the charge of gross indecency which had been levelled at the sculptures. At their meeting of 1 July 1908, the B.M.A. Council reaffirmed their intention of proceeding with the commission, after taking advice from Sir Charles Holroyd, Director of the National Gallery.[8] Similar squeals of outrage were provoked by Epstein's **Tomb of Oscar Wilde** at Père Lachaise cemetery, Paris, in 1912. The French authorities kept the tomb covered with a tarpaulin until the outbreak of the 1914-18 War, when it was discreetly exposed to public view once again.

The next onslaught on a commissioned work by Epstein was directed at **Rima**, the memorial to the naturalist and writer, W.H. Hudson, erected in the Bird Sanctuary of Kensington Gardens in 1925. This beautiful bas-relief was inspired by a passage from Hudson's eponymous poem which describes Rima's fall to her death from a treetop, and is indirectly based on the Ludovisi Throne.[9] One of the signatories to a letter demanding the removal of **Rima** was the then President of the Royal Academy, Sir Frank

Dicksee, a fierce opponent of modernity in art. The monument was daubed with green paint in November 1925, but Epstein had powerful supporters among respected artists and critics; many students from the Royal College of Art and from the Slade School also signed a petition against its removal. Despite a vicious press campaign led by the *Morning Post*, the memorial was left in position. Thus it was courageous of Charles Holden, supported by Frank Pick of the London Passenger Transport Board (as it was later to become), to recommend Epstein as one of the leading sculptors in a scheme for the decoration of the new L.P.T.B. headquarters above St. James's Park Underground station in 1928. Epstein's carvings of **Night** and **Day** over the north-east and south-east doors, respectively, aroused mixed feelings among the critics, and **Day** was regarded as more difficult to accept. Sir Reginald Blomfield, a past President of the R.I.B.A., launched an attack against 'The Cult of Ugliness', but since he was later to recommend the

[7]*The Times*, 23 June 1908, p.16. Other correspondence is reprinted in Jacob Epstein, **Epstein: An Autobiography**, London, 1955, pp.23-41, and Appendix I.
[8]*The Times*, 2 July 1908, p.10.
[9]**Epstein: An Autobiography**, pp.110-14, and Appendix IV, pp.263-270, reproduces Sir Muirhead Bone's memorandum to H.M. First Commissioner (Viscount Peel), setting out the history of the commission and establishing not only that full consultation with the authorities had taken place but that full approval had been given by them.

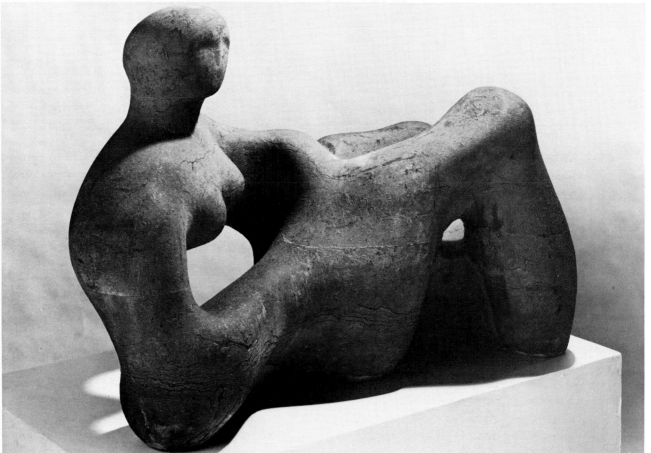

Henry Moore: **Recumbent Figure**, 1938.

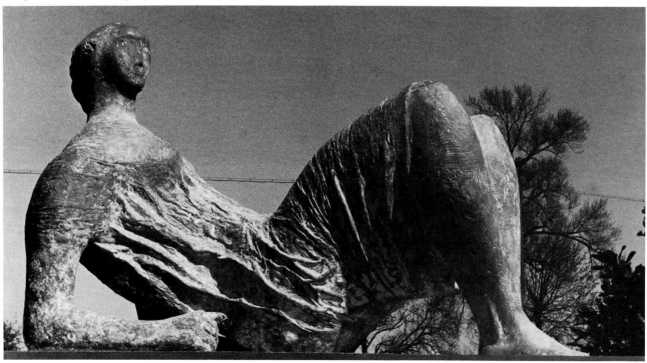

Henry Moore: **Draped Reclining Figure**, 1952-53, Time-Life Building, London.

total rebuilding of Nash's Carlton House Terrace in a Beaux-Arts classical style, he was not above 'vandalism' in the name of progress. R.H.Wilenski had no doubt, however, that these two works were 'the best things that Epstein has yet done.'[10] Whatever may have been the technical drawbacks of the St. James's Park scheme, the principle it embodied of attempting to fuse architecture and monumental sculpture into an organic whole again, but in a modern idiom, was a sound one. Henry Moore, who was given his first public whole again, but in a modern idiom, was a sound one. Henry Moore, who was given his first public commission by Holden at St. James's Park, carved a bas-relief, **West Wind**, cutting it as deeply as he could. In retrospect (1944) he recalled his reluctance to undertake the work: 'relief sculpture symbolised for me the humiliating subservience of the sculptor to the architect, for in ninety-nine cases out of a hundred, the architect only thought of sculpture as a surface decoration, and ordered a relief as a matter of course.'[11] In 1934, after some discussion and preliminary design work had been done, he refused an invitiation from Holden to carve eight bas-reliefs for the new Senate House of London University. Later, when Serge Chermayeff asked Moore to consider a suitable site for one of his sculptures in relation to a new house Chermayeff was building for himself in 1936, Moore felt this to be the right approach. He carved a **Recumbent Figure** (1938) and it was placed on an open terrace overlooking the Sussex downs. ◀ This was afterwards bought by the Contemporary Art Society and presented by them to the Tate Gallery. After the war, Moore worked in close co-operation with Michael Rosenauer on the Time-Life Building, for which he designed a stone screen and a bronze **Reclining Figure** in 1952-3. ◀

If Epstein was consistently attacked for alleged indecency and ugliness in his public monuments, other sculptors had to endure vituperative criticism for shortcomings of a different kind. The sculptor Alfred F. Hardiman (elected A.R.A. in 1936) was commissioned to execute an equestrian statue of **Field Marshal Earl Haig** for a prime site in Whitehall, ◀ not far from Sir Edwin Lutyens's **Cenotaph**. Hardiman's design had been selected from a short list of three by an expert committee, but the First Commissioner had only agreed to allow the work to proceed after the sculptor modified his design to meet criticisms from military and veterinary experts. A second leader published in The Times on Armistice Day 1937, the day the statue was unveiled, refers to

'ten years delay . . . and controversy,' and another writer recorded that 'it had taken the artist six years to surmount difficulties and opposition.'[12] Somewhat tongue in cheek, perhaps, The Times leader writer suggested that '. . . Mr. A.F.Hardiman's work possesses those qualities of vigour and distinction which always divide the opinion of the critics.' The previous day a fellow sculptor, Charles Wheeler, later to become a President of the Royal Academy, had explained in a letter to The Times that '. . . the chief criticism has been that the horse is not like the sort of horse a Field Marshal would ride, but it should be remembered that a bronze horse is not a flesh and blood horse, nor are any of the great equestrian statues of the world photographs in the round as it were of horse and rider. . . . Vituperation, prejudice and misrepresentation have followed the sculptor from the beginning, and I submit he should now be given credit for his labours.'[13] Today, the stylization of horse and rider seems innocuous enough; there is a compromise in the treatment of Haig's cloak, body, and the horse he rides, all of which are more stylized than the portrait head of the Field Marshal. Even the Marshal's son could not refrain from backhanded criticism: 'Whatever may be the technical faults of the horse, it is at the rider one looks, and that is as it should be. The whole [statue] gives one a very vivid impression of strength and calm. . . . This statue has strength and originality. . . .'[14] Sir George Frampton, sculptor of the **Peter Pan** monument in Kensington Gardens ◀ (1912, and with which Epstein's **Rima** was later unfavourably compared by some critics), was criticised for his **Edith Cavell Memorial**, erected in St. Martin's Place, London, in 1920. ◀ Here, the combination of a 'modernistic' base and bulky cruciform vertical feature with a figure in more traditional portrait style does seem incongruous.

War memorials provided sculptors with many opportunities up and down the land in the aftermath of the appalling carnage of the First World War. Every town and village commissioned some form of memorial, more often than not from a local firm of

[10]Evening Standard, 1 July 1929.
[11]**Henry Moore On Sculpture**, op.cit, p.97. For Moore's recent comment see Dennis Farr, **English Art 1870-1940**, Oxford 1978, p.251 and n.
[12]The Times, 11 November 1937, p.15, p.16; Stanley Casson, 'The Statue of Marshall Haig' in R.S.Lambert (ed.), **Art in England**, London, 1938, p.149. The military were said to be scandalized that Haig was to be represented hatless!
[13]The Times, 10 November 1937, p.10.
[14]The Times, 15 November 1937, p.9, a report of Lord Haig's speech to the Oxford City branch of the British Legion.

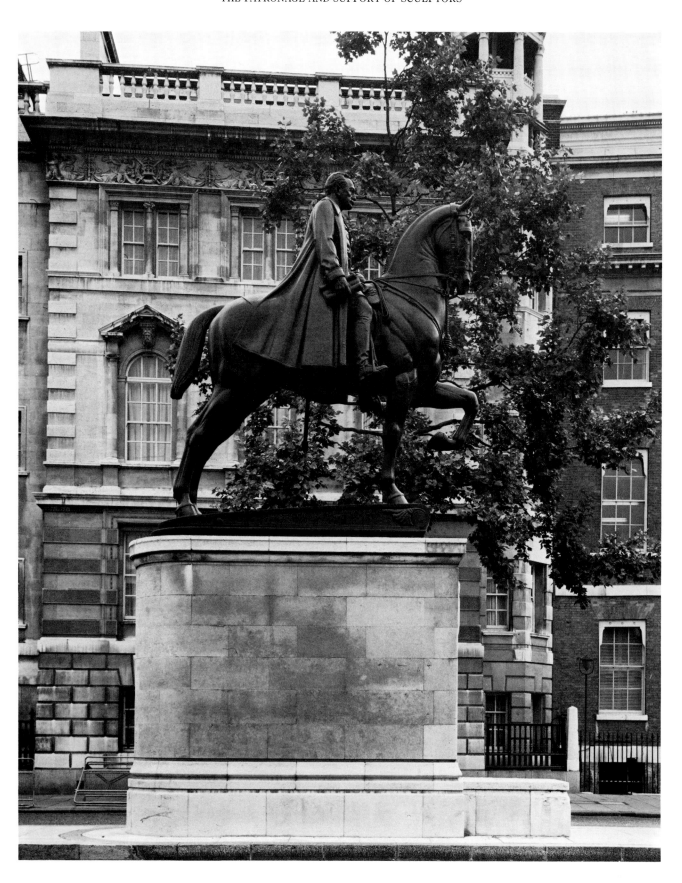

Alfred Hardiman: **Field Marshal Lord Haig**, 1936.

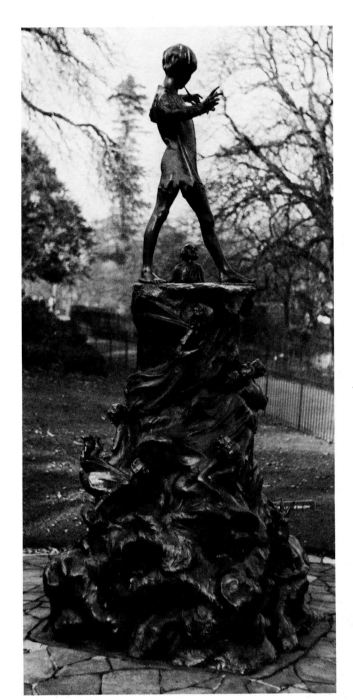

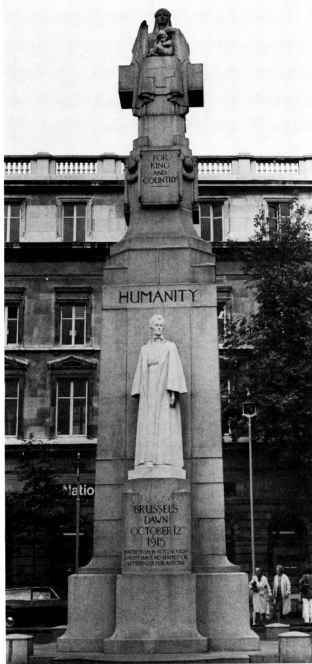

George Frampton: **Peter Pan**, 1912.

George Frampton: **Edith Cavell Monument**, 1920.

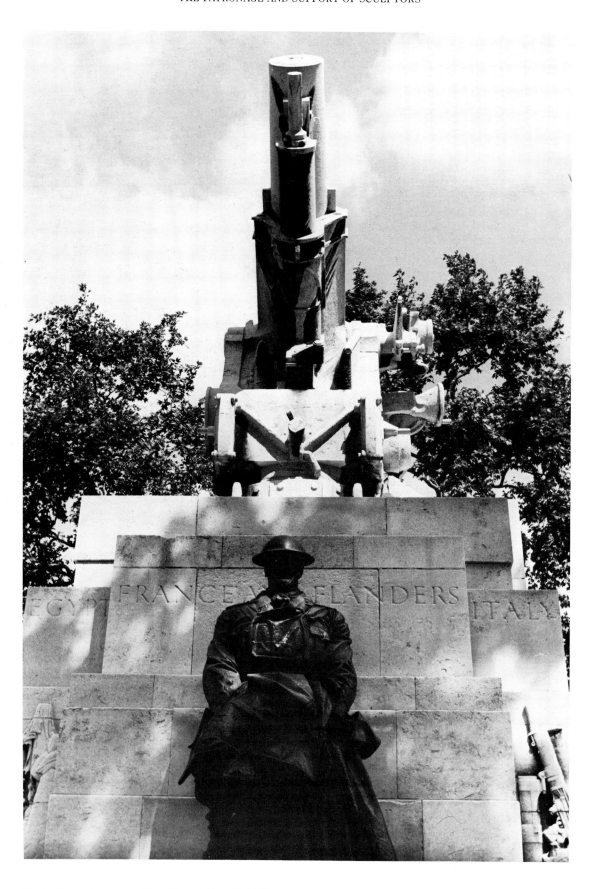

Charles Sargeant Jagger: **Artillery Memorial** (detail), 1925.

monumental masons. It can also be argued that the
great demand for such memorials, predominantly in a
traditional format, led British sculptors to opt for an
unadventurous, conventional style, which set back
the cause of modern sculpture in this century for over
a decade. In London and other great cities, ambitious
schemes were adopted, such as the **Hall of Memory**
in Birmingham (1923-24). This is a Portland stone
'Palladian' octagon by S.N. Cooke and W.N. Twist, with
four bronze sculptures by Albert Toft representing the
services. It has been crisply dismissed by Nikolaus
Pevsner as 'insipid'. Perhaps the least controversial
war memorial is Lutyens's **Cenotaph** (1919-20), an
architectural rather than a sculptural monument,
conceived without effigies or statues and consisting
of subtly proportioned slabs set just off the vertical.
Quite different in style and conception is the **Royal
Artillery Memorial**, Hyde Park Corner, by Charles
Sergeant Jagger, 1925. This monument is
dominated by a stone howitzer, around which stand
bronze sculptures of helmeted artillery men in a mood
of sombre remembrance. The aesthetic propriety of
including a stone representation of a howitzer was
questioned at the time, but like the **Haig Memorial**,
we have long since become accustomed to the work
and have accepted its symbolism. A more traditional
monument, by Derwent Wood, is the **Machine Gun
Corps Memorial**, also at Hyde Park Corner, and
put up in the same year as the **Artillery Memorial**.
This consists of a bronze statue of a naked youth with
a sword and is an allusion to David's Victory over
Goliath. Both this and Jagger's **Artillery Memorial**
should be contrasted with W. Robert Colton's **Royal
Artillery Memorial** for the South African War, of
1910, sited opposite the Duke of York's Steps. Colton's
work is conceived in the ambitious, rhetorical mood of
imperial grandeur which was no doubt felt to be fully
appropriate at the time. Regiments commissioned
these memorials, after having raised money by
subscription from their members and relatives. A
study of the war memorials for the Boer War and the
1914-18 War reveals an interesting change in attitude
to death in battle. The earlier monuments tend to
stress the glory of dying for one's country; those for
the First World War often bear mute witness to the
huge number of soldiers, sailors, and airmen actually
killed. Their names are listed, row after row of them,
on panels set into the monuments. The 'Lost Million'
remained a terrible national trauma long after the war
was over. **The Guards Memorial** (1923-26), by Gilbert
Ledward and H.C. Bradshaw, sited opposite Horse

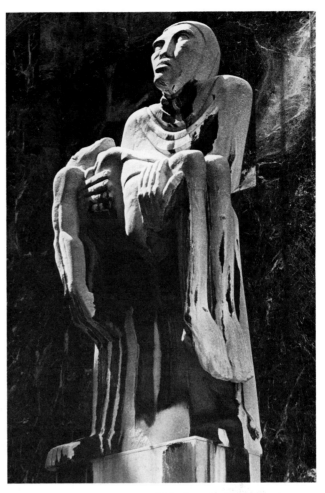

Jacob Epstein: **TUC War Memorial**, 1958, Congress House, London

Guards Parade, is a dignified roll-call of battle honours
of the five Guards' Regiments, carved in a sans-serif
face. Each of the five bronze guardsmen, who stand
on a low pedestal in front of the stone central block,
is set in a subtly varied pose. Some of the memorials
were the first major public works to be done by the
new generation of sculptors. This is true of the **24th
Division Memorial** in Battersea Park, which was
commissioned in 1924 from Eric Kennington, and he
modelled the face of one of the figures on that of his
friend Robert Graves.[15] On the other hand, Kenning-
ton's recumbent effigy of **T.E. Lawrence**, completed in
1939 for the Church of St. Martin, Wareham, Dorset,
was frankly based on medieval prototypes and is
completely different in conception. After the Second
World War one senses yet another mood, and the
nation's fallen were often commemorated by adding
their names to the memorials for those killed a

[15]Dennis Farr, 'Sculpture in London since the War' in *Country Life*,
14 November 1963, p.1241; Richard Buckle, **Jacob Epstein. Sculptor**,
London, 1963, p.403-5 for illustrations.

generation earlier. Yet again, Epstein struck a new note when asked to design a memorial to Trade Unionists killed in both wars for the new Trades Union Congress headquarters, Great Russell Street, which he completed in 1958. ◣ It was a carving in the traditional mode of a Pietà, and developed a theme the sculptor had explored in his figure of **Night**. Now, however, the mother clasps her dead son in distraught fury at her bereavement.[16]

There is another reason for the change in artistic convention which appears not only in some of the post-1918 war memorials but also in the work of the sculptors of the modern movement. This is the example set by Rodin in his **Burghers of Calais** (1895) of which a bronze cast was set up in Victoria Tower Gardens, Westminster, in 1915. He had intended the original group to be set at pavement level in the main square of Calais, so as to emphasize the link between the living and the dead; to remove the sculptural hero from his pedestal.[17] Although Rodin's group at Westminster was originally sited on a high pedestal, it has now been set on a low platform. While the pedestal has not been completely banished, for much contemporary sculpture it is either unnecessary or has been reduced to vestigial proportions. Moore's **Recumbent Figure**, referred to above, is always exhibited on a low pedestal, as are most of his reclining figure sculptures.

In medieval times the Church was one of the chief patrons of sculptors and architects. In the twentieth century, four new cathedrals have been built in England (Liverpool, Guildford, and Coventry: Anglican; and Liverpool: Roman Catholic), while the interior decoration of a fifth, Westminster, has continued. Some enlightened clergy have also commissioned fine sculpture, stained glass, and paintings for these cathedrals, and for their parish churches. I can do no more than discuss a few of what seem to me to be the most interesting of the sculpture commissions. I begin with Eric Gill's **Stations of the Cross** for Westminster Cathedral, which he completed between 1913-15. Carving in Hopton Wood stone, Gill tried adding touches of colour but removed them, preferring the carving to stand on its own. ◣ After his death, the Church authorities had the haloes gilded and the inscriptions coloured in red. The **Stations** have a Giottesque nobility and Gill's hard, linear style seems perfectly suited to the conventions of bas-relief carving. The next major breakthrough came in 1943, when Walter Hussey, as Vicar of St. Matthew's, Northampton, commissioned for his church a **Crucifixion** from Graham Sutherland and a **Madonna**

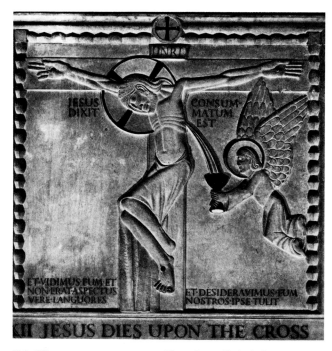

Eric Gill: **The Stations of the Cross**, Westminster Cathedral, 1913-18.

and Child from Henry Moore. ◣ Two leading modern artists were thus called on to serve the Church, and it must have required special tact and persuasion for Dean Hussey (as he later became) to convince both the artists and his Diocesan Advisory Board of the wisdom of his proposals. Moore has spoken of his initial reservations, but he agreed to make preliminary sketches and clay models. The mother and child theme was one of two which had constantly recurred in his work, but as a secular subject and he had now to consider how religious art differed: 'It's not easy to describe in words what this difference is, except by saying in general terms that the **Madonna and Child** should have an austerity and a nobility, and some touch of grandeur (even hieratic aloofness) which is missing in the everyday Mother and Child idea.'[18] The sculpture was actually donated by Hussey's father, Canon J. Rowden Hussey, and Moore carved it from Hornton stone between September 1943 and February 1944. Moore carved another **Madonna and Child** for St. Peter's, Claydon, Suffolk, in 1948-49. A few years later, in 1950, the nuns of the Society of the Holy Child Jesus commissioned Louis Osman to design a bridge to span their two eighteenth-century houses in

[16]Information from Sandy Nairne.
[17]Albert E. Elsen, **Origins of Modern Sculpture: Pioneers and Premises**, London, 1974, p.116.
[18]**Henry Moore on Sculpture**, op.cit, p.220.

THE PATRONAGE AND SUPPORT OF SCULPTORS

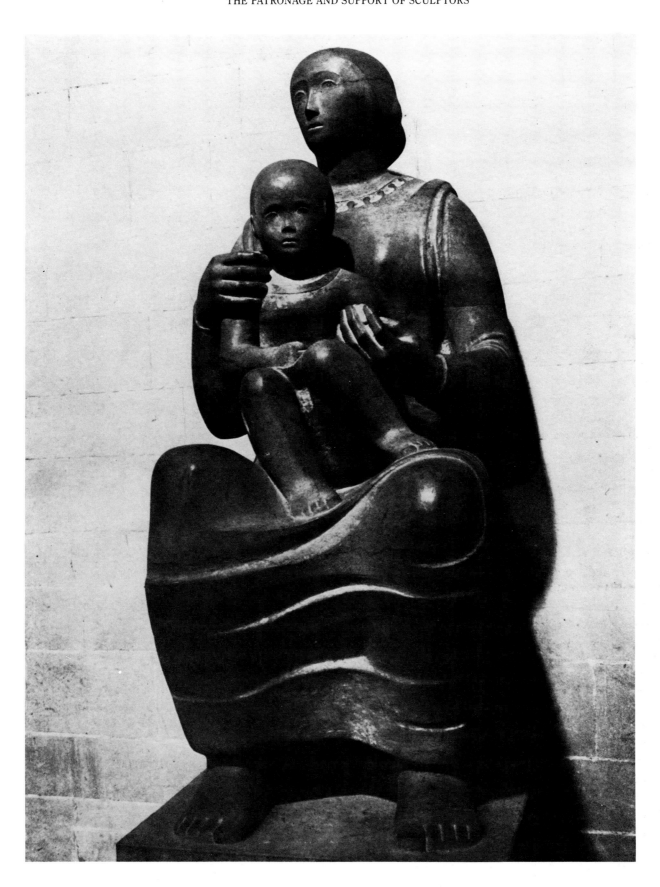

Henry Moore: **Mother and Child**, Church of St. Matthew, Northampton, 1943.

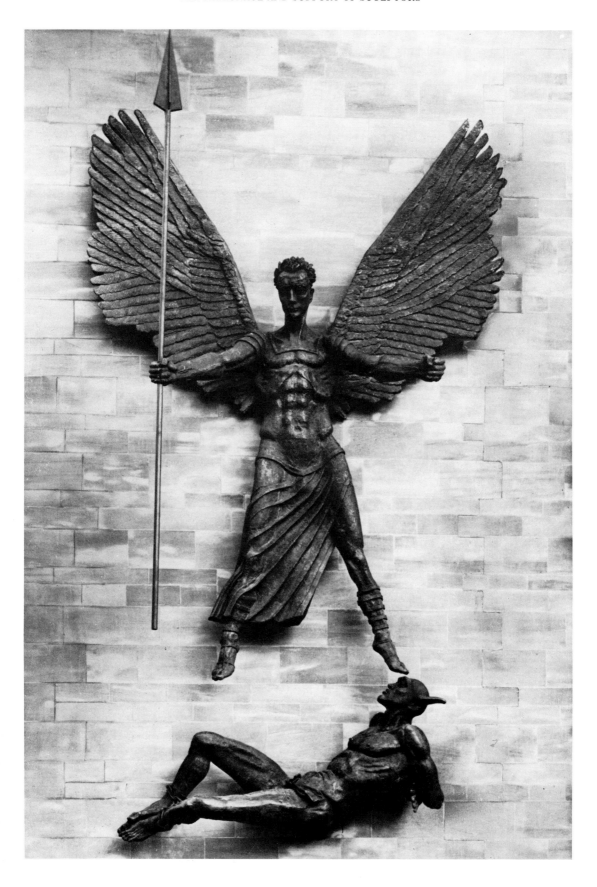

Jacob Epstein: **St. Michael and the Devil**, Coventry Cathedral, 1957.

Cavendish Square, London, and he planned to have a monumental sculpture as a focal point of the unfenestrated bridge. Epstein was secretly approached and was delighted to accept. The **Madonna and Child** was cast in lead and placed in position on Ascension Day 1953, to be unveiled by R. A. Butler, then Chancellor of the Exchequer, in May of that year. Arguably one of Epstein's finest religious works, it marks a public reconciliation towards some of his sculpture and a recognition of his greatness. His stone carving **Lazarus** (1948), with its echoes of late Michelangelo, was bought in 1952 for the chapel of New College, Oxford. Other major commissions followed: the **Christ in Majesty** for Llandaff Cathedral in 1957, **St Michael and the Devil** for Coventry Cathedral in 1959, ■ and among the secular commissions were the statue of **Field Marshal Smuts** in Parliament Square (1955), and the **Bowater House Group** (1959).

When Moore voiced his misgivings about the subordinate role too often accorded sculpture by architects and planners, he was only echoing a complaint made forty years earlier. Spielmann records a story of one architect who, when it came to settling up with the sculptor whom he had sub-contracted to adorn his building, simply sent him a small cheque for what the architect felt he could spare after the client had paid him for the completed building.[19] One hopes that a more equitable arrangement was made between the architect, H. S. Goodhart-Rendel, and Frank Dobson for the glazed pottery reliefs which Dobson made for the river façade of Hay's Wharf (1931-32). Here is a building in a recognisably modern idiom, and Dobson has integrated his art déco reliefs with the general design so well that one feels he was brought into the discussions at a very early stage. Another successful collaboration between architect and sculptors took place over the fountains in Trafalgar Square commissioned by Parliament as memorials to Lords Jellicoe and Beatty, whose portrait busts are sited in the terrace wall behind the fountains. Designed by Lutyens in 1936-37, the fountains are embellished with bronze mermen and mermaids by Charles Wheeler and William McMillan, which were not completed until 1948. Both sculptures are agreeably unpompous and they have a Scandinavian air. Although the Festival of Britain commissions are discussed elsewhere, the example set by joint state and municipal sponsorship of the arts on this scale undoubtedly rekindled private patronage. One must also remember that at the 1948 Venice Biennale

Moore carried off the International Prize for Sculpture, the first Englishman ever to do so. Four years later at the 1952 Biennale, Britain was represented by a formidable group of younger sculptors: Robert Adams, Kenneth Armitage, Reg Butler, Lynn Chadwick, Geoffrey Clarke, Bernard Meadows, Eduardo Paolozzi, and William Turnbull. The first of the open-air sculpture exhibitions took place in Battersea Park in 1948, followed by others in Glasgow (1949), Battersea Park and Holland Park. One result of the Battersea Park exhibition was the gift to the L.C.C. (now G.L.C.) of Moore's stone **Three Standing Figures** (1947-48) from the Contemporary Art Society, as a permanent landmark in the park. There was a new feeling of self-confidence. For in addition to the post-war public sculpture already mentioned, there were a number of private initiatives in the 1950s and 1960s which show that sculpture had begun to capture men's imagination once again. Thorn Electrical Industries commissioned Geoffrey Clarke to produce a bronze sculpture for the exterior of the tower block of their new Upper St. Martin's Lane headquarters in London. Clarke evolved a piece, completed in March 1961, which symbolized the darting power of electric current. A thin, spiky central rod, based on the filament of an electric light bulb, is combined with a section of a bulb case. In 1956 Barbara Hepworth produced a copper sculpture, **Theme on Electronics,** for the window of Mullards, Torrington Place, London, and subsequently made two monumental works for commerce. The fifteen foot high bronze **Meridian** was commissioned for State House, High Holborn, in 1958 and was unveiled in March 1960; the John Lewis Partnership commissioned an eighteen foot aluminium **Winged Figure** for the exterior of their Oxford Street store in 1962, and this was placed in position in the following April. Gilbert Ledward's fountain in Sloane Square, which was completed in 1952, is a much more intimately scaled work. On the drum below the basin is a bas-relief commemorating King Charles II and Nell Gwynne. Quite different in scale and format is the thirty foot high totem-pole like fountain by Franta Belsky (1962), commissioned by the G.L.C. and sited at the Shell Centre, South Bank. The fountain has clusters of scallop shell basins around the stem down which the water gently cascades. A more traditional piece is David Wynne's **Girl with a Dolphin** (1973), sited further downstream on the north bank of the Thames by Tower Bridge. This is

[19]Spielmann, op.cit, p.10-11.

a considerable technical tour de force, involving a careful counterbalancing of the two figures of swimming girl and dolphin within a vertical spiral around the central jet.

Perhaps the most sustained attempt at the integration of sculpture and architecture in the early 1950s at least, was the Time-Life Building, where Moore was not only commissioned to do the **Screen** which overlooks New Bond Street at second-floor level, but also agreed to sculpt a **Reclining Figure** in bronze for the terrace behind the **Screen.** The four elements in the pierced stone screen were originally meant to pivot on vertical axes, but practical difficulties and the building regulations conspired to kill the idea. The **Screen** successfully complements the austere, rectilinear character of Michael Rosenauer's architecture; but the **Screen** can best be seen only at an angle from Conduit Street, since Bond Street is so narrow, and it is placed at a height which makes it difficult to appreciate its qualities to the full. On the steel transom over the main entrance to the Time-Life Building in Bruton Street there is a nickel-bronze abstract **Symbol of Communications** by Maurice Lambert. The interior design of the building was co-ordinated by Sir Hugh Casson and Sir Misha Black.

The significance of the series of open-air sculpture exhibitions at Battersea and Holland Park, and of the series of sculpture commissions for the post-1945 new towns at Harlow and Stevenage, of the sculpture commissions for schools initiated by Hertfordshire Education Committee, is dealt with in greater detail by Richard Calvocoressi. It would be wrong to claim that these pioneering efforts created a completely new climate for sculpture overnight, and that a new age of civic patronage had dawned. The history of events since the 1946 Act which allowed local authorities to spend up to sixpence (or 2.5p decimal) in the £1 per annum of the General Rate Fund on cultural activities shows not only that virtually no authority took full advantage of this, but also how unevenly spread across the country are those municipalities who have tried to fund the arts as generously as other, more pressing, economic demands would permit. Nevertheless, much has happened in the public sector since 1945, and more particularly since the 1960s, which provides solid evidence that the idealism of the immediate post-war era continues to bear fruit. We have discussed sculpture in an urban setting and this also continues to provide opportunities to contemporary sculptors. Even more recently, sculpture in a rural or

parkland environment has again become a live issue. Sculpture in the open air is hardly a new idea, and one thinks of the formal splendours of Versailles or, nearer home, of the magnificent eighteenth-century gardens at Stourhead. Permanent open-air museums of sculpture had been established at Middelheim Park, Antwerp, and at the Rijksmuseum Kröller-Müller, Otterlo, in the early 1950s. Not until September 1977, however, did we in this country open a permanent open-air sculpture park, significantly, perhaps, in Yorkshire, the home county of two of our most famous contemporary sculptors. This was the Yorkshire Sculpture Park at Bretton Hall, eight miles from Wakefield.

Sculptors have themselves fostered the idea of setting their work in the open air. The fields adjoining Moore's house at Much Hadham have been gradually converted by him into a landscaped estate in which he has placed stone and bronze sculptures at the end of vistas or walks, or in more open settings according to the nature of the work. The element of surprise plays its part. The late Barbara Hepworth set some of her work in the luxuriant garden of her house at St. Ives, Cornwall. F.E.McWilliam's garden in London also contained some of his late 1930s stone sculptures; and Reg Butler, Anthony Caro, Chadwick and Paolozzi have experimented with work set out in their own backyard, so to speak. Perhaps the first private patron to do this on the grand scale with contemporary work was the late Sir William Keswick, who, with the sculptor's advice, decided in 1955 to site Moore's bronze group **King and Queen** (1952-53) on a natural rocky outcrop on his moorland estate at Glenkiln Farm, Shawhead, Dumfries. ◀ In addition to a **Standing Figure** by Moore, ◀ he later bought **Upright Motive No. 1,** generally known as the **Glenkiln Cross** (1955-56), which he put on a hillside spur overlooking a loch on the estate, and **Two-Piece Reclining Figure No. 1** (1959). Sir William already owned Epstein's **Visitation** and Renoir's **Madame Renoir.**

The work of the Arts Council at home and of the British Council abroad in promoting British artists since 1945 cannot be too strongly emphasised. They have not only organized exhibitions of individual artists and group shows, but have also bought work for their permanent collections. Between 1956 and 1970, for example, the Arts Council (including the Scottish and Welsh Arts Councils) spent £165,000 in building up its collection of some 1200 paintings and sculpture and over 1100 prints and by 1978-79 it was spending

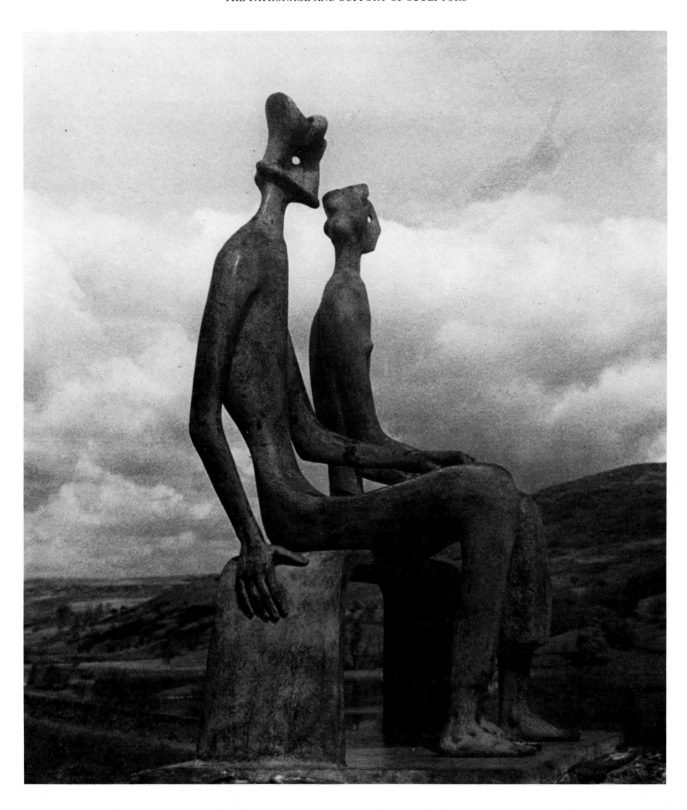

Henry Moore: **King and Queen**, 1952-53.

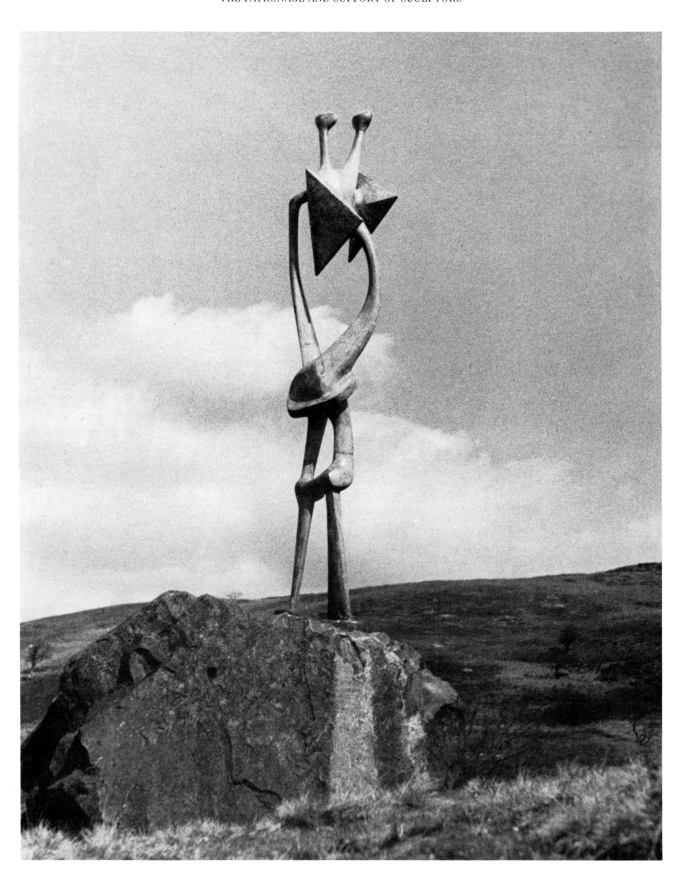

Henry Moore: **Standing Figure**, 1950.

£79,000 a year.[20] Comparable sums have been spent by the Fine Art Department of the British Council. These collections have been used to build exhibitions for touring in Britain and worldwide. At least four private bodies have supported British painters and sculptors: the Peter Stuyvesant Foundation, the Gulbenkian Foundation, the Contemporary Art Society (founded as long ago as 1910 to stimulate the purchase of contemporary art for public collections in this country), and the Institute of Contemporary Art (founded in 1947). Before pursuing the theme of urban sculpture in the late 1960s and 1970s, the emergence of new institutional patrons, especially the newer universities, must be discussed. We have also to consider the role of some of our major museums as 'opinion formers' either directly, through purchasing policies, or more indirectly by setting an example or standard of informed adventurousness. It should be recalled that the Tate Gallery, founded in 1897 as a national gallery of British art, had no independent purchase fund until 1945. The collections were enriched chiefly by gifts and bequests, and the Trustees of the Tate Gallery did not, and still do not have, the power to commission works from artists. During the 1920s and 1930s there was no state aid for artists, and some of the economic difficulties they faced were examined by Francis Watson in his book, **Art Lies Bleeding,** published in 1939. Samuel Courtauld, John Maynard Keynes and others combined as guarantors to form the London Artists' Association in 1925. They guaranteed a number of young painters and sculptors a weekly wage of between £3 to £5, on condition that if the artist earned more than this from the sale of works contributed to the L.A.A. in any one year, he would not draw a salary. The L.A.A. organized exhibitions to promote sales and levied a modest commission to cover their running expenses. Fred Mayor was the first Secretary and later made his name as a distinguished dealer in contemporary art. Frank Dobson and Henry Moore were two sculptor members of the L.A.A. The Association was wound up in March 1934 after having performed valuable service in launching a number of promising new artists who were subsequently to make great reputations for themselves.[21] The chief source of regular income for artists then, as now, came from teaching, either whole or part-time; but today there are many more art schools and thus more opportunities for employment of this kind, despite recent cuts in public expenditure which have affected art education. But artists value their independence, and

often do not wish to become too heavily committed to teaching. The Arts Council has assisted artists since 1968 with grants towards the cost of converting suitable premises into studio and workshop space; this is in addition to the discretionary awards and bursaries which are intended to help individual painters and sculptors prepare work for exhibitions. In 1980-81, for example, the Arts Council made nineteen grants, ranging from £2000 to £6000, from a total of £50,000 allocated for this purpose. No fewer than 670 applications were received, and, wherever possible, each award was to be for a purchase or commission. Since 1965 money has been set aside by the Arts Council to assist in the commissioning or purchase of works of art for public buildings and sites. The success of this scheme, so far as it affects sculptors, will be touched on below.

Although museums cannot normally commission sculpture or paintings, they can provide exhibition space for contemporary work which enables the public not only to see what the latest developments are, but also to see these in a historical context. Retrospective exhibitions of individual sculptors, and international surveys such as the Gulbenkian Foundation's 'Painting and Sculpture of a Decade 1954-64' held at the Tate Gallery in 1964, all help to foster a climate of informed opinion. The Gulbenkian Foundation has also assisted provincial museums to purchase sculpture in one of several schemes designed to promote specific objectives at a time when it felt help was most needed. Apart from the 'Unknown Political Prisoner International Sculpture Competition' organized by the Institute of Contemporary Art and shown at the Tate Gallery in 1953, the Tate has held a series of one-man retrospective exhibitions since 1945, either organized in collaboration with the Arts Council or independently. British sculptors honoured in this way have included: Epstein (1952 and 1962), Moore (1951 and 1968), Hepworth (1968), Paolozzi (1971) Turnbull (1973), Kenneth Martin (1975), and John Latham (1976). Yet the first major anthology of contemporary British sculpture to be shown in London since the war was not held until early 1965 at the Tate Gallery. Organized by James Melvin, Bryan Robertson, and Alan Bowness for the C.A.S. with the financial support of the Stuyvesant Foundation, it included work by thirty sculptors. The established artists were

[20]**The Arts Council of Great Britain Twenty Sixth Annual Report and Accounts 1970-71**, 1972, p.15-26.
[21]Farr, op.cit, pp.236-7, for a summary of the history of the L.A.A.

represented, of course, but many new names appear: Ralph Brown, Anthony Caro, Robert Clatworthy, Hubert Dalwood, Elizabeth Frink, George Fullard, Anthony Hill, John Hoskin, Bryan Kneale, Oliffe Richmond, Matt Rugg, Peter Startup, Brian Wall, Gillian Wise, and Austin Wright. The 'New Generation' exhibition held concurrently at the Whitechapel Art Gallery presented an even younger generation of sculptors. Still more surprisingly, the Royal Academy agreed to open its doors in January 1972 to a lively exhibition of twenty three sculptors' work, 'British Sculptors '72', masterminded by Bryan Kneale, who had been elected an A.R.A. a few years earlier. The Stuyvesant Foundation sponsored the show. Bryan Robertson headed a review of the exhibition 'after this, will the Royal Academy ever be the same?'[22] The answer was to be 'no', and credit for the much more sympathetic attitude must be given to Sir Thomas Monnington, then President, and to some of his like-minded Academician colleagues. Again, familiar names mix with those of younger, and at the time less well-known sculptors, including Kenneth Draper, Garth Evans, Nigel Hall, Martin Naylor, John Panting, Roland Piché, Carl Plackman, William Pye, Christopher Sanderson, Michael Sandle, William Tucker, and Brian Wall. The exhibition was to some extent a curtain-raiser for the City Sculpture Project financed by the Stuyvesant Foundation, with assistance from the Arts Council for the documentary exhibitions which accompanied the sculpture projects in each of the eight cities that participated. The City Sculpture Project was the brainchild of Jeremy Rees, director of the Arnolfini Gallery in Bristol, and Anthony Stokes, who co-ordinated it for the Stuyvesant Foundation. Mr. Rees had seen the success of the 'New British Sculpture/Bristol' exhibition of 1968 and felt that after the Battersea and Holland Park open-air shows, it would be worth commissioning sculpture for specific city centre sites from those sculptors 'who were basically "object makers"'.[23] It was 'to provide an opportunity for sculptors to produce works related to a specific city environment, which can then be evaluated by a general public over a reasonable period of time and with the benefit of additional documentary material.' The eight cities which agreed to provide suitable sites and to help with the preparation of those sites were: Birmingham, Cambridge, Cardiff, Liverpool, Newcastle, Plymouth, Sheffield and Southampton. This was a reasonably good geographical spread and took in a wide band of population. Two centre sites were provided in each city and sixteen

sculptors produced work for an exhibition period of six months. Only Tim Scott's **Walk** at Liverpool was not realized. There was a hope that if any of the sculptures won enough public support the local authorities concerned would purchase the work and site it permanently. At Birmingham, for instance, Nicholas Munro's twenty-foot high fibreglass **King Kong** excited considerable comment, some of it quite favourable, but it was not accepted as a permanent feature. The sculptor took it away after it had adorned a secondhand car dealer's yard ('King Kong Kar Sales') and survived attempts to burn it. Robert Carruthers' oriental-style temple gateway, sited originally at Colmore Circus, was later moved to a central Birmingham housing estate, Lea Bank, where it still stands. Barry Flanagan's four 'totem-poles' grouped around a goalpost-like structure at Laundress Green, and Brower Hatcher's painted steel-wire 'hedge' on Christ's Pieces, both in Cambridge, aroused great ire among local residents, and both were soon mutilated and destroyed! Garth Evans' huge mild steel piece survived at Cardiff, as did Bernard Schottlander's and Kenneth Martin's constructions at Sheffield. William Pye's stainless steel tube and wire rope geometrical structure, sited at Cardiff Castle, explored the idea of a hanging steel curtain later developed in his ill-fated thirty-foot high Æolos at Birmingham (1972-75). ◤ Perhaps the most amusing piece was Luise Kimme's brightly coloured reinforced fibreglass giant 'insect' which appeared to be growing from a wall of the Laing Art Gallery at Newcastle. Two sculptors introduced lighting effects into their sculpture, Liliane Lijn's turning cone had a neon tube spiralled round it at Plymouth, while Nigel Hall's project for the Hyde Park Housing Development, Sheffield, consisted of seven angled searchlight beams set along the ridge of the hill. Other sculptors who took part were: Turnbull (Liverpool), Tucker (Newcastle), John Panting (Plymouth), Peter Hide (Southampton), and Bryan Kneale (Southampton).

William Tucker, in a review of the City Sculpture Project, pleaded for the 'autonomy of Sculpture', and quoting Brancusi as his mentor, insisted '. . . that the making and appreciation of sculpture is a fundamentally *private* activity . . . and if . . . it re-enters the public world, it does so on its own terms, to transform and take possession of that world: the public

[22]*Vogue*, January 1972, n.p.

[23]This, and subsequent quotation from 'City Sculpture', special issue of *Studio International*, January, 1972, p.11. This contains much useful documentary material including contemporary press comments.

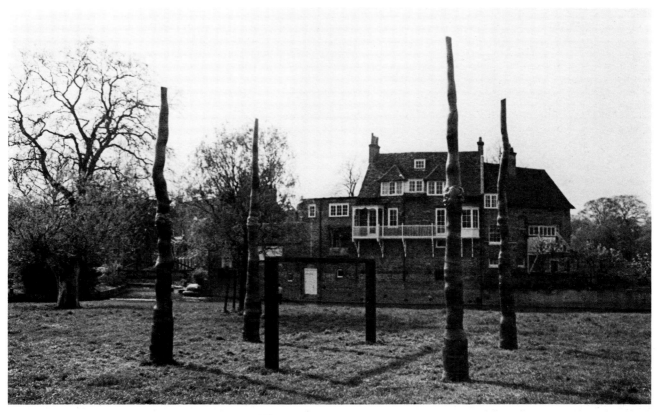

Barry Flanagan: **Peter Stuyvesant City Sculpture Project**, 1972.

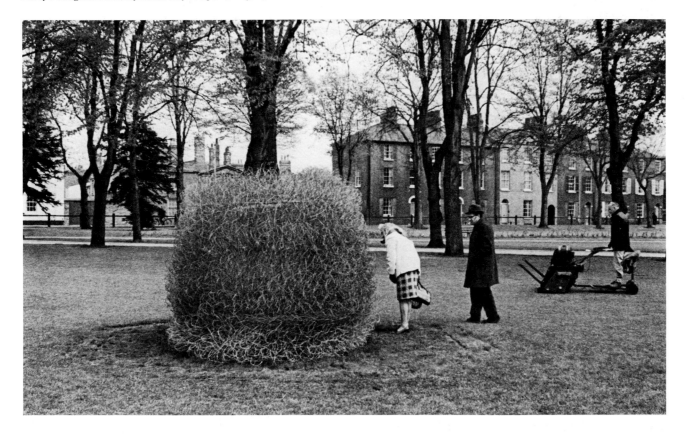

Brower Hatcher: **Peter Stuyvesant City Sculpture Project**, 1972.

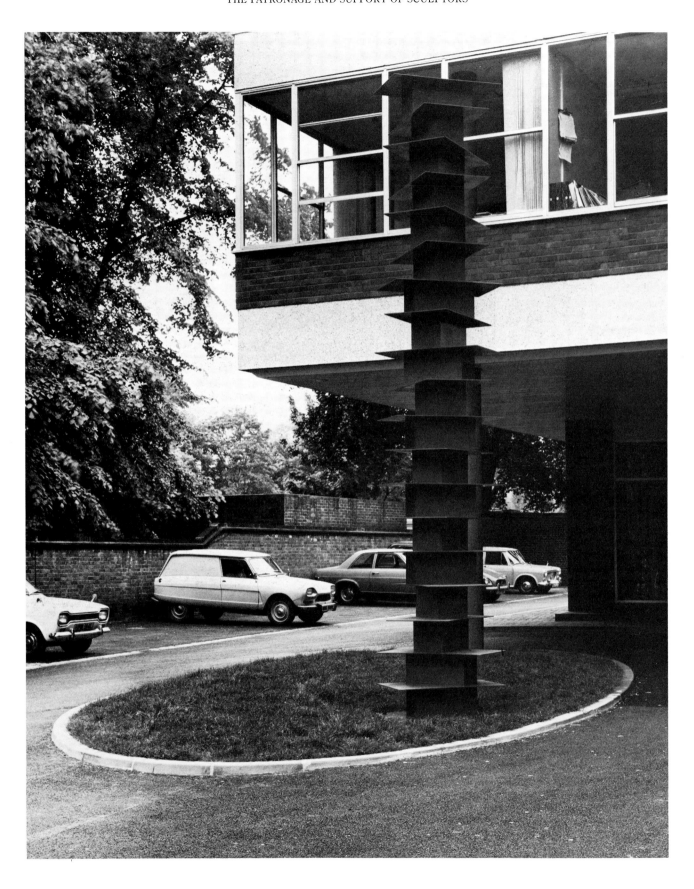

Kenneth Martin: **Peter Stuyvesant City Sculpture Project**, 1972. Now outside Commonwealth Institute, London.

THE PATRONAGE AND SUPPORT OF SCULPTORS

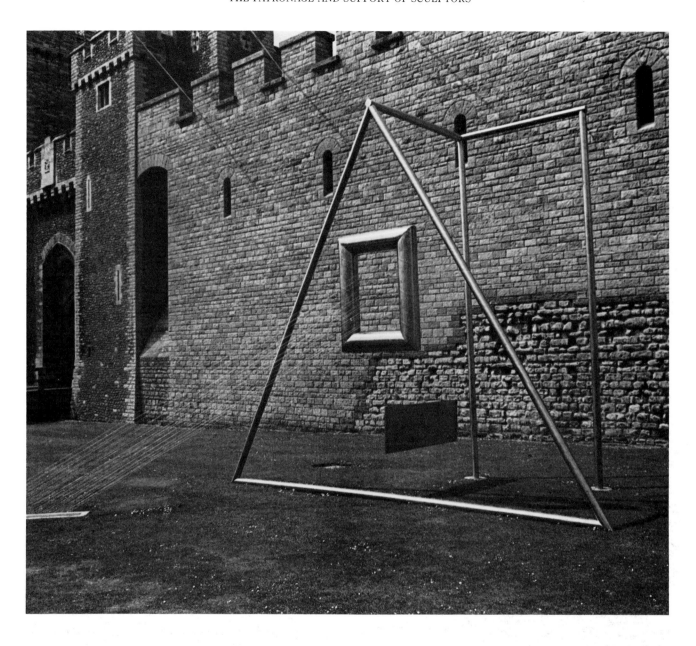

William Pye: **Mirage**, Cardiff Castle, 1972.

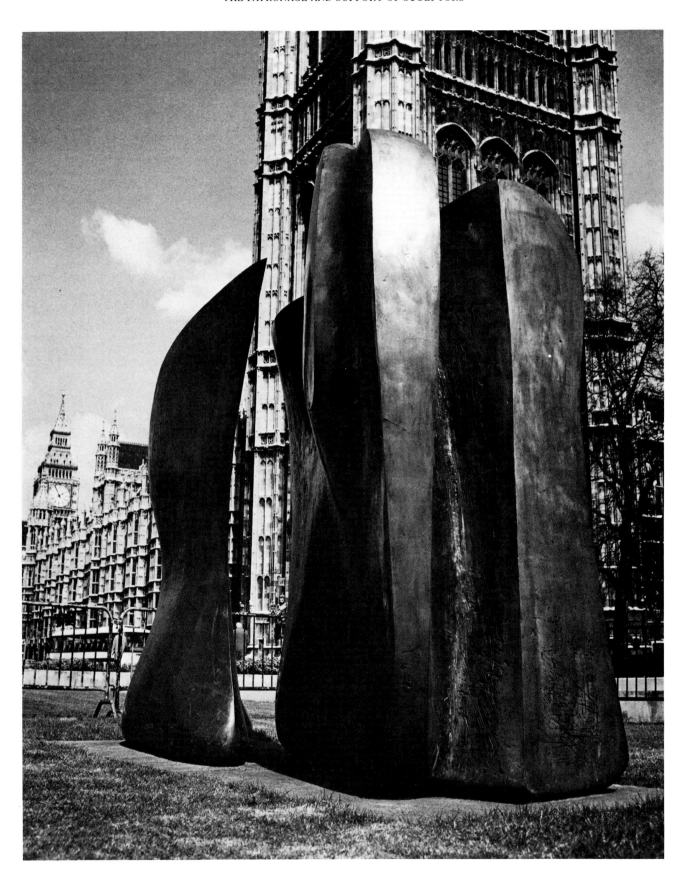

Henry Moore: **Knife Edge Two Piece**, 1962-65.

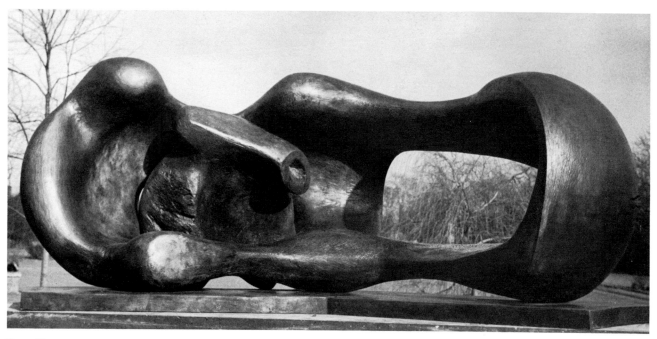

Henry Moore: **Reclining Mother and Child**, 1960-61.

opportunity extends, gives breadth and air, to the private vision.'[24] In contrast to the early Renaissance sculptors' approach, Tucker cautioned against sculptors succumbing 'to do something for the event, rather than using the event to move into new territory, to stretch himself.' The problem in accepting patronage, he seems to be saying, is that one might be coerced into a compromise or that one's private vision could become subverted by the client's requirements. He returns to this theme in his catalogue introduction for 'The Condition of Sculpture' exhibition at the Hayward Gallery, selected by him in 1975. For Tucker, an essential part of the independent life of a piece of sculpture is its quality as a free-standing object. In this he echoes Moore's strongly held view that sculpture must not be subservient to architecture. One wonders what Bernini, pre-eminent both as sculptor and as architect, would have made of this implied dichotomy. Yet there is now a different attitude to sculpture. Free-standing pieces by Moore are sited in prominent positions in London (and indeed in many major cities of the world), such as the **Knife-Edge Two-Piece** (1962-65) ◼ on a green opposite the House of Lords, the monumental **Locking Piece** (1963-64) on the Embankment near the Tate Gallery, and **Reclining Mother and Child** (1960-61) in Birdcage Walk. ◼ Then there are the Moore sculptures in Kensington Gardens and Hyde Park, retained after the 1978 open-air exhibition in response to public demand, and the Hepworths placed on loan in Hyde Park. Perhaps

we are now beginning to recognize the claims of our sculptors.

Several sculpture commissions have come about as a result of support, usually on a 50:50 basis, from the Arts Council which began its Art in Public Places scheme in the mid-1960s to encourage local authorities, universities, and private bodies to collaborate in a long term programme of patronage.[25] The University of Bradford began negotiations in 1972, with a £3000 Arts Council 50 per cent grant, to hold a limited competition for a sculpture on the campus near the Main Building. Eventually, in 1976 Kenneth Draper was commissioned, and in September 1980, his sixteen-foot high **Oriental Gateway** was formally handed over to the University. Under the same scheme Birmingham Polytechnic selected a maquette by Dalwood, from a four-man short-list, in 1969, for a bronze garden sculpture to be sited in the courtyard of the Art and Design Building at Gosta Green. This work was completed in 1974. In 1968, Glasgow University, through its Department of Fine Art, began informal negotiations with Paolozzi about a piece of sculpture, but it was not until the design of the new Hunterian Art Gallery had been more fully developed in the 1970s that Paolozzi accepted

[24]William Tucker, 'Notes on sculpture, public sculpture and patronage' in *Studio International*, January 1972, p.9.
[25]I am indebted to Alister Warman, Anthony Stokes, William Pye, and Deanna Petherbridge for information about recent developments.

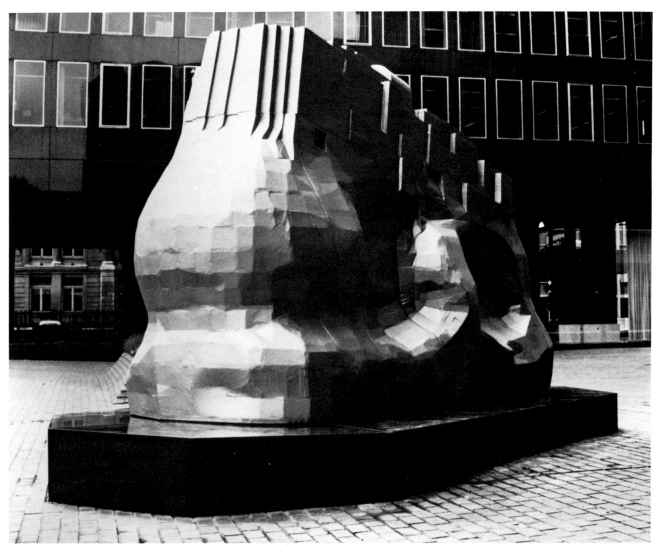

Eduardo Paolozzi: **Euston Head**, 1980.

a suggestion to produce the two bas-relief cast aluminium doors for the main entrance of the gallery, officially opened in June 1980. Paolozzi's latest public commission in this country is for a **Head** recently installed outside Euston station. ☛ This has been sponsored by British Rail and the Fluor Corporation of America. William Pye was selected from a short list of three to produce a sculpture funded jointly by the Arts Council and Lucas Industries in 1972, with the co-operation of Birmingham City Council. As Director of the City Museums and Art Gallery at the time, I was called in to advise my Committee on the project. The total available was originally £5000, and the site was to be on a large newly landscaped area outside the Lucas factory in Birmingham. Pye chose a spot where the ground rose gently above a main roadway and designed a thirty-foot high gantry in tubular steel

from which were suspended two hanging 'curtains' of weighted tubes threaded on steel wires set at an angle to each other. The idea was for the curtains to sway gently in the wind and produce a low melodic chiming. The technical problems were formidable, and the City Engineer's structural experts decreed a massive reinforced concrete base, sunk into the ground, to provide the essential stability. There were protracted planning negotiations before permission was given to go ahead, by which time costs had soared, and the Arts Council increased its grant to £3500, and Lucas Industries eventually almost doubled their contribution. The sculpture, which was now called Æolos, was formally handed over to the City in July 1975. ☛ It received a cautious welcome and looked very splendid against a sunlit sky. Then disaster struck. High winds, aggravated into a vortex by the configuration of the

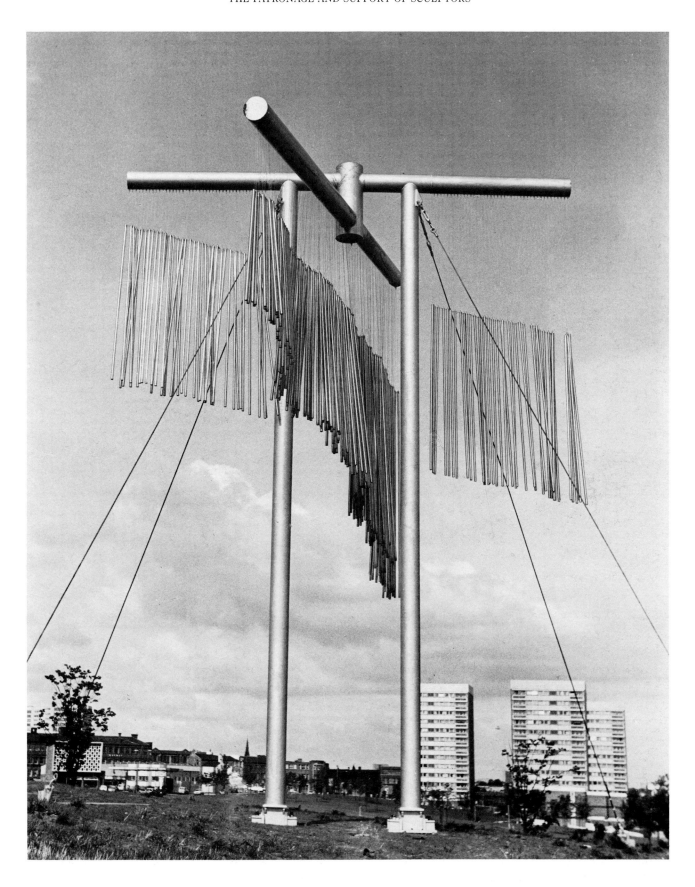

William Pye: **Æolos**, 1975.

Barry Flanagan: **Camdonian**, 1980.

site and adjoining tower blocks of flats, caused the hanging curtains to break loose and hammer against the uprights. The noise was like a steel rolling mill in full production and complaints from irate residents soon flooded in. Temporary repairs, followed by more extensive modifications, failed to correct the fault. No new site could be found, so *Æolos* (or *The Clanger* to locals) had to be dismantled and sold for scrap. Pye has been more fortunate with other commissions. At Kings Cross House, Pentonville Road, he designed a long vertical feature for an exterior wall, which was unveiled in 1974, and cost £10,000. The architects were Chapman, Taylor Partners, and it was Chapman who was responsible for obtaining the commission for Elizabeth Frink's equestrian statue outside the Aeroflot offices in Piccadilly. Pye's **Zemran** (1971), in stainless steel, was placed outside the Queen Elizabeth Hall, South Bank, as a gift from Nadia Nerina to the G.L.C. Miss Nerina paid for the materials and fabrication, but the sculptor agreed to forego a fee.

Anthony Caro's **London West** is an example of joint-funding by the Arts Council (£7500), I.L.E.A., Haomersmith West London College, and the building contractor who between them made up the balance of the total cost of £15,000. Caro was called in at a late stage when the Hammersmith and West London College was almost completed. Another London borough, Camden, funded a sculpture competition from lottery income, and spent £5000 with a further £2500 provided by the Arts Council. Awards of £350 each went to the four competitors invited to submit maquettes (from a field of 35 artists 'living or working in the Borough'), and a first prize of £2000 was won by Barry Flanagan for a fifteen foot sheet steel cut-out form, **Camdonian**. ◣ This witty piece, allusive of antlers or oak leaves, is sited in Lincoln's Inn Fields, and was unveiled in October 1980.

I have suggested some reasons for this encouraging expansion of patronage and support for sculptors since 1945, but it would be remiss of me to omit any reference to the diligent campaign carried on by critics to shape public opinion. In the late 1920s and early 1930s R.H.Wilenski wrote many articles and books sympathetic to modern art, in particular, **The Meaning of Modern Sculpture** (1932) in which he sought to demolish the widely held prejudice that only the ancient Greek ideal (whatever that meant) in sculpture was valid. Herbert Read was also a tireless and provocative propagandist, writing and broadcasting frequently before the 1939 War, and later, as

co-founder of the I.C.A., providing a forum for new ideas. Eric Newton, Robert Melville, David Sylvester, and Lawrence Alloway, in articles, books and exhibitions, all helped to create a more receptive climate. Private collectors, such as Kenneth Clark, Colin Anderson, Robert Sainsbury, Hans Juda, Peter Watson, Eric Gregory, Alistair McAlpine, and Gabrielle Keiller have supported individual sculptors in difficult times. So, too, have certain dealers, notably the Leicester Galleries, Dudley Tooth, Fred Mayor, Rex Nan Kivell of the Redfern Gallery, Dorothy Warren, and Lucy Wertheim before the war. The new post-war generation included Charles and Peter Gimpel, Heinz Roland and his partners in Roland, Browse and Delbanco; Erica Brausen of the Hanover Gallery; Harry Fischer of Marlborough Fine Art (and latterly Fischer Fine Art); and more recently, Alex Gregory-Hood of the Rowan Gallery. The list is not complete. But one man, Henry Moore, by his bluff, no-nonsense Yorkshire manner, has done most to charm the British public into accepting modern sculpture on its own terms. Articulate, sincere, and respected internationally, he has become a household word for modern sculpture in this country.

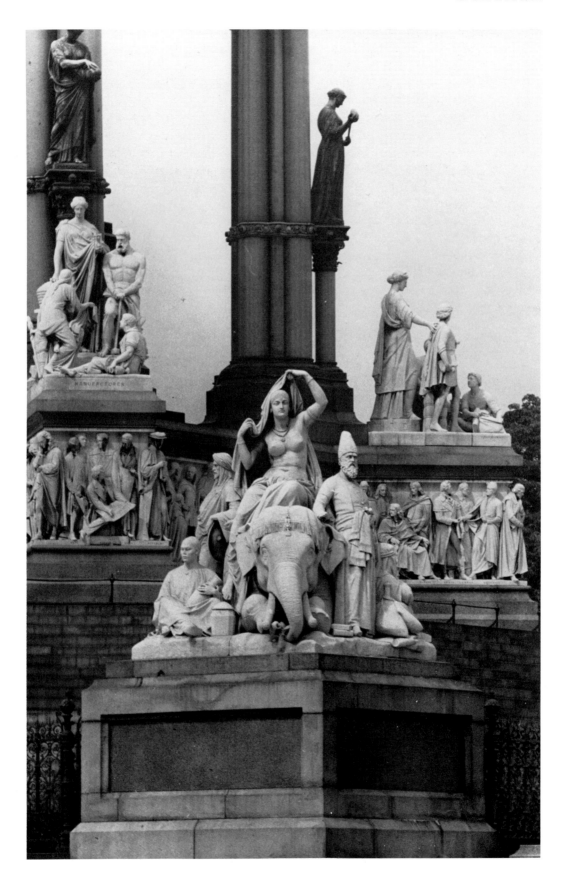

Albert Memorial, general view.

II. Classical and Decorative Sculpture.

The founding of a Society of British Sculptors in 1904 and its subsequent rapid promotion to Royal status (in 1911) could be taken as demonstrating that by the beginning of the twentieth century sculpture had achieved a major position in the artistic life of the nation. The committed artistic observer might agree with Marion Spielmann who opened his **British Sculpture and Sculptors of To-Day** of 1902 with the claim: 'Since the year 1875 or thereabouts a radical change has come over British Sculpture – a change so revolutionary that it has given a new direction to the aims and ambitions of the artist and raised the British school to a height unhoped for, or at least wholly unexpected, thirty years ago.' Much the same opinion was implicit in the writings of Edmund Gosse, Spielmann's fellow sculptural apologist, particularly in the 1890s; a similar assessment was made by a more widely-based critic, Alfred Lys Baldry, in his **Modern Mural Decoration** of 1902, while some time before (as Spielmann acknowledges – and quotes) one of the most established and senior painters of the time, Sir John Millais, had recognised and described the burgeoning of the art of sculpture in this country.

Spielmann was right in a way to detach the sculpture of his time from that of the previous generation – in style, in handling of materials, in formal and conceptual terms: in the sheer range and variety of work then practised, the situation had changed out of all recognition. But in another way, and to an extent still generally unrecognised and unrecorded, the position of sculpture in 1900 owed much to the achievement of the men of the 1850s and 1860s, artists such as John Henry Foley, John Bell, William Calder Marshall, Matthew Noble and others. They had consolidated a career structure and established a framework based on work-type for their profession; by this a livelihood could be obtained (with some difficulty and much labour) via public statues, portrait statues and busts, church monuments, so-called 'ideal' works (representing subjects from literature etc.) and architectural sculpture; and this to a production level of almost industrial proportions. Their symbolic *chef d'oeuvre* was the London **Albert Memorial**, conceived and set up between 1862 and 1876, to which ten of the nation's leading sculptors contributed. ☛

Their achievement was the essential basis on which the major developments of the rest of the century could be launched. These involved changed attitudes to materials, scale, modelling, subject matter, and training – in effect many of the key facets of the art of sculpture. The first big sign of changes came with Leighton's **Athlete Wrestling with a Python** exhibited in 1877. ☛ In subject matter its latent classicism combined with a certain novel idealised naturalism; technically quite new for Britain was the way rippling musculature was modelled, then transferred into bronze. For help in this respect Leighton called on Thomas Brock, principal pupil and technical executor of Foley, one of the major figures of the previous generation; Brock was currently finalising the casting of a number of his master's works and so had considerable experience in handling fine work at this stage of execution.

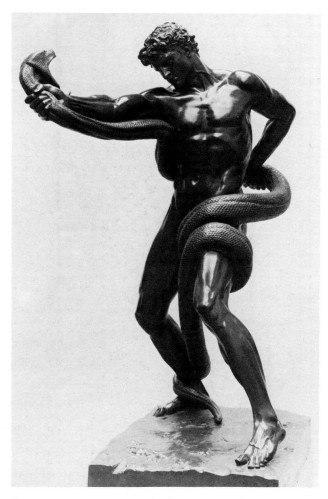

Frederic, Lord Leighton: **Athlete**.

Leighton's concern that bronze should reflect naturalistic modelling at this scale prefigures a major change in attitude to materials. In the 1880s the lost-wax method of casting bronze was revived in England, probably imported from Europe where it was still current. This enabled a much more complex and intricate modelling, particularly of details, to be transferred into the final medium of bronze, allowing a

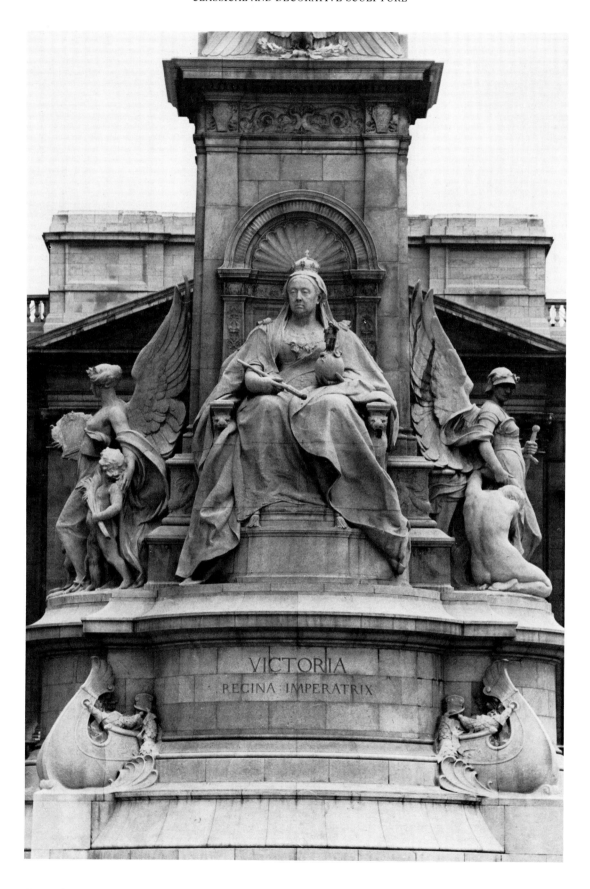

Thomas Brock: **Victoria Memorial**.

dazzling effect to be achieved. This could be in large scale figures entirely or in part cast in this way, or in the more intimately-scaled statuettes which some sculptors (e.g. Gilbert, Thornycroft) produced in series, supervising each individual casting so as not to impair its uniqueness as an art-object; these came to be regarded as an appropriate form of domestic sculpture for the new era. Terracotta now began to be used more often – as a material it could embody much more accurately and crisply the original modelling of details, for instance. Still other sculptors, as we shall see, began to experiment with a much wider range of materials, sometimes incorporating many different substances into a single composition, particularly as a means of including colour.

Two factors undoubtedly encouraged a new attitude to material and formal properties in sculpture. One was a sudden opening up of English insularity to French influences, the other was a considerable shift in emphasis in sculptural education. The presence of the French sculptor Jules Dalou in London in the 1870s affected both of these: quite apart from encouraging Leighton to carry through his initial idea for the **Athlete Wrestling with a Python**, Dalou initiated a new French-based approach to freer modelling in his capacity as teacher at both the National Art-Training School (later the Royal College of Art) and at the Lambeth School; at the latter this coincided with a new, more craft-oriented approach to sculpture teaching from W. S. Frith and John Sparkes. When Dalou returned to France, French influence was maintained through the teaching of Lantéri and Legros, while increasingly a period of training in Paris (or sometimes Italy) became as important for a trainee sculptor as assisting in a London studio had been previously. Meanwhile Leighton, the year after he had exhibited the **Athlete Wrestling with a Python**, became President of the Royal Academy and quickly set about reforming the teaching of sculpture at the Schools there too.

The overall effect of these changes in emphasis came to be felt throughout the decades around 1900. It was sometimes apparent simply in a new dimension to a traditional formula, in the presence, say, of a new formal handling in an established work type. For one must emphasise the extent to which traditional types of sculpture (e.g. portrait statues and busts) continued to be produced. The idea of the Public Monument was a most conspicuous inheritance from the preceding generations, and to the ranks of statues and memorials to Peel, Wellington, Prince Albert –

and many other heroes great and small – the late Victorians added their quota. Queen Victoria provided the most opportunities for commemoration, starting with her Golden Jubilee in 1887. This was the occasion of Alfred Gilbert's **Monument** at Winchester, and the choice of a leading sculptor of the new movement resulted in a work of dazzling formal and technical virtuosity. The Queen's Diamond Jubilee in 1897 followed by her death in 1901 unleashed a plethora of monuments not just in Britain but throughout the far-flung corners of the then rampant Empire. Thomas Brock was chosen as sculptor of the **National Memorial** in front of Buckingham Palace. ◥ He was a suitable choice in certain ways: rooted in the formalism of Foley, tinged with the modified freedom of Leighton, he brought to the principal work of his career a successful blend of academic and novel tendencies. The figure of the Queen is both regal and realistic; the fact that she is surrounded by allegories is traditional though in form these reflect the new fuller modelling; Brock's **Motherhood** on the Memorial ◢ is straight out of French work such as Dalou's **Charity** or Delaplanche's **Education Maternelle**. **Victoria Memorials** by Frampton were set up in Leeds, Calcutta and St. Helen's: the latter in its elaboration again reveals how far the new men had developed their handling of so standard a medium as bronze compared to the blandness of forty years earlier. ◢ The mixed pattern of tradition and innovation applies equally to Gladstone statues – Hamo Thornycroft's London and Glasgow examples show what the new could achieve in formal subtlety (for instance, the almost evanescent reliefs in bronze on the base of the Glasgow statue), while Mario Raggi's Manchester **Gladstone** represents a still valid statement of the creed of Noble (whose pupil Raggi was) and others of that generation. ◢

A more distinctive new strand in the sculpture of the end of the century is that identifiable with a classical allegiance. There had been a colossal neo-classical hangover earlier in the century, but in spite of such achievements as Gibson's **Tinted Venus** of 1851-56, this movement had petered out by the 1870s. The new classicism was based on a fusion of classical and Renaissance sources and ideals: first set out by Leighton in his **Athlete Wrestling with a Python**, it was Leighton who gave a crucial impetus to its subsequent adoption by leading sculptors of a younger generation. Alfred Gilbert's **Icarus** of 1884 is the masterpiece of this genre: its original version was a direct commission from Leighton, provoked by

Thomas Brock: **Victoria Memorial**.

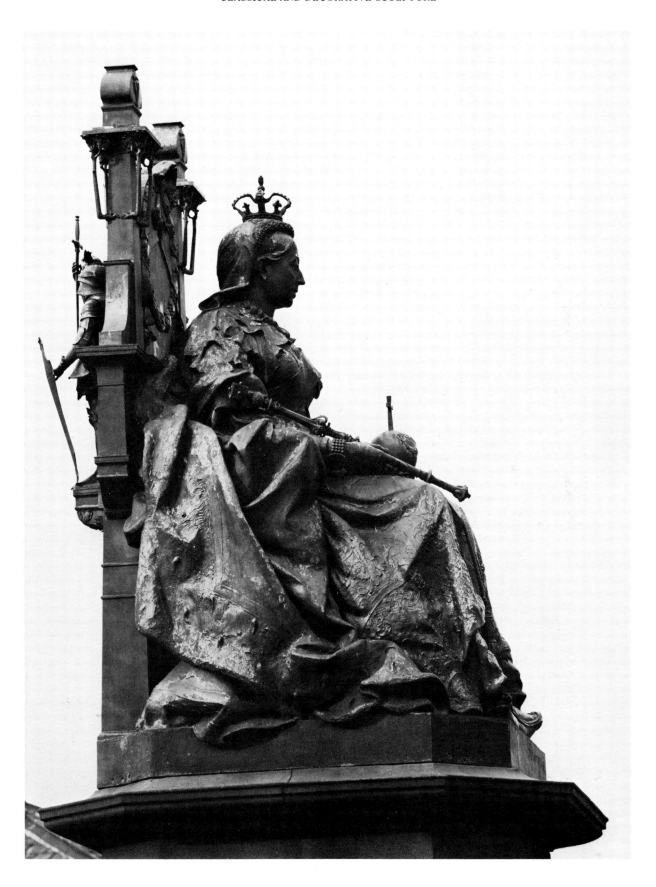

George Frampton: **Victoria Memorial**, St Helen's.

Mario Raggi: **Gladstone**.

Gilbert's **Perseus Arming** of 1882. Their subjects drawn from classical myth, their formal prototypes to be found in Italian Renaissance bronze statuettes, their execution by the lost-wax casting method indicating new technical concerns, these works illustrate the principal polarities of this genre over the following decades. Gilbert's **Eros** (Tate Gallery) is classical (subject), Renaissance (form) and technically innovative (the principal figure being cast in aluminium); Pomeroy's **Perseus** (National Museum of Wales, Cardiff) can be plausibly related back to Gilbert, to Pomeroy's experience in Paris (under Mercié) and in Rome, then back to the Renaissance and its own roots in Antiquity. Havard Thomas's **Lycidas** (Tate Gallery, and Aberdeen Art Gallery) is another variant on these themes: the bronze specifically finished in the ancient Greek manner, a subject intentionally only vaguely classical, evolved in Italy near Naples where the traditions of Greece and Rome and their great Revival all commingle. McKennal's **Circe** (Birmingham Museum and Art Gallery, and Fitzwilliam Museum, Cambridge), 'a fine piece of modelling' (Spielmann), is a classical *femme fatale* reformulated, while Derwent Wood's **Machine Gun Corps Memorial** at Hyde Park Corner in London, a large nude bronze figure of **David** of as late as 1925, could be classified as Michelangelo-cum-Donatello in modern undress.

A corner of yet another field of sculpture can have its fruits credited to Leighton's brand of classicism. Hamo Thornycroft's **The Mower** of 1884 (Walker Art Gallery, Liverpool) fits most easily into a category of Genre sculpture, although the fullness of its particular ramifications is exceptional. The work is based on a natural observation, a mower seen by the sculptor on the banks of the Thames (compare Leighton's commitment to naturalistic modelling). When first shown at the Royal Academy the sculptor attached to it a quotation from Matthew Arnold's **Thyrsis**, a work which under a veneer of classicism is in effect an elegy not so much to the ostensible subject of commemoration, the poet's friend Clough, as to the Thames Valley that is described in detail. In this respect, **The Mower** would seem to connect up with the idealised naturalism of the painters Mason and Walker, who like Thornycroft were Leighton's protégés. And while in sculpture this nexus of Leightonian naturalism and classicism seems to have been short-lived, in its choice of subject Thornycroft's **The Mower** prefigures other much later scenes of idealised labour (Toft's **Iron**, Brock's **Manufacture** on the Victoria Memorial).

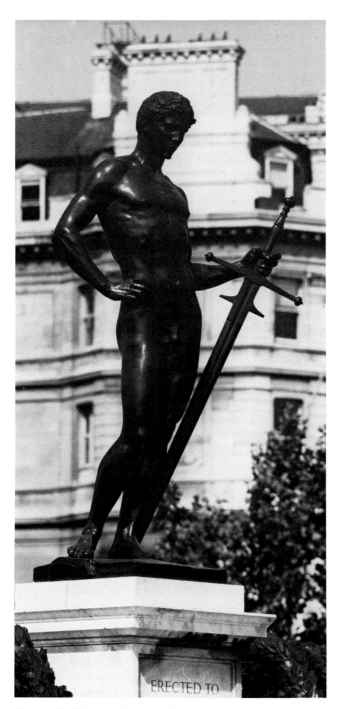

Derwent Wood: **Machine Gun Corps Memorial.**

involvement with European Symbolism – (see for example Gilbert's **Post Equitem Sedet Atra Cura** or **The Enchanted Chair**; Frampton's **Mysteriarch**), but these intense spiritual vibrations were only a specialised extreme of a much wider category. Onslow Ford executed a series of statuette-scale naked ladies with titles like **Peace**, **Applause**, **The Singer**: that is, the specificity of their allegiance to Genre could vary considerably while their form remained much the same (appended details obviously varied). Alfred Drury evolved a series of ideal busts: that is, studies of this particular form in which the beauty of the expression and the treatment are what count, the titles are only partly relevant (**St. Agnes**, **Griselda**, **The Age of Innocence**). Other examples by other artists are of a much simpler order, playful, saucy, sometimes even vapid in subject, but excellent excuses to display a knowledge of human form and an ability to express this in three-dimensional terms – see Colton's **The Girdle** (Tate Gallery) or Goscombe John's **The Elf** (National Museum of Wales, Cardiff).

Frampton's **Mysteriarch** (Walker Art Gallery, Liverpool) is notable in another important respect, one that is a further major feature of the sculpture of this time. Though executed in plaster – an entirely regular practise as a stage in the practical execution of most sculpture – it is in addition coloured. Polychrome sculpture had been known earlier in the century – John Gibson's **Tinted Venus** (again) being the most noteworthy example, possibly because the tinting was carried through to probably an almost unique degree – but this was in a way the archaeological pedantry of a committed neo-classicist. Frampton's coloured sculpture is quite different. It is a determined seeking of an ultimate in decorative effect, using often a range of precious materials to enhance this. Frampton put his ideas into practise in works of different categories – **Lamia** (Royal Academy of Arts, London) is in one way simply and traditionally a literary subject (from Keats), but the bronze, ivory and semi-precious stones of its materials produce an effect that is neither ordinary or conventional. His **Dame Alice Owen** (Dame Alice Owen's School, Potter's Bar) again can be taken as a traditional portrait statue, but there is rather more to it than that. ◼

Alfred Gilbert was equally concerned with a new dimension of decorative effect. His bronzes of the 1880s already show him straining to exceed the medium's traditional potential; he took to metallurgical research, began to incorporate much wider ranges of material, and the **Duke of Clarence Memorial**

More symptomatic of a new type of Genre are works with a certain spiritual connotation. **The Spirit of Contemplation** by Toft (Laing Art Gallery, Newcastle) and **The Myrtle's Altar** by Lucchesi (Birmingham Museum and Art Gallery) are straightforward examples of an established work-type. The parameters of this were chiefly defined by Gilbert's intensely personal symbolic art and Frampton's

George Frampton: **Dame Alice Owen.**

(1892-99 and later) at Windsor (from which **The Virgin and St. Elizabeth of Hungary** (Church of Scotland) ultimately derive) runs through a panoply of textures, colours and mixed media to quite sumptuous effect. Onslow Ford was another sculptor concerned with pushing back the limits of what materials had previously defined. His **Folly** of 1886 was one of the earliest instances in which the revived lost-wax casting method was known to have been used in England; in his memorial statue of **Sir Rowland Hill** in London of 1881 he demonstrated in public the new more expressive use of bronze that the use of lost-wax casting implies, while **St. George and the Dragon** or **Snowdrift** (both Lady Lever Art Gallery, Liverpool) shows an intricacy of manipulation of materials at a relatively small scale, whether in combination or alone. ◤

The 'New Look' in late Victorian sculpture, based on a new appreciation of a much more varied expressive potential of the materials used, can be cited as probably the major feature of the sculpture of the time in this country. This can certainly be seen in the context of other changes that affected not just sculpture but the other arts as well – a return to Nature, the revival of craftsmanship and vernacular styles, emphases on both the physical objectivity of a work or its immanent (rather than its specific) subject. Sculpture's relation to other arts could be close. It was a sculptor, George Simonds, who served as first Master of the Art-Workers Guild, while Frampton, Gilbert, Goscombe John and others did quite extensive work in the applied arts. A 'special relationship' certainly existed with new tendencies in architecture: Belcher's Institute of Chartered Accountants in London was supposedly an Arts and Crafts manifesto; its sculptural decoration is an integral part of it, and Hamo Thornycroft was perfectly prepared to portray in his frieze of the Arts the particular craftsmen who were his studio assistants. ◤ This would have been unthinkable in a more formal age – the frieze on the base of the London **Albert Memorial** portrays 'great' artists, while other representations of the arts in architectural sculpture in mid-century use *putti* in action or generalised figures.

At its best, the new integral architectural sculpture could give an added dimension to a building's articulation. At other times the new approach could lose sculpture its distinct identity as an art, merging into mere background decoration. In fact the entire gamut of new tendencies contained within them seeds for their own dissolution. In the years around 1900 the

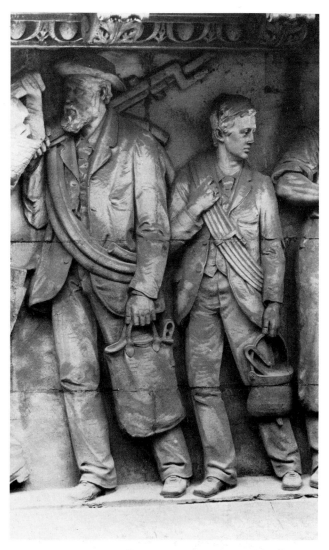

Hamo Thornycroft: Institute of Chartered Accountants frieze.

(Left) Onslow Ford: **St George and the Dragon**, Lady Lever Art Gallery, Liverpool.

various tendencies achieved a certain equipoise in relation to each other, before the art of sculpture became, one might say, too clever for its own good. Gilbert's manipulation of forms to decorative effect becomes his 'teased ornamental work' (MacColl) while Roger Fry refers to Frampton's multi-medial polychromy as 'playing tricks' with materials. But in extending the concept of what sculpture could express and utilise, the sculptors of this time can be seen to have broken the barriers of their art's conventions and to have left their successors a rich melting pot on which to develop.

Jacob Epstein: reconstruction of **Rock Drill**.

III. Cubism and Sculpture in England before the First World War.

There has been very little discussion of the relationship between Cubism and the sculpture produced in the British Isles in the first two decades of this century. One of the main problems confronting such a discussion is the difficulty of assessing what could properly be called 'Cubism' in sculpture and whether this or a more general conception of Cubism had repercussions in England. Recent discussion of sculpture in this period has focussed almost exclusively on the work of Jacob Epstein and Henri Gaudier-Brzeska and concentrated on establishing their work within the nexus of Vorticism[1], tying it into the aesthetic and to the development of the formal means of Vorticist painting. Therefore discussion of Cubism has been subsumed into comparisons between the formal means of French and English painting and has been assigned a temporary, although influential, role for the Vorticist painters and by implication the sculptors. But this view oversimplifies a more complex situation in the awareness and interpretation of Cubism within late Edwardian and early Georgian culture. The rejection of Cubism by the Camden Town painters, by Sickert and by the critics, for example of the *Daily Chronicle* and the *Illustrated London News*, when set beside the apparent acceptance of Cubism by Roger Fry, Wyndham Lewis and David Bomberg suggests a simple polarity between conservative and modern taste. But this view takes no account of the different attitudes to French culture in England in this period, nor does it account for what was understood by the term 'Cubism' in English criticism and artistic practice between 1908 and 1914. How far this was predicated on an understanding of Cubism in France requires a more thorough examination before the comparisons which have been made between the formal means of Cubism and Vorticism can have any meaning.

By linking the work of Gaudier-Brzeska and Epstein exclusively to the development of Vorticism the differences between their work, their connection to sculptural practice and patronage in England (indeed why they came to England at all) have been obscured. Epstein, after all, did not sign the Vorticist Manifesto in **BLAST** 1 nor was he, unlike Gaudier, an active participant in Vorticist events. Thus his link with Vorticism rests tenuously on his inclusion by Wyndham Lewis in 'The Camden Town and Others' exhibition at Brighton (December 1913), in the publication of his drawings in **BLAST**, and post facto in linking his aesthetic position with that of Lewis. This aesthetic position, first discussed in general terms by

T. E. Hulme, is characterised as opposition to a Renaissance, and thus a classical humanist, tradition, combined with an energetic search for a modern style, linked to a primeval precondition for that style. Yet Epstein asserted the importance of tradition, albeit retrospectively: 'The whole integrity of art lies in its tradition. Tradition does not mean surrender of originality. On the contrary all great innovators in art were in the great tradition, you cannot quote one exception, however much they may have been considered rebels by their contemporaries.'[2]

This view is essentially tied to a nineteenth-century aesthetic within which in general terms Epstein's work should be placed. Insofar as it is known, his early work in Paris, like that of Brancusi, indicates how closely he worked within an Ecole des Beaux Arts tradition of monumental and portrait sculpture. Moreover his work between 1908 and 1911 relied either on Rodinesque expressive forms or on Renaissance models, for example the statues for the British Medical Association in the Strand (1907-8), or the portraits of **Mrs McEvoy** and **Euphemia** (both Tate Gallery, London). There is more justification for setting Gaudier-Brzeska's work within a Vorticist aesthetic. His rejection of 'the SOLID EXCREMENT in the cinque e quattro cento,' in favour of the primitive vortices of 'the Palaeolithic, the Egyptians and the Chinese'[3] in his **Vortex 1914** indicates preoccupations broadly similar to those of Lewis and Pound. But as Pound warned in 1916, 'Gaudier's sculpture would have been just what it is, even if there had been no "Vorticist movement". . .[4] Moreover the rejection of a humanist tradition and the coexistent concern with primitivism has, as Christopher Middleton has noted, 'been one of the factors bedevilling aesthetic rationales . . . both a vital and a deadly force in social and cultural life since its epiphany around 1900'[5]. It is its connection with English culture between 1900 and 1914 that gives this stance meaning within sculptural practice at this time.

[1] For example in **Vorticism and its allies** by Richard Cork, Arts Council of Great Britain catalogue, London 1974, and R. Cork, **Vorticism and Abstract Art in the First Machine Age** (2 vols) London 1976.
 The writings of T. E. Hulme on Epstein (see below) and Ezra Pound's **Gaudier-Brzeska, a memoir**, London 1916, have been the principal works examined in writing of sculpture in this period. While they are obviously important they are obviously also partisan accounts and reveal very little of critical views on Cubism.
[2] J. Epstein and A. Haskell, **The sculptor speaks**, London 1931, p.144.
[3] **BLAST** 1, 1914.
[4] E. Pound, **Gaudier-Brzeska, a memoir**, op cit. p.15.
[5] C. Middleton **The rise of primitivism and its relevance to the poetry of Expressionism and Dada**, 1970, reprinted in **Bolshevism and Art**, Manchester, 1978, p.23.

The polarities in English sculpture were diagnosed in 1910 by Roger Fry: 'For many years now the annual exhibitions of sculpture have produced two main classes of work. There is the ordinary merely representative and non-expressive sculpture which we always have with us; the other class, the work of artists who attempt some serious expression has shown almost exclusively the influence of Rodin's dominating genius.'[6] While the work of Frampton, Thornycroft and Reginald Wells apparently belong in the former category, Epstein and Gaudier's early work clearly belong in the latter. In both sculptors' work their modelled clay and plaster pieces depend upon the expressive qualities of the material – malleable form and light reflective qualities. Thus Epstein's portrait busts such as the **Self-Portrait in a Cap**, 1912 (Epstein Estate), **Admiral Lord Fisher**, 1916 (Imperial War Museum, London) **Augustus John**, 1922 and **Otto Klemperer**, 1957 (Earl of Harewood collection) and the numerous portraits of his family depend upon these qualities. Pound acknowledged that the 'Rodin mixture'[7] was 'purged from his [Gaudier's] system when he quit doing representative busts of Frank Harris and Col. Smithers' but it is also in his subject pieces of 1912 that the expressive qualities are derived from Rodin, for example **Workman Fallen from a Scaffold** (Victoria and Albert Museum, London), **Women Carrying Sacks** (private collection) and **The Firebird** (clay, destroyed).[8]

The influence of Rodin must have been confirmed and reinforced by the publication, in 1912, of a translation of his book, **L' Art**. The discussion of movement (Chapter IV) as 'the transition of one attitude to another' is particularly relevant to these works of Gaudier's, as well as Epstein's series of **Nan**, 1911.[9] Moreover, Rodin's comment that 'I have always endeavoured to express the inner feelings by the mobility of muscles. This is so even in my busts to which I have often given a certain slant, a certain obliquity, a certain expressive direction, which would emphasise the meaning of the physiognomy'[10] certainly has a bearing on both Epstein's and Gaudier's conception and handling of the portrait bust, particularly Gaudier's busts of **Alfred Wolmark** (Walker Art Gallery, Liverpool) and **Horace Brodzky** (Fogg Museum, Cambridge, Mass.) ◤ In his memoir of Gaudier, Brodzky makes quite clear the economic necessity for Gaudier of undertaking portrait busts,[11] and this suggests that the two busts of his friends, Wolmark and Brodzky, unlike the commissioned busts of Haldane MacFall, Major Smithies and Enid Bagnold

contain greater nuances of meaning. The Brodzky bust is surely based on a close analysis of Rodin's bust of the sculptor Jules Dalou in pose and meaning, while Gaudier borrows the quizzical engagement of the relationship of head to shoulders in the Wolmark bust from Rodin's monument to Balzac. However when the two busts were exhibited by Gaudier at the Allied Artists Association in July 1913, P.G. Konody commented on their 'frenzied cubism',[12] a description subsequently employed by Gaudier in his description of the works and by Brodzky who described his own bust as 'cubic' and linked it with the 'over life size pastel portrait of myself.'

This pastel portrait and a group of self-portrait drawings and a pastel by Gaudier with a pastel portrait of Sophie Brzeska (Southampton City Art Gallery) and of Alfred Wolmark, show a limited facetting of form, based in the pastels on broad planes of high colour disposed in irregular facets. ◤ In the self-portrait drawings and to a limited extent in the bust of Brodzky, Gaudier employs concave and convex forms which could loosely be described as 'cubic'. In Brodzky's bust this occurs chiefly in the treatment of the eyes, particularly the areas beneath the eye where the form is pulled forward in fragmented planes, and in the cheek and shoulder planes.

But on what, in 1913, was the term 'Cubism' based, and does the use of the term necessarily imply more than a descriptive definition not necessarily tied to an awareness of Cubist painting drawing and sculpture?

Gaudier's conception of sculptural form as related to mathematical form led him between 1911 and 1912 to a conception of organic form conceived in cubic planes revealed by light and shade. Tentative models in the

[6] R. Fry, **The sculptures of A. Maillol**, *Burlington Magazine*, no. 85, vol. xvii (April 1910), pp. 26-32.

[7] Pound, op. cit. p. 90. He is of course referring to **Major Smithies** (Tate Gallery, London).

[8] A concern with figures in movement characterised English sculpture c. 1910-1912, eg. Gaudier's **The Dancer**, 1913 (Tate Gallery, London) and Gill's **Tumbler** and **Acrobat** (both lost). But Gaudier in the letters to Sophie Brzeska moves from an interest in the figure in movement to a more abstract conception of movement – movement in form.

[9] Such as **Nan** and **Nan seated** (Tate Gallery, London), and **Nan (The Dreamer)** (estate of the late W. A. Evill).

[10] A. Rodin, **Art**, translated Mrs Romilly Fedden, London 1912, p. 68.

[11] H. Brodzky, **H. Gaudier-Brzeska**, London 1933, pp 67-9 and 76-8.

[12] *The Observer*, July 13th, 1913. Gaudier exhibited 6 works at the Allied Artists Association. Three portrait busts: **Haldane MacFall** (cat 1215) **Horace Brodzky** (cat 1216) and **Alfred Wolmark** (cat 1217) and three commissioned pieces: **The Firebird** (cat 1212) **The Wrestlers** (cat 1213) and **Madonna** (cat 1215). There were possibly three works by Brancusi in this exhibition: (cat 1167) **Muse endormie** and 1167 a and b. For discussion of the confusion surrounding these exhibits see D. M. Magid, **A Note on Brancusi and the London Salon**, *Art Journal*, Winter 1975/6, pp105-6. These and the three heads by Zadkine were the first recent work from France seen in England.

Henri Gaudier-Brzeska: **Bust of Horace Brodsky**, Fogg Museum, Cambridge, Mass., USA.

Henri Gaudier-Brzeska: **Self Portrait**, black crayon. Private collection.

Drawing in a letter to Sophie Brzeska, 3 June 1911.

formulation of his ideas can be found in his letters to Sophie Brzeska, ▬◣ and to some extent his ideas were confirmed and extended through his friendship with Middleton Murray, and later in 1913 in discussion with Roger Fry. Fry's analysis of Maillol's work in geometric terms coincided with Gaudier's developing interests.[13] Undoubtedly Gaudier's involvement with the Omega Workshops in the Autumn of 1913 determined his further development of a Cubist syntax of fragmented facetted forms in, for example, the two trays (Victoria and Albert Museum, London) he designed in 1913.

Roger Fry's 'Second Post-Impressionist Exhibition'[14] in October 1912 is generally acknowledged as introducing Cubist canvasses to England. But following the first exhibition, 'Manet and the Post-Impressionists' (Nov. 1910-Jan. 1911) in which Picasso's **Portrait of Clovis Sagot**, (Zervos II(1), 129) was exhibited, Cubism began to be discussed in terms of its geometrical structure: 'the artist divides up his patterns into as many angles as he may and dwells upon the triangles found in anything, from a face to the lapels of a coat'[15] (G.K.Chesterton, *Illustrated London News*).

'The Cubists, those drear reviled folk, who are geometricians first and painters second, arouse interest with their figures and architecture, and still lives, emerging from canvasses that look like coloured, symbolical frontispieces to editions of Euclid.' (Lewis Hind, *Daily Chronicle*).[16]

This discussion engendered considerable debate in the correspondence columns of *The New Age* in 1912 on the language of criticism (coining the derogatory verb 'to Picass'), and on the issue of geometry rejected by Huntley Carter, art critic of *The New Age*, in an article accompanying the reproduction of Picasso's **Mandolin et verre de Pernod**, (private coll. Prague, Zervos II(2), 259). Carter quoted a letter from Middleton Murry in support of his argument against mimetic representation: 'it will be remembered that Plato, in the sixth book of the Republic, turns all artists out of his ideal state on the grounds

[13] Fry, op.cit. p.27 'Maillol . . . insists on the geometric intelligibility of form, believing that expression lies more in the immediate apprehension of a few correctly related elements than in the emphasis on various and peculiar characteristics.'
[14] 'The Second Post-Impressionist Exhibition', Grafton Galleries, 5 October 1912-31 December 1912. Re-opened 4 January 1913 until the end of the month when new works and a separate catalogue were issued. See B. Nicholson, **Post-Impressionism and Roger Fry**, *Burlington Magazine*, no. 574, vol. xciii, January 1951, pp. 11-15.
[15] G.K.Chesterton, **Our Notebook** (*Illustrated London News*, 9 December 1911, p.978.
[16] Lewis Hind, *Daily Chronicle*, December 1911.

that they merely copy objects in Nature, which are in their turn copies of the real reality – The Eternal Idea.'[17] Carter goes on to suggest that Picasso is pursuing abstraction 'which to him is the very soul of the subject'[17]. A similar argument was presented by Fry in his introduction to the French Section of the Second Post-Impressionist Exhibition catalogue, where he argued that the intention of Picasso, Braque, Derain, etc. was 'not to imitate form, but to create form . . . in fact they aim not at illusion but at reality.'[18]

The extent of Middleton Murry's knowledge of Picasso and Cubism is still unclear but his wide knowledge of French culture must have provided a common basis for his friendship with Gaudier-Brzeska. The extent of the interest in French culture in the artistic community in England in the pre-war years has never been fully examined.[19] Gaudier's involvement with Middleton Murry, who published one of the earliest appreciations of Bergson in English in 1911, and also wrote on the classicism of Barres and Charles Mauras, with Pound, who portrayed himself as a student of French 'clarity' and after 1912 explored the prose of Stendhal, Flaubert, Maupassant and praised the work of Remy de Gourmont, with *The Egoist*, (which contained reviews and articles on French writing) and with *The New Age*, (which under the editorship of A.R.Orage presented a considerable forum of European thought and art) indicates the complex network and diversity of interest in French culture. Yet what emerges is only a sketchy view of a set of artistic and social assumptions about French culture held within several interlocking circles. One facet of these assumptions is embodied in G.K.Chesterton's parody of the readership of *The New Age*, in December 1911: 'There are running about England today some thousands of a certain sort of people. They are, of course, a small minority of the nation; but they are a large majority of the middle class. . . They are in revolt against something they have forgotten in favour of something else which (by their own account) they have not yet found. They are always alluding to Thought of various kinds – Free Thought and Higher Thought and Advanced Thought.'[20]

This group he identified as 'the ordinary artistic Socialist' and he attacked the adoption of Picasso's work by *The New Age* as part of both a Socialist and 'a progressive stance'. *The New Age* underwent a transformation in discussion and criticism of contemporary art during 1911/12, when Sickert's critical reviews were gradually replaced by those of Ezra Pound and T.E.Hulme. In a series entitled 'Modern

Art'[21] Hulme focussed on what he identified as new issues within English art. His championship of 'primitive prototypes', 'geometric and monumental art' which he distinguished in the work of Bomberg and Epstein in particular, he saw as derived from three separate elements in modern painting: 'One might separate the modern movement into three parts, to be roughly indicated as Post Impressionism, analytical Cubism and a new constructive geometrical art. The first of these, and to a certain extent the second, seem to me to be necessary but entirely transitional stages leading up to the third which is the only one containing possibilities of development.'[22]

This clearly marks his position from that of Roger Fry, whose understanding of Cubism was derived from his admiration for the work of Cézanne, indeed he subsumed Cubism into his general term 'Post-Impressionism'. What emerges from 'The Second Post-Impressionist Exhibition' is a view of Cubism dominated by work from Kahnweiler's Gallery – principally the work of Picasso.[23] No work by the 'other cubists', Jean Metzinger and Albert Gleizes, whose **Du Cubisme** was translated into English during 1913, was included. The exhibition was dominated by the work of Matisse which included seven pieces of sculpture[24] dating from the 1899/1900 **Jaguar dévourant un lièvre, d'après Bayre** (private coll. France) to the unfinished **Head of Jeanette** which the reviewer of the exhibition for the *Illustrated London News* found 'monstrous hideousness. . . ▰ Matisse's bust has mordant thrusting frightful features'. The only other sculptures included were pieces by Eric Gill whose

[17] *The New Age,* No. 23, 1911, p.88.
[18] R. Fry, 'Second Post-Impressionist Exhibition', Grafton Galleries, October-December, 1912, catalogue introduction, 'The French Group', p.26
[19] For discussion of the involvement of the literary community with French culture see E.Homberger, **Modernists and Edwardians** in P.Grover, (ed.) **Ezra Pound: The London Years**, New York. 1978 pp.1-14.
[20] G.K.Chesterton, **Our Notebook**. *Illustrated London News*, 9 December 1911, p.978.
[21] T.E.Hulme, Modern Art 1 – The Grafton Group, *The New Age* 15 January 1914, pp.341-2.
T.E.Hulme, Modern Art II – A preface Note and Neo-Realism, *The New Age*, 12 February 1914, pp.467-9.
T.E.Hulme, Modern Art III, The London Group, *The New Age*, 26 March 1914, pp.661-662.
T.E.Hulme, Modern Art IV, Mr David Bomberg's Show, *The New Age*, 9 June 1914, pp.230-232.
[22] T.E.Hulme, Modern Art I, op.cit.
[23] The exhibition included 13 drawings and canvasses by Picasso; 5 canvasses by Derain, 4 by Braque, 11 by Herbin, 4 by Marchand, 11 by L'hote which included several watercolours.
[24] Matisse: **L'Araignée** (plâtre) (cat. A.) **Buste de femme** (3 éme état and plâtre 2 éme état) (both cat. A); **Femme acroupie** (bronze) (cat. C.); **Buste de femme** (bronze) and (plâtre ler état) (cat. E and F); **Jaguar dévourant un tigre** (plâtre d'apres Bayre) (cat. G) and **Le Dos** (plaster sketch) cat. 1)

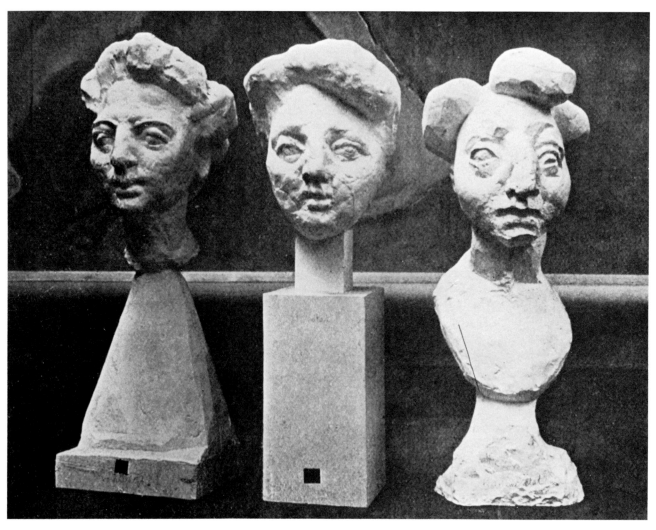

Henri Matisse: **Heads of Jeanette**. Illustration from the 'Second Post Impressionist' exhibition catalogue, London 1912/13.

work Fry had admired and collected since *c*. 1910. Were Bell and Fry then unaware, or uninterested in recent developments in sculpture in France? At the two contemporary exhibitions in Paris, the 'Salon d'Automne' and 'La Section d'Or' (Galerie de la Boetie, October 1912), recent work by Aegero, Archipenko, Modigliani and Duchamp-Villon was shown. Fundamental changes in sculptural practice took place in Paris between 1906 and 1912, but there is as yet only a fragmented view of the history of these changes. A cluster of questions surrounds this change. While it is generally accepted that Cubism composed a variety of styles sharing common principles, it must be asked whether the changes within sculpture share these principles or reflect the nuances of style. Is there necessarily any connection between the two media? Are the sculptural changes predicated on the formal or the philosophical and

critical premises of the painting? Does the sculpture rather emerge from a different set of nineteenth-century preoccupations and traditions? etc.

Clearly the work of the painter-sculptors Derain, Picasso, Modigliani and Matisse have a central place in this discussion. There is general acknowledgement of the importance of the exhibition of Derain's **L'Homme acroupi**, 1906, at Kahnweiler's Gallery in the autumn of 1907, in initiating the fundamental change in sculpture from modelling in clay and plaster to direct carving in wood and stone.[25] Geist has demonstrated the impact Derain's figure had on Brancusi,[26] in the raw boldness of the technique, the vigorous quality of the carving, the assertion of the material and the retention of mass without making deep incursions into it, particularly in two works executed immediately after the exhibition of Derain's figure, namely **The Kiss**, 1907-08 (Muzeul de arta R.S.R., Bucharest) and

Première pierre directe, 1907 (lost). Similarly there is general acknowledgement of Picasso's **Head** of 1909 (Museum of Modern Art, New York) as a primary document of Cubist sculpture in the employment of concave and convex forms, paralleled in Picasso's contemporary painting.[27] In general terms, the **Head**, like Matisse's **Jeanette** series, exhibited at the 'Second Post-Impressionist Exhibition', must be related to a concern with the head as an expressive sculptural vehicle current among Parisian sculptors since *c.* 1904, for example – Brancusi, **Head of a Girl**, 1907 (lost); **Naiade**, ?1909. (Apollinaire coll. Paris); Nadelman, **Head**, 1906, (Hirshhorn Museum, Washington D.C.); Modigliani, various heads, *c.*1910; Duchamp-Villon, **Maggie**, 1911 (Guggenheim Museum, New York). However until there is some clarification of the chronology and interaction between the work of Nadelman, Archipenko, Brancusi, Modigliani and Raymond Duchamp-Villon no detailed discussion of sculpture in Paris between 1906 and 1912 is possible.[28] Moreover very little of this work was seen by English sculptors. An exhibition of Nadelman's work in April 1911 (Paterson Gallery, London), was an isolated example. Cork has discussed the importance of the inclusion of Picasso's drawing, **Head of a Woman**, of 1909, in 'The Second Post-Impressionist Exhibition' in the development of a Cubist syntax among English painters in 1913.[29] The inclusion of the 1909 Picasso drawings is particularly pertinent in a discussion of sculpture as they present the first exploration of a sculptural treatment of volume in facetted, subdivided forms, and it was for precisely these qualities that Pound recalled, in 1916, Epstein's admiration for Wyndham Lewis's work: 'Jacob said, "But Lewis's drawing has the qualities of sculpture". (He may have said "all the qualities" or "so many of the qualities")'.[30]

The interaction between Epstein's and Lewis's work requires a careful analysis, and whether the sudden change in Epstein's drawing during 1912 can be attributed to his contact with Lewis when they both were at work in the *Cabaret Theatre Club, The Cave of the Golden Calf* in the spring of 1912 or to his friendship with Modigliani in Paris later in the same year is far from clear.[31] In his drawings between 1912 and 1913, Epstein gradually abandons the naturalistic figure drawing of his earlier work and increasingly introduced a syntax of simplified abstracted semi-circular and angular forms. Moreover in the drawings associated with the **Figure in Flenite** and with the **Rock Drill**,[32] the main figures in the composition are viewed from

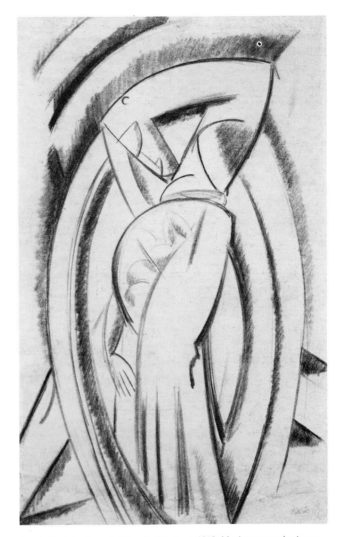

Jacob Epstein: **Female figure in flenite**, c.1913, black crayon. Anthony D'Offay, London.

[25] Whereas direct carving in marble had continued since the Nineteenth century, this was primarily in smooth surfaced neo-classical garden and household figures.
[26] S. Geist, **Brancusi's The Kiss**, New York and London, 1978, p.30-3.
[27] For example, the work executed at Horta San Juan in the summer of 1909, such as **La femme aux poires** (private coll. New York); for a full discussion of Picasso's work at Horta, see J. Golding, **Cubism**, p.75.
[28] For some discussion of this confused chronology see: A.Werner, **Modigliani as a sculptor**, *Art Journal* V.no.2.pp Winter 1960-61.pp.70-8 and G.H. Hamilton, **Raymond Duchamp-Villon**, New York 1967, and J. Michaelsen. The chronology of Archipenko's Paris Years, *Arts Magazine*, Nov 1976, Vol 51.no.3.
[29] Cork, op.cit. p.113. In fact two works entitled **Head of a Woman**, cat. nos 64 and 66, were included, only one of which can be certainly identified from the catalogue illustration.
[30] **Selected Letters of Ezra Pound 1907-1941**. Letter to John Quinn, London, 10 March 1916. New Directions paperback edition No.85, p.74.
[31] There is very little evidence for the dating of Epstein's drawings between *c.* 1912 and *c.* 1915. See R. Buckle, **Epstein's drawings**, London 1962, and Cork, op.cit.pp.117-122 and pp.454-472.
[32] Most of these drawings are reproduced in Cork, op.cit. pp.466-472; see also catalogue **Jacob Epstein, The Rock Drill Period**. Anthony D'Offay, London 1973.

below, thrusting the volume forward, and the heads are turned in profile, stressing the geometric angularity of the relationship of the head to the rest of the body. ◀ There is also an integration between the figures and the space around them, unlike Epstein's earlier (and later) drawings in which objects are frequently presented in a planar frontal position separate from any pictorial space.

For Gaudier also the example and discussion of Cubism in London in 1912/13 appears to have resulted in a sudden change in his drawing. The reliance on a general disposition of form as enclosed within a boundary line characterised his drawing until the **Self-Portrait** drawing (National Portrait Gallery, London), of Christmas 1912. Pound's discussion of Gaudier's drawing is pertinent, although his current preoccupation with ideograms and Chinese and Japanese art in general determined his view, yet he linked Cubism with Japanese prints while distinguishing the treatment of space as flat (in the prints) from the solid forms of Cubism.[33] He suggests that the drawings for Brodzky's bust show 'the effect of a theory that painting and drawing are first of all calligraphy. It is a belief Chinese in origin . . . Brzeska's later drawings, so far as I personally know, are done invariably without any trace of this belief . . . In many of them he had undoubtedly no further intention than that of testing a contour for sculpture; certainly this was the case in the numerous sketches he made for my bust.'[34]

Pound is surely correct. In general Gaudier's drawings for modelled and carved works rely on a general disposition of form, for example in the drawings for the **Red Stone Dancer** (Musée d'Art Moderne, Paris), for the brass door-knockers (Kettle's Yard, Cambridge) and for **Bird Swallowing Fish** (Kettle's Yard, Cambridge), while the relationship of unit to mass was worked out in the process of carving. Yet the drawings for Pound's bust, (Kettle's Yard, Cambridge, and private collection) are more ideographic, indeed emblematic, than Pound allows in his discussion, in their direct oriental connotations. There are moreover considerable variations in Gaudier's drawing, as Pound noticed, from explorations of contour and of mass, for example in the drawings for one of Gaudier's last works, **Seated Woman**, (Musée d'Art Moderne, Paris), and in drawings in Kettle's Yard, Cambridge, which explore contour and the disposition of mass and plane in different drawings, and drawings such as the three **Self-Portraits** ◀ (Kettle's Yard, University of Cambridge) probably not

related to sculpture, but in which Gaudier rigorously explores a Cubist syntax, in a manner quite alien to Epstein's drawing. After 1913 Gaudier appears to abandon the directly observed figure and animal studies that characterise his earlier drawings and work from memory, or observation in museums, for example drawings made apparently from tribal art (several in Kettle's Yard, Cambridge) and the precise crisp linear drawing of abstract and abstracted forms, such as **Dog**, (Tate Gallery, London), a drawing of two heads (Kettle's Yard, Cambridge) and the **Abstract Drawing** (Musée National d'Art Moderne, Paris).

The Bennington photographs of Gaudier at work on Pound's bust indicate the transitory relationship between drawings and sculpture. Only front and side elevations are sketched on to the stone, and these are broken down in the finished bust. Significantly the

Henri Gaudier-Brzeska at work on the bust of Ezra Pound.

[33] 'I have here also the design out of 'Timon' marked Act III, and a Japanese print which is curiously cubist.' *The Egoist*, 15 June 1914, p.234.
[34] *The Egoist*, 16 March 1914, p.109.

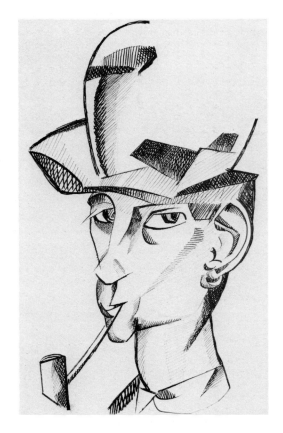
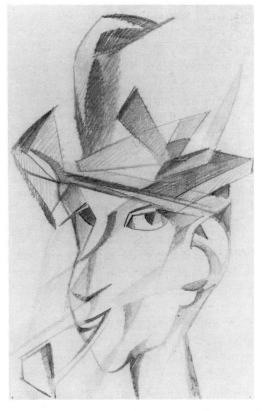

Henri Gaudier-Brzeska: **Three self portraits with pipe**, pencil, pen and ink. Kettle's Yard, Cambridge.

exploration of Cubist syntax appears only in the drawings of Gaudier-Brzeska and Epstein and not among their contemporaries such as Eric Gill.

One further point generally acknowledged in the development of Cubism in Paris is the importance of African art, although differences emerge in the status given to formal properties and to the content and interpretation of tribal art within the Parisian avant garde between 1905, when André Derain bought a 'white faced' African mask, and in 1917 when Apollinaire and Paul Guillaume published **l'Art Nègre**. Among sculptors, however, this influence is less clear. A whole range of sculpture including Gallo-Roman, Iberian, Cycladic and early Greek, Romanesque and Gothic seems to have been drawn on between 1907 and 1910 in a move towards direct carving in stone, by Brancusi, Modigliani, Derain and Picasso, while formal borrowings from tribal and ethnographic sculpture are less apparent until about 1912.[35]

Epstein's visit to Paris in summer 1912 to supervise the erection of the **Tomb of Oscar Wilde** is generally credited with introducing him to the preoccupation with tribal sculpture within Parisian studios, an interest transmitted to Gaudier-Brzeska on his return. Epstein's visit to Paris can only have extended an interest in 'primitive' sculpture already rooted in an interest in Egyptian, Assyrian and Indian sculpture. It is difficult to identify with any certainty the beginnings of Epstein's interest in tribal art, certainly it was well enough known to be caricatured by Adrian Allison in the review, *Colour*, in November 1914, 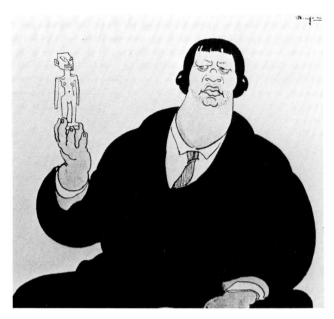 and he may originally have been stimulated to look at the ethnographic collections in the British Museum through his friendship with John Fothergill, who in 1906 translated Emmanuel Loewy's **The Rendering of Nature in early Greek art** (1907).[36]

A generalised influence from tribal art appears in Epstein's work during 1913 combined with a residual interest in the rhythm and disposition of mass and the hieratic frontality of Egyptian sculpture. In the **Figure in Flenite** (Minneapolis Institute of Art and Tate Gallery, London) and in **First Marble Venus** (Museum of Art, Baltimore, Maryland) and **Second Marble Venus** (Yale University Art Gallery) of 1913-16, there are generalised borrowings from Egyptian crouching figures and in the relationship between the form of the head and the neck from Baoule figures, and in the abstraction of facial features from Senufo figure types. The strict frontality of these sculptures and Epstein's maintenance of simple planar forms distinguished his work from that of Gaudier-Brzeska between 1913 and

Adrian Allinson: 'Mr Epstein doubts the authenticity of a South Sea Island Idol', in *Colour,* November 1914, p.142.

1915. In **Stags** (Art Institute, Chicago), **Birds Erect** (Museum of Modern Art, New York) and **Boy with Rabbit** (Rachelwitz collection), all of 1914, Gaudier employs smooth rounded forms that break down the rectangularity of the block into interlocking planes. There is moreover a limited facetting of some forms with open planes in these works, most notably in **Birds Erect**. These works however owe nothing to tribal and ethnographic sculpture although Gaudier made several pieces that do derive directly from ethnographic art, such as **Men with Bowl**, a free copy of a food bowl from the Hawaiian islands (British Museum) the **Bust of Ezra Pound** which is loosely modelled on the carved figure Hao-Haka-Nana-Ia from Easter Island (British Museum, London), a more

[35] It is suggested that in the **Double Caryatid** (Museum of Modern Art, New York), 1908, Brancusi mimicked Gallo-Roman sculpture, in Geist, **Brancusi**, New York 1968, p.30, while **Première pierre directe** (present whereabouts unknown), which appears to have had such a profound influence on Modigliani's **Heads**, may well have been suggested by similar carving. Golding discusses the importance of Iberian sculpture in Picasso's 1906 canvasses, Golding op.cit.p.52-4. The interest in such a diversity of work must be related to earlier anthropological and ethnographic analyses, and set within the context of the Gauguin retrospective exhibition at the Salon d'Automne, 1905, the opening of the Egyptian galleries in the Louvre in 1905, and the exhibition at the Louvre of an important series of Iberian reliefs from Osuna in the Spring of 1906.
[36] Loewy discussed the characteristics of early Greek art in terms of simplification of form, stylisation and representation and drew general parallels between Assyrian, Egyptian and certain forms of primitive art. Loewy's book appears to have had some influence on Roger Fry who discussed it in an article on 'Bushman paintings' in the *Burlington Magazine* no. 84 vol. xvi, March 1910, pp. 4-8.

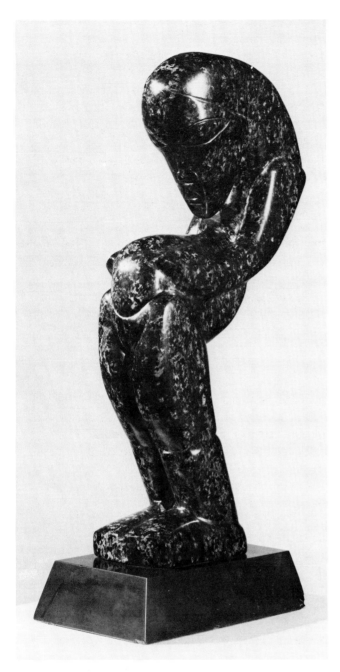

Jacob Epstein: **Figure in Flenite**, 1913, serpentine. Tate Gallery, London.

Henri Gaudier-Brzeska: **Birds Erect**, 1914, *ciment fondu* cast. (Original in Museum of Modern Art, New York), Kettle's Yard, Cambridge.

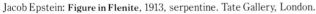

generalised conception of 'primitive', for example **Maternity**, 1914 (Musée des Beaux Arts, Orleans) and the **Red Stone Dancer**, 1913-14 (Tate Gallery, London). For T. E. Hulme interest in the primitive and Cubism were components in a 'rather fumbling search for an appropriate means of expression'.[37]

The use of the term 'Cubism' in English criticism between 1911 and 1914 embodied a range of different meanings. The most direct use of the term was in relation to work in exhibitions such as the inclusion of Cubism in Frank Rutter's 'Post-Impressionist and

Futurist exhibition' (October 1913), and the separation of some canvasses into 'The Cubist Room', at 'The Camden Town and Others' exhibition held in Brighton (December 1913),[38] and by 1914 the work of Lewis and his fellow Vorticist painters was frequently discussed

[37] T. E. Hulme, 'Modern Art III,' op. cit. p. 661.
[38] The Cubist room was orchestrated by Wyndham Lewis who undoubtedly intended to intensify the impact of the work hung there and simultaneously to distinguish it from the canvasses of the Camden Town painters in the rest of the exhibition. There is an oblique reference on Lewis's part to similar group presentation of Cubist work in the Paris Salons of 1911 and 1912.

as Cubist painting.[39] Hulme's defence of Epstein's drawings, in his first one man show at the Twenty One Gallery in December 1913, against their criticism in newspapers and weekly journals as 'cubistic' turns on Hulme's expressive theory of art (he saw in Epstein a sculptor seeking 'a new means of expression')[40] and on his belief expressed more fully in the Quest Society Lecture (March 1914) that Cubism represented a temporary stage in the development of geometric abstraction formulated around a machine aesthetic. Thus his interpretation of Cubism in Epstein's work depends upon Epstein's employment of geometric forms, which Hulme identified in the drawings for the Flenite figures and for the **Rock Drill**. To support his view Hulme contrasted Epstein and Lewis's work with the reproductions in Gleizes and Metzinger's **Cubism** suggesting that the latter depended solely on an embryonic analysis of natural form, in contrast to the work of Lewis and Epstein which is constructive.

For Ezra Pound, Cubism was 'a pattern of solids', while Roger Fry employed 'mosaic' and 'patchwork' as descriptive terms for the work of Bomberg and Lewis respectively.[41] Although in general discussion the terms 'Cubism' and 'Futurism' were used interchangeably by 1914 to signify modernist angular forms in painting, interiors, furniture and fashion,[42] 'Cubist', 'Cubistic' and 'Cubism' within English criticism was applied to geometric forms, as a cartoon of 1914 in Punch signifies. ☛ The application of the term to sculpture was much rarer, and normally applied only to drawings.

THE SPREAD OF CUBISM.

John Golding has suggested that 'in actual fact by 1912 no truly 'Cubist sculpture existed, except the bronze head of Picasso and the experimental constructions which he and Braque were executing to supplement their researches into pictorial form and space.'[43] Yet by 1912 Brancusi, Archipenko, Aegero and Duchamp-Villon were associated with Cubism principally through their employment of large clearly defined volumes and the relationship of these to the work c. 1908-9 of Picasso and Braque. In his sculpture

Vortex of 1914, Gaudier stressed the importance of Brancusi, Modigliani, Archipenko and Epstein and his opening statement that sculpture is 'the appreciation of masses in relation. Sculptural ability is the defining of these masses by planes', suggests that if a relationship between Cubism and sculpture in England can be defined it must be within these terms, rather than on formal relationships with French Cubist painting. Thus Archipenko's **Women with Cat**, 1910, **Draped Woman**, 1911 and **Dancers**, 1912 which was reproduced on the cover of *The Sketch* (29 October 1913) in the treatment of mass in rounded volumes and fragmented rudimentary planes parallel Gaudier's treatment of mass and volume between 1913 and 1914 in works such as the **Red Stone Dancer** and **Birds Erect**.

Photographs of Picasso's latest sculpture were included by Roger Fry in the Second Grafton Group exhibition in January 1914, and while it is not clear what these included (a reviewer described 'eggboxes and other debris',[44]) they were clearly some of the constructions made in string, cardboard, wood, paper and other materials, between 1912 and 1914. ☛ The radical innovations in material, process, construction and even subject matter, had no repercussions in England, unless Gaudier's cut brass ornament/toy **Ornement torpille** of 1914 (Grattan Freyer collection) was an immediate response to Picasso's work. ☛ This tiny brass sculpture, like Picasso's sculpture of 1912-14 destroys earlier conventions of planar relief sculpture, the fractured contour, the breaking open of planes destroying the solidity of the form and the illusion of volume, of modelling are all present.

In Epstein's work there is a consistent continuity in the sequence of his sculpture that indicates that, like Brancusi he worked within the constituents of sculpture in terms of subject matter and material. Thus his preoccupations with monumental figure sculpture, reinforced through his friendship with Eric Gill, determined the degree to which his work was affected by Cubism. While Gaudier-Brzeska, on the other hand, was more eclectic, and therefore more susceptible to the influence of Cubism.

[39] The critic of *The Athenaeum* in March 1914 identified Lewis as 'leader of the English Cubists'; T. E. Hulme writes of Cubist work in the London group exhibition, 'Modern Art III', op. cit. p. 661
[40] Hulme, Mr Epstein and his critics, *The New Age*, 25 December 1913.
[41] R. Fry, Two Views of the London Group. *The Nation*, 14 March 1914, p.1000
[43] For example the discussion in the press of the Rebel Art Centre in Great Ormond Street. *Vanity Fair*, 25 June 1914.
[43] Golding, op cit. p.123-6.
[44] Anonymous reviewer in *The Athenaeum* 10 January 1914.

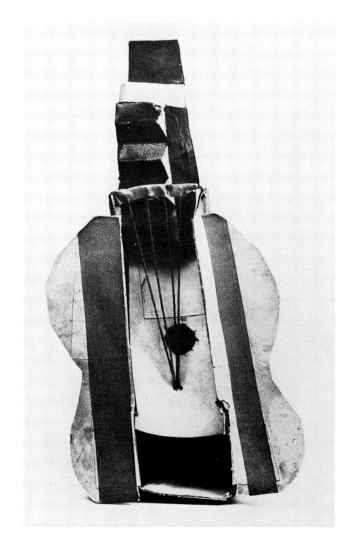

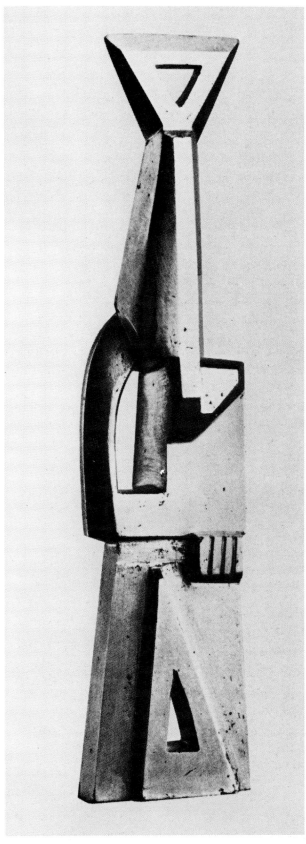

Pablo Picasso: **Construction Guitar**, 1912, cardboard, papier collée. Musée Picasso, Paris.

Henri Gaudier-Brzeska: **Ornement torpille**, 1914, cut brass. Collection Grattan Freyer.

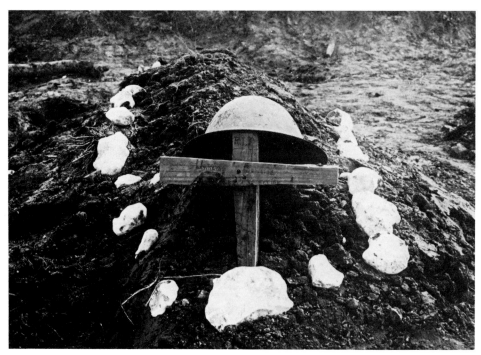

Grave of an unknown Canadian soldier, Western front, October, 1916.

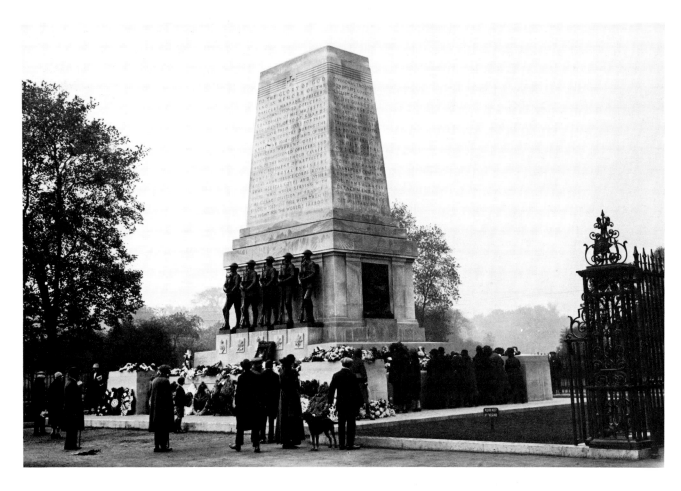

Gilbert Ledward: **Memorial to the Guards Division**, unveiled 1926, Birdcage Walk.

IV. War Memorials.

The monument which overlooks Horseguards Parade commemorates the losses suffered by the Guards Division in the First World War: 50,000 men, more than 40 times the number who take part in Trooping the Colour each year. British Empire forces, as a whole, lost 1,104,890. Every parish in the British Isles was affected and all 16,436 of them marked this in some way. Schools, businesses, colleges and other groups also commemorated their dead.

It is hardly surprising then that some of the energy of the war effort should have been soon converted to making memorials. Expressing collective grief became almost an industry. Several books, including Laurence Weaver's **Memorials and Monuments** of 1915 were published. The Imperial War Graves Commission was established in 1917 and charged with the care of the graves of those killed on active service all over the world. The Victoria and Albert Museum held a two-part exhibition in 1919, the first showing monuments from the collections to give ideas to the memorial-makers and the second showing 411 new ideas. The Royal Academy followed suit with its exhibition of 398 proposals for memorials 'selected and arranged for the purpose of assisting the promoters of War Memorials and others . . . by providing them with a useful survey of modern work by competent artists, and by suggesting the various forms which memorials might suitably take'. (These varied from bookbinding to tapestries, from memorial tablets to monuments and architectural schemes.) The schemes were vetted by a Royal Academy War Memorials Committee, one of whose first tasks had been to announce 'It is felt that all men of goodwill should express the ideals fought for by the free nations of the world'. The guidelines that they gave are a model for public commissions. Use a professional artist, importance of site, have a budget for landscaping, importance of matching materials to both budget and place ('If for example, there is a suitable and durable local stone, this should be used in preference to stone imported from a distance; and if such stone is used due account must be taken of its qualities in the design'), care in letter forms ('bold Roman or Italian 16th century') and, above all, simplicity, scale and proportion. ('It is the imaginative and intellectual quality of the work that gives it its final value.')

Artists and architects found it almost impossible to present the soldier as an heroic figure, for the horror of the war had touched everyone. This distinguishes the First World War memorials from those for the Boer War: walk in St James's Park and you can see this clearly by comparing the **Boer War Artillery Memorial** by W. R. Colton with Gilbert Ledward's **Guards Memorial**.

The impulses of the major architects and artists appear to have been two-fold, on the one hand a form of naturalism (with implied heroism) and on the other a restrained classicism culminating in Lutyens' geometrically complex designs for the monuments at Thiepval and the **Cenotaph**. Many variants of the cross were built in smaller towns and villages, none perhaps as elegant as Eric Gill's at Trumpington. Some adopted the cross which Blomfield had designed for the war cemeteries: its prototype was shown in the courtyard of the Royal Academy during the exhibition.

'Heroic' naturalism is found perhaps most clearly expressed in Jagger's **Artillery Memorial** at Hyde Park Corner. This caused a furore when it was unveiled by Field Marshal, The Duke of Connaught in 1925, because the howitzer surmounting it was made of stone and not bronze. Jagger explained that it would have been most unsatisfactory to have a black object against the skyline. What is perhaps more shocking is Jagger's portrayal of everyday trench warfare here and in the monument to the Tank Corps at Louveral.

The following photographs show only some of the most important memorials alongside several commissioned by small towns or individuals. ☛

C.S. Jagger: **Artillery Memorial**, Hyde Park Corner. Unveiling ceremony by Field Marshal the Duke of Connaught, October, 1925.

Details of **Artillery Monument** showing Artillery battery in action and the fallen soldier in battledress.

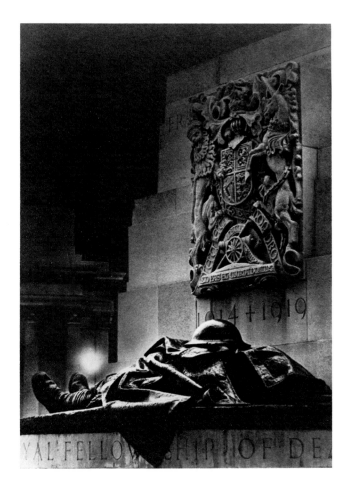

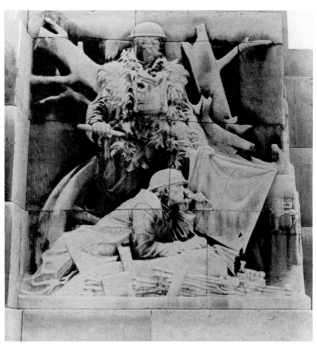

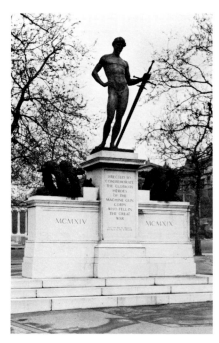

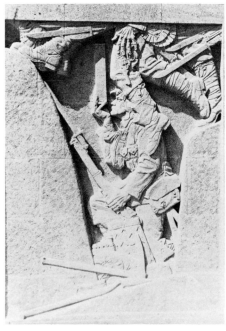

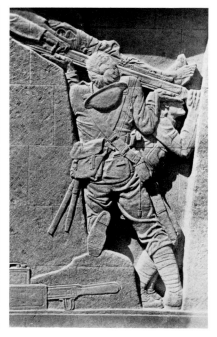

Derwent Wood: **Machine Gun Corps Memorial**, Hyde Park Corner.

C.S. Jagger: **Cambrai Memorial**, Louveral. (Architect H. Charlton Bradshaw). The

memorial is to the Tank regiment but shows infantrymen engaged in trench warfare.

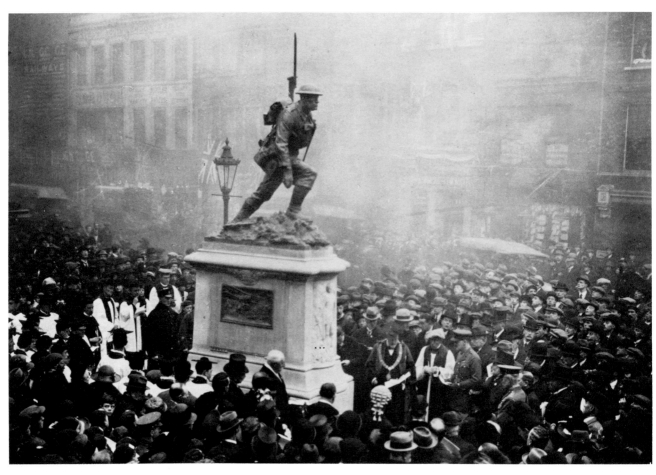

P. Lindsey Clark: **Southwark War Memorial**, unveiled by Lord Hume.

Albert Toft: **Royal Fusiliers War Memorial**, unveiled by the Lord Mayor of London, November, 1922.

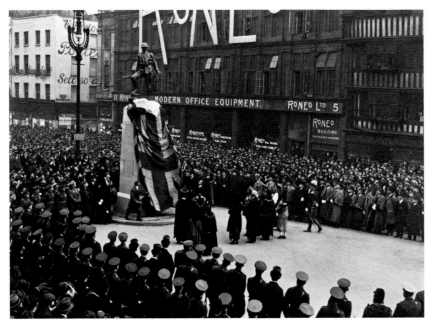

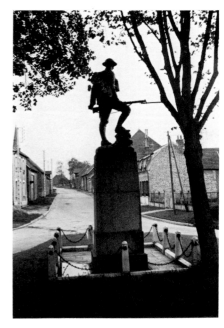

On many occasions the British 'Tommy' was used and, as this example shows, several casts were made and became memorials for different regiments or associations.

Memorial to the 41st Division, Flers, Normandy.

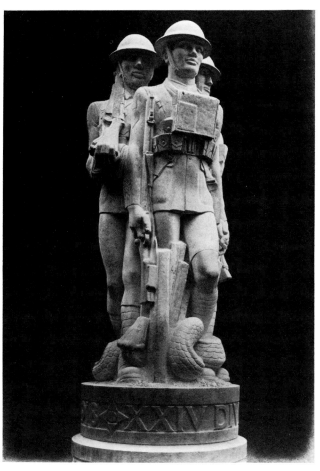

Eric Kennington: **Memorial to the 24th Division**, Battersea Park, unveiled by Lord Plumer, 5 October, 1924.

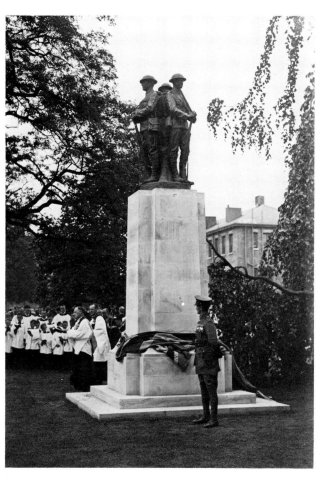

Memorial to other ranks, Royal Military College, Sandhurst, unveiled by the Prince of Wales, 1927.

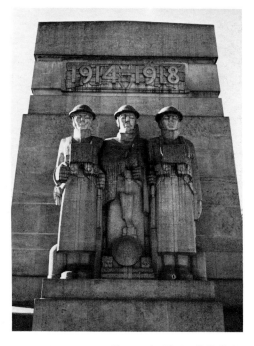

Eric Kennington: **The Soissons Memorial**, France. Architects G.H. Holt and V.O. Rees.

Eric Gill: **War Memorial at Trumpington**, Cambridgeshire.

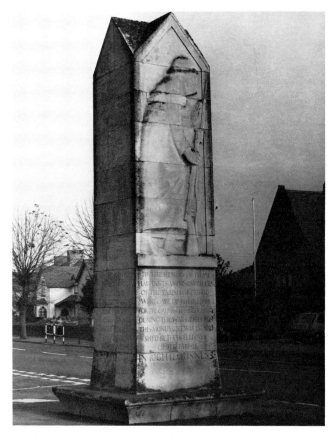

Eric Gill: **Memorial at Chirk**, Clwyd. Gill has clearly followed the suggestions from the Royal Academy Committee especially with regard to the choice of material and lettering.

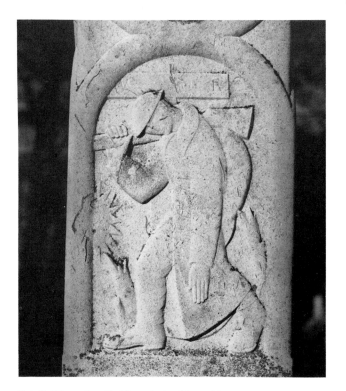

Detail of figure from the Trumpington Memorial.
Compare Gill's simple memorial here with that at nearby Royston.

Cardiff Cenotaph, unveiled 1929.

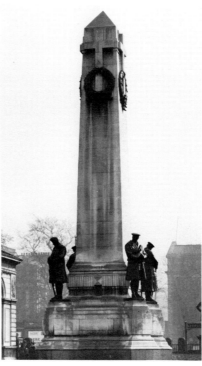

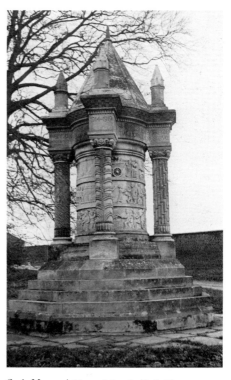

Royston War Memorial. In many cases the losses from the Second World War were added to the earlier memorial.

War Memorial, Euston Station, now destroyed.

Carlo Magnoni: **Memorial to the Yorkshire Waggoners**, Sledmere, commissioned by Sir Richard Sykes, showing the involvement of the Waggoners from their mobilisation to the routing of the enemy.

Edwin Lutyens: **The Somme Memorial**, Thiepval, with Sir Reginald Blomfield's cross which was widely used in the foreground.

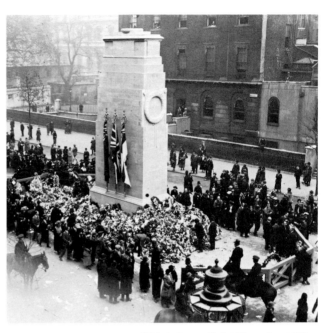

Edwin Lutyens: **The Cenotaph**, Whitehall, unveiled 11 November, 1970.

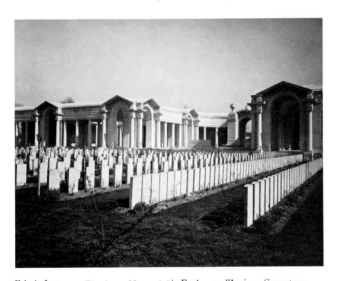

Edwin Lutyens: **The Arras Memorial** in Faubourg d'Amiens Cemetery, sculpture by William Reid Dick.

Reginald Blomfield: **Menin Gate Memorial**, Ypres, Belgium, with sculpture by William Reid Dick.

Lutyens, Blomfield, Sir Herbert Baker and later Holden were appointed principal architects for the (then) Imperial War Graves Commission in France. They established a unity of style, with Lutyens' preference for complex geometrics and entasis pre-eminent.
No bodies were exhumed from the graveyards or battlefields and all ranks were treated as equals in death and given a simple headstone or cross.

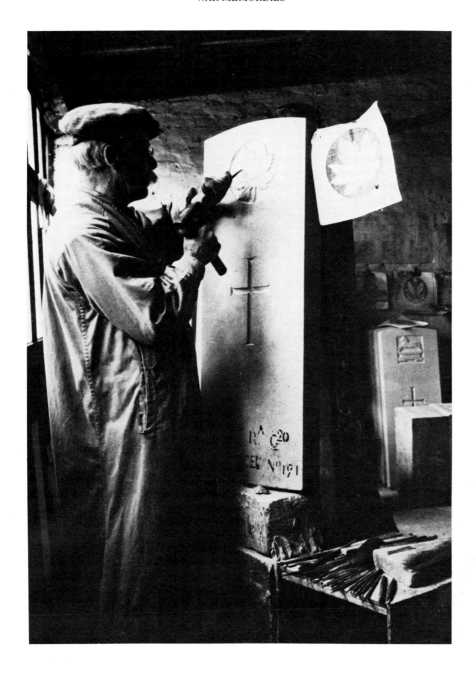

Engraving headstones at Messrs. Arrowsmith Stockwell.

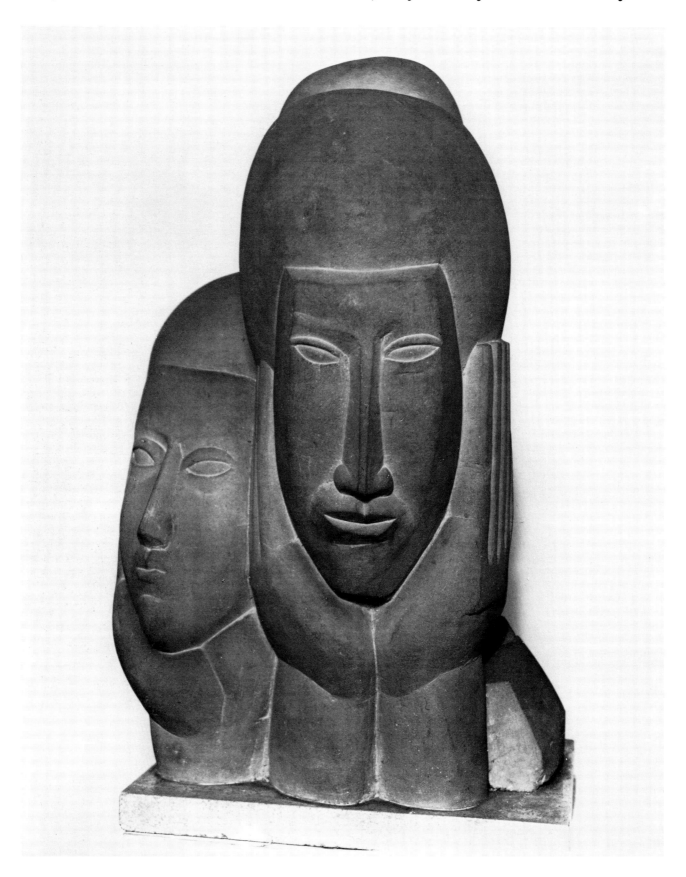

Frank Dobson: **Two Heads**, 1921. Courtauld Institute of Art, (Samuel Courtauld Collection).

some issues in British Sculpture in the 1920s.

The 1920s are easily viewed as a period of stasis and retrenchment in British art, falling between two bursts of innovatory activity. In the field of sculpture, Epstein's decision to truncate **The Rock Drill** by the removal of the drill itself was an obvious break with the more radical implications of pre-war modernism. The image is confirmed by the emergence of Frank Dobson as a major figure who rapidly rejected the Vorticist angularity of his earlier sculpture such as **Two Heads** of 1921 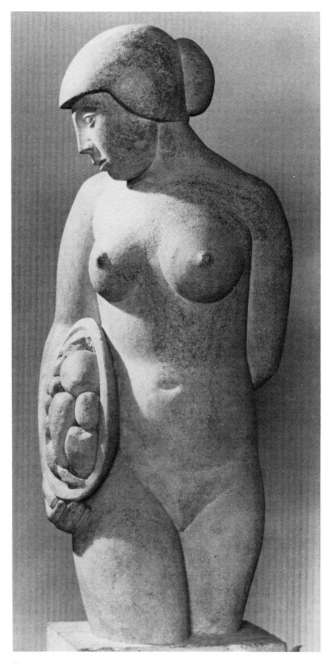 (Courtauld Institute) in favour of a serene and classicised treatment of the nude. However, one way to qualify this characterisation would be to confront it with two contemporary images relating to sculpture.

At the 1926 Royal Academy Summer Exhibition, John B. Souter exhibited a painting entitled **Breakdown**.[1] A white girl with bobbed hair is jittering in an abandoned fashion while a black musician in evening dress arrogantly wields an unmistakably phallic saxophone. In a background evocative of the ruins of an antique temple, there lies, half obscured in the dim atmosphere, a broken and overturned classical statue. It is as though an entire civilisation faced dissolution through the interpolation of a more visceral and less self-disciplined culture.

A year earlier, *Punch* had published a drawing commenting on Epstein's new and controversial Hudson Memorial in Hyde Park.[2] It was the work of Sir Bernard Partridge, the magazine's regular 'serious' cartoonist and one of the signatories of a petition published in the *Morning Post* demanding the removal of the sculpture. The cartoon confronted **Rima** with Gilbert's **Eros**, who fires an arrow at the former's heart. A subtler image-maker than Souter, Partridge set up a whole series of oppositions in both drawing and caption. There is an angular primitivism against a suave curvilinearity, a figure trapped by the relief format is set against one which moves through the air with a supernatural ease. 'Kamarad!' proposes Epstein's 'female' only to be rebuffed by an unequivocal 'I think not!' from Gilbert's **Eros**. An alien political subversion is opposed to a robust English conservatism; the raw, unmediated sexuality of the 'female' confronts the classical and civilised refinement of **Eros**.

The conflicts and tensions implicit in such images may appear to come solely within the category of 'public response' and be irrelevant to the 'real development' of art. Yet they do represent a reaction, albeit somewhat hysterical, to issues which preoccupied sculptors and informed writers on the subject

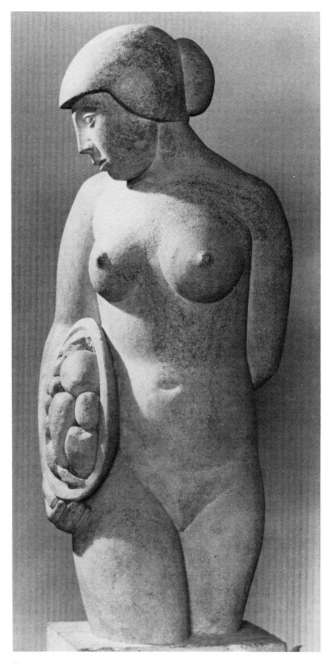

Frank Dobson: **Cornucopia**, 1925-27. University of Hull Art Collection.

during the period, notably the implications of a response to non-European 'primitive' cultures and the potentials and restrictions of materials. These issues cannot be treated simply in terms of a dichotomy between academic and modernist. Indeed concepts of modernism as they would be understood today can only be applied to discussion of art in Britain in the 1920s in a highly qualified manner. Certainly a view

[1] Royal Academy Illustrated, London 1926, p.91.
[2] *Punch*, 3 June 1925.

FOR THIS RELIEF NOT MUCH THANKS.

EPSTEIN'S FEMALE. "KAMERAD!"
GILBERT'S EROS. "I THINK NOT."

Bernard Partridge cartoon in Punch, 3 June 1925.

of modernism, entailing the validation of formal and technical innovation by reference to a developed and self-conscious historicism, is not unknown at the time. Frank Rutter's 1926 study **Evolution in Modern Art** invokes Nietzsche and Ibsen in order to emphasise the distinction between the 'Vital Artwork' which is 'controversial and displeasing to the majority' and the 'art of respectful plagiarism . . . perfectly intelligible, widely comprehensible . . . It consists of doing the same old things in the same old way because our forefathers did them in the same old fashion.' Nonetheless, Rutter's choice of intellectual mentors relates his thought clearly to the pre-war era and the very title of his book evokes and revises the same author's pamphlet of 1910 inspired by the First Post-Impressionist exhibition in London, 'Revolution in Art'.

Discussion of modern art continually took place against the background of a far more developed and entrenched historicism implicitly hostile to 'modernist' art. When at the Royal Academy banquet of 1948, Sir Alfred Munnings, in his notorious attack on 'modern art' declared that 'in spite of all those who painted skies in the past, we should be painting skies much

better'[3] the mode of thinking appeared a quaint and naïve anachronism. Yet he was giving voice to an idea which retained a powerful hold early in the century, that progress in art was definable in terms of ever-increasing prowess in the practice of representation. The view is associated with an attitude to culture and civilisation both optimistic and ethnocentric, an attitude which the Great War and the Bolshevik Revolution could hardly leave secure and unquestioned. As Spengler ironically pointed out referring to larger currents of history: 'The ground of Western Europe is treated as a steady pole, a unique patch chosen on the surface of the earth for no better reason, it seems, than because we live on it – and great histories of millenial duration and mighty far-away cultures are made to revolve around this pole in all modesty. It is a quaintly conceived system of sun and planet'[4].

These associations are revealed by texts such as the *Connoisseur's* comments on the Post-Impressionists. 'They did a problematical service to art by engendering a taste for greater simplicity in technique, brighter colouration and a more decorative feeling, but this is a small compensation for the anarchy they originated, which threatens to thrust back painting into a state of primeval barbarism.'[5] This fear of regression is not the mere hysterical and irrational gut reaction of a confused reactionary. It is of a piece with a much broader and more authoritative current of aesthetic thinking.

E. Loewy's study **The Rendering of Nature in Greek Art** (of which an English translation was published in 1907) traced the development of Greek art from the archaic period in terms of increased subtlety in representation. It drew the conclusion that 'where we are able to follow an entire development of art, there we find that its morphological progress is from the psychical to the physical, i.e. to the image on the retina, the objectively received patch of nature with all its incidental and accessory detail. We should not be led away from this principle by temporary retrogressions and collateral tendencies.' Loewy's English translator J. R. Fothergill made substantial use of this book in his authoritative entry on drawing in the **Encyclopaedia Brittanica**.[6] This argued for a concept of 'pure drawing' the content of which was

[3] Alfred Munnings, 'The Finish' 1952, quoted in Andrew Brighton and Lynda Morris (eds), *Towards Another Picture,* Nottingham 1977, p.59.
[4] Spengler, **Decline of the West**, trans. Charles Francis Atkinson, Vol. 1, London 1926, p.14.
[5] The Editor (C. Reginald Grundy), 'Spurious Art', in *The Connoisseur*, March 1920.
[6] **Encyclopaedia Brittanica**, 11th ed. 1910, Vol 8, pp.552-556.

the representation of form only' and therefore was 'essentially the same activity as sculpture'. On this basis Fothergill maintained that it was possible to arrive at a judgement of quality in art which went beyond 'personal predilection only'. As this lay in knowledge of form, he pointed out that 'people may differ in their tastes, but they may not, nor do they, differ on questions of real knowledge'. Artistic skill is equated with objective and measurable knowledge of a particular kind. A rational basis is provided for the elevation of the judgement of a professional elite above that of the 'average' spectator as the exercise of 'objectivity' above 'taste'. The tactical value of this argument to the supporter of art encountering public hostility hardly needs to be stressed. At the same time, despite a bow to Hokusai who is mentioned in the same breath as Ingres and Dürer, little scope is available for a positive assessment of art from outside the European tradition. Neither does the emphasis on 'intelligent ideas of the forms of nature' provide much validation for 'modernist' art.

Yet much discussion of art, and in particular sculpture, in the 1920s is only comprehensible in the light of this current of thought. The tensions are most clearly visible in the writings of R. H. Wilenski. As art critic of the *Evening Standard* he addressed a broader readership than Roger Fry or Clive Bell and so could not assume the complicity of his audience with his own judgements. Hence the provocative and positive affirmations of the objectivity of his own valuations contrasted with the subjective responses of the ordinary spectator. This stance was maintained partly through claims of a pseudo-technological nature. 'The competent art critic always seems to have a prophetic vision but, in truth, he is no more a prophet than any other expert in a special field. When the critic tells us that our grandsons will want the works of Othon Friesz in France, Severini in Italy and Paul Nash over here, he makes a statement of the same nature as the statement by a car expert that a certain car will take particular gradients and consume a certain quantity of petrol in the process.'[7] Instead of Fothergill's claim for the artist's empirical grasp of the forms of nature transcending the subsidiary accidents of style, he proposes the value of abstract form both culturally universal but comprehensible only to initiates who can see beyond merely sensuous attraction. In an only half frivolous article entitled 'Woman and the Artist' he contrasted '. . . the war between the artist whose mission is the search for abstract beauty and the woman who sees no purpose in any beauty but her

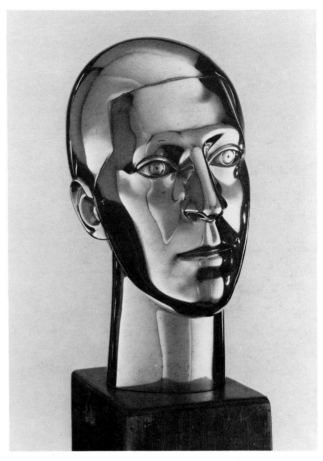

Frank Dobson: **Osbert Sitwell**, 1923. Tate Gallery.

own.[8] This latter he equated in Shavian terms with the 'life-force' so bringing to mind Fry's comment that 'biologically speaking art is a blasphemy'.[9]

This view was of particular relevance to the discussion of sculpture as it permitted the positive valuation of work from outside the European tradition not assimilable into more conventional standards of 'beauty' or 'realism' alongside that of young artists such as Dobson, Kennington and Underwood'.[10] At the same time a pretext was provided for the de-bunking of the sculpture of classical antiquity, a task which Wilenski carried out with undisguised relish. 'The average Greek sculpture' he wrote in 1924 'is practically devoid of formal beauty. It is sensually pure and at the same time purely sensual . . . The hedonism of ancient Greece remained the standard of Christian sculpture for five centuries. But thanks to the camera,

[7]R. H. Wilenski, 'A Defence of Art Critics', *Evening Standard*, 23 October 1924.
[8]*Evening Standard*, 31 October 1924.
[9]'The Artist's Vision' in *Vision and Design*, 7th Impression, London 1957, p. 47. (Originally published 1919).
[10]These artists are cited as representatives of Wilenski's concept of Cubism in sculpture, in 'Form in Sculpture', *Artwork*, April 1925, pp. 138-144.

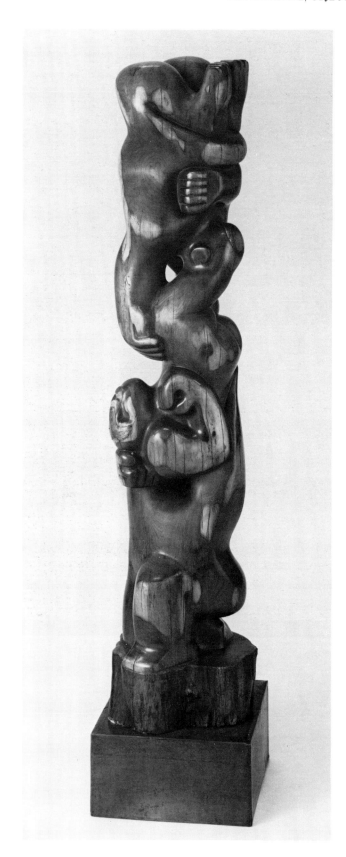

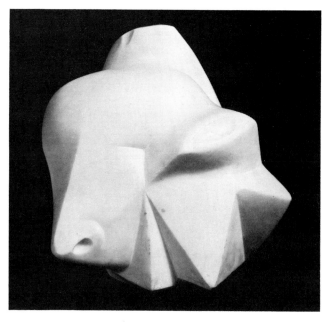

Leon Underwood: **Nucleus**, c.1923. Private collection.

the motor and the patient labours of critics, the worship of Greek sculpture has already run its course. No intelligent sculptor in these days believes that Greek sculpture holds the key to absolute beauty or is the be-all and end-all of the sculptor's art.'[11] Emphasising the effect of photography he pointed out that 'without leaving his studio he [the sculptor] can gain a reasonable impression of the monumental art of Egypt, of Buddhist and other sculpture in China, India, Java and Japan.'[12] The curious omission of African sculpture in this list is perhaps symptomatic of a desire to establish a position independent of Bloomsbury. It accompanies a more radical divergence from the approach of Bell and Fry in which Wilenski connects the argument on abstract form with technical controversies on the respective values of carving and modelling. Contrary to received opinion, Roger Fry's famous essay on African art contains little support for any theory of 'truth to material'.[13] Wilenski, on the other hand, makes a specific equation between the artist's search for 'the secret that binds together the finest sculpture of all ages' with choice of technique. The sculptor 'knows now that sculpture is not the art of investing clay with the beauty of the human body but the art of fashioning stone, wood and marble into beauties of their own'.[14]

[11]R. H. Wilenski, 'Passing of an Art Fetish', *Evening Standard*, 21 November 1924.
[12]Ibid.
[13]See e. g. Alan Wilkinson, **The Drawings of Henry Moore**, London 1977, p.147.
[14]Wilenski op. cit.

Leon Underwood: **Totem to the Artist**, 1925-30. Tate Gallery, London.

Affected as it is by a strongly journalistic quality and frequently displaying symptoms of a need to survive as a popular controversialist in a highly competitive market, Wilenski's early writing nonetheless focusses with great clarity on a number of themes crucial to sculpture in the 1920s and draws them into a coherent framework. His views on the importance of non-European art were echoed by Frank Dobson who stated that 'Never at any time, I think, has the creative workman had at his disposal so much in the way of tradition. Not just a little tradition of the Mediterranean basin and the rechauffée, the Renaissance, but all the sculpture which has been done since man first scratched on a piece of ivory, and it seems to me that this has a lot to do with the activity known as modern sculpture'.[15]

The sleek and elegant sculpture of Maurice Lambert appears today as totally of its period with its somewhat schematic presentation of movement combined with exploitations of novelty in mixed materials. Yet he professed to a similar transcendental view of world art crossing barriers of time and culture. 'Fifty thousand years ago a man was charged by a bison. As a result he made a drawing in a cave at Altamira . . . I claim descent from this very great artist. These works of mine are probably produced for a similar reason.'[16] The very remoteness of non-European art from the conventional standards of prettiness could make its appeal appear the consequence of a more elevated approach to beauty. Eric Gill wrote of Indian sculpture: 'It is the work of men who regarded Beauty not merely as a thing ministering to man's comfort and pleasure but as a thing having a value utterly independent of any pleasure it might give to men or of any power it might have of making human life endurable.'[17] Here the tenor is not so dissimilar from the sleight-of-hand by which Fry regarded the sensuous nudes of Dobson as exercises in 'pure' sculpture, as their full and rounded bodies were so distant from the currently modish flat-chested ideal. For Henry Moore, awareness of the gamut of world sculpture resulted in the 'removal of Greek spectacles from the eyes of the modern sculptor . . . which has helped him to realise again the intrinsic emotional significance of seeing mainly a representation value, and freed him to recognise again the importance of the material in which he works, to think and create in his material by carving direct,

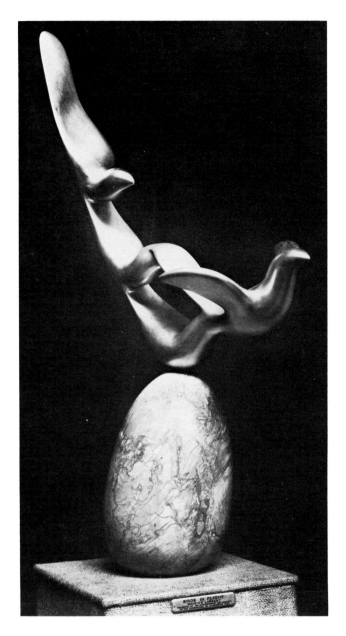

[15]Architectural Association Journal, April 1930. Dobson is speaking in response to a paper presented by Eric Gill on 'Style in Sculpture'.
[16]Catalogue of exhibition at the Lefevre Gallery 1932.
[17]Eric Gill, 'Indian Sculpture', 1922, in *Art Nonsense*, London 1929.

Maurice Lambert: **Birds in Flight**, 1926. Manchester City Art Gallery.

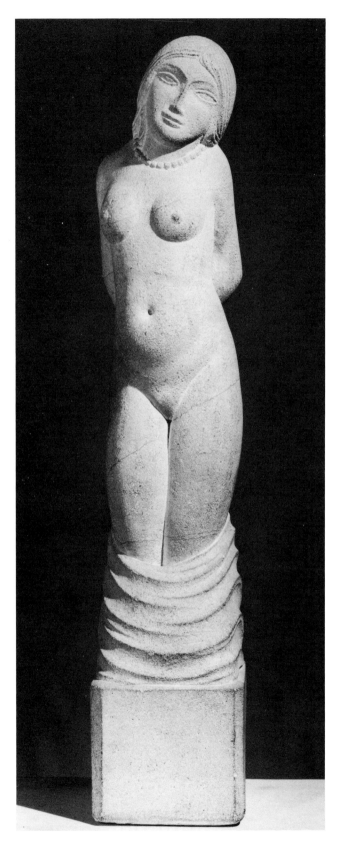

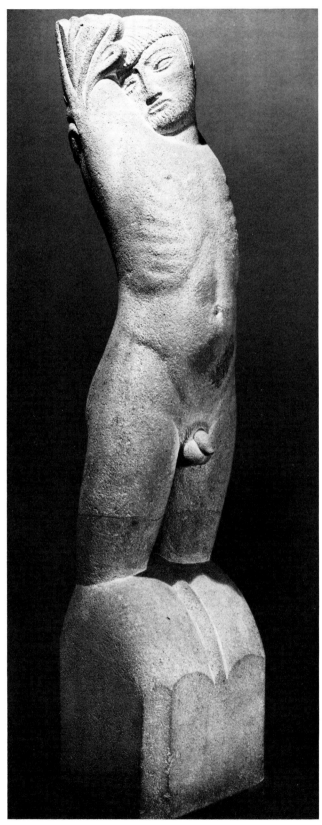

Eric Gill: **Eve**, 1928. Tate Gallery, London.

Eric Gill: **Adam**, 1928. Humanities Research Center, The University of Texas at Austin.

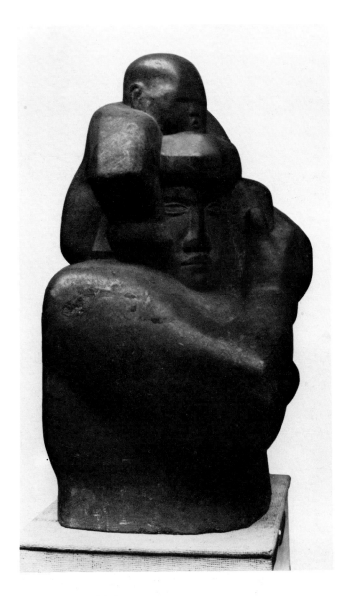

understanding and being in sympathy with material so that he does not force it beyond its natural constructive build, producing weakness'.[18] The theoretical statements of Wilenski are here enriched by the sculptor's practical experience of his medium.

Exhibitions of African sculpture were held in London at the Chelsea Book Club in 1920 and the Goupil Gallery in 1921. Coinciding with the first of these, the *Burlington Magazine* published an essay by the French critic André Salmon which reads as though it were intended to allay fears that interest in such work represented an eruption of the savage, by linking it to a return to classicism. In Salmon's view it was necessary to look at African art with 'eyes completely purified from a love of the curious and the picturesque'. Relating this interest to contemporary tendencies he wrote '. . . Gauguin could not have enriched us with negro art such as it appears to us today. Our concern with order, with constructive values, the desire for form and harmony, which have since come to govern our aesthetics, were totally lacking in the undisciplined and irritable impressionist.'[19] In 1928 the dealer Sydney Burney mounted an exhibition which showed African sculpture side by side with contemporary artists including Zadkine, Epstein, Dobson, Hepworth and Skeaping. *The Times* obligingly picked up the bait commenting that 'what the exhibition brings out is the traditional character of all good sculpture, independent of place and period.'[20]

This deeply ingrained belief in a category of 'good sculpture' provides useful ammunition for the embattled artist against the hostile judgements of the amateur. Here one find a significant and revealing contrast between the views of those sculptors most officially favoured with commissions in the immediate post-war years to those identifiable with 'modernism'. Gilbert Bayes while invoking the 'abstract laws underlying the art of sculpture' of which, he maintained 'the modern stunt school knew nothing' held that 'it should be the mission of art to appeal directly to the average man'.[21] Jagger, the sculptor of the **Artillery Monument** at Hyde Park Corner emphatically associated himself with the response of the common man. 'I have often watched the pathetic spectacle of the passer-by gazing in bewilderment at some twisted contraption of lead piping and copper wire or at some strange shape

[18]Henry Moore in Architectural Association Journal, May 1930.
[19]André Salmon in 'Negro Art' in the *Burlington Magazine*, April 1920.
[20]*The Times*, 26 November 1928.
[21]Gilbert Bayes, 'Treatment of Sculpture in Architecture' in *Architect's Journal*, 5 April 1922.

Henry Moore: **Mother and Child**, 1924-25. Manchester City Art Gallery.

Eric Kennington: **Head of T.E. Lawrence**, 1926. Tate Gallery, London.

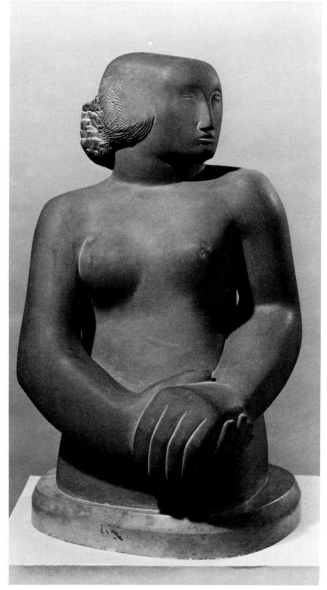

Barbara Hepworth: **Figure of a Woman**, 1929-30. Tate Gallery, London.

in stone, both according to his catalogue intended to represent the human form divine. I have watched him glance furtively right and left lest his bewilderment should be detected by the self-elected intellectual snobs who find these monstrosities an opportunity for loudly demonstrating their assumed intellectual superiority over their fellow men'.[22] By contrast, Epstein and Dobson both emphasise that the appreciation as well as the practice of sculpture is a matter of training. Epstein commented that 'so little is known about sculpture. People have not yet formed their own standards'.[23] In an interview Dobson remarked ironically that '. . . as far as I can see it is generally accepted that every human being is completely equipped as an art critic at birth!' and that the 'ordinary man' 'simply must spend quite a long time before he becomes an authority on football or hunting, but when he comes to works of art he assumes that he knows all about it'.[24] The comparison between art and sport assumes some similarity in the existence of objectively assessable aims and accomplishments.

Yet far more extreme in the expression of an elitist view was the British sculptor working in France Vernon Blake, an impassioned advocate of direct carving. In his book **Relation in Art** he wrote 'In fifteen years of application one can penetrate far into the mysteries of such a subject as Mathematics or

Physics; yet on such matters the profane never utter an opinion. It is only on the two specially abstruse subjects of the governing of states and the making of works of art that ignorance feels itself licensed to pronounce.'[25] Yet 'ignorance' was incapable of worthwhile judgements of art precisely because its purpose

[22]Charles Sargeant Jagger, 'The Sculptor's Point of View', *The Studio*, November 1933.
[23]Jacob Epstein and Arnold Haskell, **The Artist Speaks**, London 1931, p.11.
[24]Casson (ed.), **Artists at Work**, London 1933, pp.49-50.
[25]Vernon Blake, **Relation in Art**, London 1925, p.233.

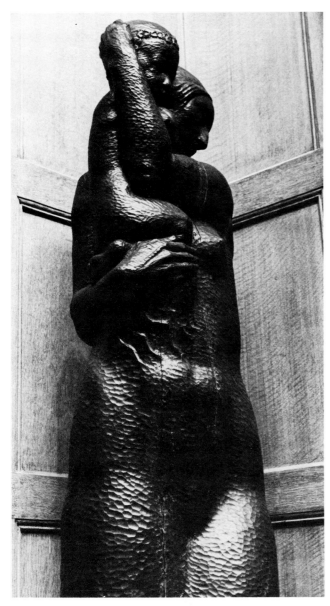

Charles Wheeler: **Mother and Child**, 1926. Wolverhampton Art Gallery.

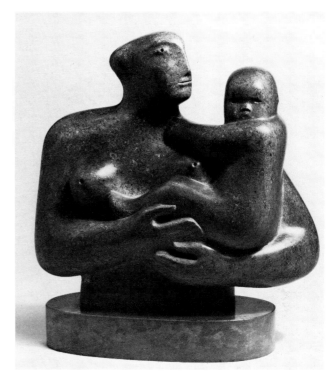

Henry Moore: **Mother and Child**, 1930. Private collection.

was not, as Fothergill would have it, a realism testable by direct references to the form of nature. '. . . we propose that artistic validity should be defined as an analogy between the integral relations of the work of art and the integral relations of the universe'.[26] It would be understandable for anyone to assume from such a passage that Blake was some forgotten pioneer of abstraction. In fact he was a monumental sculptor whose war memorials show a rigorous and rigid stylisation which might not have proved readily acceptable in a British context but are not too far

removed from similar treatment in the relief sculpture of such leading British monumental artists as Jagger and Bayes.[27]

This kind of paradoxical relationship should show how difficult it is to maintain a specific concept of modernism during these years. Like Moore and Dobson many of the younger sculptors who exhibited at the Royal Academy, such as Gilbert Ledward and Charles Wheeler, felt a similar dissatisfaction with the accepted modelled and pointed sculpture and practised direct carving. To view the nineteenth century as an age of decadence in sculpture was not necessarily the mark of the avant garde. Jagger, although deploring the excesses of modern sculpture, considered that 'The worship of ugliness today is the natural reaction from the sweetness and prettiness of yesterday, and it is my firm conviction that out of this violent convulsion which has shaken the very foundations of art a finer and nobler school of sculpture will presently emerge.'[28] Where he and others differed from Dobson or Moore was in their unwillingness to abandon sculpture as a public language. The aspiration may have been admirable but the results appear today as a grotesque compromise.

[26]Ibid. p.316.
[27]See Parkes, **The Art of Carved Sculpture**, London 1931, Chapter 4.
[28]Jagger, op.cit.

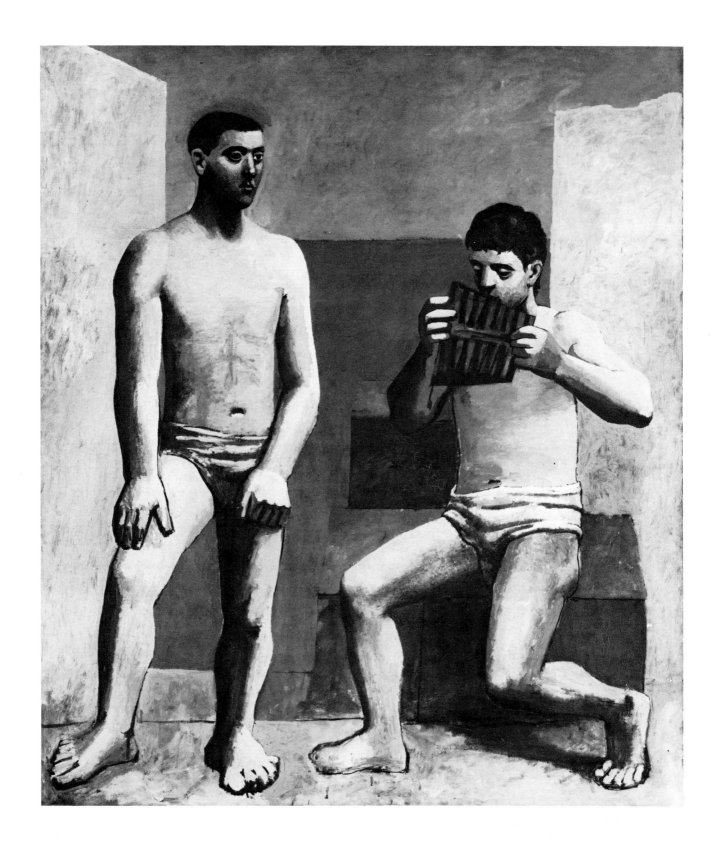

Pablo Picasso: **La Flûte de Pan** 1923, Oil, Musee Picasso, Paris.

VI. Painting and Sculpture in the 1920s.

Although the plump female nude had made many appearances in European painting and sculpture before 1920 (right back to the Paleolithic **Venus of Willendorf**), there seems to have been at about that date and for a few years afterwards, a particular rash of women with Michelinesque proportions. They are characterised by enormous thighs, rather short in length, thick torsos, pudding-mould breasts, clumsy fingers and feet; their hair is invariably pulled back into a bun, accentuating the generous oval of the face above a stocky neck. They are usually reclining (propped on an elbow) or seated and are rarely found in laborious or energetic poses (the two colossal females of Picasso's curtain for **Le Train Bleu**, based on **La Course**, 1922, are an exception). Sometimes a similarly pneumatic creature clings to a breast or lolls on a supportive shoulder. Whereas the male nude figure, much less frequent, watches his waist-line, the female abandons herself to an unprecedented plastic corpulence. As it always had, female anatomy lent itself more naturally to these exaggerations; the male body, creation of the male, remained within fairly naturalistic bounds. While Picasso takes the lead as creator of such monumental women, some pretty hefty counterparts were produced throughout Europe in the 1920s. And England, hardly noted for its pre-occupation with the nude, contributed examples as massive as those found anywhere else.

To establish some of the reasons for this phenomenon is not so difficult; much less easy to pinpoint is the relation and mutual influence between the painted and sculpted image. Did Frank Dobson, for example, simply take a leaf out of Maillol's book, or had he been studying Picasso at Paul Rosenberg's Gallery, or Grant and Smith in the London Group exhibitions? What knowledge had English artists around 1920 of Renoir's late nudes? Might there be a relation between the reclining Venus in Grant's **Venus and Adonis** c.1919, (Tate Gallery) and some of Moore's early figures? Did some of the impetus to create swelling thighs and wide shoulders come from oriental and primitive sculpture, much written about and exhibited in London and Paris after the First War? The relationship between painting and sculpture has always been tenuous and problematic; it is usually found to be slight (save, of course, among the practitioners of both – Degas, Matisse, Picasso). In England painter-sculptors have been virtually non-existent – the drawings of sculptors tend to be exactly that and few painters of note have ventured into sculpture. But in the early twenties there was enough

overlap of image and stylistic similarity between the two to warrant investigation.

To understand something of the background to this phenomenon as seen in England, we must look across the Channel. The classical revival (or neo-classicism) which characterises the work of several painters and sculpture. But in the early 1920s there was enough 1920s was not simply due to the fragmentation and turmoil brought about by the First War. Its origins go further back and are considerably more complex. But, for the sake of brevity, we can say that Picasso's 1917 visit to Italy to collaborate with the Ballets Russes on 'Parade' is of great significance in the gradual formation of the neo-classical style. [1] (The inspiration he is supposed to have gained from Ingres' drawings has been overrated.) Graeco-Roman sculpture, the Renaissance masters, especially Raphael, and the Roman frescoes he saw in Naples – all these contributed to the formation of the monumental, 'realistic' style which dominated Picasso's ensuing work. [2] From this period we have several grand and austere depictions of the nude – **La Grande Nue, La Source, La Flûte de Pan** and many smaller works which closely derive in subject and handling, if not in colour, from the Roman frescoes. ◀ Although the fruits of this Italian visit were to be influential in France and elsewhere after the War, Picasso was not alone in his discovery of Italy at first hand.

The freedom to travel, brought about by the ending of hostilities in late 1918, precipitated a flurry of trans-European journeys. In 1921 Derain was in Rome and Castelgandolfo, English painters flocked across the Channel like lemmings, Italian painters were once more in Paris. Rome became something of an artistic centre with the establishment of the *Valori Plastici* group and its related publications (such as Carlo Carrà's astringent monograph on Derain of 1921). [3] The Mediterranean coast from Nice to Collioure found favour with a whole new generation of painters – Picasso at St Raphael (1919) and Juan-les-Pins (1920), Segonzac at St Tropez, Marchand at Cagnes, Braque

[1] For discussion of classical features in an earlier phase of Picasso's art see P. Pool, 'Picasso's Neo-Classicism: First Period, 1905-6' *Apollo*, February 1965, pp.122-127.
[2] For a closer examination of what Picasso saw in Italy and a comparison of his work and its sources, see A. Blunt, 'Picasso's Classical Period (1917-25)', *Burlington Magazine*, April 1968, pp.187-191.
[3] For an account of the neo-classical characteristics of the Valori Plastici group and others see P. Vivarelli, 'Classicisme et Arts Plastiques en Italie entre les Deux Guerres', in **Les Réalismes 1919-1939**, exhibition catalogue, Centre Pompidou, Paris 1981, pp.66-73.

at Cassis.[4] No Salon or London Group exhibition was complete without its views of the Alpes Maritimes or the ports and resorts with their sunlit bathers and quayside markets which provided fare for often lugubrious still-lifes. Naturally, this local colour must not be confused with a definite return to classic, Mediterranean themes.

Among those themes, the serene, large-limbed female was paramount. Others include the Italian landscape, mythological scenes, figures from the Commedia dell'Arte, *fêtes galantes*. But the distillation of all these was the massive female, a timeless image of multifarious associations – from the unadulterated sensuality of Renoir's **Grandes Baigneuses** through Picasso's meditations on maternity to the heroic steadfastness of Maillol's **L'Action Enchaînée**. The art of the past was invoked as a confirmation of the traditionalism of such a symbol. The literature of the period, as much as the works themselves, refers repeatedly to the great classics – Raphael, Poussin, Ingres. Raphael's name was constantly on Derain's lips in the early 1920s ('Le plus grand incompris'); he was copied by de Chirico, expounded by Lhôte. In **L'Esprit Nouveau** (no.4, 1920) Roger Bissière wrote: '... our race, having furnished a great effort and gone through incredible convulsions, feels a desire to be calm, to add up the sum total of the treasures it has amassed. In short, we aspire to a Raphael, or at least to all that he represents in the way of certitude, order, purity, spirituality.[5]

In sculpture the great exponent of such ordered classicism at this time was Aristide Maillol. Although not a product of post-war neo-classicism (his archetypal **La Mediterrannée** in the Jardins du Louvre dates from c.1902-5), his work was becoming widely known outside France at this period. In England Roger Fry had written favourably about him in the *Burlington Magazine* in 1910; after the war Fry and Clive Bell consistently praised him – 'the best sculptor alive' Bell called him in 1921. At the Leicester Galleries in 1919 Maillol showed cases of terracotta figures alongside Matisse's work, the painter's first show in London. Maillol's follower Marcel Gimond (1891-1961) had a certain vogue at this time, with his schematised Graeco-Roman portrait busts. The American sculptor Gaston Lachaise, in Paris in the early 1920s, was similarly imbued with the neo-classic spirit, if more raffish and mannered in his concessions to contemporary fashion. His work gained a wider currency through the pages of *The Dial*, as did the line drawings and classic heads of Picasso and the nude drawings of

Maillol ('the peer of any living sculptor', Thomas Craven called him in *The Dial* in February 1924).

In England, it was the painters rather than the sculptors who first embodied something of European neo-classicism as represented by the nude female figure. The last works of Renoir (who had died in 1919) seemed to have captured the imagination of several painters who were forging a more plastic, ample figurative style at that moment. Vanessa Bell gave some large black and white photographs of Renoir's nudes to Duncan Grant for Christmas 1919; Osbert Sitwell brought similar photos back from Paris to give to Edward Wolfe; in 1921 Mark Gertler thanked Carrington for some Renoir reproductions with 'How massive and grand!' Among Grant's photos were the **Grandes Baigneuses** (c.1918, the Louvre) and the **Woman Tying Her Shoelace** (c.1916-18, Courtauld Institute Collection). But coming nearer to Renoir in his treatment of the female nude was Matthew Smith, who in the early 1920s painted some of his best and most luscious reclining women – the nude or partly-clothed figure of the painter Vera Cunningham. Picasso's neo-classic nudes were mainly known to English artists through reproduction and visits to Paris; a few examples were seen at the Leicester Galleries in early 1921. Grant and Vanessa Bell visited Picasso in 1920 and 1921 and on the former visit saw **Les Deux Soeurs** 'an astonishing painting of two nudes most elaborately finished and rounded and more definite than any Ingres, fearfully good I thought' wrote Vanessa Bell.[6] Little of this revelation is conveyed in Vanessa Bell's own attempts at the monumental – the female model for her **Nude** 1922-3 (Tate Galley) appears weighed down by her own massiveness, lacking the other-wordly solemnity of Picasso's figures. One of the earliest of Picasso's works to show such large-limbed figures is **The Sleeping Peasants** (1919, Museum of Modern Art, New York) and it directly inspired the young Blair Hughes-Stanton to paint a similar canvas (private collection, London) in about 1924 after a visit to Paris. The seated and reclining girls of Dod Procter's

[4]Of the English artists mentioned in this essay, Matthew Smith was in Paris in early 1922; Duncan Grant and Vanessa Bell were in Rome in 1920, at St Tropez winter 1921-2 followed by a stay in Paris; Dobson was in Paris in 1922; Mark Gertler paid the first of several visits to Paris in spring 1920 and was in St Tropez in 1924 and again in 1925.
[5]See further C.Green, 'Léger and l'Esprit Nouveau 1912-1928', in exhibition catalogue, **Léger and Purist Paris**, Tate Gallery 1970-71, particularly **La Tradition**, pp.64-67.
[6]Letter from Vanessa Bell to Roger Fry, 17 May 1920, in the Charleston Papers, Tate Gallery Archives. For a fuller account of this and subsequent visits to Picasso see R.Shone, **Bloomsbury Portraits**, London, 1976, p.217 passim.

paintings of the 1920s, widely acclaimed at the time as both modern *and* intelligible (eg: **Morning**, 1926, Tate Gallery) perhaps owed something to Picasso, though they now appear closer in spirit to the 'realism' of the *Novecento* group in Italy, particularly Sironi, and to the work of William Roberts.

Before 1918 colour had been the great pre-occupation of several English painters of the post-impressionist school – Smith, Bell, Grant, J. D. Fergusson. But it bred dissatisfaction, after some years, as we can see from the following letter of Vanessa Bell to Roger Fry of about 1925. '. . . there was a great deal of excitement about colour then . . . I suppose it was the result of trying first to change everything into colour. It certainly made me inclined also to destroy the solidity of objects but I wonder whether now one couldn't get more of that sort of intensity of colour without losing solidity of objects and space.'[7] This 'solidity' was in huge supply in exhibitions of the London Group and in shows of modern English and French art at the Independent and Leicester Galleries. Some of the weightiest pictures came from Duncan Grant – an apparent *volte face* after the lyrical exclamations of a few years before. In fact, in his easel paintings, he had always been concerned with solidity, with the articulation of objects in space; the period from 1911 to 1917 now appears as a partial, if exhilarating, break in the realist tenor of his work. Continual decorative painting for the Omega Workshops tended to dissolve objects into brilliant and often arbitrary colour and an over-worked surface. (His first post-war decorations – murals for Maynard Keynes in King's College, Cambridge – are notable for their subdued earth colours and strong contours.)

Grant himself had begun to see the dangers of this fluidity in about 1917. Thereafter the limbs of his figures began to swell, outlines became more emphatic, the paint surface was thicker, brush-strokes modelling the curve of thigh and breast. In his 1918 **Juggler and Tightrope Walker** (private collection, London), the latter figure, seen from below, gains considerably in wit from this new-found amplitude. In the following year **Venus and Adonis** embodies both classic myth and neo-classic style. ☛ The languishing yet alert figure of Venus seems a remarkable precedent for some of the slightly later reclining women of Henry Moore. Indeed Moore may well have seen the painting when a student at Leeds School of Art 1919-21, as it was then in the collection of Sir Michael Sadler, the University Vice-Chancellor; Moore has testified to Sadler's influence at this time. Grant has carried the

broad rhythms of Venus through the rest of the picture – curtain, couch and clouds. The suggestion for this scheme appears to have been derived from the portrait of **La Bella Simonetta** by Piero di Cosimo at Chantilly with which Grant was certainly familiar.

Through the 1920s, Grant continued to produce ample female nudes but increasingly they were reserved for murals and decorative projects, which culminated in the Pompeian **Toilet of Venus** of 1929-30 (Southampton Art Gallery). In his easel paintings he tended to observe the slimmer contours of reality, although models were often chosen for fullness of figure. It is perhaps in his drawings of the 1920s, combining generous contour with heavy, hatched modelling, that he best approximates the neo-classic features of his contemporaries. There are striking similarities in handling and pose between some of these drawings of the nude and those of Henry Moore (and we can detect a corresponding influence in Barbara Hepworth's drawings such as the 1928 **Female Nude** reproduced in her **Pictorial Autobiography**, 1978, p.15). Indeed many of Grant's drawings have the appearance of sculptures of the female nude rather than of the model herself. It is interesting that he and Vanessa Bell acquired several drawings of female figures by Maillol and Gimond at this time. But Grant's lighter, more lyrical manner of treating this subject can be seen in the **Nymph and Satyr** ☛ (c.1925, ex-collection Raymond Mortimer, London) with its unspecific classical subject and an abandoned pose much in keeping with Smith's contemporaneous nudes and with sculpture by Frank Dobson such as the marble **Reclining Nude**.

Taking part in this ubiquitous display of flesh (at a time, it must be remembered, when fashion was dictating a flat-chested, low-calorie look) we find Mark Gertler with several chalk drawings and an exotic if unappetising **Queen of Sheba** ☛ (1922, Tate Gallery); more healthy-looking female figures from J. D. Fergusson (and some sculpture too); work on canvas and in stone by Leon Underwood (such as his **Torso**, finished in 1925, reproduced in **Leon Underwood** by Christopher Neve, 1974, p.83); and by Bernard Meninsky (although the period of his large-limbed, pastoral goddesses was twenty years later). A tardy addition to the canon was Stephen Tomlin's *alfresco* lead figure for Bryan Guinness at Biddesden which, when shown in the 1935 London Group exhibition, was described as 'about four tons of purplish grey womanhood.'

[7]Charleston Papers, Tate Gallery Archives.

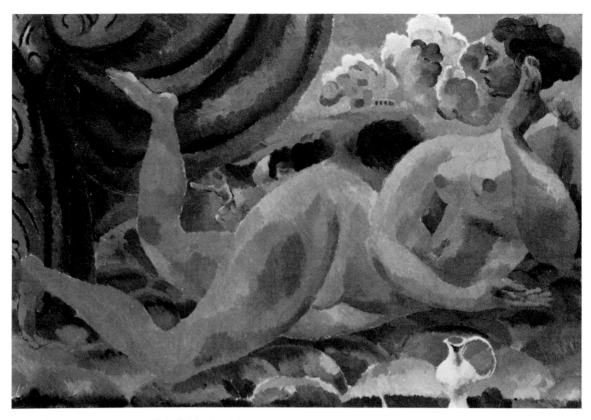

Duncan Grant: **Venus and Adonis**, Tate Gallery, London.

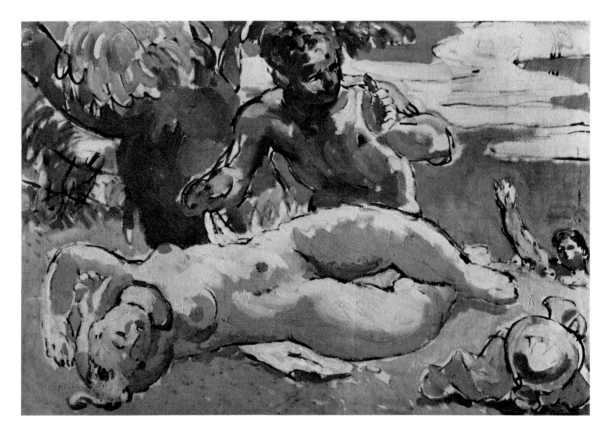

Duncan Grant: **Nymph and Satyr** c.1925, Private collection, London.

PAINTING AND SCULPTURE IN THE 1920s

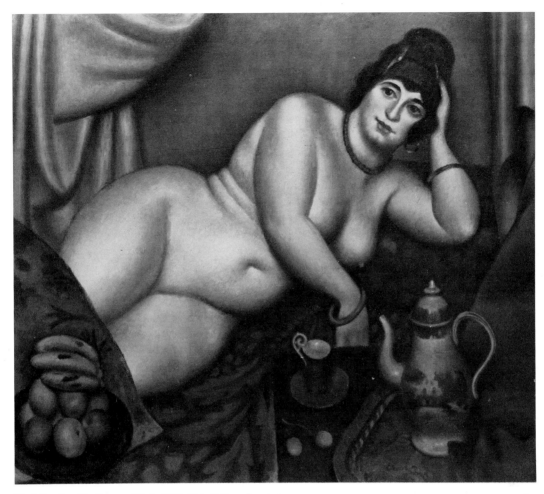

Mark Gertler: **The Queen of Sheba** 1922, Tate Gallery, London.

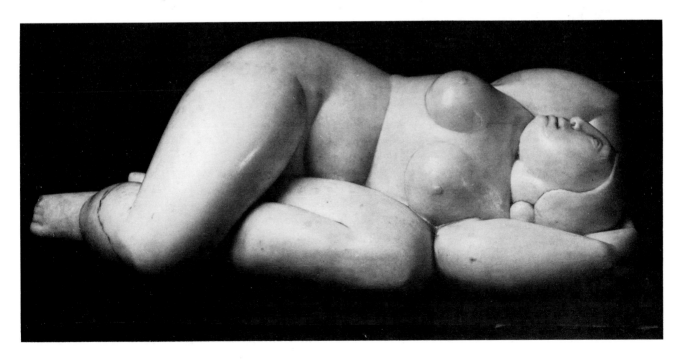

Frank Dobson: **Marble Woman** 1924-25, Courtauld Institute Galleries.

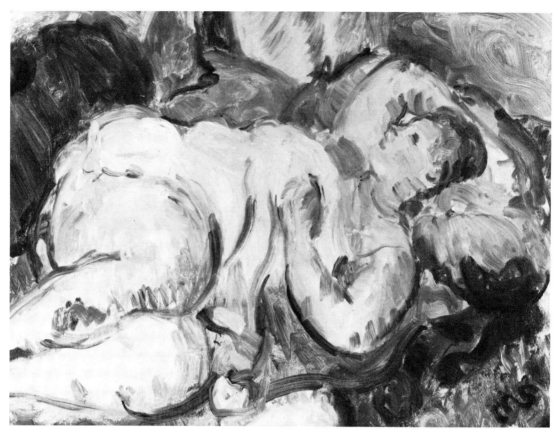

Matthew Smith: **Couleur de Rose** 1924, British Council.

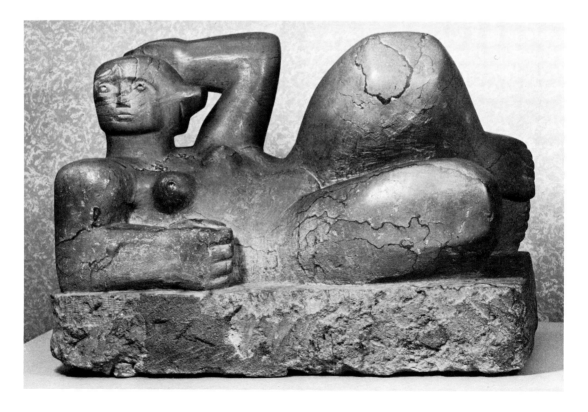

Henry Moore: **Reclining Figure** 1929, Stone, Leeds City Art Galleries.

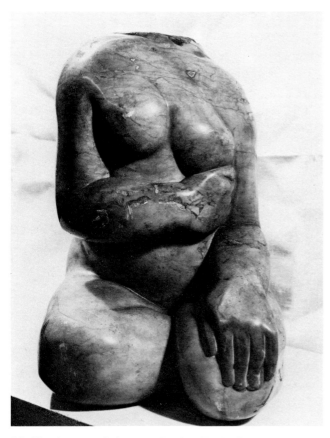

John Skeaping: **Torso**, before 1933, Bradford City Art Gallery.

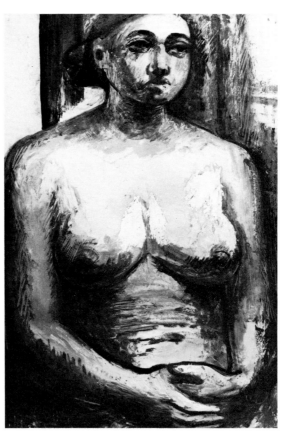

Henry Moore: **Drawing from Life**, 1929. Oil on paper. Whitworth Art Gallery, University of Manchester.

In Western painting, the reclining female nude is a constant theme; in sculpture, it is much less common than one might think. It appears as part of an overall scheme (as in Bernini's fountain in the Piazza Navona or Michaelangelo's **Night** in the Medici Chapel) and is occasionally seen as a separate entity (as in Canova's **Pauline Borghese**). But it does not emerge as a considerable iconographic presence in sculpture until early this century.[8] In painting, attention was lavished on the theme by Picasso and Matisse at crucial moments in their developments; in sculpture, Moore, since the 1920s, has been its obsessive interpreter. He has stressed its importance to him as a subject allowing him 'to try out all kinds of formal ideas . . . The subject matter is *given*. It's settled for you, and you know it and like it, so that within it, within the subject you've done a dozen times before, you are free to invent a completely new form-idea.'[9] This 'given-ness' applies too to Matthew Smith, painting the same model in the same room in the Villa Brune; to Duncan Grant who, with more changes in his models, produced nevertheless a Grant-type, languorous yet innately forceful, even domineering (in his mytho-logically inspired pictures, man is frequently a victim,

woman triumphant or at the least holding the reins of pictorial action); and to Frank Dobson who, in his small terracottas is less complex in his sensuous celebration of the female figure. Where Moore's female figures are, among other things, alert (the propped elbow suggesting surveillance), Dobson's, even when in a similar pose, are endowed with a self-reliant air of tranquillity.

Uniting these artists' treatment of a similar theme is a confidence in the traditional properties of the nude to convey certain formal and rhythmic perceptions. In each one considerable tension is achieved from the balance of objective observation of the figure and a variously derived conceptual idealisation. Classic, hieratic postures persist within the private turbulence of Smith's colour as much as in the democratic health of Moore's maternal groups. If Picasso and Moore, in the 1920s and 1930s, revitalised a familiar image, lesser artists reaffirmed that tradition in works which can be accounted as among their most successful.

[8]For a discussion of the female nude in sculpture at this period, particularly in Maillol's work, see W. Schnell, **Der Torso als Problem der Modernen Kunst**, Berlin 1980.
[9]Quoted in J. Russell, **Henry Moore**, London 1973 edition, p.48.

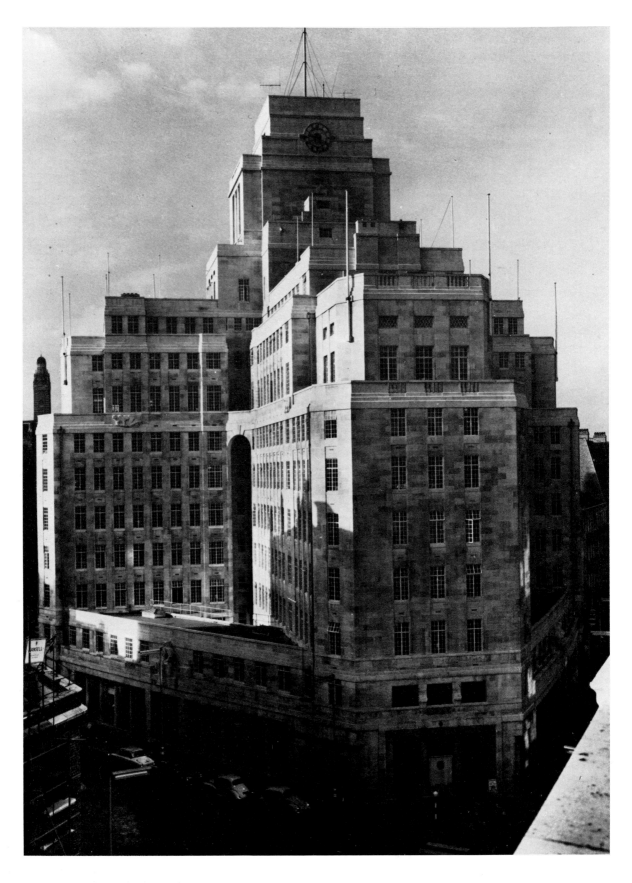

The Head Offices of the Underground Railway (now London Transport), 55 Broadway, Westminster, London.

VII. Overhead Sculpture for the Underground Railway.

Collaboration between architects and sculptors has usually produced, in twentieth-century Britain at least, token embellishments which discredit the whole notion of public art. Even an exception as remarkable as the headquarters of the London Underground, where no less than seven sculptors carried out an ambitious scheme of carvings, is marked by a curious reluctance to allow them the prominence they deserved.

Although they look uncontroversial enough today, the carvings commissioned for the headquarters attracted bitter criticism after their completion in 1929. Only an architect committed to the importance of imaginative art-works would have risked bypassing the academic sculptors normally employed on building projects. Charles Holden was prepared to court that danger, even though he had provoked an uproar twenty years before by inviting Epstein to carve an extensive series of figures for the British Medical Association building in the Strand.[1] Holden, an austere and taciturn Quaker, numbered many artists among his friends, sympathised with their aims, and realised that an architect should never expect them to fritter their energies away on irrelevant ornamental diversions. Better by far to let sculptors carry out work which, even as it responded to the demands of the building, retained its individual identity.

But architects rarely possess freedom of manoeuvre when they, in their turn, receive commissions from clients. It is most unlikely that Holden would have been able to implement his unconventional views about public sculpture without the courageous support of Frank Pick, who had already employed him on the design of new Tube stations. Pick was passionately concerned about applying the highest standards in art to the fabric of everyday life. And since bureaucratic timidity was anathema to him, he was even willing to let Holden persuade him out of his personal misgivings about Epstein's work. Pick must have been fired by Holden's proposal[2] to construct a monumental cruciform block in Portland stone, its central tower rearing proudly above the jumble of narrow streets nearby. The symbolic impact of such an apparition, especially in contrast with the fussy complexities of the Victorian buildings around it, was inescapable. So far as Pick and his board were concerned, it probably affirmed the energetic optimism with which their Company had burrowed through the entrails of the metropolis and supplied it with a transport system fit for the machine age.

But rather than just signifying the hard, commercial ambition which had brought the Underground system into being, the Head Office seems to set great store by the dignity of traditionalist associations. They do not reveal themselves at once. Holden was enough of a modernist to ensure that nothing was allowed to impede the insistent rhythm of window patterns or the receding progression of the cruciform wings as they lead up to the triumphant tower above. Yet within this bare rectilinear exercise, distinct elements of revivalism are asserted. On the seventh storey, the wings' inner corners are suddenly softened by the introduction of classical arches. They are symptomatic of a design which also cultivates neo-Georgian proportions in its windows and is unafraid to invite ecclesiastical associations. This gigantic structure, set diagonally on its site and pointing fearlessly down Tothill Street towards Westminster Abbey in the distance, dominates its environment like a secular cathedral.

A similar mixture of boldness and reticence marks Holden's attitude towards the artists he employed. By inviting seven of the most adventurous sculptors in Britain to work on his building, he clearly accepted that the outcome would constitute a challenge to conservative opinion. But instead of encouraging them to interpret the theme of underground travel in any literal way, Holden asked everyone except Epstein to carve flying figures symbolizing the four winds. Eric Gill, the most well-known of these six sculptors was put in overall charge of them and received a commission to execute three separate figures. The others – Aumonier, Gerrard, Moore, Rabinovitch and Wyon – were given one carving each, so that all the winds were represented twice.

The trouble with the flying figures concept is that it fails to suggest underground transport with any directness. Moreover, the placing of the figures on the seventh storey only encourages the notion that they refer to the winds in the sky rather than the Tube tunnel draughts beneath the ground. And by relegating them to such a distant position, eighty feet from the pavement on a band of stone which runs round the building to mark the point at which the wings begin stepping back towards the tower, Holden also impaired the carvings' visibility. Large in themselves, they look diminished when placed far away on so massive an edifice.

[1] The eighteen Strand statues were commissioned in 1907 and unveiled, to widespread abuse, the following year. In 1937 the new owner of the building, the government of Southern Rhodesia, mutilated the statues so badly that they are now ruined.
[2] For a more detailed account of the building's protracted genesis, see Christian Barman. **The Man Who Built London Transport. A Biography of Frank Pick**, London 1979, pp. 125-6.

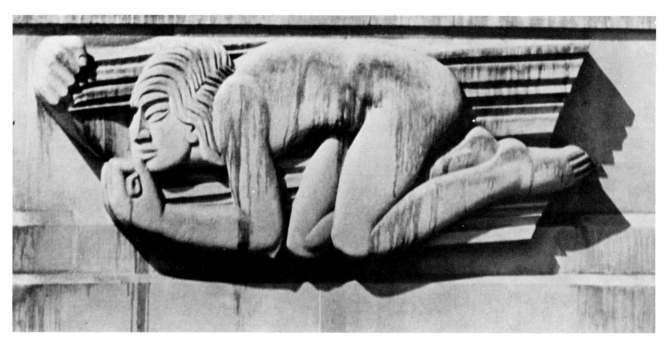

Eric Gill: **North Wind** (on the east side of the south wing).

Eric Gill, whose passionate beliefs about the artist's role in society made him acutely aware of such anomalies, deplored his position when he began work on site at Westminster. Writing in December 1928, he told a friend that 'I am at present doing some big but unimportant sculptures on a building in London – architectural fal-lals merely but a valuable experience. We are working against time – horrible clanging and noise and mess all round – revolting contrast between our (there are 5 sculptors on the job) attempts at "love-making" and the attitude of mind of the 1000 "hands" around us. The building is good and plain – iron with plain stone facing – we are quite out of place.'[3]

Quite apart from disclosing Gill's despair about the alienation of the workers engaged on the building, this fascinating letter shows him fighting a battle with himself, torn between his pleasure at receiving a substantial commission for public sculpture and his misgivings about the whole idea of carving at an architect's behest. On the evidence of his three figures, though, he did succeed in preserving his individuality as a sculptor. There is a distinct contrast between the austere organisation of Holden's façade and the more playful rhythms Gill employs. As if embarrassed by the geometry of his surroundings, Gill's hunched embodiment of the **North Wind** appears to hide away on his allotted portion of wall. ☛ Far from representing energy in triumphant motion, his limbs curl into a Puck-like attitude of impish cunning. He seems to be hatching a private plot; and although

some vitality is created by the zig-zag patterning of his hair, it does not allay the suspicion that he is slinking away from his responsibilities as a generator of elemental fury.

A more appropriate langour affects Gill's **South Wind.** ☛ Endowed with the ample dimensions of a goddess, she stretches her sensual body until its full length is nearly extended along the stone surface. Her right arm runs in an unbending line towards equally straight heels, thereby providing the carving with an upper edge which chimes well with the window frame above. As befits a wind usually regarded as soft and beneficent, she seems to be floating in a sea of physical contentment rather than whirling through the sky. And the full extent of her relaxation can be gauged by comparing her with Gill's third carving, **East Wind.** ☛ For this figure succeeds in embodying a more aggressive amalgam of speed and power. With one massive shoulder pushed forward, and both legs straining to project his body through the air, he hurtles across the north side of the building's west wing with an urgency which evokes the natural force he represents. Gill's sense of humour ensures that **East Wind** looks pleased with his prowess, too, turning his head away from the direction he pursues and grinning at the gravity-bound pedestrians on the street below.

But does even the animation of **East Wind** suffice for a building erected above the irresistible onrush of

[3]Eric Gill to Graham Carey, 2 December 1928, **Letters of Eric Gill**, (ed.) Walter Shewring, London 1947, p.242.

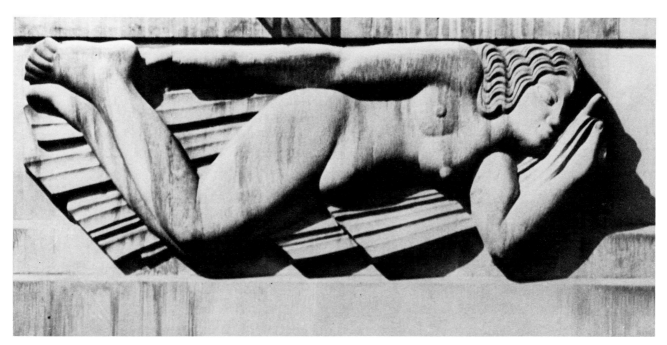

Eric Gill: **South Wind** (on the east side of the north wing).

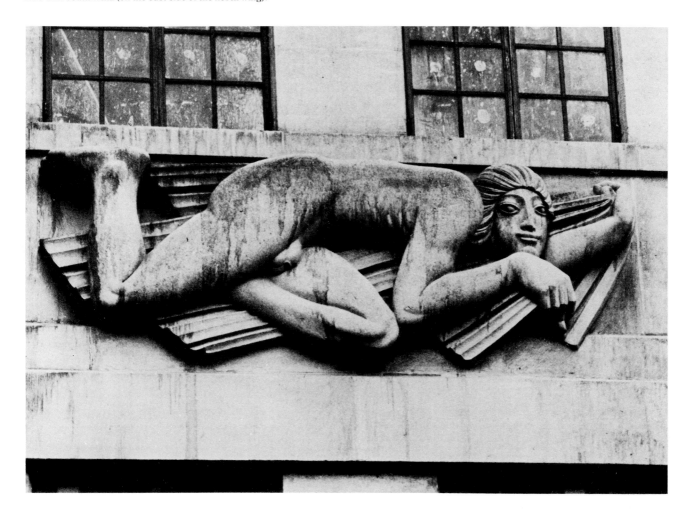

Eric Gill: **East Wind** (on the north side of the west wing).

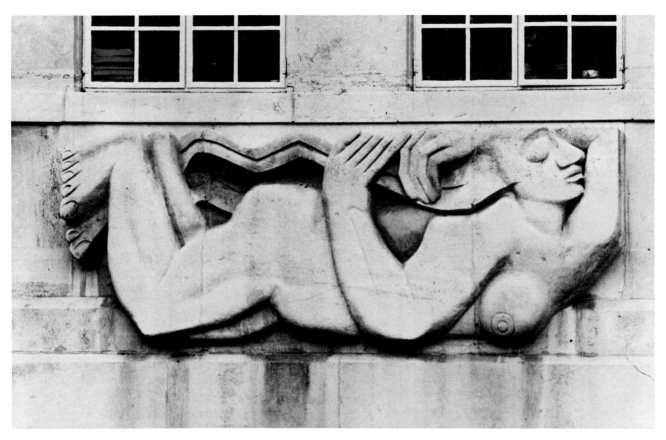

A.H. Gerrard: **North Wind** (on the west side of the south wing).

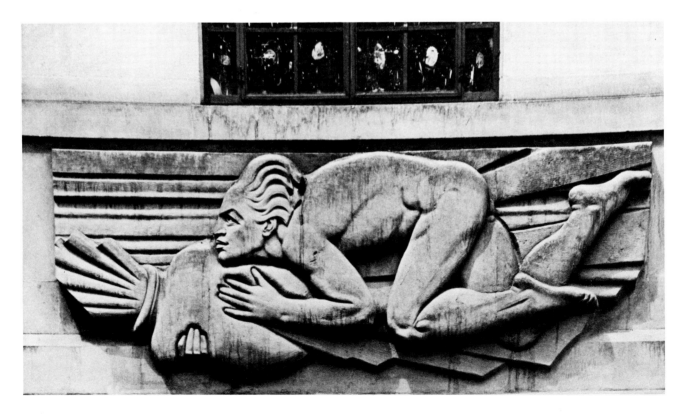

Allan Wyon: **East Wind** (on the south side of the west wing).

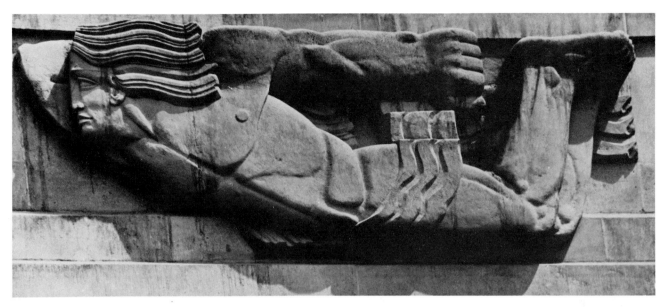

Eric Aumonier: **South Wind** (on the west side of the north wing).

the tube transport? No doubt aware of this challenge, both Gerrard and Wyon tried rather desperately to give their figures an additional element of drama. Gerrard's **North Wind** seems convulsed by a seismic tremor (or is it a stray electric current from the Underground voltage?). ◄ It almost wrenches her head from its body and twists her right arm into anatomically impossible distortion. But none of this violence avails. The figure remains oddly squat, crippled rather than galvanised into motion by her misshapen posture. As for Wyon, he attempts to signify speed with the aid of an all too literal prop. His **East Wind** broadcasts his identity by clasping a wind-bag and forcing it to emit a gust of air. ◄ But the hands pressing against it seem remarkably ineffectual, and the wind it issues looks no more blustery than a bunch of flowers fanning out of a pot.

In this respect, Aumonier's muscular **South Wind** does convey the necessary amount of potency. ◄ With one arm bent right back at the elbow as if to shield himself from the onrushing gale, he thrusts out his other arm in a mighty horizontal terminated by a formidable bunched fist. Aumonier has carefully aligned this arm with the figure's flowing hair, upturned heels and clenched elbow, so that the entire top body contour fits even more tightly below the window-ledge than Gill's **South Wind**. This is a figure surging forward with as much swiftness as he can possibly summon, and even his loincloth reacts to the superhuman effort by hardening into a jagged series of thunderbolt patterns.

Aumonier may lack Gill's suave and delightful poise,

but his carving is more attuned to the character of its location. The same merit can be found in Rabinovitch's **West Wind**, where still greater pains are taken to stress the straight upper line formed by its feet, right arm and tightly clasped left fist. ◄ He has even emphasized a comparable line along the lower edge of the figure by including a flying bird in the space which Aumonier left empty. If the result is rather rigid in its strict obedience to the architectural setting, Rabinovitch does nevertheless integrate his Amazonian woman with the building, thereby demonstrating a commendable grasp of the demands which architectural sculpture makes.

But to define the difference between a sculptor who efficiently fulfils his task, and one who transcends it by an unusually intense act of the imagination, Rabinovitch's figure should be compared with Henry Moore's **West Wind**, the finest of all the Underground reliefs. ◄ The commission for this carving (which is mistakenly entitled **North Wind** in most of the Moore literature) was nearly given to someone else. For when Moore was approached by Holden, apparently at the urging of Jacob Epstein, the thirty-year-old sculptor viewed the invitation with considerable scepticism. The drawback, as he admitted later, was that 'relief sculpture symbolised for me the humiliating subservience of the sculptor to the architect, for in ninety-nine cases out of a hundred, the architect only thought of sculpture as a surface decoration, and ordered a relief as a matter of course.'[4]

[4]Henry Moore, **Sculpture in the open air**, London 1955, published in **Henry Moore on Sculpture**, (ed.) Philip James, London 1966, p.97.

OVERHEAD SCULPTURE FOR THE UNDERGROUND RAILWAY

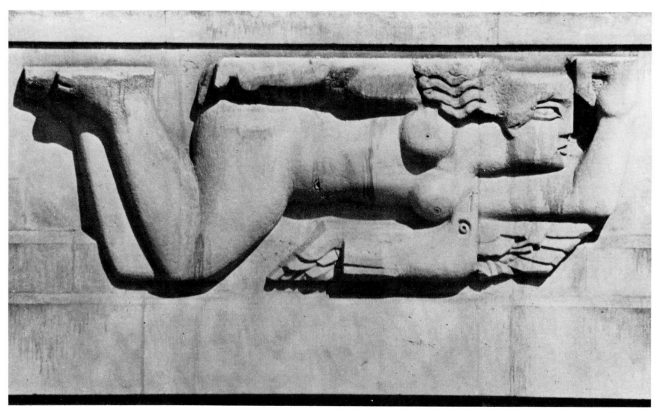

F. Rabinovitch: **West Wind** (on the south side of the east wing).

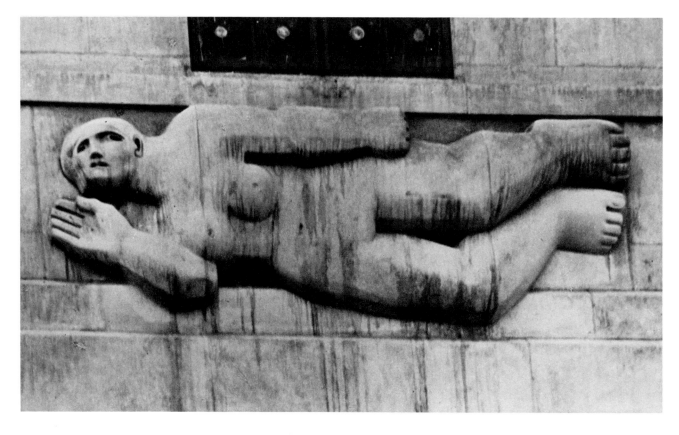

Henry Moore: **West Wind** (on the north side of the east wing).

Holden, sensing Moore's doubts, eventually won him round. 'He talked to me like a father', Moore recalled, 'and he was very nice to me.'[5] This direct, friendly contact, so different from the usual relationship between architect and sculptor, helped allay his fears. Indeed, once Moore had made up his mind to do the carving, he went about his task with more enthusiasm than his recollection of events in later years would suggest. The existence of abundant preparatory drawings, mostly in a 1928 **Sketchbook for the Relief on the Underground Building**,[6] shows the avidity with which Moore approached this commission. Well over a hundred sketches of reclining figures can be found on these sheets, and they testify to his excitement at finding a theme which yielded such rich possibilities.

He had already executed several smaller sculptures of the subject, and the first drawings in the sketchbook are still allied to the static pose explored a year earlier by his cast concrete **Reclining Woman**.[7] But there is no precedent for the sudden proliferation of sketches in 1928, when the theme finally began to dominate Moore's imagination. So the Holden commission precipitated Moore into an intensive exploration of a subject which would remain supremely important to him for the rest of his life. In his drawings the sculptor felt free to take as his starting-point the posed figure already defined in **Reclining Woman** and gradually lift her into a range of possible flying positions.

When Moore was ready to carve the sculpture itself, the enormous three-part portland stone was delivered to his small studio at the Royal College of Art. 'I did the roughing-out there', he recalls. 'Then, when it was nearly finished, we put it up on the building. I completed the carving on a scaffolding platform where there was only about three feet to stand on, and at first I was alarmed. It was so high up. But when I got back down and looked at it from the ground, I realised that the figure's navel couldn't be seen properly. This was terrible, because the umbilical area is absolutely central to me – the cord attaches you to your mother, after all. By this time the scaffolding had been dismantled so I went up again in a cradle, winching it up myself from side to side until I reached the carving. But once there, I found I couldn't carve properly: every time I struck a blow, the cradle shot back from the figure. So in the end I got out some charcoal and shaded the navel in: I knew that it would wash off eventually, and that the navel would by then have darkened with London grime and become

prominent enough. The cradle zig-zagged all over the place on the return journey as well. Epstein watched me, after I'd come down he said: "I wouldn't have done that for all the money in the world." '[8]

The scrupulous attention Moore paid to the impact of the sculpture *in situ* was justified. Unlike its flying counterparts, which contain too much detail and lose some of their significance from a distance, Moore's **West Wind** spurns all superfluities. Apart from a few facial features, the nipple-rings incised on each breast, and the schematic navel originally drawn onto the stomach, this noble body is restricted to a simplicity of form which suits Holden's building admirably. Where Gill lavished consummate but unnecessary skill on articulating the precise anatomical construction of his figures, Moore staked everything on the bold masses which he knew would be the only element fully visible to a pedestrian below. Seen from the ground, they impress with their primordial weight.

But the impact of **West Wind** does not derive solely from Moore's intelligent response to the demands of architectural sculpture. After all, Rabinovitch shows a similar understanding of the context his **West Wind** inhabits, and he does not persuade us to believe in the mythological figure he has created. Moore's carving, by contrast, possess an authentic *gravitas* which makes her appear eminently capable of administering the awesome powers at her disposal. The cropped hair flattened helmet-like over her skull, the deeply shadowed eyes and sombre mouth are all redolent of a woman who broods with almost melancholy seriousness over the immense forces she controls. Nor does she appear confined by the sculptural simplifications which, in Rabinovitch's case, threaten to cage the figure inside a modernist straitjacket. Moore's **West Wind** moves through the empyrean with an ease and confidence unimpeded by her palpable bulk. Utterly in control of her calm limbs, she has no need to employ the frantic gestures paraded by several of the other flying figures. Instead, one mighty hand is raised in command, and its tacit sense of authority convinces us that gales will blow all round the world if she so desires.

Looking back on the Underground project years afterwards, Moore believes that it turned out to be 'a

[5]Henry Moore, conversations with the author, 1 December 1980 and 26 May 1981.
[6]Owned by the Henry Moore Foundation, and discussed by Alan G.Wilkinson in **The Drawings of Henry Moore**, London 1977, pp.76-7.
[7]Owned by Mrs Irina Moore.
[8]Henry Moore, conversations with the author, 1 December 1980 and 26 May 1981.

valuable experience,'[9] despite the understandable misgivings he had harboured. Working on an unprecedentedly large scale, with the prospect of a far larger public than he had ever encountered before, he does seem to have pushed his fast-developing abilities to a new limit. But Moore could never reconcile himself to the notion of architectural relief carving, and in 1934 he refused Holden's request for eight seated figures high up on the façade of the Senate House Building in London.

Epstein, however, could hardly have complained that his contributions to the Underground building lacked prominence. Holden, who seems to have approached him before the other sculptors, asked his old friend to carve a group above each of the two doorways at street level. Epstein also appears to have been given *carte blanche* over his choice of subject. He maintained that 'I proposed groups of **Day** and **Night** as appropriate to a building that housed offices for transport and for speed.'[10] His logic may not have been readily apparent, but Epstein had already been planning a **Pietà** carving[11] and he realised that it could be transposed to the theme of sleep in a **Night** sculpture'. ☛

Holden was brave enough to accept Epstein's proposal without demur, and the sculptor went down to Westminster to carve on site. It proved an arduous experience. 'I began a six months' work which took me through the entire bitter winter months of 1928', Epstein recalled, 'working out of doors and in a draught of wind that whistled on one side down the narrow canyon of the street . . . I had to be oblivious to the fact that for some time tons of stone were being hauled up above my head, on a chain, and if this chain broke. . .'[12]

These physical tribulations were replaced by public execration once the carvings reached completion. After a gang of vandals incongruously dressed in plus fours drove past **Night** and bombarded it with glass containers full of liquid tar and feathers, it was vilified in the *Daily Express* as a 'prehistoric blood-sodden cannibal intoning a horrid ritual over a dead victim.'[13] Then Sir Reginald Blomfield, Past President of the Institute of British Architects, reinforced the lurid comments in the popular newspapers by writing a rhetorical letter to the *Manchester Guardian*. 'Bestiality still lurks below the surface of our constitution,' he growled, 'but why grope about for it in the mud, why parade it in the open, why not leave it to wallow in its own primeval slime?'[14]

Looking at Epstein's carvings today, it is difficult to understand why they provoked such fury in 1929. But they are, admittedly, far more provocative than his preliminary studies had indicated. In maquette form,[15] **Night** had paid sensitive, unexceptional tribute to Michelangelo's **Pietà**, and nothing suggested that Epstein would depart very radically from this hallowed Christian precedent. But the finished carving raises the mother's face into full view, and discloses features which are Mongolian rather than Western in derivation. The gentle, near-helpless gesture of her left arm in the maquette has become a hefty downward thrust, fingertips directed very decisively at closing the sleeper's eyelids. And Epstein has given the woman such a pronounced sneer that a macabre ritual might be taking place. It is easy to imagine that the rest of her forearm, poised so threateningly above, could at any moment fall on the body and crush the breath out of it. For this sleeper is as much a victim laid out for possible sacrifice as he is the peaceful beneficiary of the woman's attentions.

The position **Night** occupies, above a north-facing doorway, adds to the impression that we are witnessing a ceremony from some remote culture. For the implacable goddess is seated on a bare, throne-like block which immediately enhances her status as a deity. This time, Holden chose his place well. The only problem for Epstein lay in the step where the woman rests her feet. Its height obliged him to terminate her legs too soon, and the perfunctory treatment of the robes hanging down from her knees betrays his uncertainty. The folds are awkwardly handled, wavering between formalised pattern and a more naturalistic treatment. They contrast unfavourably with the folds in the upper half of the woman's garment, which Epstein resolved with a few simple incised lines.

Compared with the stylistic unity of Moore's flying figure, both **Night** and **Day** look tentative in their grasp of formal cohesion. The draperies covering the man's legs in **Day** are once again unconvincingly rendered, and the startling distortion of his face is at odds with the high degree of naturalism so evident in his hands. All the same both carvings are, in their own

[9]Ibid.
[10]Jacob Epstein, **Let There Be Sculpture. The Autobiography of Jacob Epstein**, London 1940, Readers Union (ed.), 1942, p.139.
[11]For the preliminary Pietà drawings see Richard Buckle, **Jacob Epstein, Sculptor**, London 1963, p.164.
[12]**Let There Be Sculpture**, op.cit, p.139.
[13]Quoted by Christian Barman, op.cit, p.129.
[14]Sir Reginald Blomfield, 'The Cult of Ugliness', *The Manchester Guardian*, 27 July 1929.
[15]Bronze, collection Philip Dyer.

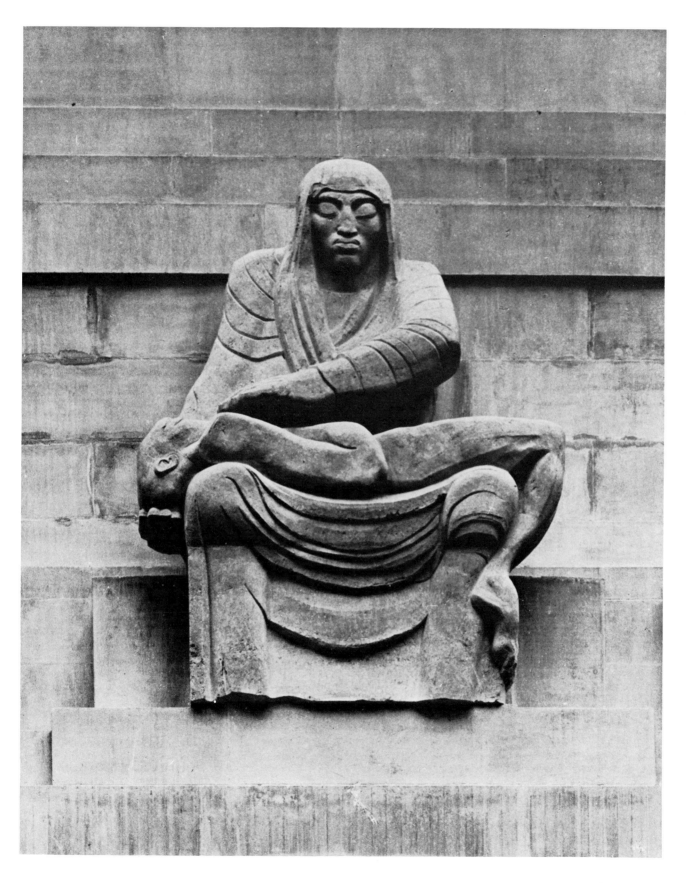

Jacob Epstein: **Night** (above doorway on the north-east side).

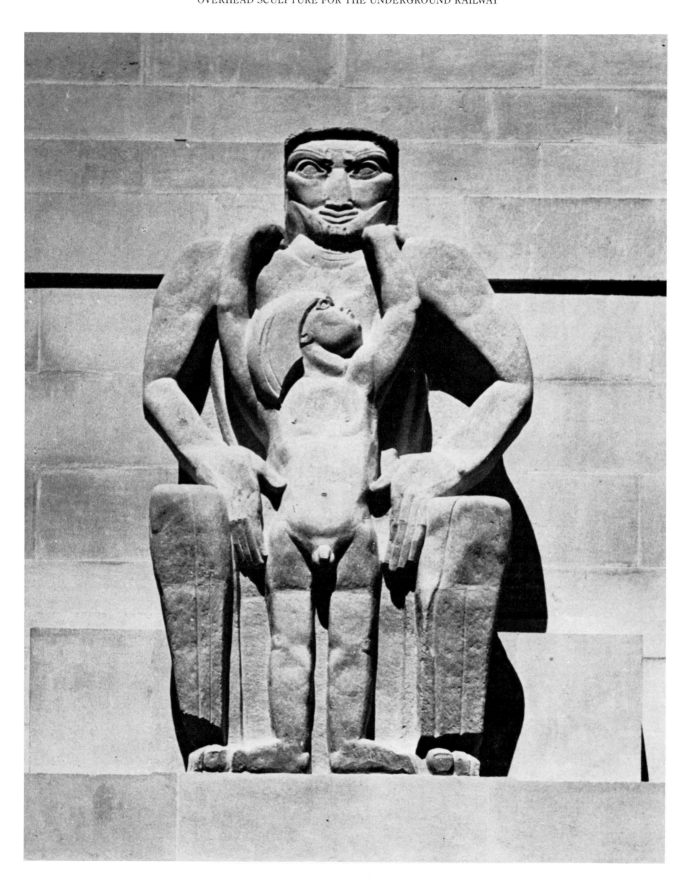

Jacob Epstein: **Day** (above doorway on the south-east side).

idiosyncratic way, mesmerising examples of how sculpture can retain its imaginative independence even as it honours an architect's specifications. **Day**, placed over the eastern door to meet the light at dawn, centres on the stretching movement of a boy whose limbs seem to unfold in response to the warmth of the rising sun. ▬ Epstein asserted that the carving 'represented a Father and a Son',[16] and it does convey paternal emotion. The parent's hands hover near the child without actually restricting the young body, and in that sense they appear to protect him. But Epstein, exploring the same ambiguity which characterizes **Night**, also gives the patriarch a ferocious and perhaps even censorious scowl. It wars with the half-smile on his slightly curved mouth, prompting speculation that the boy's arms may be imploring as well as aspiring. He looks up at his father with a mixture of affection and trepidation, wondering perhaps whether this muscular guardian is preparing himself to protect or dispense with his vulnerable charge.

Whatever Epstein's intentions, he had once again managed to flout accepted standards of public decency, and incensed letters from shareholders of the Underground company led to an intemperate meeting of the board in July 1929. Sir Ernest Clark, one of its directors, remembered that 'the shaking of heads was finally interrupted by another director, Lord Colwyn, the septuagenarian cotton and rubber magnate. The sculptures should come down and some other sculptor should be asked to replace them with works more acceptable to the people of London. Lord Colwyn personally would foot the bill, the new sculptures were to be regarded as a gift. It was a generous offer, and the board received it with suitable expressions of gratitude.'[17]

Faced with the imminent destruction of Epstein's work, over which he had laboured for so long, Pick offered his resignation by letter and obtained a few days' reprieve for the sculpture. He asked Holden to have an urgent talk with Epstein. Afterwards Stanley Heaps, the Underground's staff architect, confirmed that scaffolding was re-erected in front of **Day** so that Epstein could climb it and shorten the boy's penis by an inch and a half.[18] Although this utterly gratuitous censorship preserved the rest of the carving, Holden afterwards found that his appointment as architect to the new London University buildings rested on the strict understanding that Epstein would have no part in them.[19]

Nevertheless, by enabling Epstein to place two of his most arresting works in such prominent positions

on an important London building, Holden proved that it was possible for architects to collaborate with sculptors on projects which escaped from timid, hackneyed or merely ornamental solutions. And despite his unfortunate decision to place the 'wind' carvings too high, the experience also helped the other Underground sculptors to work with greater assurance in public contexts elsewhere. Aumonier, whose **South Wind** is now sadly invisible from the street because access has been blocked by another building, went on to execute the monumental **Empire** relief panels in Robert Atkinson's splendid entrance hall for the *Daily Express* building. Gill was invited to carve some bas-reliefs and a successful free-standing group of **Prospero and Ariel** for the façade of Broadcasting House in 1931. And Moore, while determined never again to supply reliefs for buildings, has shown a consistent readiness to work in the round for architectural commissions. He always prefers his sculpture to retain a strong, separate identity, enjoying a spatial relation to a building rather than decorating its surface. But he insisted, a quarter of a century after carving **West Wind**, that 'architecture is the poorer for the absence of sculpture, and I also think that the sculptor, by not collaborating with the architect, misses opportunities of his work being used socially and being seen by a wider public.'[20]

Moore's remarks point to the principal reason why the Underground Headquarters experiment still retains its relevance. For this flawed but memorable building attempted, through revitalising the tradition of architectural sculpture, to place art in a public domain where it could be seen by people who never dream of visiting galleries. The results of Holden's collaborative enterprise, at once so adventurous and so timid, repay the close attention of anyone concerned with the expansion of art's social role in the future.

The author thanks Henry Moore for discussing the Underground commission with him.

[16]**Let There Be Sculpture**, op.cit, p.140.
[17]Quoted by Barman, op.cit, p.130.
[18]Op.cit, pp.130-1.
[19]Epstein did not receive another commission for a public building until 1950.
[20]Henry Moore, **Henry Moore on Sculpture**, (ed.) Philip James, London 1966, p.230.

The most comprehensive source of contemporary information and comment on the Headquarters project is Walter Bayes, 'Sense and Sensibility. The New Head Offices of the Underground Railway, Westminster, London', *The Architectural Review*, November 1929, pp.225-41.

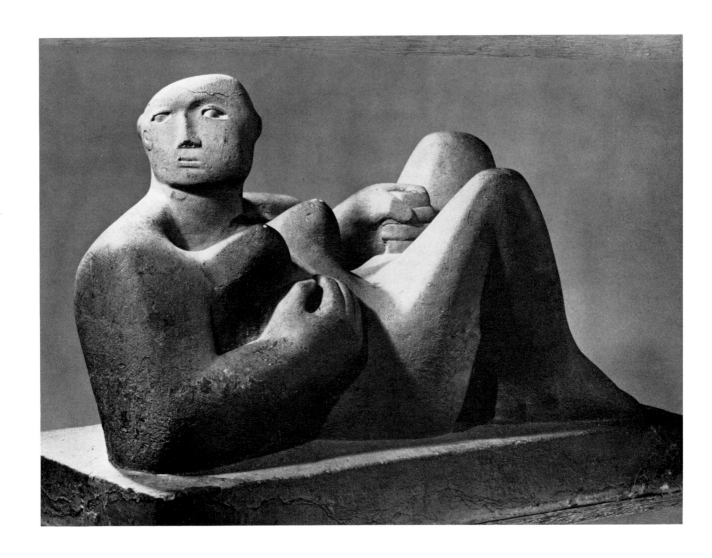

Henry Moore: **Reclining Woman**, 1930, green Hornton stone. National Gallery of Canada, Ottawa.

VIII. Sculpture and the New 'New Movement'.

For a decade after the failure of the X Group, the social and intellectual world of English art was remarkably quiescent. The leading figures of the pre-war radical-modernist avant garde had either died in the war (Hulme and Gaudier) or had retrenched from what had been seen as extreme positions (Lewis, Epstein, Bomberg). For all that Epstein's carvings of the 1920's and 1930's were identified by the lay public with Bolshevism, obscenity and wilful idiosyncracy, it seems with hindsight that the truncation of his **Rock Drill** during the war symbolically marked the historical terminus of a brief period of aggressive anti-humanism in English art. On the other hand, the hegemony of French art was well established. (The revival of a kind of classicism in Paris around 1920 was no doubt largely responsible for the support which Frank Dobson received from Bloomsbury, whence French influence was mediated and transmitted.)

For those younger English artists who were to rise to prominence during the 1930s the image of a modern tradition was established after the war not simply by a view of immediately antecedent practice, but also – and perhaps more emphatically – by the internalisation of a set of interests and topicalisations by means of which the 'whole of the world's art' could be scanned for authentic aesthetic experience. Some measure of the criteria of authenticity is provided by Moore's often quoted acknowledgements that 'Once you'd read Roger Fry the whole thing was there'[1], and that '. . . Fry opened the way to other books and to the realisation of the British Museum'.[2]

Among the significant pointers to a modernist ambition were: a belief in the unity of all experience of 'aesthetic form'; a stress on the autonomy and 'disinterestedness' of that experience, which entailed devaluation of the descriptive, discursive and narrative functions of art; an interest in the supposedly 'pure' and vigorous art of 'primitives' and of children (conflated then as they could not now defensibly be); and the association of classical Greek, Roman and later Renaissance art with a conservative authority. Fry's **Vision and Design** (1920) and Clive Bell's **Art** (1914) were the principal handbooks to modernist decorum, and were so used in the 1920's even by many who resented the influence of the authors. (Both books were continuously reprinted throughout the 1920's. In 1929 Bell's **Art** was in its ninth printing.)

Henry Moore seems so much the ideal token of the modern sculptor of his generation that it is easy to forget how restricted was the type. R. H. Wilenski offered a sympathetic defence of the work and

concerns of the younger sculptors in 1932 in his book **The Meaning of Modern Sculpture**. Besides Epstein and Gaudier he illustrated the work of Moore, Barbara Hepworth, John Skeaping, Maurice Lambert (brother of the composer Constant Lambert), R. P. Bedford and Leon Underwood. He might have added two or three more names, Betty Muntz and Alan Durst perhaps, but that would certainly have exhausted the list of feasible candidates, and within a couple of years the nature of development among the avant garde had been such as to leave all but Moore, Hepworth and possibly Bedford looking like moderates or imitators.

It has generally been considered that a commitment to carving – as against modelling – and to 'truth to materials' was the principal pointer to modernist ambition among sculptors, but this is to underestimate both the extent to which carving was practised among exhibitors in the Academy and the persistence of monumental and ecclesiastical carving as means of employment even for many with modern interests (including Epstein, Eric Gill and indeed Moore). Of much more importance was the younger sculptors' assertion of their right to range 'over the whole field of extant sculpture' (Wilenski) in the characterisation of their practice, and their commitment to the modernist assumption that 'a work which has sculptural meaning need have no other' (ibid. a virtual paraphrase of Clive Bell's dogmatic assertion of the autonomy of aesthetic experience). The nature of the quarrel between generations – or between the supposedly academic teachers in art schools and their supposedly progressive students – was not so much over the kinds of technical procedure by means of which sculpture was to be made; it was rather over the question of what it was appropriate to include among the determinants and exemplars of representation – and particularly of representation of the human form.

What was at stake was indeed the meaning that any work could be seen to sustain. The younger sculptors' intemperance with respect to the classical tradition (or the 'Greek prejudice' as Wilenski called it) was a symptom of their unwillingness to see the references of the human figure in sculpture as circumscribed by the associations of a traditional mythology and of a literary culture antagonistic to their own interests and self-identifications. The exceptional position of Epstein and Gaudier among sculptors in pre-war England was in part a function of their status as immigrants,

[1]Henry Moore, 'Conversations with Henry Moore', *Sunday Times*, London, 17 and 24 December 1961.
[2]Henry Moore, statement in *Partisan Review*, vol. XIV no. 2, New York, March-April 1947.

their literal outlandishness. Moore's origins in the industrial working class, and his and Hepworth's upbringing in Yorkshire, no doubt also provided good reasons for idiosyncratic self-assertion and for the expression of interests which might counter the metropolitan sophistication of their mentors and of the art-world in London as a whole. Both Moore and Hepworth had benefited from newly instituted scholarships to the Royal College of Art. Now that Sculpture (as opposed to architectural decoration or funerary monuments) was being made by classes of persons from whom the profession had not previously recruited (such as miners' sons and women), it was bound to serve different interests – at least until original loyalties were eroded in the satisfaction of cosmopolitan aspirations.

The modern tradition in sculpture, by the end of the First World War, had come to be a tradition of socially exceptional interests. As Moore observed later, 'There was a period when I tried to avoid looking at Greek sculpture of any kind. And Renaissance. When I thought that the Greek and Renaissance were the enemy, and that one had to throw all that over and start again from the beginning of primitive art'.[3] Following the publication and exhibition of art from a wide range of periods and cultures, around the turn of the century and in the first decades after, modernist sculptors were expressing interest in works which had never been seen as even potentially relevant to the main-stream history of sculpture, and which were thus not 'sculpture' at all for the conservative majority. Main-stream and modernist practice became so distinct as to be virtually irreconcilable.

Coherence of meaning and style in traditional English sculpture had been largely established by the resource of literary reference and the concept of decorum implicit in the classical tradition. Once that tradition was broken there was a strong need for some new theoretical basis upon which to establish coherence and to defend claims to meaning for sculpture as a modern practice. The new unifying principle, as expressed in the statements of the sculptors themselves and in the writings of sympathe-tic critics, was that 'sculpture' was to be interpreted not merely as referring to a finite category of objects or to a distinct set of techniques and practices, but as identifying an innate category of experience – the manifest response to what Bell had called 'significant form', wherever it might be found. Once this was established, as it was in avant-garde discourse by the early 1920s, then it was possible, by categorizing them

as 'sculptural experiences' (i.e. as subject to aesthetic exploitation), to assert the relevance to sculpture of a range of interests and memories which would have been ruled out as irrelevant in the traditional pursuit of the art; not just an interest in the products of cultures untouched by the classical tradition and by humanist ideals, but a devotion to the memory of the Yorkshire landscape or an interest in the shapes of stones and bones.

The proposition of the potential all-inclusiveness of sculpture as a category of experience has been well rehearsed since then and is now plainly open to some sceptical scrutiny, but at the time it was a radical idea and one which served considerably to enlarge the permitted formal vocabulary of the art, to the point where a form of non-figurative sculpture seemed a reasonable extension of essentially naturalistic interests. By the end of the 1920s both Moore and Hepworth were producing sculptures based on the human figure, in which departures from anatomical accuracy were implicitly justified by analogies with other types of 'natural' form, and by the intensification of those qualities which Fry had identified as the 'special qualities of sculpture'. (In an influential essay on 'Negro Sculpture', reprinted in **Vision and Design**, Fry had written of the 'three-dimensionalness' of African sculptures and of 'the suggestion that they make of being not mere echoes of actual figures, but of possessing an inner life of their own'. This could be – and was – interpreted as a prescription for modernism in sculpture.) The resulting style was a type of 'vernacular modernism' in which individual particular-lising features were blurred while principal masses and formal relations were exaggerated in pursuit of metaphorical connections to other types of 'natural' form. This style reached its high point in certain of Moore's works of 1929-32 and of Hepworth's between 1931 and 1933.

In its moderation of continental influence (and particularly of the formal innovations of Cubism), its appearance of self-conscious facticity, its deliberate 'primitivism', and its tinge of naturalistic humanism, this type of sculpture was highly compatible with the kind of still-life and landscape painting developed at the same time among the painter-members of the Seven & Five Society, and notably by Ben Nicholson. Other sculptors had shown with the society in the twenties: Leon Underwood had been a founder member, though he did not show after the first exhibition in 1920; Betty

[3]'An Interview with Henry Moore', *Horizon*, vol. III no. 2, New York, November 1960.

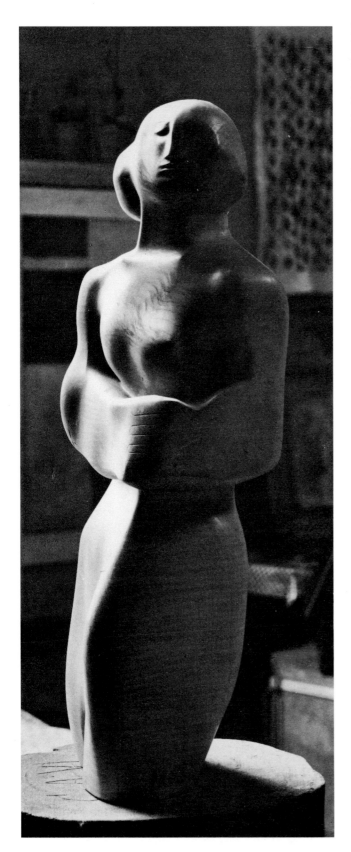

Barbara Hepworth: **Figure in Sycamore**, 1931, sycamore. Pier Gallery, Stromness, Orkney (exhibited 'Seven & Five' 1932).

Muntz had exhibited from 1926 to 1929, and Maurice Lambert was a member from 1928 to 1931, though he only seems to have exhibited once. It was not until 1932, however, that sculpture became a significant feature in the society's exhibitions, despite the original intention behind the designation; i.e. that there should be seven painters and five sculptors. In February of that year Skeaping, Bedford, Hepworth and Moore all exhibited as members in the second of four annual shows at the Leicester Galleries. (The redressing of the balance in favour of sculpture was all the more significant in view of the fact that only two new painters were recruited to the society in the years 1929-33, despite the death in 1930 of Christopher Wood, one of the strongest and most successful of the painters involved in the later twenties.) Barbara Hepworth had seen and liked Ben Nicholson's one-man show at the Bloomsbury Gallery in April 1931 and had met him soon after. Skeaping had shown with the society as a guest two months earlier. Now the interests of advanced sculpture and advanced painting were united socially and practically. Theoretical rationalisations of this convergence were provided by emerging critics, who now began to moderate the hegemony of Bloomsbury interpretations of modernism. Adrian Stokes, for instance, who applied a distinction between 'carving' and 'modelling' approaches to painting and sculpture alike (and saw Nicholson's work as a prime instance of the former), was well placed to commend the exhibition which Nicholson and Hepworth shared at Tooth's in November 1932.

The Seven & Five Society provided one important platform for the new avant garde. Unit One was another. In the course of his work as a reviewer for the *Weekend Review* and *The Listener,* Paul Nash had been prompted by his own recently aroused interest in post-war European art to speculate about the possibility of 'Going Modern and being British' at one and the same time, and had been identifying potential members of a unified 'movement' among those exhibiting new work in London. His ideas began to take shape following an exhibition of 'Recent Developments in British Painting' in December 1931, when Moore and Nicholson were brought together for the first time along with others including Edward Wadsworth and Nash himself. A year later he wrote to Moore about plans for an 'English Contemporary Group' for which the name 'Unit One' was adopted soon after. The final list of members was Moore and Hepworth (sculptors), Nash, Nicholson, Wadsworth, John Armstrong, John

Bigge, Edmund Burra and Tristram Hillier (painters), and Wells Coates and Colin Lucas (architects). Lambert had been considered for inclusion by Nash, but Moore is unlikely to have supported the candidature of one whose work looked at times like an imitation of his own.

That Moore should have been among the first contacted by Nash was a measure of the success – among sympathetic observers at least – of his second one-man show at the Leicester Galleries in April 1931. In an introduction to the catalogue Epstein had written, 'For the future of sculpture in England Henry Moore is vitally important', and from this point on Moore was seen by all actively concerned as a central figure in the development of modern art in this country. Although he continued well into 1932 to produce clearly recognisable figures in what I have called a vernacular modernist style, his Leicester Galleries show included a recent **Composition** in blue Hornton stone in a more aggressively modernist style determined by Picasso's Surrealistic bathers and studies for monuments done in 1928-9. In the same year (1931) he made a **Reclining Figure** in lead which also embodied an immoderate interest in the expressive distortion of the human form. No full-blooded work of European Surrealism was to be shown in England for another two years and it is not surprising that mainstream response to Moore's latest work should have been one of outrage.

Over the next four years he explored such formal variations as could be played upon the human figure – and particularly the mother-and-child and reclining-figure themes – without loss of the possibility of empathetic response. He was plainly encouraged in this by the examples of Arp and more particularly of Picasso and Giacometti (whose early work was to remain of interest to English sculptors over the next three decades). The more 'naked' and disturbing these works appear to be – i.e. the more effectively they seem to breach the decorum of 'disinterested' aesthetic contemplation – the more interesting they are. The concept of 'sculpture' as a category of experience is of most interest in relation to Moore's work generally just where that work is hardest to assimilate into a happily socialised view of the meaning of the represented human figure.

Unit One held a single London exhibition, in April 1934 at the Mayor Gallery, followed by an extensive provincial tour while the group fell apart. Herbert Read edited a book of statements and photographs to coincide with the show, and Moore took considerable trouble over his own contribution, which amounted to a personal manifesto of modernism in sculpture. As qualities of 'fundamental importance' he identified the following: 'Truth to material', 'Full three-dimensional realisation', 'Observation of natural objects', 'Vision and Expression' and 'Vitality of power and expression'. 'A work can have in it a pent-up energy', he wrote, 'an intense life of its own, independent of the object it may represent'.[4] Here as elsewhere the statement reflects the slogans of Fry and of Gaudier-Brzeska (and, perhaps, the topicalisations which structured Moore's own work as a teacher at the Royal College and later at Chelsea).

The affiliation with Nicholson, meanwhile, had freed Barbara Hepworth from her dependence on the example of Moore, and between 1931 and 1934 her work developed along more individual lines, notably in a series of small carvings on the themes of the torso and of mother-and-child. In 1931 she carved a small **Pierced Form**, which she exhibited as **Abstraction** though it was derived from a torso. It has not survived, but her **Figure** of 1933 is closely related to it. In 1932 and 33 she and Nicholson travelled in France and saw a considerable range of recent continental art. Arp and Brancusi were among those whose studios they visited, and they also met Giacometti, probably in 1933. In that year also they joined the Association Abstraction-Création, formed in Paris two years earlier by an international committee of artists, 'pour l'organisation des manifestations d'art non figuratif'. Hepworth's statement for the **Unit 1** book reflects her participation in the range of idealisations which supported the current ambition for a 'universal' abstract art: 'I feel that the conception itself, the quality of thought that is embodied must be abstract – an impersonal vision, individualised in the particular medium'.[5] In a statement composed for an Abstraction-Création publication in 1933 she wrote of art in terms of an affinity with music, a point of view which now clearly distinguished her interests from Moore's, and in November 1934 she made the first of a series of works in which separate geometrical or near-geometrical forms are related on a single base. These, together with a range of related abstract single forms made between 1935 and 1939, constitute her most significant contribution to the development of modernist sculpture. The modernism of her achievement lay in annexing implicit claims made in the twenties for the universality of 'sculpture' as a form

[4]Henry Moore, statement in H.Read (ed.) *Unit 1*, London 1934.
[5]Barbara Hepworth, statement in *Unit 1*, London 1934.

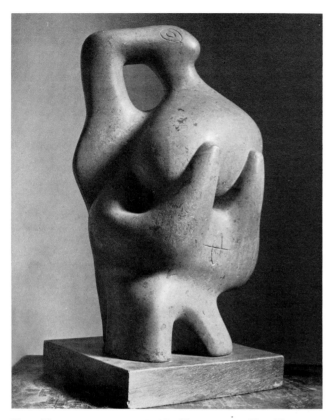

Henry Moore: **Composition**, 1931, blue Hornton stone. Mary Moore (exhibited Leicester Galleries 1931).

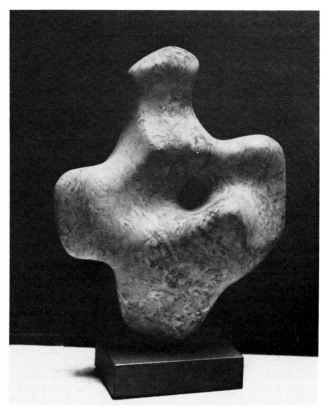

Barbara Hepworth: **Figure**, 1933, grey alabaster. C.S. Reddihough (exhibited Unit One, Mayor Gallery 1934).

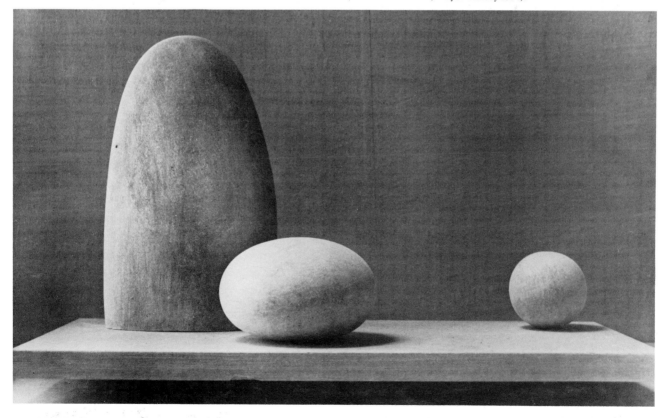

Barbara Hepworth: **Three Forms**, 1934-5, grey alabaster. Barbara Hepworth Museum, St. Ives.

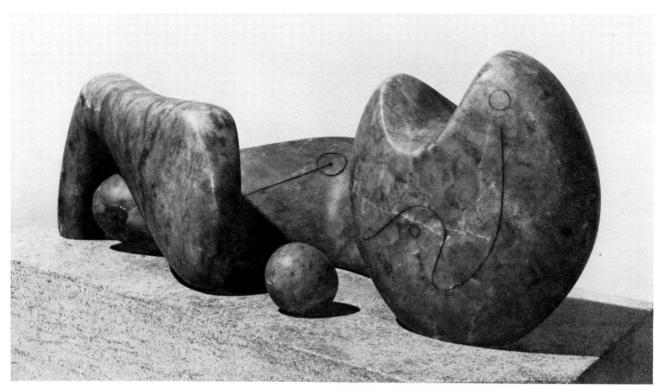

Henry Moore: **Four-piece composition: Reclining figure**, 1934, grey Cumberland alabaster. Tate Gallery (exhibited Seven & Five 1935).

'Abstract and Concrete exhibition', 1936. Installation view showing construction by Eileen Holding beside white relief by Ben Nicholson.

of experience to explicit claims made within the
European Modern Movement for the universality of
'abstract art' as a form of experience. The two were
united in practice – in the studio as it were – by the
persistence of an Arts-and-Craftsish concept of
integrity, by means of which the actual consequences
of the division of labour were idealised away: 'The
language of colour and form' was to give 'the same life,
the same expansion, the same universal freedom to
everyone'.[6]

The compatibility between Hepworth's abstract
carvings and the white reliefs which Nicholson made
from the spring of 1934 until 1939 was sufficient to
establish the identity of a coherent abstract movement
in English art in the 1930s, at least in the eyes of
interested contemporary observers. The last Seven &
Five exhibition, held at Zwemmer's in October 1935,
was seen at the time as the first all-abstract show in
England, and though the figurative connections of
much of the work shown are now easier to perceive,
it is still clear how the impression of a strong and
coherent avant garde must have been made. The show
included white reliefs by Nicholson, Hepworth's
carved wooden version of **Discs in Echelon** (Museum
of Modern Art, New York) and Moore's **Four-piece
Composition: Reclining Figure** (Tate Gallery). John
Piper showed abstract paintings derived from a
Synthetic-Cubist formal repertoire, and his first wife,
Eileen Holding, showed some white-painted free-
standing constructions.

Although there were no further Seven & Five
exhibitions, Nicholson's ambition to use the society
as a base for international shows of abstract art was
reflected in the touring exhibition 'Abstract and
Concrete', organised by Nicolete Gray in association
with the newly-founded magazine **Axis.** The show
reflected the composition of Abstraction-Création and
of the remnants of the Seven & Five, and included
Moore, Hepworth and Holding alongside Calder,
Domela, Erni, Gabo, Giacometti, Hélion, Jackson
(Hepworth's cousin, A.J. Hepworth), Léger, Miró,
Moholy-Nagy, Mondrian, Nicholson and Piper. It is
perhaps significant that no other English sculptors
were included. Moore made a series of comparatively
geometrical single forms in 1935 and 36 and it was
principally from among these that his contribution was
selected. They were not really representative of his
true interests, however, and his work must have
looked much more at home in the 'International

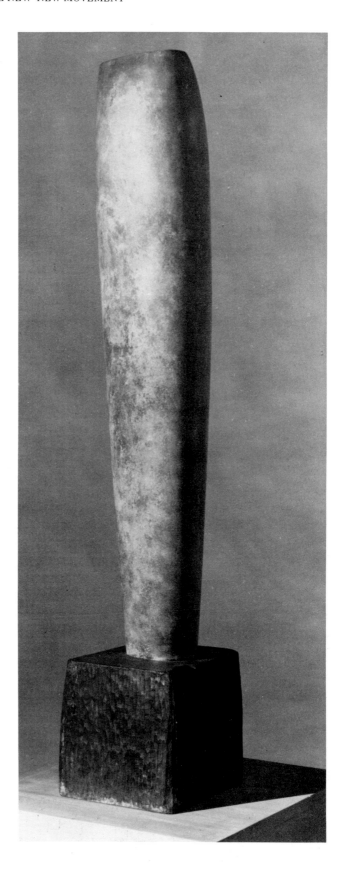

[6]Barbara Hepworth, 'Sculpture', in J. L. Martin, Ben Nicholson, and
N. Gabo (eds.) *Circle*, London 1937.

Barbara Hepworth: **Single form**, 1937, bronze. Barbara Hepworth
Estate.

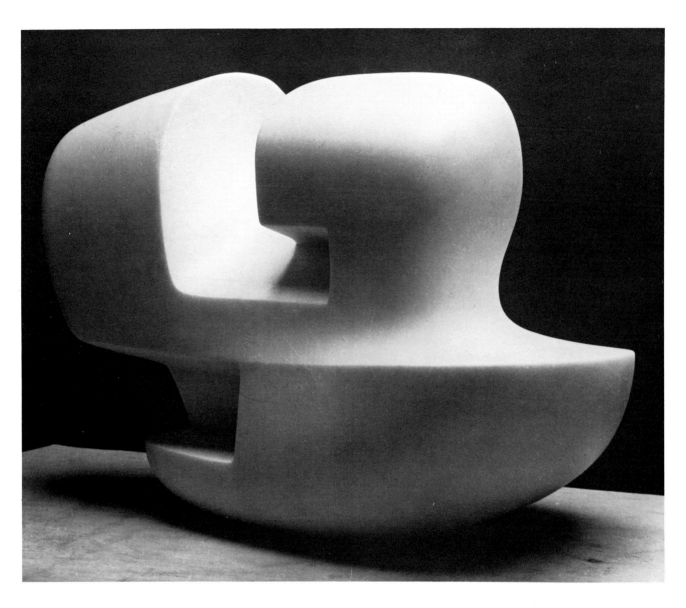

Henry Moore: **Carving**, 1935-6, marble.

Naum Gabo: model for **Construction on a Line,** c. 1937, plastic. Tate Gallery, London.

Surrealist Exhibition', held at the New Burlington Galleries in the same summer.

By the second half of 1936 the polarisation of interests between abstract art and Surrealism was becoming clear (as it had been on the continent for at least a decade) and Moore, who believed that 'all good art has contained both abstract and surrealist elements'[7], was the only artist who managed to move easily between the two camps. The abstract tendency was strengthened by the involvement of the Russian emigré Naum Gabo, who came to England to get married in 1936 and got to know Nicholson and Hepworth over the course of the 'Abstract and Concrete' exhibition. It was he who was largely responsible for the incorporation of the small group of English abstract artists into an international 'constructive' tendency, embracing painting, sculpture, construction, design and architecture in the purported embodiment of 'the definite constructivism of the whole of our culture'[8]. This was the utopian idealisation which invested the publication of **Circle** in 1937 as an 'International Survey of Constructive Art'. Among the sculptors included, Moore, Hepworth and Holding were again the only English representatives. Gabo set about with missionary zeal persuading those he could to identify themselves as 'constructivists', and Hepworth, Holding, Moore and Nicholson all showed, together with some other unlikely candidates, in a show of 'Constructive Art' at the London Gallery in July 1937. Insofar, however, as there was a

real constructive tendency in English art, and one to which sculptors made some sort of significant contribution, it was not to be discernible for another ten years, by which time Gabo had left England for America.

In the context of political events in Europe, the mythical possibility of the unification of all the arts under some universal aesthetic rationality had in fact ceased to be credible some time before the publication of **Circle**, although it still survives today in attenuated forms in the imagination of artistic idealists. On the other hand, Moore's pursuit of such idiosyncratic psychological interests as could be expressed in a range of evocative formal types ensured the continued interest of modernist observers of different loyalties and persuasions, and established the basis for his post-war success as the senior English exponent of that mildly 'agonised', lay-pantheistic humanism which was to predominate in Europe in the forties and early fifties.

[7]Henry Moore, 'The Sculptor Speaks', *The Listener*, vol. XVIII no. 449, London, 18 August 1937.
[8]Naum Gabo, 'The Constructive Idea in Art' in *Circle*, London 1937.

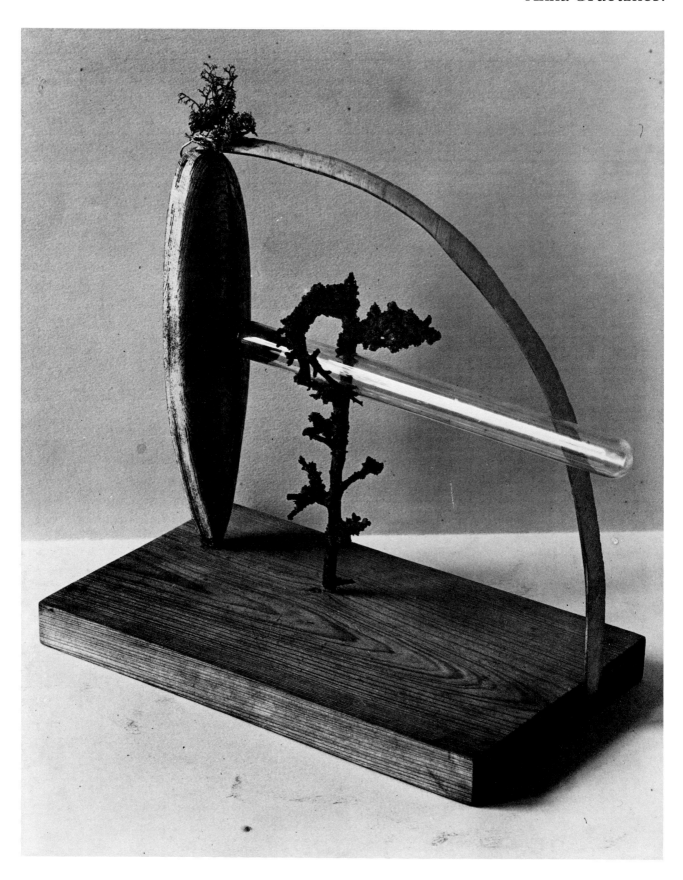

Paul Nash: **The Archer**, 1937.

IX. The Surrealist Object and Surrealist Sculpture.

In November 1937 the exhibition 'Surrealist Objects and Poems' opened at the London Gallery with a sensational private view at midnight.[1] The English surrealist Julian Trevelyan (wearing mirrored spectacles) wandered through the crowded gallery saying: 'I am a blind man in search of sight' and later he made a speech composed by Roland Penrose and himself, giving a definition of the surrealist object. Chance was essential to this definition. The surrealist object was not constructed according to the rules of a formal pictorial aesthetic: on the contrary, it was Lautréamont's definition of beauty as 'the chance meeting of a sewing machine and an umbrella on a dissecting table' which allowed fantasy, the marvellous and the irrational to inspire its making. The idea behind the surrealist object was essentially poetic. The surrealists regarded such objects as concrete manifestations of their dreams, secret fantasies and fears. They believed that an object was created through its discovery and that each object had a special animistic quality which made it a 'modern' token or fetish and an expression of a primitive shared state of mind which the surrealists thought they had acquired once they had freed themselves from the conventions and inhibitions of their own society. They collected the art of primitive people, children and the insane because they thought it was the product of the same shared impulse.[2]

The catalogue for 'Surrealist Objects and Poems' listed the exhibits under the following categories: surrealist objects, found objects, found objects interpreted, interpreted objects, objects collages, oneiric objects, objects for everyday use, objects by a schizophrenic lunatic, mobile objects, book objects, poem objects, perturbed objects, ethnological objects, constructed objects, collages, photo-collages and natural objects. The exhibition itself was a deliberate, extraordinary and awesome array assembled as it was on walls, grouped on shelves and pedestals, and amassed in glass cases.

Although the erotic and the sexual were important elements in European surrealism, they are strangely absent from much of the English work. However, Roland Penrose made several objects which express and explore sexual fantasies. Of all the English surrealists he had had the most contact with surrealism on the continent. His close friendships with surrealists in France gave Penrose a first-hand experience of the movement. Furthermore he had participated in the important exhibition of surrealist objects held in Paris at the Charles Ratton Gallery in

May 1936. One of Penrose's most evocative objects, **Captain Cook's Last Voyage** (private collection) was given a central position in a room of the 'International Surrealist Exhibition',[3] the first exhibition of surrealism in London, in June 1936. The erotic connotations of a classical female form become explicit in this work, which comprises a nude torso painted with cartographic strata encased in a wire globe. Its message was that Captain Cook's last voyage would be an exploration of sexual love. The globe is a symbol of man's universal bond, which was one of the surrealist goals, but it is also a cage which imprisons this female dummy and there is a further hint of violence in the saw handle which protrudes from the severed figure.

Sexual violence is also implied in Penrose's **The Dew Machine** (destroyed) which was prominently displayed in a glass case at the London Gallery. ☛ The object consists of an upside down mannequin's head with long blonde hair which cascades through a complicated system of wires which constrain and support it. Cocktail glasses filled with pebbles and other matter protrude from the severed neck. **The Dew Machine** was listed as an 'object for everyday use'. With it Woman becomes a machine with a mechanical task – 'to moisten the stale air of clubs, offices, banks, waiting rooms.' Also in the same category, but in a more humorous vein was Penrose's **Guaranteed fine weather suitcase** (lost) which was designed to invoke good weather through its blue sky and white clouds painted on its two sides.

Surrealism provided many of its English exponents with a new and greater freedom of expression than had been possible in their earlier experiments with other styles. Eileen Agar began working with great energy on collages and objects, for instance, after her initial contact with surrealism in 1936. Pieces of fabric, fur and feathers, shells, buttons and other bric-a-brac (which she had always collected) were put to new uses in covering a portrait bust, a construction of child-like fantasy, **The Angel of Anarchy**. However, in spite of its child-like appearance, this fantasy also contained meanings which had more serious implications. English surrealism developed in a strongly political climate. There was an enormous sympathy for the Spanish Anarchists within the English group and several manifestos were issued on their behalf. In 1937

[1] The exhibition ran from 24 November to 24 December, 1937.
[2] See Bruce Adams, *The Surrealist Object*, unpublished M.A. report, Courtauld Institute of Art, 1975.
[3] 'The International Surrealist Exhibition' opened at the New Burlington Galleries, on 11 June, 1936.

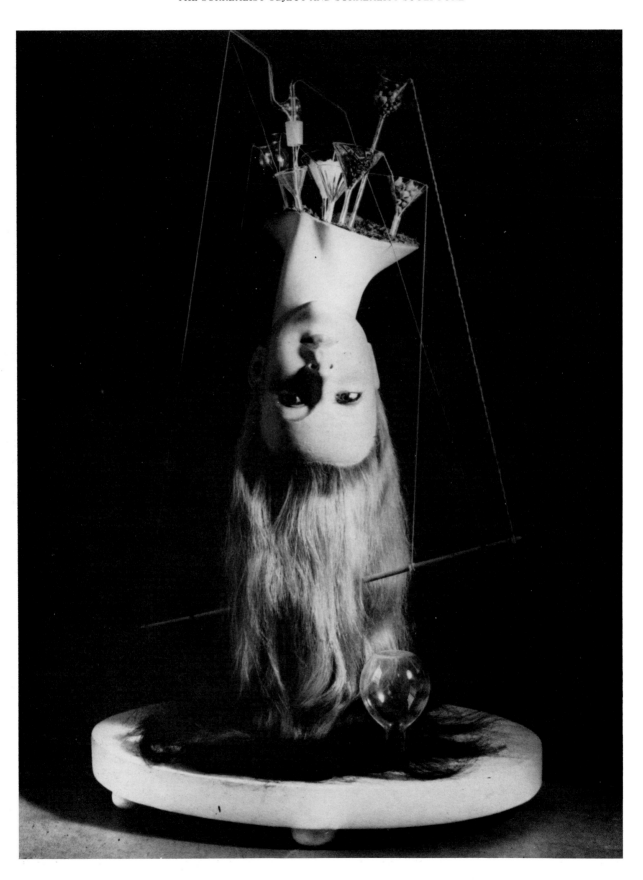

Roland Penrose: **The Dew Machine**, 1937.

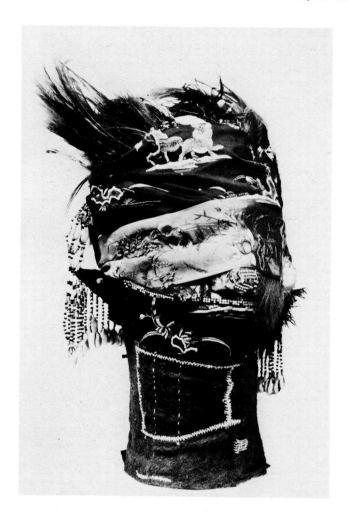

(Left) Eileen Agar: **The Angel of Anarchy**, 1936-40.

(Below) Norman Dawson: **A Gust of Wind did This**, 1937.

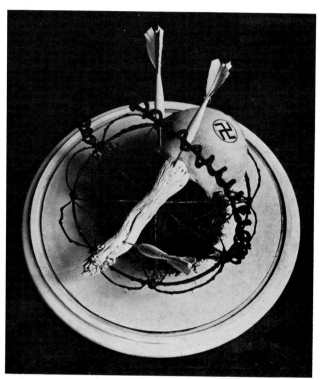

Herbert Read, who was the 'angel of anarchy' and author of **Surrealism**, published by Faber and Faber in 1936, announced his commitment to Anarchism and published **The Necessity of Anarchism**. But the outbreak of the Second World War complicated and confused these political causes and when the second version of **The Angel of Anarchy**[4] was made in 1940, Eileen Agar added a blindfold because the future was so uncertain. ☞

Before the war, the English surrealists were deeply concerned about the danger of Hitler and developments in Nazi Germany with the threat to political, creative and individual freedom. Several attempts were made to protest against Nazism and Chamberlain's Munich agreement with Hitler.[5] Some artists used the surrealist object to express their fears about this threat. In Norman Dawson's **British Diplomacy** (destroyed) the small mannequin doll ensnared in a fishing line is a metaphor for the position of the British government, while another construction, **A Gust of Wind Did This** (destroyed), which takes its title from a newspaper clipping stuck on a breadboard, expresses the fear that Fascism could appear and spread without check. ☞ A swastika-painted piece of flotsam is ensnared with other jetsam in a coil of wire and pinned to a breadboard with darts to create a feeling of foreboding in which nature has been molested and disturbed.

Nature played an important role in English surrealism. Unlike their French counterparts, who combed the flea markets and junkshops of Paris, the English turned to the seashore and countryside for their 'chance discoveries'. They recognised that nature could arrange the incongruous, and mould and transform the ordinary to create an awesome fantasy.

James Cant's 'mobile object', a scarecrow, was found in the Essex countryside. Although it is not constructed from natural objects, this strange assemblage of a shovel, two pot lids and a bucket which swings

[4]The first version was exhibited at the London Gallery in 1937 and then sent to the 'International Surrealist Exhibition' at the Galerie Robert, Amsterdam in spring 1938. It was never returned from Amsterdam.
[5]See Anna Gruetzner, 'Some early activities of the Surrealist Group in England', *Artscribe*, No.10, 1978, pp.22-25.

suspended from a cleft stick had stood in the landscape as a disconcerting and distressing 'modern' totem designed to frighten away the unwanted.

However, it was Paul Nash, of all the English object-makers, who established the closest affinity with nature. In the early thirties he had introduced natural objects as subjects in his painting, under the influence of de Chirico. But de Chirico's still-lifes only provided a guide for Nash, and his interest in natural objects had closer links with English Romanticism and its tradition of landscape painting. Nash himself acknowledged and encouraged this connection with English Romantic poetry and pointed out that Wordsworth was one of the first to recognize that natural things and elements had an animistic quality. Nash's position was that of a 'natural' as opposed to a 'political' surrealist. The strongest surrealist phase in his painting had by now passed, but this contact encouraged him to use his interest in the animate in nature as a basis for

object-making. As a child, Nash had collected things found on his grandfather's farm and although this interest continued into adulthood it was only the 'International Surrealist Exhibition' which made it possible to exhibit these 'found objects' as works of art.

Nash divided natural phenomena into the three scientific categories – animal, vegetable and mineral – and initially used these classifications as titles of works. **Marsh Personage**, shown in 1936 as **Found Object Interpreted, Vegetable Kingdom**, was Nash's first exhibited object.[6] The fetishistic quality of this assemblage of driftwood and bark was close to that of the primitive art hung alongside sculpture and paintings in the exhibition. Choosing 'found objects' allowed Nash to view the English landscape with new imagination, and selecting concrete forms whose

[6]For a complete list and description of Nash's objects see Andrew Causey, **Paul Nash**, Oxford, 1980, pp.477-479. I am grateful to Dr. Causey for his assistance.

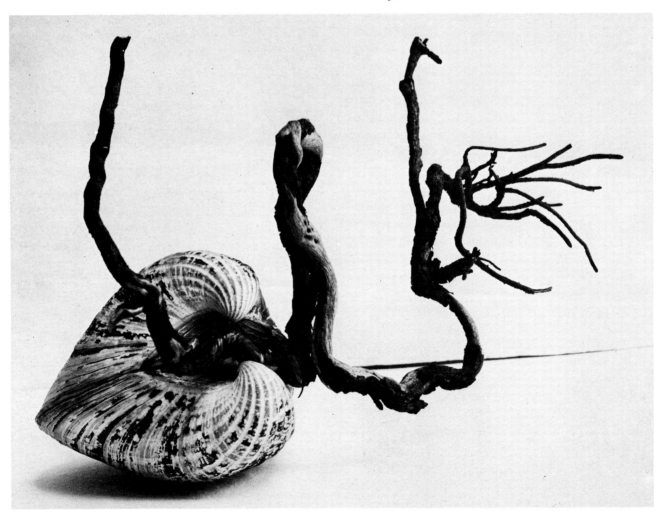

Paul Nash: **The Bark is Worse than the Bite**, 1937.

animism was a material manifestation on the presence of nature gave new meaning to the English landscape tradition. Stones and flints also appealed to him and were used to create poetic dialogues in his painting.

Nash also made and exhibited constructed objects. He was often inspired by the powerful presence and force of the sea and it is significant that he frequently incorporated seaweed, shells, coral and other sea-worn matter into these constructions. **The Bark Is Worse Than The Bite** (lost), made from a convoluted, twisted branch caught in the opening of a stripey heart-shaped large shell, is like a sea monster, a living spirit of the sea. ☞ Others made from a more elaborate collection of material have a poetic presence and the same metaphysical quality which is evident in his painting. In **The Archer** (dismantled) a wooden toy boat turned on its end has a glass tube for its mast. ☞ Supported by a moss-covered twig, this mast forms the arrow which strings the seaweed-covered wooden

bow: a poetic expression of the metaphysic of time and space. In other objects ivory hands and tatting bobbins were interspersed with natural material to create the unexpected and bizarre. In **Forest** (private collection) wooden glove stretchers slotted into a wooden frame become trees.

Making objects had a greater appeal to the writers, poets and painters than to the sculptors associated with the surrealist movement. Like the other surrealist sculptors, Henry Moore was generally too conscious of the demands of sculpture to enter the spirit of surrealist object-making.[7] However, he did send one work, **Object to Hold**, to the exhibition 'Surrealist Objects and Poems'. ☞ His wife, Irina, also contributed a **Natural Object**. Nevertheless, a case can be made for a connection between surrealist interests and Moore's own preoccupations. One

[7] I am grateful to Henry Moore for the time and patience he gave in answering my questions during two conversations in October 1980.

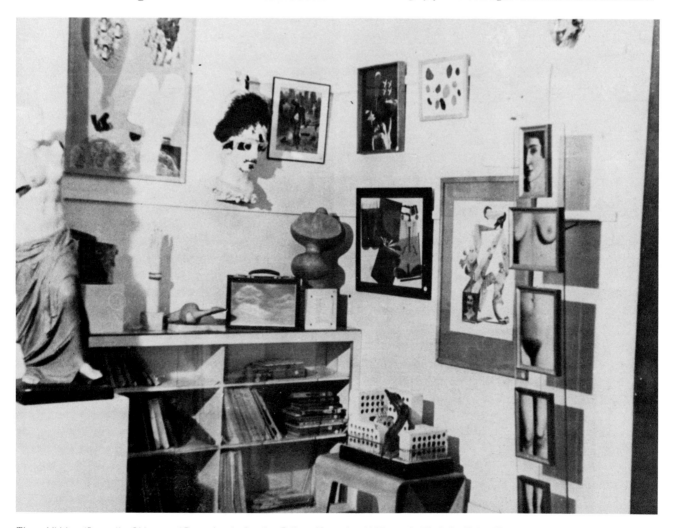

The exhibition, 'Surrealist Objects and Poems' at the London Gallery, November 1937: top shelf includes Roland Penrose: **Collage**, Eileen Agar: **Rococo Cocotte**. Bottom shelf includes Henry Moore: **Object to Hold**, Roland Penrose: **Guaranteed Fine Weather Suitcase**.

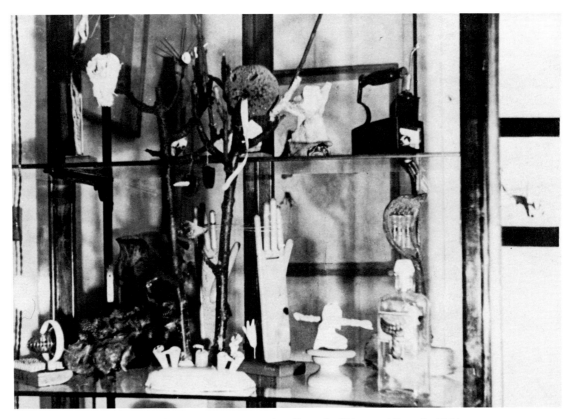

Objects in glass case includes Paul Nash: **Goodness How Sad**, from 'Surrealist Objects and Poems' exhibition.

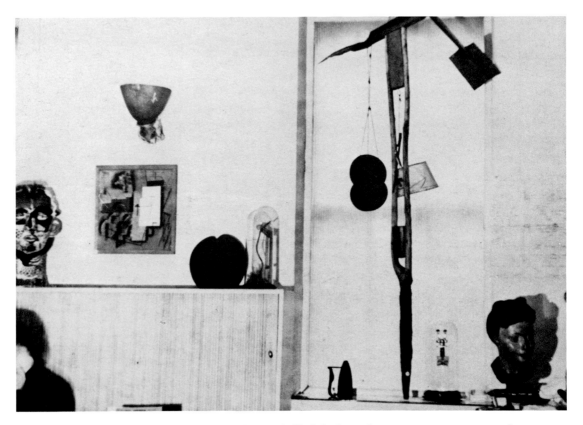

Top shelf includes Eileen Agar: **The Angel of Anarchy**, bottom shelf includes James Cant: **Scarecrow Found in Essex**, from 'Surrealist Objects and Poems' exhibition.

THE SURREALIST OBJECT AND SURREALIST SCULPTURE

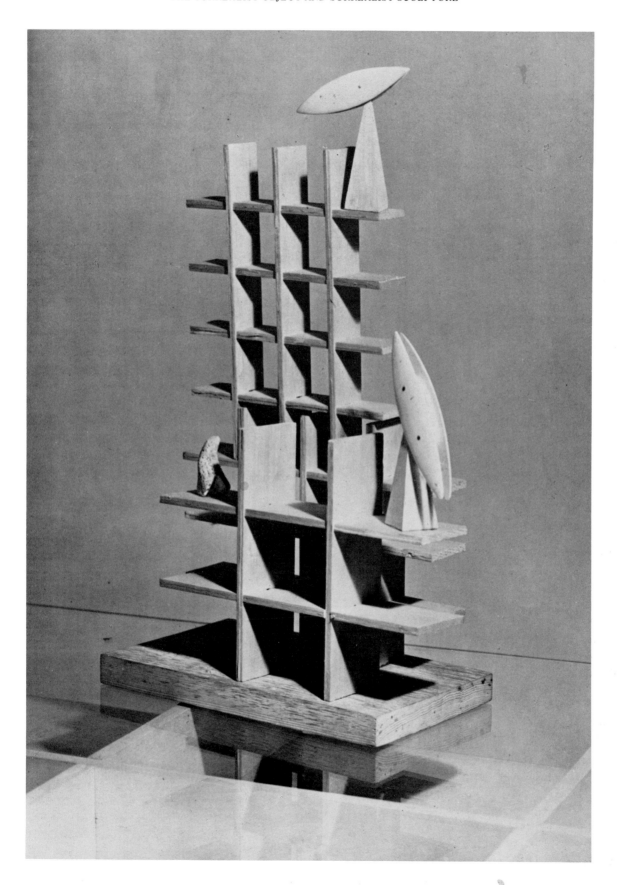

Paul Nash: **Moon Aviary**.

example is the group of stringed figures on which Moore worked from 1937, inspired by mathematical models in the Science Museum. These models were also admired by other surrealists, who published several photographs of them in the special issue of **Cahiers d'Art**, devoted to the surrealist object, which was on sale at the large surrealist exhibition in London in 1936. A photograph was also reproduced in Herbert Read's anthology, **Surrealism**, also published in 1936. But this connection with the surrealist object is a purely formal one.

Indeed, Moore's relationship to surrealism is complex. Since a formal aesthetic was his first priority, he never fully adopted its ideas and practises, though surrealism was a great source during his highly creative and formative decade of the thirties. From 1936 to 1940 Moore maintained close connections with the surrealist group, participating in its events and exhibitions in England and abroad. During this period he had the support and approval of the surrealists, including André Breton and Benjamin Peret who grouped him with Arp and Giacometti as the leading sculptors connected with the movement.

Long before he participated in the officially sanctioned 'International Surrealist Exhibition' in 1936 he had been aware of the pictorial forms of surrealist art. ☛ By 1932 he had come across work by Picasso, Arp, Giacometti and Miró but, initially, it was the inventiveness of Picasso's biomorphic figures which had the most impact. Picasso's sculpture, **Metamorphoses**, in particular, influenced Moore's first biomorphic piece, **Composition**, 1931 (private collection).[8]

Moore had been making regular visits to the collection of primitive sculpture at the British Museum since the mid-twenties in order to widen his understanding of sculptural form, structure and material. He also began to appreciate the animistic quality of primitive art and its fantasy element. This admiration was shared by the surrealists, who were amongst the first to draw attention to its totemic qualities and the marvellous, magic and irrational forces behind its making. Like Moore, their interest extended to a much wider range of primitive sculpture than the African sculpture which was first admired by painters in the first decade of the century. Moore was especially drawn to Oceanic sculpture with its strong element of fantasy not found in African sculpture. Having looked to a European model for distortion and invention of the human figure, Moore now turned to a primitive source for another important sculpture of

1931. Moore has recently said that the oddly juxtaposed strange shapes of the lead **Reclining Figure** (private collection)[9] were directly inspired by Oceanic sculpture. One is reminded of Moore's liking for the 'emasculated, ribbed wooden figures of Easter Island'.[10] The example of primitive art, which combined bizarre and unusual shapes and forms while still retaining its figurative meaning, was important for the **Reclining Figure** because it allowed Moore to break away from the monolithic pose used in earlier reclining pieces.

The paintings of de Chirico were also an important oblique influence on Moore. Two de Chirico exhibitions in London, in 1928 and 1931, and Nash's enthusiastic reviews must have encouraged Moore's interest. He has subsequently acknowledged his particular enthusiasm for those paintings which included the reclining classical statue of Ariadne.[11] Several pieces by Moore, executed in the mid-thirties, have an enigmatic timelessness reminiscent of the metaphysical quality of de Chirico's painting which was so admired by the surrealists. It is particularly evident in the **Reclining Figure** 1934-35 (private collection).[12] The continuum of space between the two mounds which rise from the swathed box-like form enforces a silent timelessness which is made more disconcerting by the deep cavity carved in one end. The deep vacuum-like hole which penetrates the head of the columnar **Figure**, 1933-34 (private collection)[13] is another example of Moore's use of the unexpected.

Surrealist practice and thought also directly influenced Moore's own preoccupations. Throughout this period nature was a constant source of inspiration and ideas. Initially Moore looked at natural substances and shapes because they increased his understanding of structure and form. At the Geological Museum he discovered new English stones suitable for carving and at the Natural History Museum he could study bones and other animal forms. He was also making his own collection of stones and rocks, shells and pieces of bone. In 1930 Moore began to use these natural

[8]HM99. HM refers to **Henry Moore: Volume One, Sculpture and Drawings 1921-1948**, (ed.) David Sylvester, with an introduction by Herbert Read, 1957. See Alan G.Wilkinson, **The Drawings of Henry Moore**, Tate Gallery 1977, p.83 cat.88. I am indebted to Dr Wilkinson for his help and advice.
[9]HM 101. It was exhibited at the 'International Surrealist Exhibition' in 1936.
[15]Henry Moore in conversation with the author, 2 October 1980. from HM vol.1, p.xxxvii.
[11]Henry Moore in conversation with the author, 2 October 1980.
[12]HM 155.
[13]HM 138. It was exhibited at the 'International Surrealist Exhibition' in 1936.

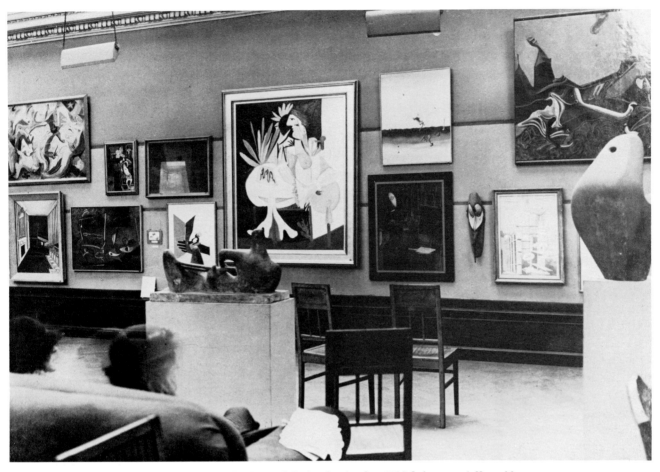

The 'International Surrealist' Exhibition at the New Burlington Galleries, London, June 1936. In foreground, Henry Moore: **Reclining Figure**, 1933 (left) and **Figure**, 1934 (right).

objects as a basis for a series of transformation drawings. Unlike Nash, he did not give these natural objects an animistic presence, rather he used a process of free association to find ideas for the form of his sculpture. Moore wrote in 1937, referring to his study of natural objects: 'There are universal shapes to which everybody is subconsciously conditioned and to which they can respond if their conscious control does not shut them off'.[14] The shapes and images which he sought in these natural forms were the basis for two important sculptural themes, the mother-and-child and the reclining figure. Recently Moore likened his study of natural forms to Leonardo's search for images in the wet marks made by the rain on a wall.[15]

In **Transformation Drawing: Ideas for Sculpture**, 1930,[16] his earliest known transformation drawing, human features were added to the existing natural shape to suggest a head and a figure, but in later drawings, executed in 1932, after Moore's contact with surrealism, natural objects were drawn in a stage of metamorphosis. **Ideas for Sculpture-Transformation**

Drawing, 1932,[17] shows a reclining figure which grows out of a hip bone.

Four-Piece Composition, 1934, (Tate Gallery)[18] is a striking example of Moore's ability to find equivalents for the human figure in other natural things. Its four separate pieces are an example of Moore's exploration of the relationship between space and form. Drawings for **Four-Piece Composition** show how Moore used dismembered parts of the human anatomy as studies for the final sculpture and, while other sculptors in England moved increasingly towards abstraction, Moore continued to insist on the importance of the human figure as the source. This is evident in the small ball which represents the umbilicus in **Four-Piece**

[14]Henry Moore, 'The Sculptor Speaks', *The Listener*, 18 August, 1937. Quoted from HM vol.1, p. xxxiv.
[15]Henry Moore in conversation with the author, 2 October, 1980.
[16]Alan Wilkinson, ibid, p.84, cat. 89.
[17]David Mitchinson, **Henry Moore Unpublished Drawings**, Turin 1971, cat.91.
[18]HM 154. See Richard Morphet, **Four-Piece Composition-Reclining Figure**, The Tate Gallery, 1976-78, pp.116-122.

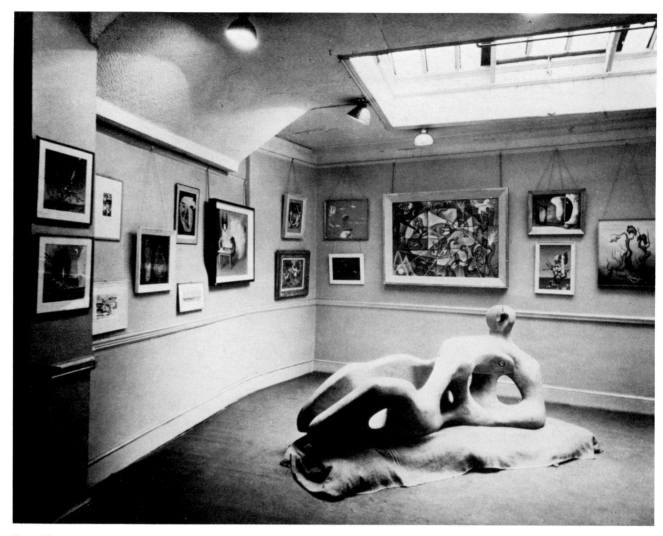

Henry Moore: **Reclining Figure**, elmwood, in foreground at the 'Surrealism Today' exhibition at the Zwemmer Galleries, June 1940.

Composition. Although they are based on the human figure, the forms in the sculpture also correspond to other natural shapes: the arched, abstracted torso and limb are bone-like, the head resembles a stone and the umbilicus seems like a pebble. The relationship to objects in nature in **Four-Piece Composition** is reinforced by the way the forms are arranged and placed on their base to suggest natural growth.

Moore has said that the fantasy element in nature was of great interest to him. It is a statement which throws interesting light on a number of sculptures made in 1937 at a point when Moore had strong connections with the surrealist group. Turning his attention from individual natural objects Moore looked at the landscape itself and sought a correspondence between its rolling forms and inclines and the human figure. Moore is at his most surreal in his invention of these figures whose forms were created from the

patterns and shapes of the natural landscape. It is significant that one **Reclining Figure**, 1939 (private collection, USA)[19] was used as an example in *The London Bulletin* in a biographical note in which Moore labelled himself surrealist.[20] Although a human presence is still evident, its mounds and bumps correspond to the contours of a landscape rather than to anatomical forms. This sculpture, which is both landscape and figure, has direct connections with surrealist art and poetry, which is often inspired by the ambiguous connections our unconscious makes between shape, image and meaning.

The monumental, elmwood, **Reclining Figure**, 1939 (Museum of Detroit)[21] also expresses the

[19]HM 178. See Andrew Causey, 'Space and Time in British Land Art', *Studio International*, March/April 1977, p.122.
[20]*The London Bulletin*, no. 8-9, January-February 1939.
[21]HM 210.

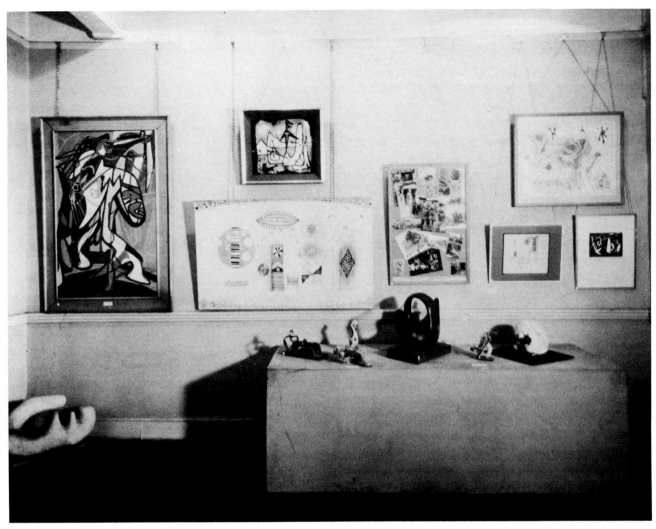

Henry Moore: **Reclining Figure**, lead, and **Birdbasket** are included in the group on the pedestal from the 'Surrealism Today' exhibition.

analogy between figure and landscape. Its size and material suggest connections with Moore's interest in the sculptural possibilities of a large tree trunk lying at random in the landscape which 'immediately looks right and inspiring'. In this **Reclining Figure** the system of subtle curves and penetrating holes give the sensation of the forms of landscape and its surrounding space. And although the shapes of the figure are not based on anatomy there is a strong suggestion of a female presence which has undergone metamorphosis into rolling landscape forms. It must have been this sculpture which Breton had in mind when he wrote: 'In opposition to all other sculptural forms Apollinaire had dreamed of a statue wrought within the earth which would not be a solid but a hollow; this is the statue which Moore has succeeded in combining with the conventional form and which harmoniously embraces it. [22]

Placed on a blanket-swathed base, the **Reclining Figure**, 1939 dominated the exhibition 'Surrealism Today' held at the Zwemmer Gallery in 1940. [23] The Zwemmer show was the final coherent effort of the original English surrealist group and Moore's last surrealist event. Also included in the exhibition was the lead version of **The Helmet**, 1939-40 (private collection)[24] which took its inspiration from ancient armour. The outer shell protects and envelops the figure inside and it is a prescient statement of what was to come as the Second World War began. Later, in 1940, Moore was appointed an official war artist and this experience was to take him in a different direction.

[22]Andre Breton, **What is Surrealism**, (ed.) Franklin Rosemont, London 1978, pp. 226-7. I am grateful to Dr Christa Lichtenstern for pointing out this reference and also for the ideas we exchanged about Moore and Surrealism.
[23]The exhibition opened on 12 June 1980.
[24]HM 212.

John Glaves-Smith:

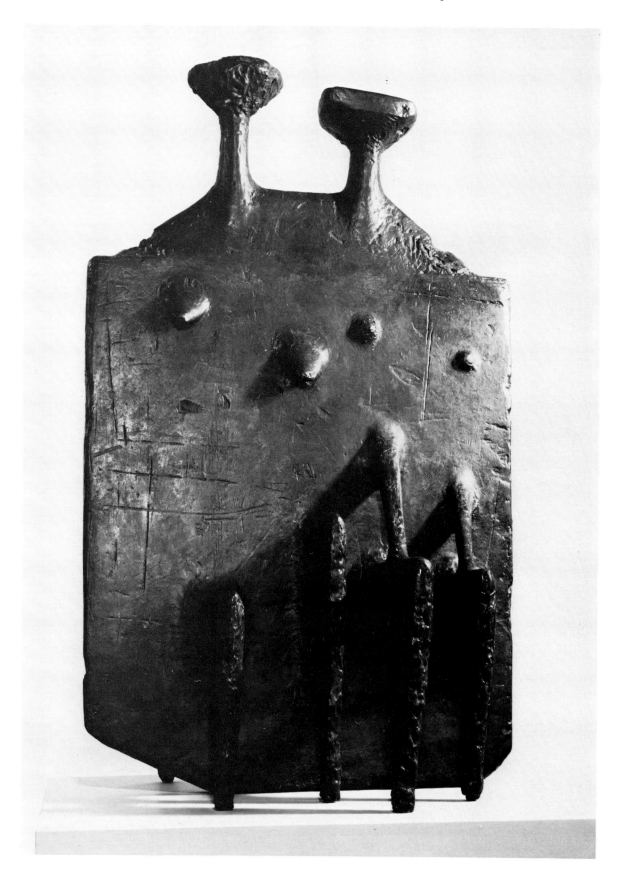

Kenneth Armitage: **Diarchy**, 1957. Tate Gallery, London.

X. Sculpture in the 1940s and 1950s: the Form and the Language.

The purpose of this essay is to examine some characteristics of that British sculpture of the 1940s and 50s which received the greatest contemporary exposure and critical attention, in the light of the working situation of the sculptors, and the language which was used about sculpture, both by writers and the sculptors themselves. It is not a comprehensive and exclusive analysis, but an attempt to discuss certain factors which affect not only the work of individual sculptors but also the appearance which the period as a whole presents to us. With these considerations in mind, I want to suggest an alternative view of the relationship between British sculpture in the 1950s and that of Caro and the 'New Generation' sculptors of the 1960s, a view which stresses continuity and development as opposed to the orthodox view, which tends to emphasize a radical disjunction.

This orthodoxy has been heavily reinforced by statements made by certain sculptors. Interviewed in 1968, Phillip King expressed his distaste for much sculpture of the previous decade in comments on the international 'Documenta' exhibition of 1960: 'The sculpture there was terribly dominated by a post-war feeling which seemed very distorted and contorted. Then you had Germaine Richier and the brutalist sculpture of the time. And it was somehow terribly like scratching your own wounds, an international style with everyone showing the same neuroses'.[1]

A more theoretical argument was provided by King's contemporary William Tucker. He has described the post-war period in sculpture as 'a time when the idea of construction was revived to give life to a dying tradition of modelling, when form was sacrificed to texture and autonomy of structure to a cheap and melodramatic imagery'.[2]

This hostile analysis is a useful starting point for analysing some of the distinctive characteristics of the sculpture of the time. In general it tends towards the pictorial, the anti-monumental and in doing so rejects the notion common in the 1960s of 'autonomy of structure' as being central to sculpture. Even where the sculpture comes close to abstraction a fundamentally different relationship to the spectator is established, compared with the purist formalist one which demands that object remain as object. Devices and formats are employed which cut the spectator off from the work and allow the creation of a separate illusionistic space. William Turnbull's **Mobile Stabile** of 1949,

[1]'Phillip King talks about his sculpture,' *Studio International*, June 1968.
[2]William Tucker, **The Language of Sculpture**, London 1974, p. 83.

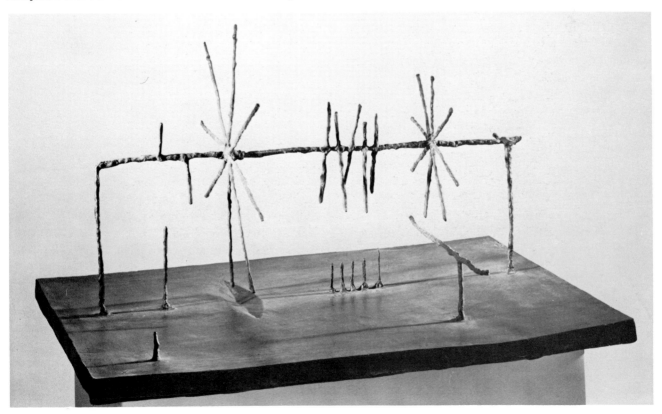

William Turnbull: **Mobile Stabile**, 1949. Tate Gallery, London.

reminiscent of the Giacometti both of the Surrealist tables of the 1930s and the dribbled plaster figures of the post-war years, is an example of this tendency.

■ The sense of physical exclusion, which in turn demands an imaginative participation in the illusory space of the piece, is reinforced by the title. The components cannot be moved or manipulated. The possibility is merely suggested by the device of spokes on an axis and the relationship of these to the lip-like indentation in the base. Scale and size are implied through an unstressed analogy between the vertical elements and the human figure. Against this approach, we may contrast that of Anthony Caro who was to say of his 1965 sculpture **Yellow Swing**: 'This sort of sculpture is entirely to do with the sort of space that the onlooker or the artist who's making it, inhabits. Scale is our scale, scale is the onlooker's scale . . . I mean a small sculpture would be sitting on a stand, and inhabiting its own world. One can then enlarge it until it becomes a large sculpture'.[3]

Leading sculptors of the generation before Caro had a similar attitude to the question of scale. Many of Kenneth Armitage's pieces were made in both large and small versions, while Lynn Chadwick's 1952 sculpture **The Inner Eye** (Museum of Modern Art, New York) was remade in five slightly different small versions.[4] ■ All are based on the form of an up-ended eye with a piece of uncut glass clasped in the centre and pivoted to allow for movement. The combination of glass with forged and welded metal was common in Chadwick's sculpture at this time.[5] The glass is presented like a jewel in an elaborate setting although the implications are more sinister than decorative. As in Turnbull's **Mobile Stabile**, the structure tends to discourage the spectator from carrying through the implied possibility of physical manipulation. One perceives the core through a network of ribs. In contrast with the formal and structural clarity of a piece by King or Tucker, deliberate visual barriers are set up. A characteristic of Chadwick's work is a sparseness of support and through this an emphasis on the suspension of form. The attempt to deny the weightiness of sculpture is another feature which is characteristic of much sculpture of the 1940s and 1950s. In Chadwick's work it is manifested through the combination of the emphatic use of linear elements with traces of a vertical, anthropomorphic structure. This in turn reflects his particular approach to direct metal technique. Instead of accepting the flat surface of the sheet metal as Caro was to do, he cut and forged the

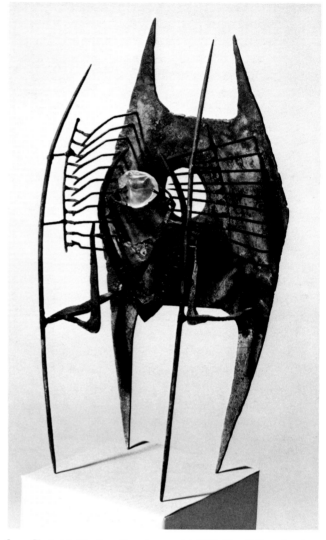

Lynn Chadwick: **The Inner Eye**, (maquette), 1952. Tate Gallery, London.

material. As Tucker subsequently pointed out, the technical approach of such work has more to do with modelling than construction.

The potentials and the contradictions of this approach to material are most richly worked out in the series of iron sculptures made by Reg Butler between 1947 and 1952. Butler had trained as a blacksmith during the war, after originally studying to be an architect. At that time the oxy-acetylene torch was only gradually being introduced,[6] and to an extent

[3]'Anthony Caro interviewed by Andrew Forge', *Studio International*, January 1966.
[4]Tate Gallery Acquisitions 1970-72.
[5]See also **St Louis Woman**, in Museo Civico di Torino.
[6]Culpin, **Farm Machinery**, 2nd ed., London 1944: 'The Rural Industries Bureau has assisted many country smiths to become expert welders and it is hoped that village blacksmiths of the future will have an oxy-acetylene or electric welding outfit as a regular part of their equipment.'

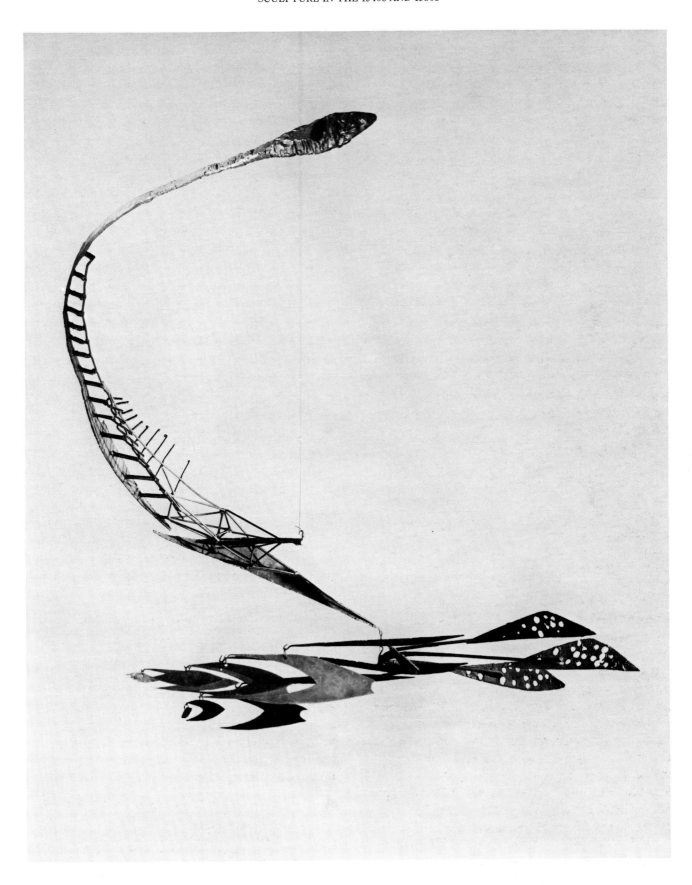

Lynn Chadwick: **Dragonfly**, 1951. Tate Gallery, London.

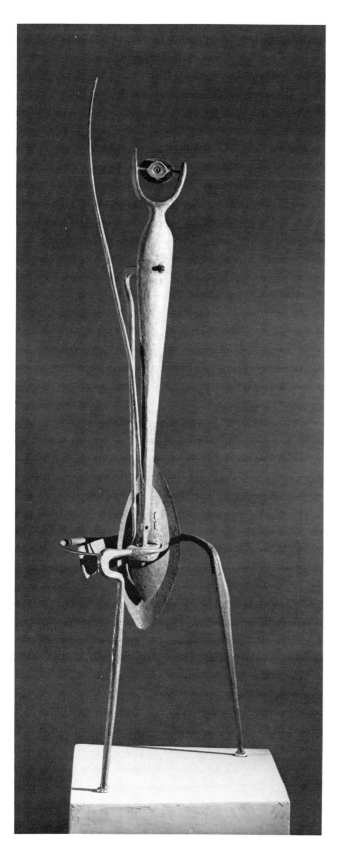

greater than any other sculptor this century (with the possible exception of the Spaniard Eduardo Chillida), Butler has exploited the possibilities open only to the hand forger of metal. Working from the bar, he could twist and change section while achieving far smoother transitions from one line to another than can be gained with the oxy-acetylene or arc-welder with its inevitable trace of 'bead'. 'Bead' however could also be exploited for deliberate effect, most notably in some of the later sculptures such as **Girl and Boy,** 1950-51 (Arts Council of Great Britain). 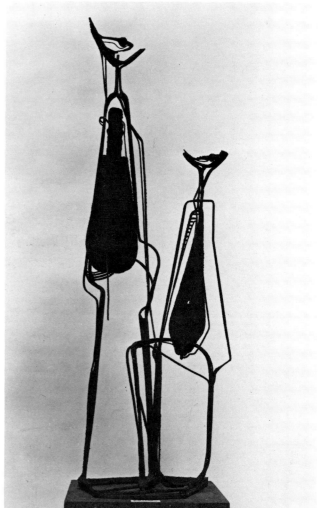 The limitations of the technique lie in the dependence on the bar as a basic unit, and in Butler's larger works continuous plane surfaces are made from bars welded in parallel. This causes some support problems which in turn partially dictates the form of the sculpture.

The Birdcage, made for the Festival of Britain in

Reg Butler: **Woman**, 1949. Tate Gallery, London.

Reg Butler: **Girl and Boy**, 1951.

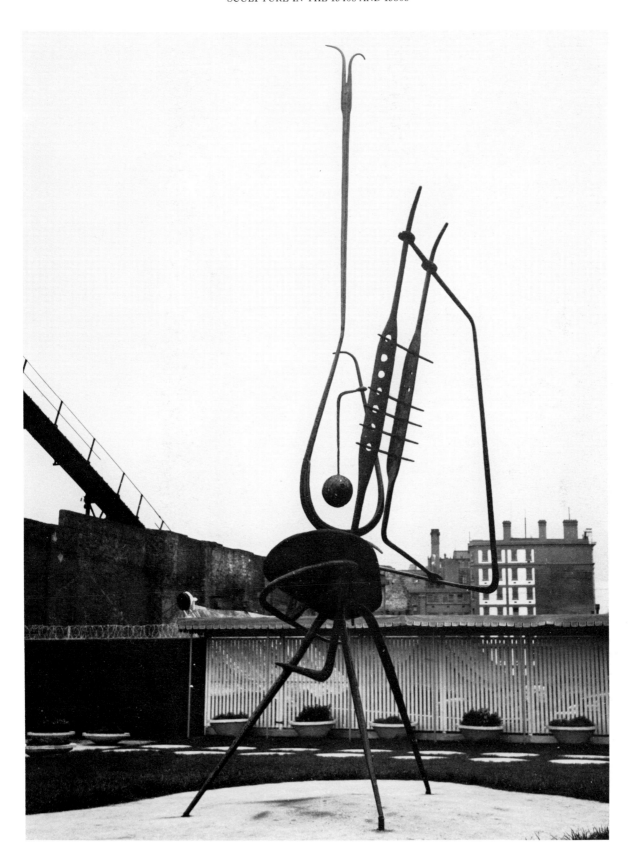

Reg Butler: **The Birdcage**, 1951. Greater London Council (photographed at the 'Festival of Britain' Exhibition).

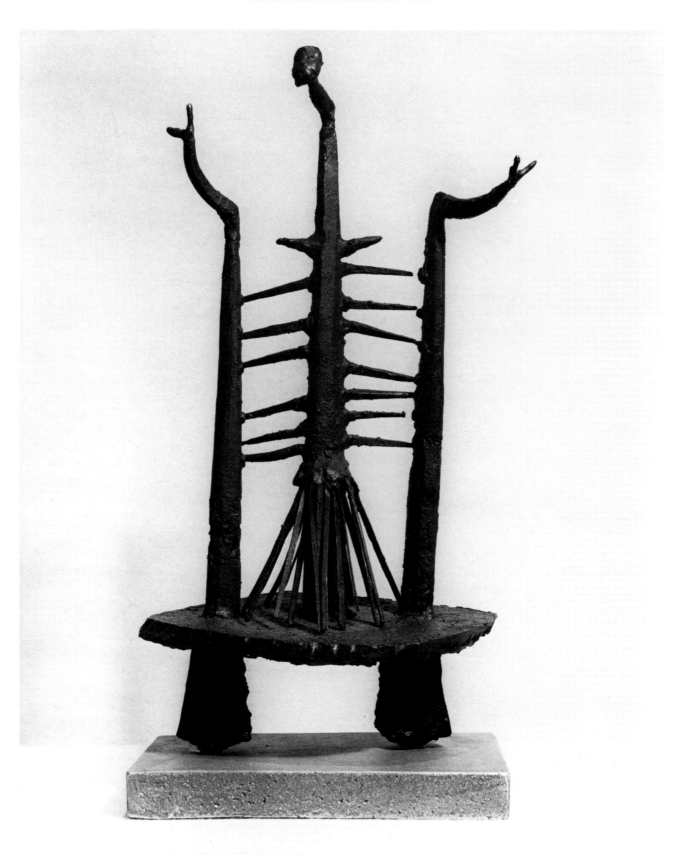

Geoffrey Clarke: **Man**, 1952. The artist.

1951 (and now at Kenwood House, Hampstead), is a sophisticated and virtuoso solution to the structural problems inherent in the medium. ◼ The subject combines organic and inorganic and demands the creation of a hanging structure which remains attached to the ground. The stability of the piece requires at the least a three-legged support. In order to prevent this necessity from dominating the visual structure of the work Butler provides an illusory 'second base', an irregular curved form at an angle just above the meeting point of the three legs. The sense of suspension in the air is emphasised by the fact that one important structural element springs, not from the irregular platform, but curves around from beneath it. Attention is also drawn away from the supporting legs by a structurally redundant 'tail' which follows closely the contour of the platform and helps obscure the real support. Instead, the lines direct the observer to the hook-like construction at the top of the sculpture by which it is notionally suspended from the sky.

A similar use of this intermediate secondary base is to be found in the technically far less elaborate iron sculptures of Geoffrey Clarke. In a work such as his **Man**, 1952, the structure is given clear anthropo-morphic connotations which the broad waist allows to be combined with a more fanciful treatment of the upper part of the body. ◼ The close relationship between this kind of structure and the specific possibilities of the medium is demonstrated by the clear formal parallels with certain seventeenth-century German candlesticks in the Victoria and Albert Museum.

Choice of material may dictate form to some extent but this first choice is not an arbitrary one and the techniques and materials which one finds in much British sculpture during this period can be related to certain common factors. In the Venice Biennale of 1952 eight young British sculptors received their first major international showing. The impact made by this group exhibition is well-known. Alfred Barr of the Museum of Modern Art in New York wrote that 'it seemed to many foreigners the most distinguished national showing of the Biennale'.[7]

A striking feature of the careers of several of these sculptors was the lack of any formal training in sculpture. Their work was rooted in other crafts. Butler came to sculpture through architecture and ironwork. Geoffrey Clarke studied at the Royal College of Art, but in the stained glass rather than the sculpture department. Lynn Chadwick trained as an architect and in the late 1940s worked particularly in

exhibition design. Although Eduardo Paolozzi and William Turnbull both studied at the Slade School of Art, there is an explicit rejection of academic standards, particularly in the rawness of certain early Paolozzi's, at a time when the School was still dominated by the conservative heritage of Tonks through his successor, Randolph Schwabe. This pattern was not accidental but reflects the lack of a professional tradition of modernist art of the kind that was only to become established during the 1950s. The incorporation of techniques and skills from outside the fine art context was not in itself a new phenomenon in twentieth century art. One need only recall Braque's incorporation of commercial fake wood graining in certain Cubist works or Magritte's rejection of traditional illusionism in favour of a manner which recalls the sign painter. But these artists were concerned with a radical departure from traditional ways of seeing and representation. The generation which emerged in the 1940s did so in a context in which 'modern art' already had a codified history. The institutional and intellectual framework for its support already existed and required a form of 'recruitment'.

The strength of the early sculpture of Chadwick and Butler lies in their ingenious exploitation of novel tech-nical resources. Their comparative stagnation after the early 1950s may be explained by their failure to go beyond this and develop that new technique into a language which could respond to changing external requirements.

The models presented for the appropriate attitude of an artist to his work in conjunction with technical resources evolved in relation to practices other than the art of sculpture were particularly unhelpful. Herbert Read laid great stress on the role of the unconscious and disapproved of an analytical approach by the artist. In the introduction to the catalogue of the 1952 Venice Biennale he wrote 'the more innocent the artist, the more effectively he transmits the collective guilt'. The idea that the strength of the artist's ability to confront important themes lies in his not knowing, his literal innocence, was equally manifest in the title of the 1953 sculpture competition for the 'Unknown Political Prisoner'. The reaction which the exhibition aroused among some supporters of the Soviet system indicates, albeit in a negative way, the importance which was generally attached to the idea of the inno-cent artist. Reviewing the competition, John Berger wrote: 'It was to be an international competition open

7 *The Manchester Guardian*, 3 September 1952.

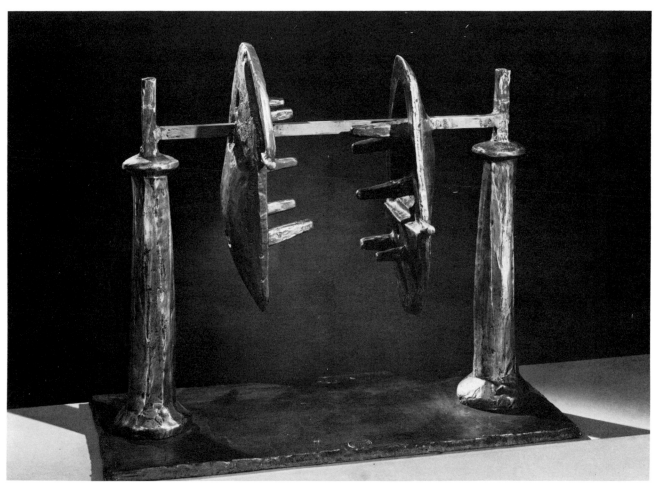

Eduardo Paolozzi: **Two forms on a Rod**, 1948/49. Tate Gallery, London.

to all ideologies; well-intentioned but imposs-
ible . . . But as soon as an artist begins to inquire (which
the artist must do) beyond the superficial facts of
appearance, one comes to the issue of the beliefs, the
intimate images of heartening strength, the ideals, the
hatreds which sustain that prisoner in his will to keep
faith with his fellow men. A trade unionist imprisoned
in Spain and a counter revolutionary in Siberia live or
die by the light of opposing images'[8]. For Berger, art
required a more specific acknowledgement of social
facts than the 'unknowing' artist could attain.

Sculptors' statements during this period frequently
stress the role of process, and the image is regarded
as the end result rather than as the conscious starting
point. In 1955 Lynn Chadwick wrote: 'The actual tech-
nique acted as a guide, and gave its character to the
work . . . I do not analyse my work intellectually. When
I start to work, I wait until I feel what I want to do; and
I know how I am doing by the presence or lack of a
rhythmic impulse. I think that the attempt to analyse
the ability to draw ideas from their subconscious

source would almost certainly interfere with that
ability'.[9] Reg Butler commented similarly: 'Proposi-
tions about art are concerned with art that has already
been manifested; the working artist's world is that of
works yet unborn'.[10]

At first sight the work of Kenneth Armitage might
appear to be part of the same pattern. Yet his idea of
sculpture, as suggested by his statements and devel-
oped in his best sculpture, particularly that of the late
1950s, fully explores the potential of an aesthetic
which had as its particular concern the creation of an
illusionistic space. The role of process is subjected to
greater conscious control. 'Uniform working or
resolving closes in the sculpture so that it becomes
imprisoned in its own stiff facade and is less
comfortable in relation to its environment and the
surrounding space'.[11] One recalls Sartre's comments

[8]*New Statesman*, 21 March 1953.
[9]*New Decade*, Museum of Modern Art, New York, 1955.
[10]Op. cit.
[11]Op. cit.

Kenneth Armitage: **Figure lying on its side No. 5**, 1957. Arts Council of Great Britain.

on Giacometti and his protests against the deathly rigidity of the sculpture in museums'.[12] Although working with traditional modelling, Armitage shares some of the formal and structural preoccupations of the welded sculpture of the period. Several pieces display an interest in the relationship between the figure and an architectural structure, which is close to some of Butler's early work. The concern with flat surface perceived frontally is characteristic of a general reaction against the three dimensional monumentality of Henry Moore, which runs through much British sculpture of the time. More far-reaching in its significance was the extent to which this rejection of the monumental led Armitage to evolve a far more sophisticated treatment of the problem of effects of suspension and weightlessness than his contemporaries. Armitage is unique, in work such as the **Two Seated Figures** of 1957 or the **Figure Lying on its Side No.5** of the same year, in his necessity to acknowledge the ground in order to free the sculpture from it. ☛ Works such as these anticipate the radical solutions of Caro in the 1960s to a far greater extent than any abstract constructed sculpture of the time. One feels the weightlessness of the limbs through comparison with a heavier bulk of the torso which emphasises the ground. Armitage's work shows that what was formally and expressively most radical in the sculpture of the 1950s did not always coincide with novelty of technique and imagery.

[12]Sartre 'La recherche de l'Absolú' in **Les Temps Modernes**, Paris, January 1948. See also Bauer, **Sartre and the Artist**, London 1968.

Reg Butler: **Monument to the Unknown Political Prisoner**, 1953. Photomontage showing sculpture on proposed site, the Humboldt Höhe, Wedding, near the border with East Berlin.

XI. Public Sculpture in the 1950s.

'The sculptor must come out into the open, into the church and the market place, the town hall and the public park; his work must rise majestically above the *agora*, the assembled people. But one must also point out that the people should be worthy of the sculpture'.
Herbert Read, 1948

'The usual, immediate reason why architects don't use sculpture is a financial one; the profound reason is that as a society we lack the spirit of an heroic vision'.
John Berger, 1954

In the fifteen years or so after the end of the Second World War this country experienced a renewal of interest in the possibilities of sculpture as an outdoor public art such as had not been seen since Victorian times, and has not really been seen since. [1] In the Nineteenth century, confidence in certain widely held social, political and religious ideals made it easier for edifying or commemorative monuments sharing a common plastic symbolism to be erected, with little fuss, in early every market-place in the land. By the early 1960s it had once again become almost commonplace for observers to rejoice in the health of British sculpture, pointing this time to its high international reputation and praising official bodies such as the London County Council and the Arts Council for their enterprise in commissioning works for public sites. 'It is said that there are more sculptors in this country today than ever before and by a happy coincidence, more opportunities for them', wrote a *Times* correspondent in October 1962, adding that, 'sculpture today is becoming more and more a part of the buildings that surround us'. [2]

Sculptures placed on or outside modern buildings in London since the war formed the subject of a survey compiled by the art critic Edwin Mullins which was published in *Apollo* in August 1962. [3] Mullins focused attention on the imaginative efforts of the L.C.C., which since 1956 had been spending £20,000 a year on works of sculpture for its schools and housing estates. His invaluable report was followed just over a year later by a short article in *Country Life* by Dennis Farr (then working at the Tate) who was more sceptical of the supposedly progressive taste of official bodies, finding instead that it had been 'left to private initiative to commission some of the best post-war works'. [4] Both authors, however, agreed on the central, perhaps insoluble, problem facing contemporary sculptors: how to integrate their work with modern architecture.

The difficulty, it seems, was primarily due to lack of understanding between architect and sculptor; neither spoke the same language or was motivated by the same beliefs. However far it had drifted away from its obligations as a narrative and commemorative art, sculpture was, in the 1950s, to a large extent still anthropocentric and it was still made in traditional materials, though metal welding had begun to replace the more expensive techniques of stone carving and bronze casting. Building technology, on the other hand, had undergone a revolution, and the dreams of the Modern Movement were now rapidly transformed into reality. Cheaper materials and new methods of construction resulted in an architecture vastly different in terms of scale, severity of outline and regularity, even monotony, of surface from all but a tiny proportion of pre-war mass housing. Reconciling the two became something of a challenge to sculptors and there were conflicting schools of thought as to how this should be done. Some, including the sculptors Franta Belsky and the ubiquitous Bainbridge Copnall, spoke of 'humanizing' mass-produced buildings by furnishing them with sculpture, thus subscribing to the orthodox view that urban sculpture is essentially decorative or 'architectural' in function. [5] Others, like Hubert Dalwood and Henry Moore, strongly objected to the utilitarian 'idea that sculpture can be brought in to provide a veneer of culture to a building'. [6] For Moore, the kind of routine relief sculpture with which artists were asked to ornament buildings before the war symbolised 'the humiliating subservience of the sculptor to the architect'. Now that the idea of free-standing sculpture placed in a spatial relationship to a building had become accepted practice, though

[1] There are signs, however, of an increase both in the opportunities for public commissions and in the number of sculptors prepared to undertake them, compared with the general apathy of the 1970's – a reaction in part to the proliferation of hack work in the 1960's. These are the findings of Deanna Petherbridge in 'Sculpture up Front', *Art Monthly*, no.43, 1981, pp.7-15. Miss Petherbridge's balanced and informative account of the current situation, published after this essay was written, makes familiar reading. The same appeals to sculptors to 'communicate' with the people, the same vexed relationship between architect and artist, the same debate about the nature and function of public sculpture – twenty or thirty years on, the picture has changed little.
[2] 'Sculpture As New Status Symbol', *The Times*, 31 October 1962.
[3] Edwin Mullins, 'The Open-Air Vision: A Survey of Sculpture in London since 1945', *Apollo*, August 1962, pp.455-63.
[4] Dennis Farr, 'Sculpture in London since the War', *Country Life*, 14 November 1963, pp.1240-41.
[5] The views of Belsky and Copnall are given in *The Times*, loc.cit, (see note 2 here). 'Architectural' sculpture was the term commonly used for reliefs and other embellishments of structure.
[6] Dalwood, quoted in 'No Accord on Public Sculpture', *The Scotsman*, 14 April 1967, a report of Scotland's first conference on public sculpture held at Dunfermline.

often only as an afterthought, he foresaw a new danger – the interference of the architecture itself: 'The setting makes a difference to the mood in which one approaches a sculpture and a good setting is one in which the right conditions are present for a thorough appreciation of its forms . . . '[7] This meant the minimum of background fenestration, which could easily compete with sculpture's outline and mass, especially the free organic forms characteristic of Moore's own work.

If architects gave any thought to the issue, most would probably have resented the idea that their buildings needed to be enhanced by sculpture, whilst those who admitted the necessity would almost certainly have done so for reasons of prestige, or have regarded it as mere space-filling, at best a foil to the architecture; it is unlikely that many of them would have had a particular sculptor in mind to carry out the commission.[8]

One who could see little reason for elevating sculpture to the status of a public object, in an age hard put to claim a collective iconography, was Reg Butler. After the scandal surrounding his prize-winning entry for **The Unknown Political Prisoner** competition early in 1953 and the controversy over his commissioned piece for the entrance hall at Hatfield Technical College (part of the Hertfordshire Schools Scheme), he retreated into a world of more personal meaning. Butler's only other commission for a permanent site, to make a sculpture for the new, £2 million Recreational Centre at Crystal Palace, fell foul of the L.C.C. in the summer of 1963. His proposal to erect a large female nude was rejected on the grounds that it was wholly irrelevant to its surroundings whereas what was really required was 'a magnificent sculpture reflecting the themes of vigour, strength and sport'.[9] More perceptive critics interpreted the affair as a paradigm of the artist's refusal or failure to respond to the special conditions of a public work of art.

Despite his stated preference for seeing his sculpture sited in landscape rather than 'in or on the most beautiful building I know', Henry Moore showed no such reluctance in rising to the challenge. In 1955 he said: 'I think architecture is the poorer for the absence of sculpture and I also think that the sculptor, by not collaborating with the architect, misses opportunities of his work being used socially and being seen by a wider public'.[10] Of all British sculptors active since the war, Moore is pre-eminent in having found a public voice, though like Epstein before him this was not achieved without opposition, amounting at times to

open hostility. As late as 1967 the art critic of the *Daily Telegraph* could complain that there were pitifully few Moores to be seen in public places in Britain, let alone works by other major sculptors.[11] Ironically, Moore received as many if not more official commissions abroad where his reputation was stronger, thanks largely to massive British Council support after he was awarded the International Sculpture Prize at the first post-war Venice Biennale in 1948.

But the situation had improved, at least in London. Whatever the obstacles to a sculptural statement in an urban environment, in 1967 the capital was able to boast a number of important outdoor works by Clarke, Epstein, Frink, Hepworth, Moore and others, all erected after 1945. Informed commentators may have had their reservations but few dissented from the opinion that public sculpture had come a long way since the first few isolated projects initiated in a flush of democratic zeal during the period of social reconstruction – that Brave New World of new towns, new schools and State welfare which came into being after the war. By 1965, the year of two important exhibitions, 'British Sculpture in the Sixties' at the Tate and the 'New Generation' at the Whitechapel, where every exhibitor was a sculptor, the emergence of a climate favourable to the flowering of the art under a school of young sculptors exploring new materials, new forms and new techniques more closely related to the impersonal language of contemporary architecture was generally recognised. And in the three weeks after announcing their Sculpture Competition, early in 1968, the *Sunday Times* received over 1,000 proposals for two works to be placed on a new City of London site – surely a remarkably positive reaction, by any standards.[12] If not accepted, sculpture was at least

[7]Moore's remarks are taken from *Sculpture in the Open Air — a talk by Henry Moore on his sculpture and its placing in open-air sites,* edited by Robert Melville and specially recorded, with accompanying illustrations, by the British Council, 1955, pp.1,9 (transcript in Tate Gallery Archive). This is a crucial document, hereafter referred to as Moore, 'Sculpture in the Open Air'. Parts of it are reprinted in Philip James, (ed.), **Henry Moore on Sculpture**, London 1966.
[8]See Sir Hugh Casson's account of the disappointing results of his appeal to architects to submit the names of sculptors with whom they would like to collaborate on the 'Festival of Britain Exhibition', in *Image 7,* spring 1952, pp.57-8.
[9]Antony Fletcher in a letter to *The Times* from County Hall, 12 August 1963. Lynn Chadwick (in the film 'Five British Sculptors' 1964, directed by Warren Forma) also confessed difficulty in reconciling what for him was an essentially private art with the demands of a public sculpture.
[10]Moore, 'Sculpture in the Open Air', p.2.
[11]Terence Mullaly, 'Monuments to Man', *Daily Telegraph*, 6 May 1967.
[12]See Misha Black, 'Humanising Our Cities', *Sunday Times,* 18 February 1968; and *Sunday Times*, 10 March 1963.

acknowledged by society as a force to be reckoned with once more.

Who were the key figures behind this sculptural renaissance and what means were used to impress the work of contemporary sculptors upon the popular consciousness?

The answer to the first question is simpler than one would expect. A small group of dedicated individuals, the majority employed by cultural or educational organisations – national and provincial museums, the Arts Council, the British Council, the I. C. A. – joined in what seems to have been a conscious attempt, well planned and adequately financed, often by public money, to promote sculpture as a social art – as *the* art of the post-war era. These individuals served on exhibition committees and competition juries, which usually included at least one sculptor of note.[13] The most eloquent and persuasive of all was probably Herbert Read, whose rallying cry to the contemporary sculptor is quoted at the head of this essay; its idealism is typical of the hopes and fears of the 'austerity' period. In an article published in *The Studio* for December 1950 (originally given as a lecture), the sculptor Alan Durst, echoing Read, spoke of his conviction that 'Sculpture can only survive on a worthwhile scale if and when there is a real call for it – in the home, on public buildings and in public parks, in churches and churchyards, in the town square – wherever it can bring a sense of harmony and delight and dignity into the lives of ordinary people'.[14]

A number of these idealists came from, or had worked in, the north of England, especially Yorkshire. Here the story really goes back to the Twenties when Henry Moore was encouraged by art collectors such as Sir Michael Sadler, Vice-Chancellor of Leeds University whilst Moore was a student at Leeds College of Art, and the Bradford printer and publisher E. C. ('Peter') Gregory whom he first met in 1923. Later, in 1950, Gregory established the Gregory Fellowships at Leeds University, which enabled a painter, a sculptor, a musician and a poet to work in a university environment untroubled by financial worries, usually for periods of two years at a time. The first Gregory Fellows in Sculpture were Reg Butler (1950-2), the Leeds-born Kenneth Armitage (1953-5) and Hubert Dalwood (1955-9). Gregory, Moore and Herbert Read, all three Yorkshiremen, were on the committee of the Institute of Contemporary Arts (Gregory was its Honorary Treasurer) which in 1952-3 promoted the controversial Sculpture Competition for a 'Monument to the Unknown Political Prisoner'. This

was probably the first and last venture of its kind to be mounted on an international scale; for this and other reasons – not least the adverse publicity which it attracted – it merits some attention here.

In the 1950s the I. C. A. (founded in 1948) became renowned in intellectual and artistic circles for its varied and stimulating programme of 'theme' exhibitions, lectures, discussions, films, poetry recitals and concerts. At the time of London's two 'Unknown Political Prisoner' exhibitions (national and international) early in 1953, Herbert Read, a member of the ten-man international jury, gave four lectures at the I. C. A. on 'The Aesthetics of Sculpture'. Members could also take part in a discussion on the interior of the new Time-Life building in Bond Street, hear a lecture by Lawrence Alloway on 'The Human Head in Modern Art' and join an excursion to Harlow New Town. Speakers on a diversity of subjects during this four month period included Jane Drew (who with her husband Maxwell Fry had designed the I. C. A.'s new gallery in Dover Street in 1951), Geoffrey Grigson, E. L. T. Mesens, Robert Melville, David Sylvester, Jacquetta Hawkes, William Empson, J. M. Richards, Max Ernst, Kathleen Raine, David Gascoyne, Julian Huxley, John Berger, A. J. Ayer, Will Grohmann and Alfred Barr Jr. – the last two also members of the 'Unknown Political Prisoner' jury, both in London for the judging. Barr spoke at the Tate after the private view of the International Exhibition on 13 March, when the work of 140 finalists from 54 different countries went on show to the world. The exhibition ran for over six weeks and was seen by more than 30,000 people, each paying 1 shilling.

The competition was proposed to the I. C. A. by Anthony Kloman, an energetic former U. S. cultural attaché in Stockholm, who came to London with the backing of a number of important Americans. The I. C. A. agreed to promote the scheme and received £1000 for its trouble. Rumour has it that funds for the competition came from an agency of the American Government such as the C. I. A., though the source of the anonymously donated prize money, some £11,500, has never been revealed. Official U. S. involvement, however indirect, would have been fully in line with that country's foreign policy during the early years of the Cold War, which sought to support and influence cultural activities abroad – activities which in some

[13]Frequently Moore but also Epstein, Wheeler, Charoux, Dobson, Hepworth, McWilliam, Butler and later Chadwick.
[14]Alan Durst, 'Sculpture Can Survive', *The Studio*, December 1950, p.177.

way reflected the Western democratic ideals of individualism and freedom of expression. Kloman was particularly anxious to persuade the Queen and other members of the Royal Family to attend the opening at the Tate and did everything he could to conceal the rôle of the U.S. by portraying the competition as a purely British initiative.

The massive task of sifting 3,500 entries (as opposed to an expected 500-800) was carried out under conditions of near secrecy by Kloman and his staff in a separate headquarters inside the I.C.A. premises in Dover Street. Because of the impracticability of having all the maquettes brought to London, it was arranged that a series of national preliminary contests should be held in twenty of the more important countries, including Britain, which sent forward twelve sculptors to the International Exhibition, among them Butler, Chadwick, Frink, Hepworth, McWilliam and Paolozzi. The jury reached its decision, after four days of deliberations, on 11 March. The Grand Prize of £4,500 was awarded to Reg Butler for his maquette, prizes of £850 were won by Mirko Basaldella, Gabo, Hepworth and Pevsner, and smaller sums were given to Adams, Bill, Calder, Chadwick, Hinder, Lippold and Minguzzi.

Although the competition was supposed to be entirely 'without political bias' (according to an I.C.A. press release), the Soviet Union's suspicions were quickly aroused. No sculptor from the U.S.S.R. or its Eastern European satellites entered work, and Professor Kemenov, who had lectured at the I.C.A. on Social Realist Art in the winter of 1951, declined the invitation to serve on the international jury. Clearly, the Communists considered the competition's emotive theme to be Cold War provocation. They probably felt confirmed in their view by the eagerness of the West Germans, led by the tireless Mayor of Berlin, Ernst Reuter (who was to die shortly afterwards), to build the winning monument on a prominent site in West Berlin overlooking the Eastern sector, in answer to the monolithic war memorial in Treptow Park which the Russians had recently erected to their soldiers killed whilst capturing the city in 1945.

Artists were in no sense restricted to a naturalistic or literal interpretation of the theme, and in fact symbolic and non-representational work carried off the bulk of the prizes. This was much to the annoyance of the New Statesman's art critic, John Berger, who accused the winning entries of being uncommitted, abstract and sentimental, and of dealing with generalisations rather than with the particular and local. Reg Butler's prize-winning maquette – severely damaged by a Hungarian refugee the day after the Tate opening but soon replaced by another – was acknowledged by Berger as 'a compelling emblem – but an emblem of Defeat'.[15] These charges were strenuously refuted by Herbert Read who took Berger to task for advocating an art of Social Realism and for implying that only Realistic art could be committed.[16]

Press reaction to the exhibition was either indifferent or belligerent, which prompted Alfred Barr to write to The Times expressing disappointment and surprise that so little had been made of the fact that British sculptors were prominent among the prize-winners. Part of the problem arose from the fact that, despite clear indications from the organisers and statements issued by certain artists, few visitors could envisage the eighteen-inch tall maquettes as full-scale monuments. In Butler's case, this would have meant constructing to a height of 300 to 400 feet, with the three figures, or 'watchers', emerging as considerably larger than life-size.

The confusion was not helped by unimaginative display and was made worse by the ridicule of the popular press. Even some of the serious art critics felt that many of the works were too 'abstract' (and therefore 'inhuman') and private in their symbolism. A common criticism of Butler's sculpture was that it too closely resembled a television aerial or piece of radar equipment. David Sylvester, for instance, reproached the artist's construction for its 'deficiency of invention and grandeur'; Butler's tower was 'devoid of that sense of inevitability which a monument on this scale needs and which can give even a television transmitting aerial a compelling magic'.[17] Another critic, M.H. Middleton, was more sympathetic. His comments on Butler extended to a more general reflection on the work of contemporary sculptors, whom he perceived were preoccupied with 'empty space': 'Perhaps we need a new word for their constructions. The word sculpture is associated in the public mind with solid mass, and hostility is aroused by its association with aims that have hitherto been regarded as the prerogative of architecture – the manipulation of space itself. (It is not without significance that both Butler and Chadwick, of the three British prize-winners, were trained

[15]John Berger, New Statesmen, 24 March 1953, p.338.
[16]Herbert Read, 'Tragic Art', New Statesmen, 28 March 1953, p.336. For a fuller account of the 'Unknown Political Prisoner' controversy, see the Tate Gallery's forthcoming Illustrated Catalogue of Acquisitions 1978-80, under Butler, T. 2332.
[17]David Sylvester, 'The Unknown Political Prisoner', The Listener, 19 March 1953, p.478.

architects)'.[18] Of the non-British prize-winners, Max Bill had practised as an architect and both Gabo and Calder were trained engineers.

A less charitable version of Middleton's view was expressed in an angry letter to the then Director of the Tate, Sir John Rothenstein. The winning sculptors were nothing more than 'frame makers', their work 'abstract patterns' and Butler's entry 'a wire contraption'.[19] Butler himself was at pains to stress that his sculpture was 'not a purely abstract architectural solution to the problem', although he hoped that its formal associations – cage, scaffold, cross, guillotine, watchtower – were sufficiently ambiguous and anonymous for it 'to become identified with the Unknown Prisoner idea'.[20] Perhaps the last word on the competition should go to Rothenstein, its host, who, writing to a disillusioned Barr after it was all over, reminded his American counterpart that the single fruitful result of the exhibition had been an 'unprecedented volume of serious discussion . . . on the question of contemporary art as a means of communication'.[21]

To indicate the extent of E.C.Gregory's commitment, it is worth recording as a footnote to all this that I.C.A. catalogues were printed by his firm Lund Humphries, as were some of the Arts Council's Battersea Park and 'Sculpture in the Home' exhibition catalogues; and from the 1950s onwards Lund Humphries printed and published the successive volumes of the Henry Moore catalogue raisonné.

During the war Gregory had been responsible for persuading Wakefield City Art Gallery and its enlightened Director, Ernest Musgrave, to buy Moore's elmwood **Reclining Figure**, 1936, going so far as to raise some of the money himself. This was the second sculpture by Moore to enter the collection of a provincial gallery in Britain. A year previously, in 1941, Leeds City Art Gallery had acquired one of the earliest and most important reclining figures, that in Hornton stone of 1929. This went on show at Temple Newsam House, which had been sold to the city in 1922 and had recently been redecorated inside by its Director, Philip Hendy. Before moving south to become Director of the National Gallery in 1945, Hendy gave both Moore (in 1941) and Hepworth (in 1943) their first retrospectives at Temple Newsam, as well as showing the work of other sculptors such as Gaudier-Brzeska and Epstein. In January 1953 Hendy served on the jury of the British national competition for the 'Unknown Political Prisoner' and later became Chairman of the Harlow Art Trust, which proceeded to acquire

examples of contemporary (and some antique) sculpture and place them in Harlow New Town.[22] Henry Moore, who lives near Harlow, took a keen interest in the scheme from the start; his stone **Family Group** was the first work to be commissioned by the Trust.

One of the most successful ways of introducing contemporary sculpture to a wide public was through open-air exhibitions. The first of these – indeed the first in the world to be sponsored by a municipal authority, according to the catalogue – was organised jointly by the L.C.C. and the Arts Council, at a cost of £10,000, and held in Battersea Park in the summer of 1948. ☛ Like its successor three years later, the exhibition was international in scope, allegedly embraced the art of the previous fifty years, and included a few examples by earlier twentieth century masters: Rodin, Maillol, Modigliani and so on. Patrick Heron in the *New Statesman* spurned the preponderance of academic works by Reid Dick, Wheeler, Thomas, Ledward, Hardiman and others, and complained about the absence of Brancusi, Gaudier-Brzeska, Picasso, Gabo, Calder and Barlach (in the case of the last two, this was remedied in the second Battersea exhibition) from a show supposed to be representative of developments in twentieth century sculpture.[23] For special praise he singled out Moore's **Three Standing Figures** in Darley Dale stone, presented to the L.C.C. two years later by the Contemporary Art Society (who had commissioned it), when it was moved to the position it now occupies in the park. ☛ This was the group ridiculed by Sir Alfred Munnings in his broadcast speech attacking modern art at the Royal Academy banquet in 1949.

With thirty five different artists showing in 1948,

[18]M.H.Middleton, 'Trouble at the Tate', *The Spectator*, 20 March 1953, p.335.
[19]Letter of 10 April 1953, kept in the Tate Gallery Archive file on the 'Unknown Political Prisoner' exhbition. The author professed a belief in 'the Munnings view' that a work of art should be 'visually recognizable' and have 'a pleasing theme.'
[20]Statement by Reg Butler issued at the time of the Tate exhibition; copy on I.C.A. archives.
[21]Rothenstein to Barr, 29 April 1953; copy in the Tate Gallery, loc.cit. A copy of Barr's letter to *The Times* (23 March 1953), in which the author exhorted Englishmen to 'Wake up' but which was not published because the case against Laslo Szilvassy, accused of malicious damage to Butler's maquette, was still before the courts, can also be found in the Tate Gallery file; as can Anthony Kloman's correspondence with Rothenstein and Lord Jowitt, Chairman of the Trustees, about charging admission and inviting members of the Royal Family to the opening of the exhibition at the Tate Gallery.
[22]See Sir Frederick Gibberd, intro., **Sculpture in Harlow**, Harlow Development Corporation in association with Harlow Art Trust, 1973.
[23]Patrick Heron, *New Statesmen*, 29 May 1948, pp.433-4.

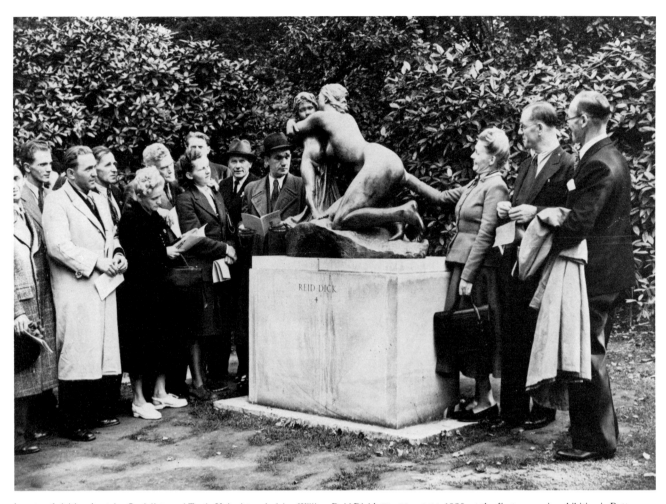

A party of visiting Austrian Socialists and Trade Unionists admiring William Reid Dick's **The Manchild**, 1920, at the first open-air exhibition in Battersea Park, September, 1948. '. . . spurious sentiment and meaningless skill. . .' (Patrick Heron).

and forty four in 1951, it is not surprising that Nikolaus Pevsner, in his catalogue introduction to the 1951 exhibition, should have pointed to the 'bewildering variety of styles' on display, even though the majority of work on both occasions was figurative – in 'the Humanist tradition', as one critic put it. [24] Visitors to Battersea I were encouraged to make sense of the mêlée by attending lectures given once and some-times twice daily in front of the exhibits. In addition, public lectures were held at County Hall in 1948 and the R.I.B.A. in 1951. The didactic nature of the exhibitions was made clear, at Battersea I, by demonstrations of carving and modelling provided by students of various London art schools who were housed in a marquee near the main entrance when bad weather prevented them from performing in the open air. 'We do not wish to influence public opinion', wrote Patricia Strauss, Chairman of the Parks Committee, somewhat disingenuously, in her Foreword to the catalogue. 'British cities contain less open-air

sculpture than those of any other European country', wrote Eric Newton in his introductory note on sculpture, ending up: 'If you like this exhibition, agitate for what I have called the "furniture" of the open air. After all, public opinion does count. And London is worthy of good furniture.'

Most critics agreed with Newton: simply bringing sculpture out of the gallery or museum and exposing it to nature was not enough. 'There is a third pretext for keeping sculptors alive while we are building and town-planning', wrote Francis Watson in his review of Battersea II. [25]

The popularity of Battersea I – it attracted 170,000 visitors at one shilling each – persuaded Glasgow Corporation, in association with the Arts Council's Scottish Committee, to repeat the experiment a year later. The same heterogeneous mixture of styles representative of 'both the academic and modern

[24]Francis Watson, *The Listener*, 24 May 1951, p.846.
[25]Ibid.

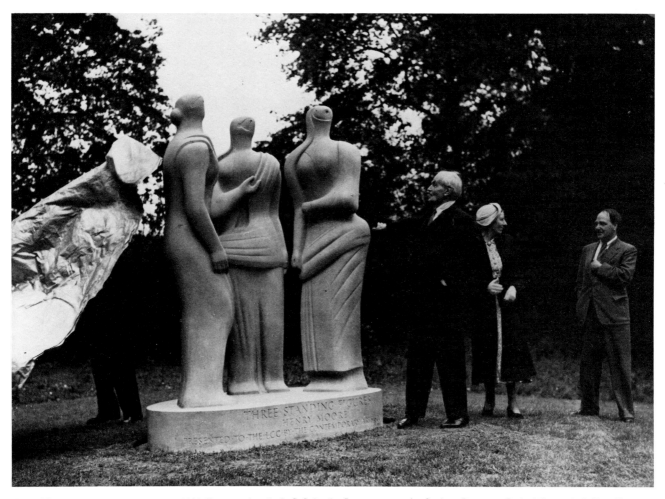

Henry Moore: **Three Standing Figures**, 1948. Presented to the L.C.C. by the Contemporary Art Society, Battersea Park, 21 June, 1950. Unveiling by Sir Edward Marsh (Chairman, C.A.S.) at the invitation of Mrs Hugh Dalton (Chairman of the Parks Committee) in the presence of the artist.

outlook'[26] occupied the banks of the River Kelvin beneath the University and opposite the Art Galleries. Not surprisingly, Scottish sculptors were in evidence (including, again, Sir William Reid Dick, the King's Sculptor for Scotland), taking their place alongside casts of Celtic crosses lent by the Museum to remind visitors of Scotland's distinguished glyptic heritage. Despite guide lectures and demonstrations of 'sculpture in the making', following the Battersea pattern, attendances were much lower than in the south: in the months of July and August 1949, not more than 20,000 adults and 1200 children entered Kelvingrove Park, instead of an expected 80,000. Several theories were advanced to explain this disappointing reception: the one shilling admission charge (introduced in part to deter vandals) in a city largely brought up on free art shows, and the coincidence of unusually fine weather – fine enough to drive people out of town, presumably – were the most frequently heard.[27]

Looking at photographs of the Glasgow and

Battersea II exhibitions, one is struck by how badly placed many of the sculptures were. 'Too many pieces are merely dotted about', was the *Architectural Review*'s verdict on the coherence, or lack of it, of Battersea II.[28] At Kelvingrove Park, a much smaller area, this lack of proper siting must have been even more noticeable, although the problem was due in part to the fact that a number of sculptures were simply inappropriate to their surroundings. Moore and Hepworth, for example, both lent small abstract carvings of an essentially domestic type which could easily have been dwarfed or made to look absurd by the monumental figures of Wheeler, Epstein, Benno Schotz (adviser to the exhibition) and others. The strongest warning against the attractions of open-air shows came from Henry Moore who has always

[26]T.J. Honeyman in Foreword to catalogue of **Sculpture in the Open Air**, Kelvingrove Park, June-September 1949, p.3.
[27]See reports in the *Glasgow Evening Times*, 29 August 1949, and *The Scotsman*, 30 August 1949.
[28]*Architectural Review*, July 1951, p.52.

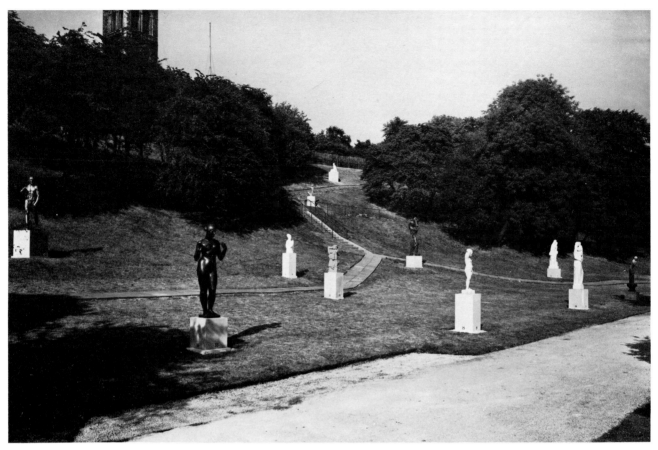

'Sculpture in the Open Air', Kelvingrove Park, Glasgow, June-September 1949. General view showing works by (left to right) Rodin, Maillol, Garbe, Innes, Bourdelle, Jonzen, Schotz, Ledward, Wheeler. In background: McWilliam, Buchanan.

insisted that sculptural forms should ideally be seen in sunlight, or at least outdoors, but who found the exhibitions a travesty of the idea of showing sculpture in natural surroundings: 'There is a danger that people will confuse their love of flowers and gardens and visits to the park with an interest in sculpture. And we shall have to fight against sculpture being reduced to ornament in landscape gardening. . .'[29]

The L.C.C. held its third outdoor exhibition to celebrate the opening of Holland Park as a public space in the summer of 1954. Once again the arrangement of works was criticised, this time for not being casual or fortuitous enough (David Sylvester in *The Listener*[30]); and once again it was regretted that sculpture had been transposed into 'highly artificial conditions' instead of anything remotely resembling a real environment (Lawrence Alloway, also in *The Listener*[31]). By the mid-1960s the look of contemporary sculpture had changed to such a degree that in the catalogue introduction to the fifth Battersea exhibition in 1966 Alan Bowness had to remind visitors – if they needed reminding – of the incongruity of many of the

works within a landscape setting.

With all this emphasis on sculpture for 'the people', it comes as something of a surprise to learn that the private patron was also catered for by official attitudes. In 1946 the Arts Council put together its first travelling show of 'Sculpture in the Home': small-scale works for the private collector, by both established and younger artists, with most pieces for sale at prices of between £20 and £100. The Arts Council not only hoped to encourage private patronage but also to accustom people to the idea of living with

[29]Moore, 'Sculpture in the Open Air', p.9. Moore's ideal setting for sculpture is not the picturesque park or garden but the informal, unplanned moor or downland which allows the wandering spectator the pleasure of coming across the unexpected. Battersea I used only a corner of the park – the *Architectural Review* called the site 'a park-within-a-park' – which must have created a somewhat crowded effect. As Robert Melville has noted elsewhere, Moore was probably thinking of his stone sculpture when he announced his preference for seeing it in sunlit landscape; bronze often looks better in dull wet weather. See Robert Melville, 'Henry Moore and the Siting of Public Sculpture', *AR*, February 1954, pp.87-95.
[30]3 June 1951, p.976.
[31]Lawrence Alloway, 'The Siting of Sculpture', *The Listener*, 17 June 1954, p.1044.

sculpture. With this end in view, the objects were shown on or against a background of modern furniture, following the example of an A.I.A. exhibition at Heal's the previous year.[32] It is not hard to detect a resemblance, if only a superficial one, between Fifties sculpture and furniture – for example, the lightweight chairs of Ernest Race – largely because much of the new sculpture tended towards open constructed forms, sometimes cage-like in appearance, and was made of bent wire or forged iron. On one occasion a piece by Geoffrey Clarke, whose work of the early Fifties is characterised by spindly anthropomorphic shapes often with aggressive connotations, was compared in *The Times* to 'a lampstand'.[33]

'Sculpture in the Home' exhibitions toured the provinces again in 1950-1, 1953 and 1958. Commenting on the second in the series, the *Architectural Review* wondered whether sculpture was 'really suitable for the decoration of the home', declaring that it had 'always been a public art and will continue to need public commissions'.[34]

In 1957 and 1958 the Arts Council also sent two open-air exhibitions of 'Contemporary British Sculpture', much of it for sale, to public parks in provincial towns and cities; the first was seen by more than 215,000 people. Meanwhile the British Council was fervently pursuing its policy of exporting sculpture abroad, encouraged by the tremendous critical acclaim which had greeted the work of eight sculptors, all under forty, at the Venice Biennale in 1952, when several pieces were bought by, among others, Alfred Barr (for M.O.M.A.) and Peggy Guggenheim.[35] ◤ A version of the 1952 exhibition, which had consisted of sculpture and drawings by Adams, Armitage, Butler, Chadwick, Clarke, Meadows, Paolozzi and Turnbull, toured America and Germany in 1955-6. British sculpture was considerably in demand on the Continent and the Council was always happy to dispatch another travelling show of Moore, Hepworth, Armitage or Paolozzi (all consequently well represented in the British Council Collection). It was not until the late 1950s, when the impact of American abstract painting was beginning to be felt in Europe, that requests for such exhibitions declined in number.

The most significant retrospectives to invite comment in the early 1950s were those of Moore in 1951 and Epstein in 1952, both held at the Tate. 1951 was very much Moore's *annus mirabilis,* with two controversial bronzes on view in public open spaces in London – his opened-out **Reclining Figure** specially

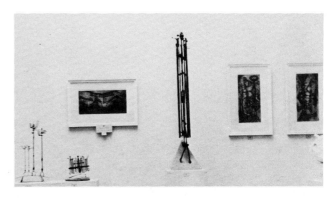

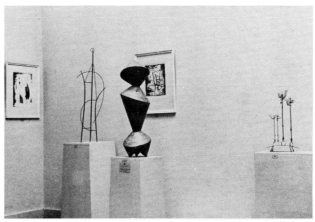

British Pavilion, Venice Biennale, 1952. (Top) Sculpture and prints by Geoffrey Clarke.

(Below) Works by Robert Adams and Geoffrey Clarke.

[32]There was an even earlier precedent for this apparently novel idea of showing contemporary art and design together. In 1936 the firm of Duncan Miller had staged in their London showrooms an exhibition called 'Modern Pictures for Modern Rooms' intended to illustrate the affinities between abstract art and interior design.
[33]*The Times*, 29 May 1953. The piece thus described was Clarke's iron sculpture commissioned by Time-Life for the reception room of its building in Bond Street. See the *Architectural Review*, March 1953, pp.156-72 for a detailed description of the interior of the building whose features included Ernest Race chairs, ashtrays by Lucie Rie, curtains designed by Edward Bawden and a Ben Nicholson mural in the entrance hall. Clarke's sculpture is shown in a drawing of the reception room on p.162. For Moore's work on the exterior of the building see later in this essay. The *AR* for August 1952, p.130, illustrates typical examples of the work of Butler, Armitage, Clarke, Meadows and Chadwick, all shown in the British Pavilion at the 1952 Venice Biennale (see later in this essay and note 35 here). These artists belonged to what Robert Melville, reviewing an exhibition of F.E.McWilliam's sculpture in the *AR* later the same year, dubbed 'the new linear school of attenuators and cage constructors'. The sculpture-furniture analogy is also drawn in connection with a work by Calder in the *AR*, August 1949, where one of his stabiles is shown against a coffee table and chair designed by Eliel Saarinen (p.118).
[34]*Architectural Review*, November 1950, p.330.
[35]The exhibition was selected by Herbert Read, Philip Hendy and John Rothenstein. In his catalogue introduction, Read spoke of 'images of flight, of ragged claws "scuttling across the floors of silent seas", of excoriated flesh, frustrated sex, the geometry of fear.' In a letter of 3 July 1952 to the *Manchester Guardian*, he recounted how everywhere he went in Venice he was told that 'the British Pavilion was the most vital, the most brilliant, and the most promising in the whole Biennale.'

British Pavilion, Venice Biennale, 1952.

Sculpture and drawings by Lynn Chadwick, including (right) the maquette for his Festival of Britain commission, **Cypress**.

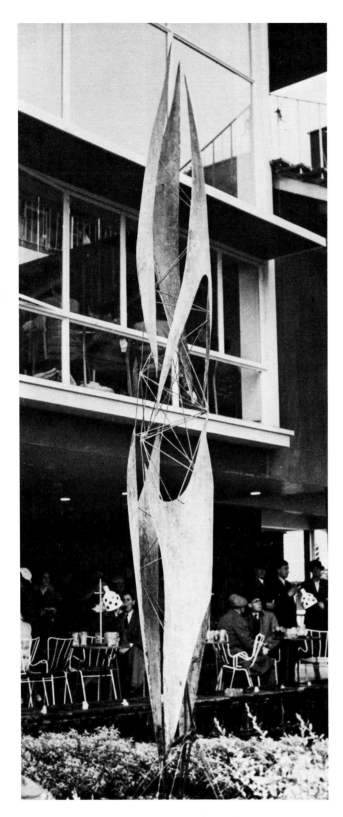

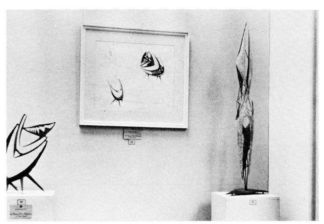

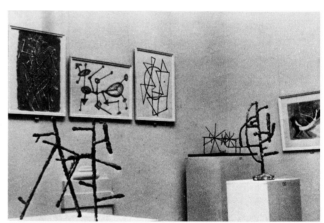

Sculpture and drawings by William Turnbull.

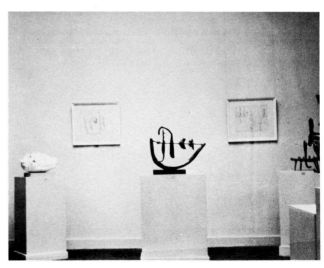

Lynn Chadwick: **Cypress**, 1951. Sited outside the Regatta Restaurant, South Bank, during the Festival of Britain.

Sculpture and drawings by Eduardo Paolozzi.

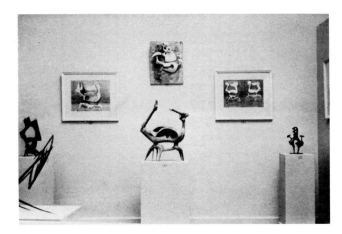

Sculpture and drawings by Bernard Meadows.

Reg Butler's **Woman Resting**, 1950-1, (Aberdeen Art Gallery).

Kenneth Armitage's **People in a Wind**, 1951.

Sculptures by Reg Butler.

commissioned by the Arts Council for the Festival of Britain and the skeletal **Standing Figure** cleverly sited beside the lake in Battersea II. There was in addition a show of recent work at the Leicester Galleries, which included the original plaster for the **Family Group** at Barclay School, Stevenage, and his first full-scale retrospective at the Tate where he had recently been made Trustee. The Epstein exhibition was so popular – it drew something in the order of 10,000 visitors a week – that a second showing was arranged for it in Plymouth, where it attracted equally large crowds. Many of them came to honour an artist whom previously they had reviled or regarded as notorious.

The media were quick to exploit the potential of this new interest in sculpture. The Tate's collection of modern sculpture was used as a backdrop for fashion advertising by *Harper's Bazaar* in their issue for November 1951, and the following June the opening reception for the London Fashion Fortnight was held in the Tate's Sculpture Galleries. On both occasions models posed in front of works by Rodin, Maillol, Epstein, Giacometti, Butler, Marini, Hepworth and others. An exhibition of McWilliam's recent sculptures at the Hanover Gallery in December 1952 provided *Harper's* with the opportunity for modelling furs and *The Ambassador* with the excuse to show off new jersey dresses by Jerseycraft. Television went into the Tate for the first time early in January 1953 and among several objects which flashed onto viewers' screens was Moore's 1938 **Recumbent Figure** in Hornton stone which had been shown in Battersea I. John Read, son of Herbert Read, made television films on Moore in 1951 and 1958, on Butler in 1959 and Hepworth in 1961. The British Film Institute also brought out a much praised film on Hepworth's sculpture called *Figures in a Landscape* (1954), directed by Dudley Shaw Ashton. Moore talked about his work on the radio in December 1955 and appeared on BBC television's *Face to Face* with John Freeman in February 1960.

Competitions during the post-war period were few and far between. A proposal in 1946 to set up carvings symbolising the four winds on the new Waterloo Bridge, which elicited some splendid designs from Barbara Hepworth but which was eventually entrusted to Charles Wheeler, came to nothing. In October 1954 the T.U.C. regretfully found itself unable to award prizes for two sculptures intended for its new headquarters in Great Russell Street. One was to commemorate trade unionists killed in both wars, the other to epitomise 'the Spirit of Trade Unionism'.

52 maquettes were submitted for the first and 71 for the second; on the panel of five judges were Herbert Read and J.M. Richards, editor of the *Architectural Review. The Times* saw the problem in the following terms: '. . . the less representational the pieces are the better, though the more abstract they become the more they evade the problem set the sculptor by his role of provider of public symbols.

'British sculptors have had but little practice in collaborating with modern architects, but that does not excuse the sheer banality of many of the ideas and the absence in many cases of a considered relationship to the building . . .'[36]

A different view was taken by Lawrence Alloway who thought that the 'complacent and nostalgic conditions' set by the T.U.C. would 'undoubtedly get the sculptor they deserve'.[37] In the end, Epstein was commissioned to carve the war memorial in the court-yard (which he did *in situ*) and Bernard Meadows, whose maquette had been one of those originally commended but 'not judged suitable for execution', was chosen for the symbolic entrance group. Both works were unveiled in 1958.

Herbert Read's appeal to sculptors to campaign for their work to be placed in churches went largely unheeded, at least until the rebuilding of Coventry Cathedral to Basil Spence's winning designs (1954-62). A rare exception was Epstein's **Christ in Majesty** commissioned in 1953 for the restored Llandaff Cathedral which had been badly damaged by a land-mine in the war. There were few people around, it seems, with the convictions, and perhaps the means, of a Canon Hussey, who in 1943 personally commissioned a **Madonna and Child** from Moore (his second public work) and a **Crucifixion** from Graham Sutherland for his Church of St. Matthew, Northampton. Epstein's thirteen-foot high **Madonna and Child** in lead for the Convent of the Holy Child Jesus on the north side of Cavendish Square is probably the most notable religious sculpture to have appeared in London since the war (it was financed partly by public subscription and unveiled by R.A. Butler, then Chancellor of the Exchequer, on May 14, 1953), though its siting, on a modern windowless bridge linking two eighteenth-century Palladian buildings, was considered unhappy at the time by Lawrence Alloway ▬. 'This floating effect,' he wrote, 'is suitable for some modern sculpture, but a traditional sculpture should

[36]*The Times*, 23 October 1954.
[37]Alloway, loc.cit, p.1044.

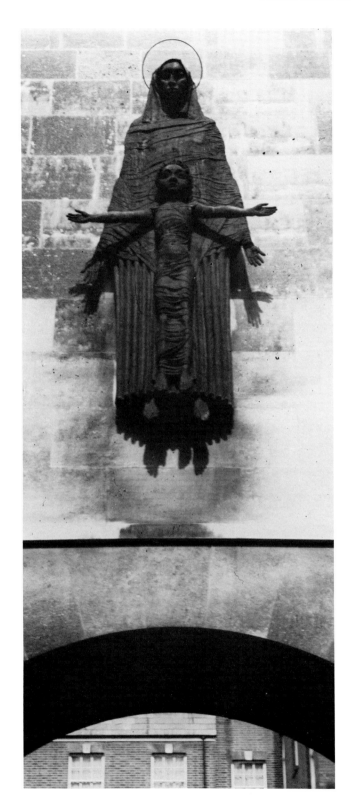

Jacob Epstein: **Madonna and Child**, 1950. Convent of the Holy Child Jesus, Cavendish Square, London. Unveiled 1953.

not be subjected to untraditional siting'[38] – a curious objection since it is precisely the work's incorporeal, levitating aspect which draws attention to the ideas of Crucifixion and Resurrection implicit in its imagery.

Sculptors fared better with new shops and office buildings. A weightless, soaring effect is characteristic of two striking pieces of abstract or semi-abstract sculpture, both erected in London in the early 1960s on the sides of modern buildings, one an office block, the other a department store. In March 1961 Geoffrey Clarke's **Spirit of Electricity**, eighty feet high, made of bronze and weighing nearly seven tons, was positioned on the bleak windowless east side of the tower of Thorn House, headquarters of Thorn Electrical Industries (now Thorn EMI), in Upper St. Martin's Lane. ☛ The building was considered by Nikolaus Pevsner to be 'one of the best office buildings of its date in England'[39] (architect Andrew Renton of Basil Spence and Partners). The strange, spiky forms projecting from the nucleus of this long crustaceous object (like an up-ended barque) were based on a study of electric light bulb filaments, and its most innovative feature was the incorporation of artificial lighting as an integral part of the design. At night, built-in lighting would emphasise the texture of the metal and reveal forms not seen in natural light. Two years later, Barbara Hepworth's eighteen-foot high aluminium **Winged Figure**, her second major sculpture to be permanently sited in Central London ☛ (the first, unveiled by Sir Philip Hendy in 1960, was the fifteen-foot high bronze **Meridian** outside State House, Holborn) was placed on the east wall above the entrance canopy of John Lewis in Oxford Street. The original proposal that the work 'should express the idea of the firm's partnership' was abandoned as being too restrictive of the artist's creative impulse and it was decided instead that the figure should be 'an exercise in pure form designed as an aesthetic embellishment to the building.'[40]

To Henry Moore, beautifying a plain or undistinguished-looking building was not, as we have seen, the sculptor's job but this did not deter him from collaborating quite closely with Michael Rosenauer, architect of the Time-Life Building in Bond Street (1952-3), whose interiors were designed by Sir Hugh Casson and Misha Black. From the start, Moore conceived of his massive stone **Screen** as 'part of the

[38]Ibid, p.1045.
[39]Nikolaus Pevsner, **The Buildings of England. London, I: The Cities of London and Westminster**, 3rd edition revised by Bridget Cherry, Pengiun Books, 1978, p.374.
[40]From a report in the *Sunday Telegraph*, 22 April 1962.

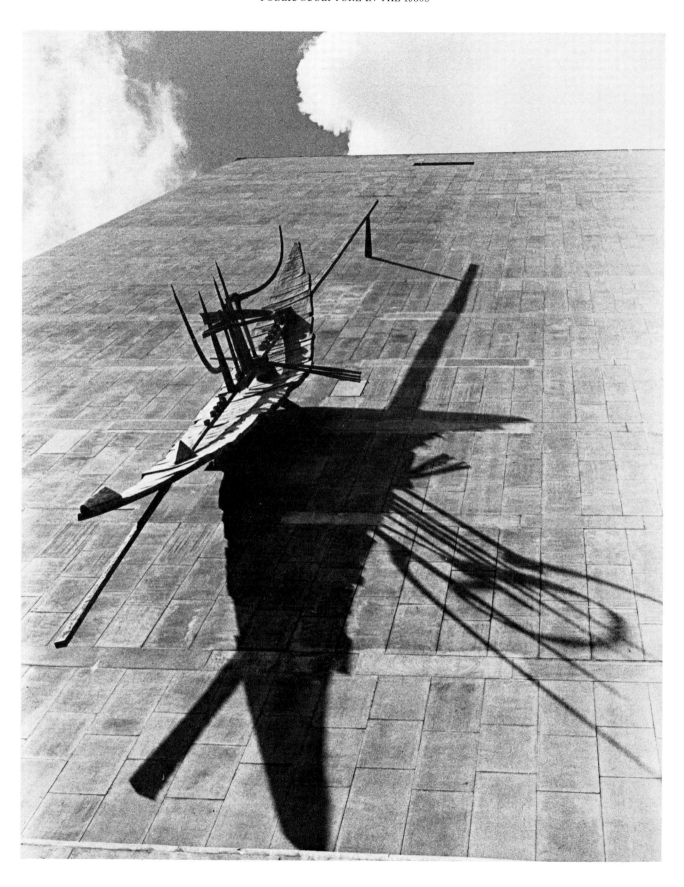

Geoffrey Clarke: **Spirit of Electricity**, 1961. Thorn House, St. Martin's Lane, London.

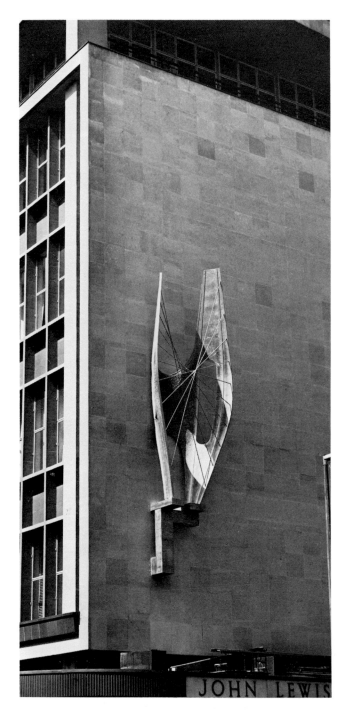

Barbara Hepworth: **Winged Figure**, 1963. John Lewis, Oxford Street, London.

architecture . . . a continuation of the surface of the building'[41]; and since it was to serve as a balustrade or parapet to the terrace behind (where lies his **Draped Reclining Figure**, also commissioned by Time-Life) he decided to carve both sides and to pierce the screen, dividing it into four open panels each containing a more or less abstract monolith. ◤ 'I found . . . that my project really demanded a turntable for each of the carvings, so that they could be turned say on the first of each month, each to a different view, and project from the building like some of those half animals that look as if they are escaping through the walls in Romanesque architecture. I wanted them to be like half-buried pebbles whose form one's eye instinctively completes.[42]

Considerations of safety frustrated Moore's ingenious scheme but the notion of using a turntable was one he favoured when circumstances prevented a sculpture from being seen in the round. This was quite distinct from the idea, popular in some circles in the 1950s but anathema to Moore, of displaying static sculpture (as opposed to mobiles) on permanently rotating bases.

Sculpture was occasionally commissioned for interior spaces where it would be on view to the public. Works by McWilliam and Bernard Meadows graced the new premises of the booksellers J. and E. Bumpus when they opened in Baker Street in November 1958. Two years earlier the Mullard Organisation, manufacturers of electronics and television tubes, had commissioned a small work in copper from Barbara Hepworth, **Orpheus** or **Theme on Electronics**, which still sits in the window of Mullard House in Torrington Place, unnoticed except by the most observant passer-by.

But it was in the planning and building of new towns to accommodate London's overflowing population, designated in the decentralising New Towns Act of 1946, that contemporary sculpture really came into its own. And in this respect it is true to say, as Mullins suggested in his 1962 survey, that public bodies gave the lead to private enterprise. Of all the local authorities concerned, Hertfordshire County Council won the highest praise for allocating one-third per cent of the total cost of each new school to be spent on works of art. This scheme operated between 1949 and 1953; by 1955, 100 schools had been built, many with prefabricated units. The first of these, Barclay School (c.1947-9) at Stevenage, was also the first co-

[41]Moore, 'Sculpture in the Open Air', p.2.
[42]Ibid, p.3.

Henry Moore: **Time-Life Screen**, 1952-3. Time-Life Building, Bond Street, London.

educational Secondary Modern School in the country; like many of these light and spacious buildings, it was designed by the firm of Yorke, Rosenberg and Mardall, one of whose partners, Eugene Rosenberg, took a particular interest in commissioning works from sculptors. In November 1950 the first bronze cast of Moore's free-standing **Family Group** was placed against a curved rubble screen in front of the entrance porch of Barclay School – a site which the artist found slightly too constricting. Elsewhere in Hertfordshire, at Hatfield Technical College (1951-3), sculptures by Hepworth and Butler appeared, not without protest. During the night of 25 March 1953, less than a fortnight after his prize-winning maquette for **The Unknown Political Prisoner** had been smashed at the Tate, Reg Butler's **The Oracle**, which stood inside the entrance hall of the College, was daubed with blue paint. ☛ Lawrence Alloway considered Butler's piece to be 'the most brilliant of the commissioned sculptures in Hertfordshire', perfectly suited to its setting: 'He has accepted the policy of sculpture as a

foil and conceived **The Oracle**, in his own words, as "a personage in the depths of the college" . . . Butler has used the tough material, iron, to give the personage long extensions out from the body, as if it were trying to possess the space itself, the space that belongs to us. That is a way of saying that Butler's sculpture lives on its site.'[43]

The chief impetus behind Hertfordshire's enlightened policy came from John Newsom, the County Council's Education Officer, who was fortunate in having as a model Henry Morris's work for

[43]Alloway, loc.cit, p.1045. For illustrations of Butler's sculpture *in situ*, as well as Hepworth's outdoor relief **Vertical Forms** 1951 and a painting by Nicholson, see the *Architectural Review's* focus on Hatfield Technical College (architects Easton and Robertson), February 1953, pp.79-87; and also 'The Arts at Hatfield' in the same issue, pp.125-6. Detailed accounts of the Hertfordshire Schools scheme can be found in the following numbers of the *AR*: February 1947, pp.63-6; September 1949, pp.153-76 (includes a photograph of the main entrance and screen at Barclay School, Stevenage); and June 1952, pp.367-87. See also the recent exhibition catalogue **Architecture in Hertfordshire 1929-1979**, Hertfordshire Association of Architects, 1980.

Reg Butler: **The Oracle**, 1952. Entrance Hall, Hatfield Technical College, Herts. '. . . an ambiguous and violent image, compounded of parts of a jet aircraft (suitable for a Training College) and organic forms which evoke a pterodactyl.' (Lawrence Alloway).

Cambridgeshire. Morris was Cambridge's Education Officer from the late Twenties to the early Fifties and pioneered the idea of art as a creative, pedagogical force. His brainchild was the village college, and for Impington Village College, designed by Walter Gropius in 1938, he commissioned a family group from Moore. Although worked on in model form this was not realised for financial reasons, but it served as a prototype for later commissions such as those for Barclay School, Stevenage, and Harlow New Town (unveiled by Sir Kenneth Clark in May 1956). In the late 1950s Morris set up an arts trust to support Digswell House in Welwyn Garden City where artists, especially sculptors, and craftsmen would work alongside one another and, he hoped, be used by local authorities, architects and industrialists.

Sculpture at Harlow was not always acquired with a particular site in mind although a number of works were specially commissioned, such as Ralph Brown's **Meat Porters** for the Market Square, one of the more successful pieces. [44] Harlow was one of those towns which in 1952 received as a gift from the Arts Council a piece of sculpture originally commissioned for the Festival of Britain – in this case Hepworth's **Contrapuntal Forms** which was duly sited in a residential area of the town. (The other beneficiaries of this scheme were Northampton, which obtained Frank Dobson's **Woman and Fish**, and Manchester, which found a home for Epstein's **Youth Advancing**.)

With the decline of the private patron and the concomitant increase in State subsidised art, collaboration with local authorities was a fact of life in postwar Britain which most artists, especially sculptors, did not welcome but which they had to come to terms with. In 1952 Moore, always concerned that the freedom of the artist should not be jeopardised, claimed that he had been able to work for public bodies 'without any surrender of what I would regard as my person style'[45]; while Franta Belsky positively embraced the prospect of an architect-sculptor partnership, feeling that it was 'stimulating and helpful to be given some limitations.'[46]

But were artists issued with any such guidelines? The new collective patron, it seems, gave no orders, only opportunities. 'Pure' sculptors commissioned by the L.C.C. to produce work for the Festival of Britain's South Bank Exhibition in 1951 were left more or less to their own devices, with the result that many critics noted the absence of a successful relationship of art to architecture[47]. Sir Hugh Casson, Director of Architecture on the South Bank, believed there were a number of reasons for this, the most prominent being the artist's inability to 'think public': 'Too many painters and sculptors . . . made the mistake of thinking that all that was wanted was their own gallery formulae writ larger. They forgot the clamour and the crowds and the ice-cream cartons.'[48]

Casson consequently thought that the best pieces on the South Bank were those placed at a distance from such distractions, 'in protecting pools or high upon an unencumbered wall.' Much the same could be said for public sculpture in general in the Fifties and early Sixties. The most imposing works in Central London dating from that period are, paradoxically, either poised way above the heads of oblivious pedestrians or, conversely, cramped into narrow streets where they cannot be viewed from an appropriate distance (Moore's **Time-Life Screen**). A few sculptures, such as Epstein's huge dramatic stone war memorial imprisoned in the glassed-in central courtyard of Congress House, are not on view from the street at all and must be sought out. The national habit of not noticing architectural sculpture and of

[44]See Gibberd, op.cit, p.10.
[45]Quoted in a review of a UNESCO Report on 'The Artist in Modern Society', *The Times*, 5 July 1954.
[46]*The Times*, 31 October 1962 (see note 5 here).
[47]See Casson, loc.cit, pp.48-60. *The Architectural Review* (August 1951, p.144) thought that 'the painters and sculptors have not risen to the occasion in the way that the architects have . . .'
[48]Casson, loc.cit, pp.59-60.

seldom looking properly at sculpture of any kind would scarcely have been cured by such apologetic siting.[49]

A far more radical ideal of co-operation between artist and architect – nothing less than the creation of an 'integrated human environment', in which the traditionally discrete functions of painting, sculpture and architecture would merge into a single unity – was proposed at the Whitechapel's 'This is Tomorrow' exhibition in the summer of 1956. The sculptors William Turnbull, Eduardo Paolozzi, Robert Adams and Leslie Thornton participated, together with architects, designers and a handful of artists of a Constructivist inclination. In the catalogue the architect James Stirling asked: 'Why clutter up your buildings with "pieces" of sculpture when the architect can make his medium so exciting that the need for sculpture will be done away with and its very presence nullified' – a sentiment which cannot have been looked on with much enthusiasm by those sculptors involved, except perhaps by Paolozzi who was already calling himself a 'Brutalist'.

However seductive its Utopianism, such an ambitious blueprint for the future as was embodied in the 'This is Tomorrow' programme had little immediate effect on the thinking of town planners and their artistic advisors, though the 'excitements' of Brutalist architecture soon began to be felt by the initiated. Sculpture continued to be introduced into public spaces in much the same way that it always had been – imposed self-consciously rather than anonymously taking its place in a total environment. And it was this sense of imposition which many people came to resent.

There are numerous instances in this century of sculpture which has upset, offended and even been regarded as a threat to public taste: one has only to think of the reaction to Epstein's outdoor works in the Twenties, which were tarred and feathered or covered in paint. But it was not until after the last war that the emotional response to public sculpture assumed a consistently negative character, either uncomprehending or unequivocally hostile. When, in March 1954, Manchester City Council decided by a majority of two against purchasing for £850 Henry Moore's **Draped Torso**, the press quoted one Councillor as saying: 'It appeared to be abnormal and could only appeal to abnormal people. Fortunately, here in Manchester we have not many people like that.'[50] Four years later Huddersfield bought a cast of Moore's **Falling Warrior** for £1500, despite the protestations of one Town Councillor who vigorously condemned 'the

purchase of an object which represented physical abnormality at best and physical degradation at worst.'[51] He was probably speaking for a good many ordinary people.

'Ordinary people' carried out a number of deliberate acts of vandalism on works of public sculpture in the Fifties and Sixties, leaving one in no doubt as to the strength of their feelings.[52] The sculpture which provoked the strongest reaction was undoubtedly Moore's **Reclining Figure**, shown on the South Bank in 1951 and subsequently loaned by the Arts Council to Leeds City Art Gallery for a period of ten years. The Gallery Director at the time was Ernest Musgrave, previously Director at Wakefield. Musgrave put the work on view in the grounds of Temple Newsam House. The *Yorkshire Post* was soon bombarded with letters from angry citizens. 'A human form in an advanced stage of decomposition which has been disembowelled, partially decapitated and had both feet severed', was how one correspondent saw the sculpture, likening it to the victims of Belsen and Hiroshima. To more prosaic temperaments it was simply 'scrap metal'.[53] During the night of 3 November 1953 it was daubed with blue paint. In 1956 the work was removed from public view and for some years no large piece of contemporary sculpture was displayed permanently on an open-air site in Leeds.

The public was confirmed in its suspicion of modern sculpture by the reactionary pronouncements of popular figures like Sir Alfred Munnings and Sir Winston Churchill. It was Churchill who had mischievously encouraged Munnings to take a swipe at Moore and other contemporary artists in his Royal Academy Banquet speech in 1949; and it was Churchill who, as Lord Warden of the Cinque Ports, helped give credence to the unfounded scare that Reg Butler's **Monument to The Unknown Political Prisoner** was destined to stand 500 feet high on the cliffs above Dover – a misconception repeated by Wyndham Lewis

[49]See an article in *The Times*, 3 February 1959, entitled 'Too lazy to look at Sculpture?'; and also the *Architect's Journal*, 6 February 1947 p.142: 'As for architectural sculpture . . . few of us notice it.' Who, for example, has ever noticed the large four-part relief in beaten copper by Elizabeth Frink on the Carlton Tower hotel?
[50]*Daily Telegraph*, 5 March 1954.
[51]Quoted in *The Times*, 6 February 1958.
[52]The following instances should be added to the defacements mentioned here and elsewhere in this essay: the controversies over Moore's Arnhem Memorial (**Warrior with Shield**) in 1956 and McWilliam's **Princess Macha** for the new North-West Hospital in Londonderry (architects Yorke, Rosenberg and Mardall) in 1958; the damage to Moore's Harlow **Family Group** in 1963; and the tarring and feathering of a work by Hepworth in Chesterfield later the same year.
[53]*Yorkshire Post*, 8 and 12 November, 1951.

153

in his attack on Butler in 'The Demon of Progress in the Arts' (1954). The affair sparked off a row in the House of Commons.[54] On 30 April 1953 Churchill, then Prime Minister, paid a brief visit to the Tate to examine Butler's maquette which he proceeded to make the object of minor ridicule in *his* speech at the R.A. Banquet later that evening. This strange enough story assumes a note of bizarre irony in the light of a proposal which had been made six years earlier to erect on the same cliffs of Dover a gigantic statue of Churchill, complete with V-sign and cigar lit day and night as a beacon to ships in the channel, and flanked by eighteen-foot-high bulldogs. The mayors of the Cinque Ports agreed in principle to the scheme but expressed reservations about the cigar beacon. Nothing came of the proposal and it seems not to have been recorded whether Churchill approved or disapproved the idea.

However sincere or well intentioned, the attitude of those who, in contrast to Munnings and Churchill, gave their support to schemes for public sculpture by contemporary artists was paternalistic and would be treated with caution in the more populist climate of today. Encouraged by the success of the first Battersea and 'Sculpture in the Home' exhibitions, men like Herbert Read and Alan Durst might well demand that the sculptor should come out of hiding and work for the good of the people. But can it honestly be said that the art which resulted from this new contract brought 'a sense of harmony and delight and dignity' into their lives, and, by implication, made them better citizens?

The answer is no, for two reasons. First, a small but significant proportion of contemporary sculpture left people genuinely bewildered because it had no clearly defined symbolic content: you could read into it what you liked. When his monumental **Reclining Figure** was put up in front of the new Unesco building in Paris in 1958, Henry Moore is reported to have said that the sculpture meant whatever anyone wanted it to mean.[55] Whatever claims have been made for the archetypal significance of Moore's shapes, not least by the artist himself, a work of art open to multiple interpretations or appealing primarily to the viewer's unconscious is not necessarily the right one for a public place. Simply to insist on sculpture's obscurities and deeper meanings and hope for the best is to evade a large part of the issue. But it is equally pointless to revive symbols which are outworn or no longer have universal currency: hence Reg Butler's unwillingness to resort to clichés or adopt a rhetoric foreign to his personal

idiom. The paradox of public sculpture in the Fifties, where often the most popular works were the least interesting artistically,[56] points to a crisis of definition which has still to be resolved before art can become truly social in the sense that Read and others of his coterie envisaged.[57]

The second reason has to do with the architecture. New towns were either over-planned, leaving no room for those curious corners to which sculpture, casually sited, might just have succeeded in bringing a little *genius loci*; or, in Lawrence Alloway's words, they were 'falling apart because of the lack of a core of public buildings' – in which case 'sculpture would look lost in them as it would on an arterial road.'[58] Today the centre of Harlow New Town has something of the feel of **1984** about it: drab, windswept, gritty. Not helped by the British weather, outdoor sculpture here seems an irrelevance.[59] One is tempted to invert and alter Herbert Read's solemn dictum and assert instead that it is the *buildings* which should be worthy, not only of the sculpture but of the people as well.

[54]Led by the Conservative member for Dover, a group of MPs (which included Jo Grimond) signed a motion in the House on 17 March 1953 deploring 'the proposal to erect on the cliffs at Dover an enlargement of the winning entry in the international sculpture competition...' A second group of MPs, led by the Labour member for Pembroke, who was supported by Michael Foot, Jennie Lee and others, quickly tabled a counter-motion which regretted, first, 'the use of the order paper for aesthetic criticism and, in particular, to disparage a work of art that has won the admiration of men and women of many nations who have devoted their lives to the study of sculpture', and, secondly, 'that philistinism should be thus advertised.' A copy of the Order Paper, sent by Desmond Donnelly to Sir John Rothenstein, is in the Tate Gallery Archive file on the 'Unknown Political Prisoner.'

[55]In *The Times*, 17 October 1958.

[56]Noted by Alloway, loc.cit, p.1045.

[57]Similar arguments over what constitutes a successful public sculpture are being rehearsed today: see Deanna Petherbridge, loc.cit, pp.13-14. Read, it is true, became disillusioned in the 1960s, and believed it was 'impossible to assimilate the essentially free art of sculpture to the strictly functional needs of modern architecture'. (**Henry Moore**, London, 1965, p.199).

[58]Alloway, loc.cit, p.1046.

[59]In a recent book on Harlow, Moore's **Family Group**, now moved to the relative safety of the Civic Square (in an obtrusive architectural environment Moore would probably loathe) but still a target for vandals, is patronisingly described as symbolising for many 'the quality of life in Harlow'. (Frederick Gibberd and others, **Harlow: The Story of a New Town**, Publications for Companies, 1980, p.244).

This essay has profited considerably from conversations with Reg Butler, Margaret McLeod, Henry Moore and Eugene Rosenberg. The author would also like to thank the following: Arthur Byron and Constable & Co. for allowing him to see proofs of Mr. Byron's **London Statues**, 1981; Sandy Nairne for showing him the unpublished catalogue of the I.C.A.'s archives, compiled by John Sharkey; and Hugh Stevenson of Glasgow Art Gallery and Gillian Spencer of Wakefield City Art Gallery for providing either photographs or information or both. Press cuttings from the period are kept in the Tate Gallery Archive. All opinions expressed in the essay are the author's.

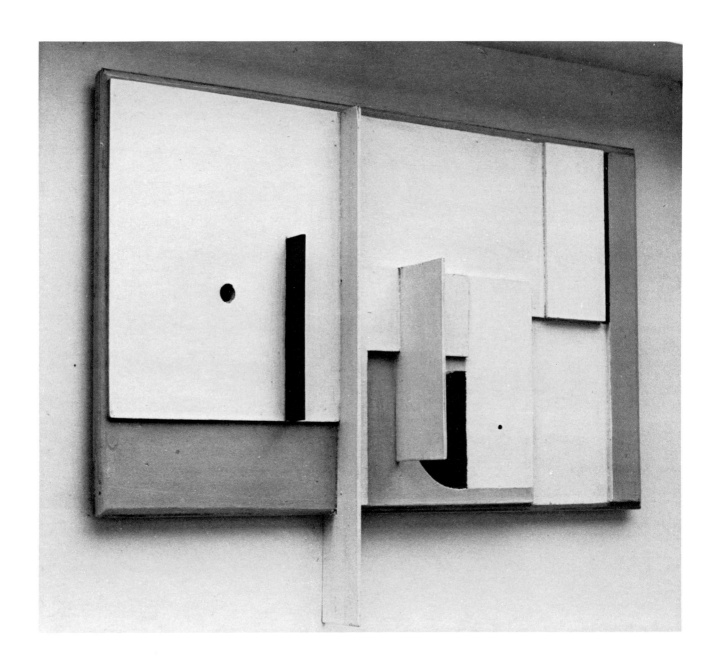

Victor Pasmore: **Relief**, 1951-53, painted wood. Private collection.

XII. Constructivism after the Second World War.

Although pure geometric abstract art was established in England before the Second War by the group of artists who produced the publication **Circle** (1937), it was too narrowly based, too much reliant on Continental precedents, to survive in the turbulent and necessarily insular mood of the forties. Artists such as Ben Nicholson, Hepworth and Piper, who before had produced rigorously constructed abstract forms, softened their compositions and introduced figurative elements. Even at the forward-looking Festival of Britain (1951) the majority of art shown officially was either realistic or suggestively abstracted rather than abstract. There was no geometric abstract art. At this time, in the late 1940s and early 1950s, an easily accessible Neo-Romantic art arose, for example the landscapes of Alan Reynolds and the welded iron sculpture of Butler and Chadwick. This art was welcomed by critics and patrons who believed that geometric abstract art was an alien graft from out-of-date pre-War Continental movements like Russian Constructivism, Dutch De Stijl and the German Bauhaus. So it was against considerable opposition, and in order to counter this opposition, that a group of artists associated with Victor Pasmore at the Camberwell and Central Schools of Art joined together to practise and promulgate constructed abstract art.

Pasmore himself had not been an avant-garde artist during or immediately after the war, but had developed his early Euston Road realism in a series of evocative and very popular paintings of the Thames and of London parks. In style these carried echoes of the great nineteenth century masters – Turner, Whistler, the Impressionists and Post-Impressionists. Then suddenly, in 1948, he made his first abstract paintings. These were small Klee-like compositions built up with basic geometric shapes – square, triangle, circle. In the following year he made larger pictures from rectangular pieces of collage and in 1950 an abstract mural of pure geometric forms for a London Transport canteen in Kingston. In 1951 he turned to relief constructions which he assembled from sheets and laths of painted plywood, metal and plastic. ◀ Former patrons and critics watched these developments in shocked amazement but Pasmore soon gathered around him an important and forceful group of artists who shared his aim of introducing constructed abstract art to England. The most notable members of this group were the painters Kenneth and Mary Martin, Adrian Heath and Anthony Hill and the sculptor Robert Adams. All these artists, with the exception of Hill who was a young former pupil of Pasmore, had practised figurative art for many years and they were converted to abstract art suddenly and with a sense of exhilarating discovery.

1951 marks the breakthrough for the group. Not only did Pasmore construct his first reliefs in this year, but Kenneth Martin made his first mobiles, Mary Martin also turned to reliefs and Robert Adams made his first abstract sculptures. That summer they held two exhibitions of their new abstract work at the Artists' International Association and at Gimpel Fils Gallery. They also issued a slim publication, **Broadsheet**, 'devoted to abstract art', which contained reproductions of their work and essays explaining their ideas. (Theory and explanation were always important for them and several ephemeral publications followed.) In **Broadsheet** Kenneth Martin wrote: 'What is generally termed "abstract" is not to be confused with the abstraction from nature which is concerned with the visual aspect of nature and its reduction and distortion to a pictorial form; for, although abstract art has developed through this, it has become a construction or concretion coming from within. The abstract painting is the result of a creative process exactly the opposite to abstraction.'

It was this sense of building up a new creation, of making something 'concrete' with its own internal laws, which was so exciting. In contrast to Neo-Romantic art and Tachisme, the abstract art style emerging in Paris at this time, constructed abstract art was exactly designed before it was made and it was made, often, from new, synthetic materials rather than traditional ones. The constructivist could use machine-age techniques and, in collaboration with post-War architects inspired by the optimisim of Le Corbusier, build a harmonious environment for modern man.

Architects were involved in the planning of further group exhibitions. In 1952 and 1953 there were three weekend exhibitions in Adrian Heath's studio at 22 Fitzroy Street and in 1954 an important (though poorly documented) exhibition at the Building Centre which aimed to show how artists could harness the machine. Two new constructivists joined the group at the Building Centre – John Ernest and Stephen Gilbert. Ernest, an American resident in London since 1951, showed an open tower made from drilled plywood sheets and dowel rods. Gilbert, an English artist resident in Paris who had just renounced painting for architectonic constructions, showed a maquette for a kiosk made of polychrome metal sheets and con-

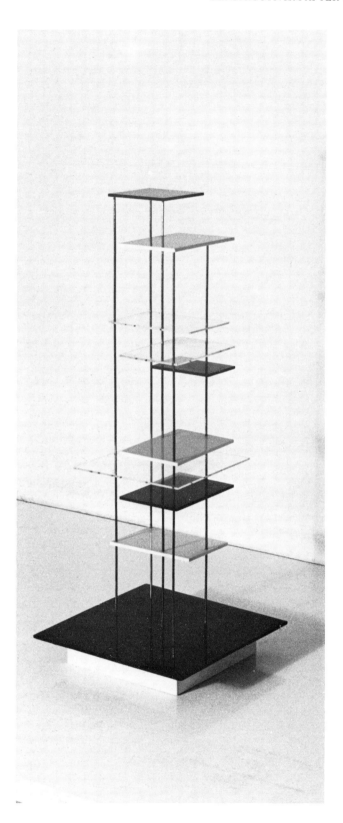

John Ernest: **Maquette for Constructed Tower**, shown at 'This is Tomorrow', 1956, Whitechapel Art Gallery, perspex and metal. Private collection.

structed on De Stijl-derived principles. These early group shows and experiments in collaboration with architects culminated in the exhibition 'This is Tomorrow' at the Whitechapel Art Gallery in 1956 where Pasmore, Adams, Kenneth and Mary Martin, Heath, Hill and Ernest all joined with architects to create unified, total art environments. ◥

Two new art forms emerge from these early exhibitions – the constructed relief and the mobile. Not only Pasmore and Mary Martin but, by the mid-1950s, Hill and Ernest as well were concentrating on the constructed relief. This art form, neither painting nor sculpture, answers many of the problems of creating truly 'concrete' art for it is built up in real space with none of the inherent illusionism of painting, nor of traditional modelled or carved relief sculpture. Unlike free-standing sculpture the relief is hung at the spectator's eye-level with a limited viewing arc of 180° so that no part of the work is hidden, there is no mysterious 'other side'. In a constructed relief of this period the planes defining shallow layers of space are made from synthetic materials such as plywood, aluminium and plastic and are built up parallel to the wall surface. Compositions often follow proportional systems such as the Golden Section. Colours are usually restricted to those inherent in the materials and to white, black and grey.

Because they had abandoned copying from the superficial appearance of nature, most members of the group became intensely interested in the laws underlying the patterns of natural growth and in theories of how to obtain harmonious compositions in art. Kenneth Martin especially spent long periods in the Science Museum looking at mathematical models and in the library reading books such as D'Arcy Thompson's **On Growth and Form** and T. A. Cook's **The Curves of Life**. They studied Mathila Ghyka's books on proportion, such as **The Geometry of Art and Life**, Jay Hambidge's books on **Dynamic Symmetry**, J.W. Power's **Elements of Pictorial Construction** and Le Corbusier's **Modulor**. Another important influence came from the writings of the American artist Charles Biederman who had himself developed from painting to relief construction in the late thirties. In 1951 Biederman's large and superbly illustrated book titled **Art as the Evolution of Visual Knowledge** (1948) and another, slimmer, book called **Letters on the New Art** (1951) came into their hands and these provided cogently argued historical justification for the abandonment of painting in favour of the constructed abstract relief made from machine-age

materials. For Biederman the relief developed logically from Mondrian's paintings just as Mondrian had built on the discoveries of the Cubists and Cézanne.

Pasmore and Hill corresponded at length with Biederman. Their letters show that they had much in common, a shared belief that avant-garde painting rather than sculpture provided the key to the new art and an admiration for Mondrian for example, but from the start strong differences in their ideas also emerge. Biederman, unlike the English relief artists, did not see any reason to use mathematical systems but always constructed his works intuitively. He stressed that he, like Mondrian and Cézanne before him, abstracted from nature, from 'the structural processes of nature' such as the almost symmetrical growth of trees, the development of leaves in space, the brilliant colours of the prism. We have seen from Kenneth Martin's statement in **Broadsheet** quoted above, that the English believed that they had passed beyond abstracting from nature to the point where they were creating 'concrete' works from man-made systems. The English group also did not realise that Biederman's reliefs were strongly coloured, for they did not see an original until 1962, and Biederman did not sympathise with their restriction of colours to those inherent in industrial materials.

Kenneth Martin alone pioneered the mobile based on proportional systems. Like the reliefs of his colleagues, his mobiles developed from his first abstract paintings and are similarly concerned with systematic change. The first two, made in the late summer and autumn of 1951, were constructed of rectangles of tin hung from horizontal wooden rods proportionally related to each other. Others followed made from loops of wire and coloured metal discs and ellipses derived from roulettes and linkages. Then in 1953 Martin showed the first of his **Screw Mobiles**.

☛ These mobiles, which developed in a variety of forms into the late sixties, were made from strips of stock brass brazed in spiral formation onto a central rod. The placing of the brass strips was determined by a system such as the Fibonacci series (1, 1, 2, 3, 5, 8 and so on). The movement of the **Screw Mobiles** is regular and continuously exciting, with reflected lights rising and falling in rhythmic sequences along the bars. From the first brass mobiles more complicated ones developed made from phosphor bronze with sinuous, undulating contours unfolding from a central core. A mobile of this type was hung in the centre of the pavilion designed by Mary Martin and the architect John Weeks in the exhibition 'This is Tomorrow'.

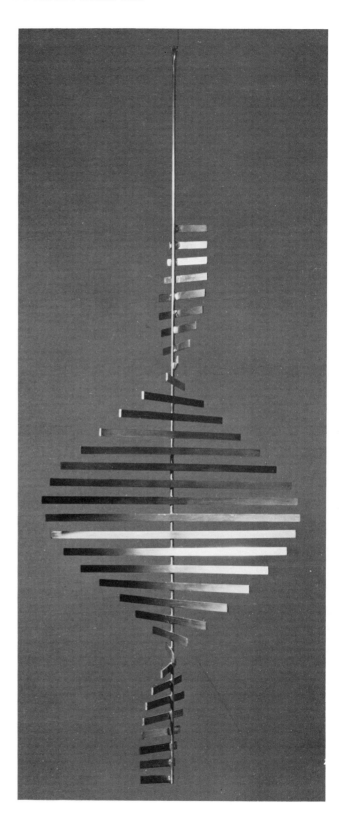

Kenneth Martin: **Small Screw Mobile**, 1953, brass and steel. Tate Gallery, London.

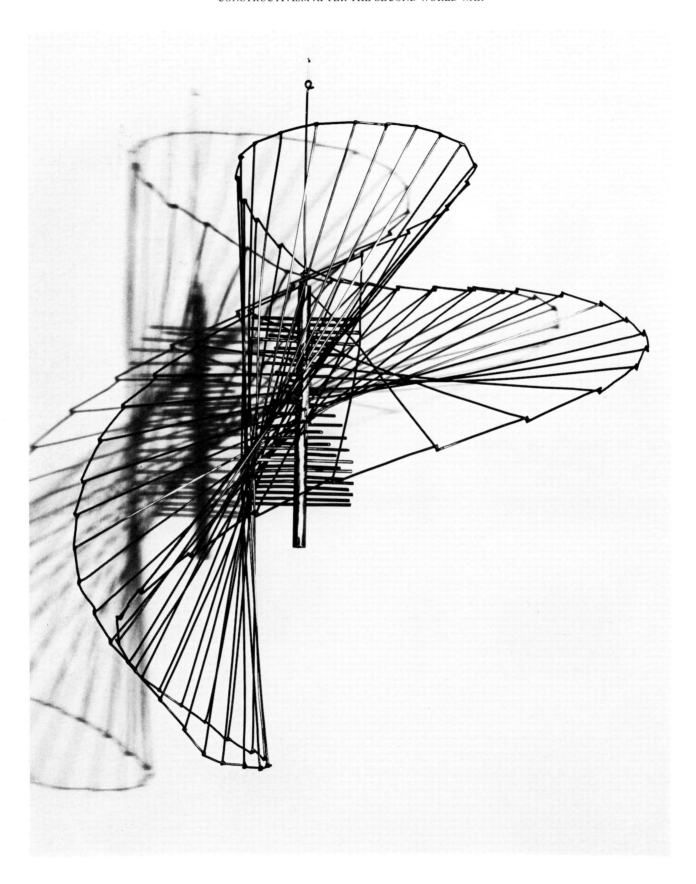

Kenneth Martin: **Screw Mobile**, 1959, phosphor bronze. Museum of Modern Art, Edinburgh.

In retrospect, the sculptor Robert Adams stands rather apart from the group, but he had a prominent place in all their exhibitions up to and including 'This is Tomorrow'. Pasmore and he were the only members with established reputations when the group came together in 1951. By then he had had several one-man exhibitions of severely abstracted figurative sculpture at Gimpel Fils Gallery and he was well enough known to receive a commission from the Arts Council for their Festival of Britain travelling art exhibition in 1951, **Apocalyptic Figure**. Adams however, did not use mathematical calculations and he confined himself, with a few exceptions, to traditional materials worked with careful craftsmanship. His sculptures of this period, in wood, stone or brass are mostly small in scale, concentrated, built up from basic forms – cylinders, cubes, rectangular blocks, straight and curved supports. They were probably the most abstract sculptures being produced in Britain at this time, with a quiet but immediately appealing organic life of their own. It was these abstract qualities which ensured their inclusion in the group's exhibitions.

Adams collaborated successfully with architects on several occasions. Perhaps his most notable commission is the very large reinforced concrete wall relief for the city theatre in Gelsenkirchen in West Germany, finished in 1959 but derived from maquettes modelled in the mid-fifties. At the same time other members of the group worked on similar or even more ambitious architectural commissions. In 1957 Mary Martin completed a large wall-screen for a Belfast hospital and in 1960 she designed a series of wall-reliefs for the liner S.S. Oriana. Pasmore and Gilbert went further and actually designed houses and flats. Pasmore, who had moved to the north of England in 1954 on his appointment as Master of Painting (!) at King's College, Durham University, was invited to work with the development team at Peterlee New Town with full executive powers. In his designs for housing there he broke with conventional ribbon development and planned instead clusters of terraces and low-rise blocks of flats interspersed with open parkland. The grouping of the blocks, disposition of windows, doors and railings and the movement of roads and paths clearly reflect his constructed reliefs. Later, in about 1958, a counter-influence from his town planning schemes can be detected in his art.

Gilbert followed his architectural maquette, shown at the Building Centre in 1954, with several models for houses and flats to be constructed by an enlightened builder, Peter Stead, based in Huddersfield. Again

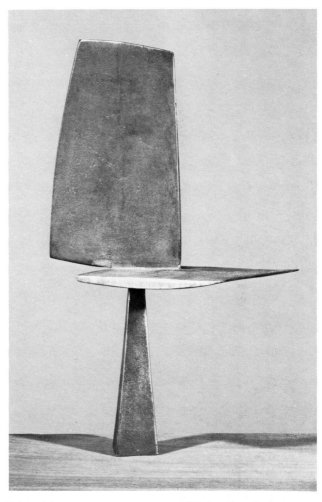

Robert Adams: **Balanced Bronze Forms**, 1955. Arts Council of Great Britain.

brightly coloured aluminium panels were brought together in orthogonal relationship to create light, open, cellular spaces. The colours and treatment of space recall the architectural projects of Van Doesburg and Rietveld, but Gilbert and Stead planned to make use of materials which had only recently become available, such as insulated panels of vitreous aluminium and double glazing. Regrettably only one small house was in fact built and many of the models were subsequently destroyed. At the same time Gilbert made some pure, free-standing constructions with the same balanced positive and negative spaces defined by polychrome metal sheets. By 1957 he started to introduce curved and triangular planes in his constructions. These were still coloured and bounded by open rectangular frames of metal angle but by 1960 he had abandoned colour and the frame for polished, naked aluminium sheet bent into dynamic curves and thrusts. These last constructions catch the light and

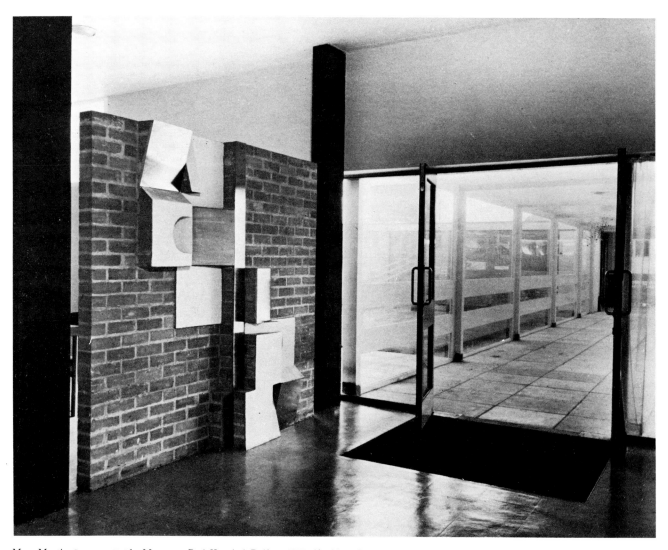

Mary Martin: **Screen relief** for Musgrave Park Hospital, Belfast, 1957. (Architect John Weeks.)

exploit the true quality of the material but they lack the architectural feeling of his previous works.

The final example of the integration of constructivist art work with architecture came in the temporary buildings designed by Theo Crosby for the 6th Congress of the International Union of Architects on the South Bank in 1961. For these buildings Mary Martin, Hill and Ernest designed large relief-murals made of asbestos, metal and glass and Kenneth Martin designed two kinetic constructions. (Their work contrasted markedly with one of Anthony Caro's first welded steel sculptures shown nearby.)

The constructions in the Congress buildings were almost the last activity in which several members of the group joined. Already, after the exhibition 'This is Tomorrow', Heath and Adams had gone their own ways – Heath to larger and more freely painted pictures and Adams again to larger sculptures in

bronzed steel, which were logical developments from his earlier work but which did not have the systematic, calculated approach that was becoming increasingly important for the Martins, Hill and the younger constructivists. By the turn of the decade the artists in the original group had become well known and the need to hold together for mutual support was perhaps less important than it had been earlier. The achievements of the decade were summed up in two exhibitions – 'Construction England, 1950-1960' held in January 1961 at the Drian Gallery, London and 'British Constructivist Art' organised by the I.C.A. to tour America in 1962. The Martins and Hill were also involved in large international exhibitions of concrete art in Switzerland and in Holland ('Konkrete Kunst', Zurich 1960, 'Experiment im Fläche und Raum', Zurich 1962, 'Experiment in Constructie', Amsterdam 1962, 'Kompas 2', Eindhoven 1962). And through very active

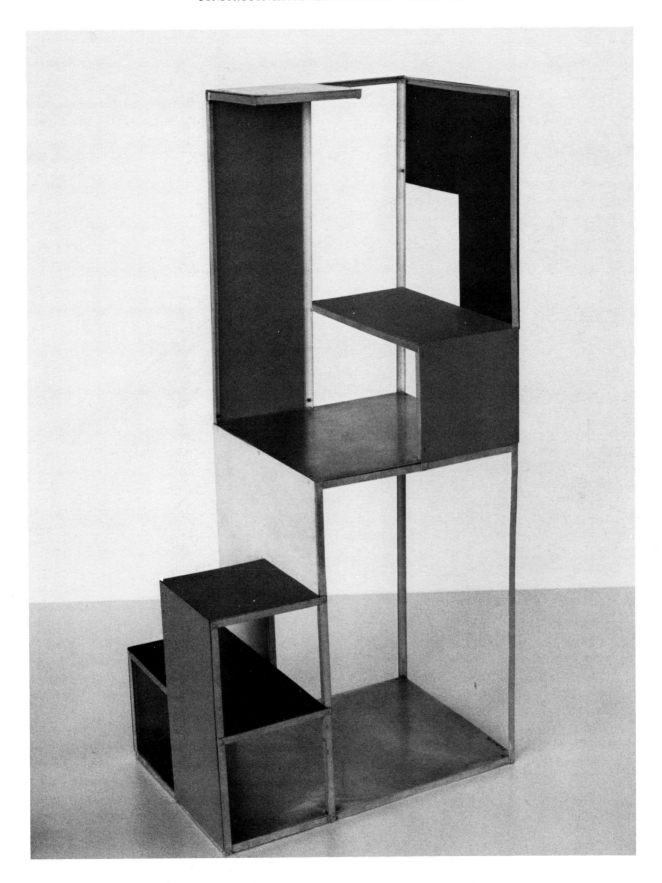

Stephen Gilbert: **Polychrome orthogonal construction**, 1954, painted aluminium. University of East Anglia Art Collection.

participation in Joost Baljeu's Dutch magazine **Structure** devoted to international constructivist art, which started in 1958, their audience increased beyond the coterie of the London art world.

In 1960 Pasmore represented Britain at the XXXth Venice Biennale. His work had grown in scale, probably influenced by contemporary American painting, and he increasingly used passages of lyrical brushwork, although it was only in 1965 that he stopped making constructed reliefs. Kenneth Martin, the other senior member of the group, continued to make mobiles and constructed sculptures with implied kinetic rhythms throughout the 1960s. In all his works proportions and rhythms are the result of systematic procedures which can be followed logically, step by step. The process always creates the form. The scale of his constructions varies widely from three or four inch high **Linear Constructions** to the Stuyvesant City sculpture commission which is nineteen and a half feet high, but medium and process are always appropriate to the scale. Martin had never given up painting but carried it on alongside his constructions and in the late 1960s he turned to painting increasingly. In 1969, the year of his wife's death, he started the **Chance and Order** series of pictures on which he is still engaged. His last constructions were made in 1974.

Mary Martin continued to produce relief constructions (and exceptionally some free-standing works) until her death. The basic vocabulary of all her mature work was established already in her first relief, **Columbarium**, in 1951. Units made of cubes and triangular half-cubes are permuted so that the eye follows a developing sequence around the relief and backwards and forwards through the shallow space between the base and surface planes. The planes in the relief are related to the horizontal and vertical surfaces of floor and wall. As in her husband's work kinetic rhythms are important, but so also is the idea of rest and stability. **Columbarium** is made of plaster

Mary Martin: **Spiral Movement**, 1954, painted plywood. Arts Council of Great Britain.

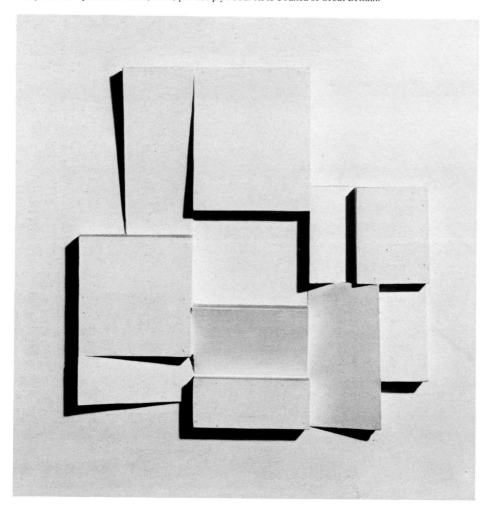

with the units hollowed into it. In subsequent reliefs the units are built up in plywood painted grey or white and from the mid-1950s other synthetic materials such as vinyl, asbestos and stainless-steel are used. After 1962 she restricted the unit to a standard half-cube, a triangular wedge faced with stainless-steel, which she assembled in a series of **Permutations** and **Inversions**. (One of these won the John Moores prize in 1969.) Because each unit is identical in these late works the emphasis lies on their systematic permutation. In this way she looked ahead to recent developments in constructivist art.

Hill and Ernest produced their first reliefs later than Pasmore and Mary Martin, in 1955. Ernest, a slow and meticulous craftsman, used rubbed aluminium and painted and stained wood. In a series of reliefs made in the second half of the 1950s he used a repeated 'L' shaped unit and this series was followed by another built from identical triangular units combined into mosaic patterns. Sadly, he turned increasingly to

teaching and almost ceased to produce works though he associated in the early seventies with the Systems Group and showed with them a construction inspired by models of the Möbius Strip.

From 1955-61 Hill's reliefs were orthogonal structures made from vinyl or metal sheet with extruding elements of aluminium channel, sometimes, though by no means always, arranged on mathematical systems. After 1961, like Mary Martin, he made more use of units of identical shape and size, in his case an open 135° section of aluminium angle, which he permuted systematically. He continued to restrict his colour range severely to the white of vinyl sheet, the silver-grey of aluminium and the tones of clear and smoked perspex. For the last ten years his reliefs have become very shallow with no extensively protruding elements. Compositions are engraved in laminated vinyl sheet with minimal surface variations. As a corollary he has also made free-standing constructions from systematically joined tubes.

Anthony Hill: **Relief**, 1959, perspex, aluminium, stove enamelled metal. Collection of the artist.

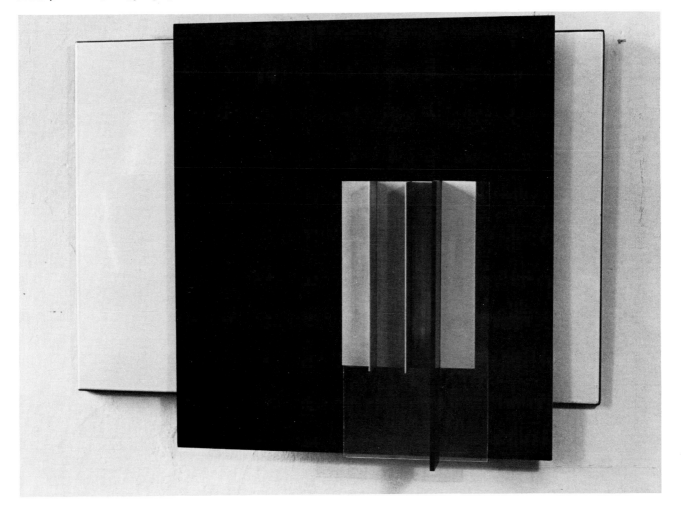

In the early 1960s a number of younger constructivists emerged who are, in many cases, pupils or associates of the artists who founded the movement in the previous decade. Gillian Wise was influenced by Biederman's writings as a student. She showed early constructions with the group in 1961 at the South Bank Congress and at the Drian Gallery and in 1963 she shared an exhibition of reliefs at the ICA with Anthony Hill whom she had met in 1958. Her work of this period is distinguished from Hill's by her bold use of colour – orange, pink, blue – and of reflected light, for some of her reliefs contain prisms and mirrors.

In 1962 Peter Lowe and Colin Jones, who had both been taught by Kenneth and Mary Martin at Goldsmiths College, showed their first reliefs at the 'Geometric Environment' exhibition at the AIA Gallery. Wise, Lowe (and Jones to some extent) were later associated with a new group of constructivists, the Systems Group, which came together when the painter Jeffrey Steele organised an exhibition of their work at the Amos Anderson Museum, Helsinki in 1969. Other relief constructivists in this group were Malcolm Hughes and Jean Spencer. Its members were certainly influenced by the British constructivists who started in the 1950s but they also looked to the Swiss artists Max Bill and Richard Lohse. From Lohse especially they derived a concern for the systematic use of colour carried through in exhaustive series of works.

Though the Systems Group has split up, individual members were still active, as are many other young constructivists, only some of whom can be mentioned briefly here. John Ernest influenced several students while teaching at Bath Academy of Art, Corsham – among them John Law and Terry Pope. Law and Pope, together with Tony Longson, are particularly interested in the mechanics of vision, in the use of computer-generated patterns and new materials such as coated glass. In contrast Emma Park makes free-standing and wall-hung series of constructions from sections of unfinished wood. Norman Dilworth makes linear constructions of extreme austerity and allies himself more closely to Dutch and German constructivists than to his British contemporaries. In some ways the work of these younger artists has similarities with the minimal art of Americans such as Carl Andre and Sol LeWitt. It is interesting that at the recent 'Pier and Ocean' exhibition at the Hayward Gallery, which was put together by the German constructivist Gerhard von Graevenitz with advice from Dilworth, Martin and Hill, these two types of art, minimal and constructivist, were brought together. The juxtaposition produced no unexpected *frisson*, but it did show that while the Americans were concerned with qualities such as endlessness, repetition and monotony, the Europeans, no matter how austere their art, suggested organic development and the possibility of change. Constructivism is the longest lived development of twentieth century art and the British contribution since the last World War has been, and continues to be, considerable.

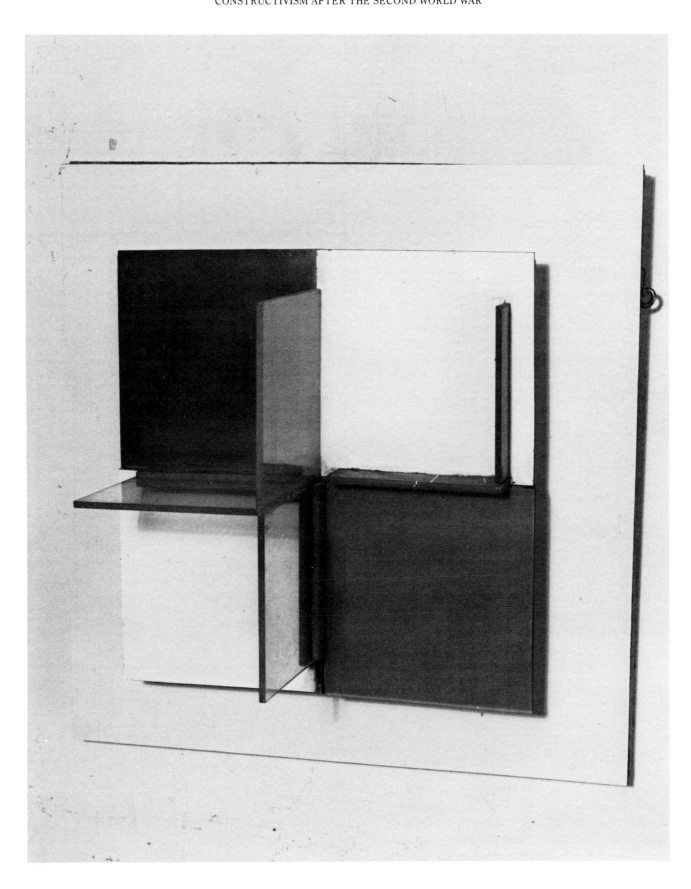

Gillian Wise-Ciobotaru: **Relief with pink and blue**, *c*. 1960, perspex and metal. Private collection.

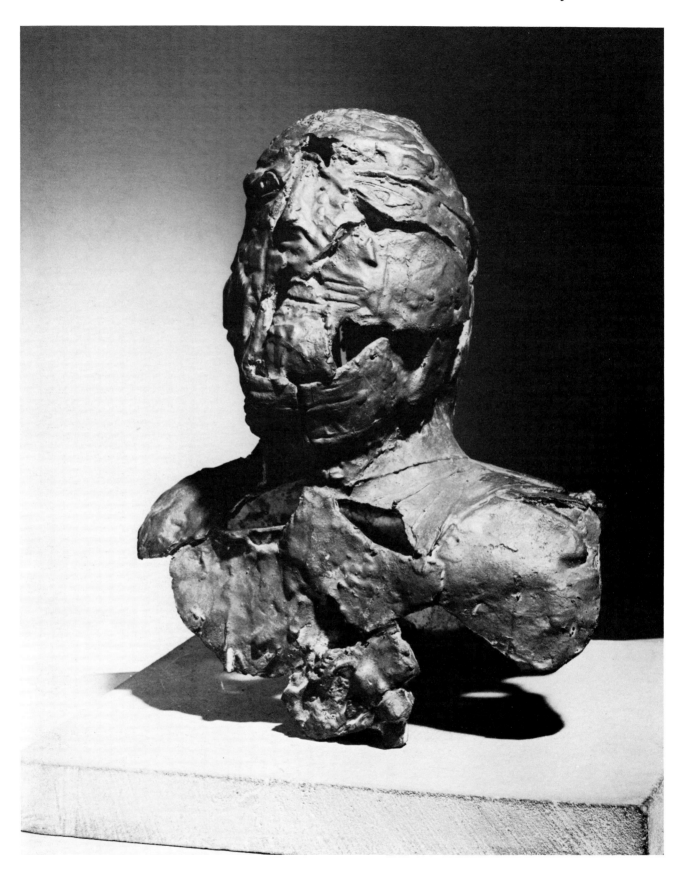

Eduardo Paolozzi: **Shattered Head**, 1956. Tate Gallery, London.

XIII. New Abstract Sculpture and its Sources.

Towards the end of the 1950s British sculpture was widely vaunted, not least by native critics, as the most flourishing school in the world. [1] Despite this acclaim from public and official circles a number of younger sculptors began to view the situation with less enthusiasm. For many the prevailing idiom of expressionistic figurative sculpture had become a clichéd mannerism: they found it totally inappropriate to contemporary experience since it had been generated by, and reflected, the mood of tension and anxiety prevailing in the immediate post-war years. [2] Their dissatisfaction was manifested in various ways, but common to all was the belief that the creation of a more valid language of sculpture entailed a return to some form of abstraction.

However, two very different attitudes to abstraction developed. Some viewed it as a non-referential language, and as a goal in itself; for them, abstraction was a necessary condition to revitalising sculpture from its moribund state. For others, however, abstraction per se was not the central issue; it was, rather, a means of producing a new kind of subject matter, one more suited to the contemporary ethos. For this latter group, the current state of sculpture was not so parlous that a complete requestioning of its fundamental principles, forms, techniques and subjects was required. They sought reform rather than a wholesale reappraisal: for them abstraction was an agent rather than an aim. Yet both groups believed that contact with mainstream sculptural traditions had to be regained in lieu of continuing local ones. This belief also helped them bypass the legacy of Moore which had proved so daunting to many of their immediate predecessors. While the 'pure' abstractionists turned to early twentieth-century sculpture and the pioneers of the modern tradition, the 'reformers' embraced a more anonymous and ancient tradition stemming from archaic and primitive sculpture. Brancusi and Picasso became the new heroes, for their work provided potent suggestions for new directions. [3]

Independent of these developments, since it did not spring specifically from pessimism with the state of contemporary sculpture, a third stream grew from the belief that traditional distinctions between genres like painting and sculpture were no longer tenable, or desirable: a more open attitude to materials, processes and forms ensued. This approach was not confined to British artists alone but formed part of the growth of that genre christened the 'assemblage tradition' in 1961. [4]

Those who sought to ameliorate or modify the extreme moods of anguish and alienation endemic to that current work known as the 'geometry of fear' turned to a morphology of simple monolithic shapes: a marked tendency to abstraction in form, though not content, resulted as images emerged more tentatively from the solid mass. Totemic images and egg/head shapes began to predominate, since such 'archaic' or 'primitive' forms were felt to carry archetypal references, conjuring a breadth of association rather than specific allusions. Thus potent if vague metaphor replaced the hybrid monster, and histrionic rhetoric succumbed to a more muted mood: a 'numinous silence'. Totemic imagery became increasingly popular at this time, as seen in Chadwick's **Watchers** of 1960, but amongst this group it was imbued with primaeval and atavistic, rather than angst-ridden qualities. This sense of a timeless, chthonic aura was enhanced by an emphasis on the factual or literal presence of the sculpture which now often stood directly in the spectator's space, or rested on the table surface, rather than on the intermediary of a base. An assertion of the weight and massiveness of form is also common to much of the work of Paolozzi, Turnbull, Startup, Dalwood and Kneale. Nevertheless, they expressed these shared tenets in individual ways – there is no stylistic homogeneity.

Around 1958 Turnbull stopped modelling and began making sculpture from rudimentary shapes in several materials, blocking out the forms with an almost

[1] See, for example, Philip James, **Contemporary British Sculpture**, Arts Council 1957, p. 2; N. Lynton, 'Review of Modern Sculpture at Middleheim', *Art News and Review*, 1 August 1959; H. Read, **Hubert Dalwood**, Gimpel Fils, 1960, n. p.; R. Pickvance, **Contemporary British Sculpture**, Arts Council 1961, n. p.
[2] Reviewing the Venice Biennale of 1960. 'Notes on Sculpture: Venice Biennale 1960', *Architectural Design*, November 1960, pp. 479-480, Alloway characterised the mannered academicism of this idiom as 'a kind of Alexandrianism'. King's response to this kind of work at Documenta 1959 was similar: 'The sculpture was terribly dominated by a post-war feeling which seemed very distorted and contorted . . . And it was somehow terribly like scratching your own wounds – an international style with everyone sharing the same neuroses'. C. Harrison, 'Phillip King Sculpture 1960-68' *Artforum*, December 1968, p. 33.
[3] There was an international revival of interest in Brancusi's work in the late 1950s. In 1955 the Solomon Guggenheim Museum staged a major retrospective, in 1959 he was accorded an honoured position at Documenta, and again in 1960 at the Venice Biennale. The English translation of Carola Giedion-Welcker's monograph on Brancusi, published in 1959, was extensively reviewed in *Arts Magazine* in January 1960, and so forth. Picasso's work was well known through exhibitions and publications; the exhibition at the Tate Gallery in 1960 however included only one three-dimensional assembled relief, **Still-Life**, 1914.
[4] **The Art of Assemblage**, Museum of Modern Art, New York 1961. In the catalogue essay William Seitz traced its heritage from Picasso's experiments of 1912, emphasising that it was a quintessentially twentieth-century method.

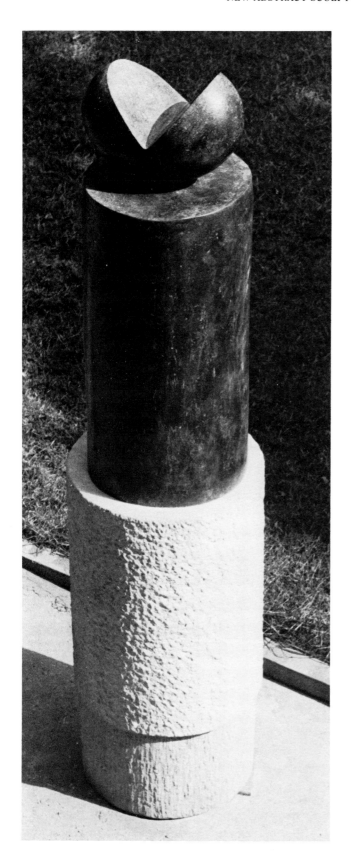

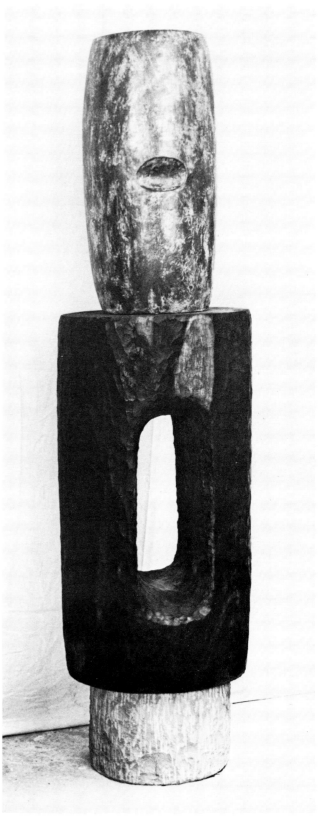

William Turnbull: **Oedipus II**, 1962. Sydney Opera House. William Turnbull: **Agamemnon**, 1962.

minimal degree of personal handling. These simple, stacked forms betray his great admiration for Brancusi, whom he had met in 1948, although in content they differ sharply. Titles such as **Agamemnon** and **Oedipus** indicate his concern with mythic realms.[5] Although Dalwood and Paolozzi continued to work in bronze others explored new techniques and processes for constructing archetypal imagery, as seen in the work of Hoskin and Kneale. Yet again the materials have been exploited for expressive ends as seen in the contrast between smooth sheet metal and roughened eviscerated welds in Hoskin's **Column** and Kneale's **Armour**, both of 1960. Although assembled rather than carved or modelled, the final form falls comfortably within the monolithic tradition of sculpture. **Armour** is a disquieting totemic hybrid of anthropomorphic and vegetal forms which Kneale claimed reflected certain experiences from his subconscious.[6] Paolozzi introduced a wealth of associations into his work ranging from popular culture to archaic prototypes by means of a richly encrusted surface, as seen in **Krokadeel** which he described as 'a metamorphosis of quite ordinary things into something wonderful'.[7] Yet, like the other sculptors of this group, he was not primarily concerned with the invention of forms, and confined himself to such familiar categories as the head, standing figure or monument.

Iconic forms with partially obliterated imagery, like relics of ancient or destroyed cults yet still imbued with mysterious force, attracted Dalwood, as did spherical forms, seen in **Object** of 1960. The vague title indicates a loss of knowledge about its function or meaning but, in spite of this, its emotive potency persists[8]. Startup's work of this period also deserves the appellation 'abstract' only in reference to his formal repertoire of simple, basic shapes, as seen in his **Head** of 1962. His deep admiration for Brancusi is evident in this piece although he does not treat wood as a sacrosanct material. Rather than cherishing its organic character he preferred found forms, often imbued with urban or junk connotations. This playful attitude to materials is carried through

[5]See **William Turnbull: Sculpture and Painting**. Tate Gallery 1973.
[6]Kneale: 'My formal discoveries correspond to interior discoveries'. **Bryan Kneale**, Whitechapel Art Gallery, London 1966, p. 8.
[7]Paolozzi was deeply influenced by the anti-art and brutalist notions of Dubuffet whose work, both paintings and sculpture, was shown at the I.C.A., London in 1955. Paolozzi himself seems to have been very influential in turn on the widespread experimentation with materials of many kinds and with diverse techniques which stressed improvisation and inspiration. His playful humour and de-emphasis of the 'preciousness' of high art were also crucial.
[8]**Hubert Dalwood**, Arts Council, 1979.

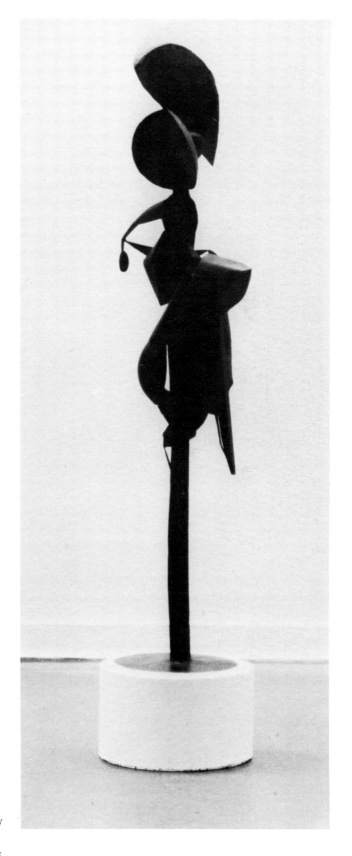

Bryan Kneale: **Armour**, 1957. Leicestershire Education Authority.

NEW ABSTRACT SCULPTURE AND ITS SOURCES

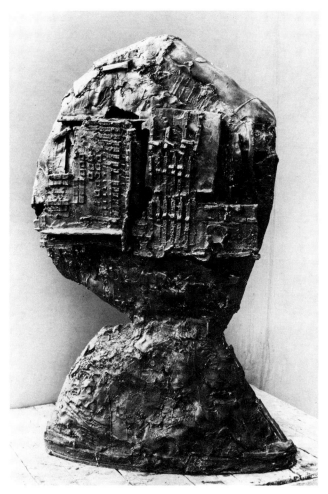

Eduardo Paolozzi: **Krokodeel**, 1956.

Hupert Dalwood: **Large Object**, 1959. Gimpel Fils Gallery. Eduardo Paolozzi: **Cyclops**, 1957. Tate Gallery, London.

Peter Startup: **Head**, 1962. Arts Council of Great Britain.

into the final strange images which nevertheless retain figurative resonances as evidenced in such titles as 'totem', 'figure', and 'head'. Like Paolozzi, his attitude to the primitive and primaeval was ambiguously interwoven with more contemporary allusions.[9]

A measure of the ready acceptability of this nascent idiom may be gauged by its closeness, in a generic and thematic sense, to certain recent works by Moore, including **Upright Motive** of 1956. ◀ Although significant differences may be discerned in terms of new materials, new techniques and the use of a more simplified language of form, certain fundamental affiliations remain, not least a belief in the role of universal archetypes for conveying fundamental truths of an emotive, intuitive order by means of association and metaphor. Not surprisingly, Herbert Read, the former champion of the 'geometry of fear' mode was highly sympathetic to this refocussing of sculptural content. In his introduction to Dalwood's first exhibition in 1960 Read welcomed its 'archaic message' and

enthused: '(He) aims to create a magic capable of appealing to our sceptical age. But what kind of magic can appeal to our bleak intelligence? Only one, I suggest, that returns to primaeval archetypes, to the mental bedrock of all significant form.'[10]

For those sculptors more deeply disillusioned with contemporary modes a regeneration of content was not the principal consideration but a more complete re-examination of the premises of sculpture itself. In Britain the central figure and immediate catalyst for this approach was Anthony Caro. A contemporary of Turnbull and Paolozzi, Caro had himself in the late 50s moved towards an archetypal imagery, as a comparison of his **Woman Waking Up** of 1955 with the monumental **Figure** of 1958 demonstrates. ◀ Its massive bulbous forms echo the **Venus of Willendorf**, but such modifications of stereotypes increasingly dissatisfied him. By 1959 he had rejected the human figure in favour of working plaster abstractly, in a manner that demanded a far greater degree of improvisation and spontaneity. But only in 1960, following a visit to the United States and contact with leading artists and the critic Clement Greenberg, did he find a way of working which allowed him that freedom to explore, which he had sought. The plaster works were destroyed, and he began using steel, welding and bolting found forms. As **Twenty Four Hours** shows, the monolith was replaced by an open-form sculpture that derived from cubist precedents. This sculpture is undeniably abstract; its forms shorn of all external correspondences or parallels, the materials rendered non-associative and anonymous, and manual dexterity eliminated. Over the next two years Caro experimented widely with works as diverse as the lowslung, compact, pugnacious **Lock** ◀ and the weighty, lumbering **The Horse**. At this time the roughened edges of the metal components were often left, a welter of bolts asserted the massiveness of form and a sense of truculent solidity resulted.

By 1963 Caro had begun to streamline and consolidate his options into a kind of sculpture that was weightless, optical and defiant of gravity, as found in

[9]'What I like are their readymade qualities . . . they are part of the discarded junk of our urban life', Startup wrote in 1962: see **Peter Startup Sculpture**, Arts Council, 1977.

[10]H. Read, **Hubert Dalwood**, Gimpels Fils, London 1960, n. p. This trend was identified by a number of other critics, including Alloway (op. cit) and Maurice de Sausmarez, who wrote also in 1960: 'Much contemporary sculpture seems to be intimating that only by a return to "primitive" sources of response and the most fundamental forms can we hope for a new sculptural development to match the present efflorescence of talent,' (Maurice de Sausmarez, 'Four Abstract Sculptors: Dalwood, Warren-Davis, Bates and Hoskin', *Motif* no. 5, Autumn 1960, p. 35)

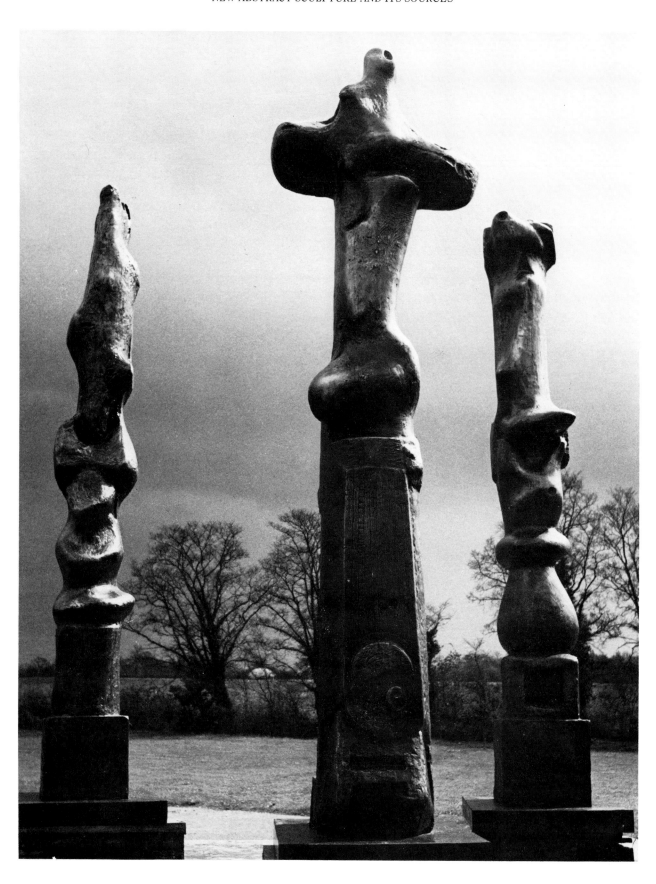

Henry Moore: **Upright Motives nos. 1,2, and 7**, 1955-56.

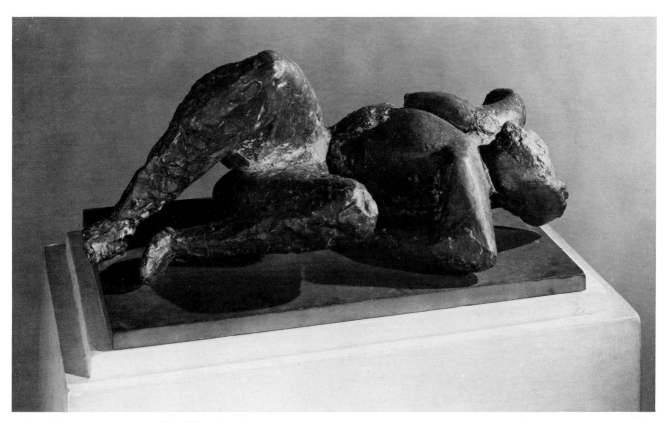

Anthony Caro: **Woman Waking Up.** Tate Gallery, London.

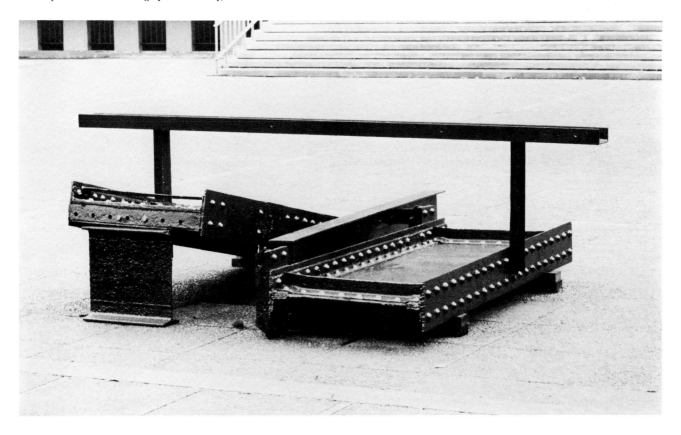

Anthony Caro: **Lock,** 1962.

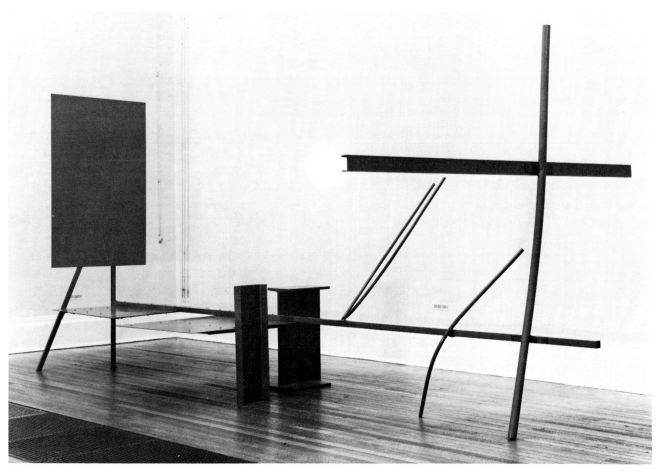

Anthony Caro: **Early One Morning**, 1964. Tate Gallery, London.

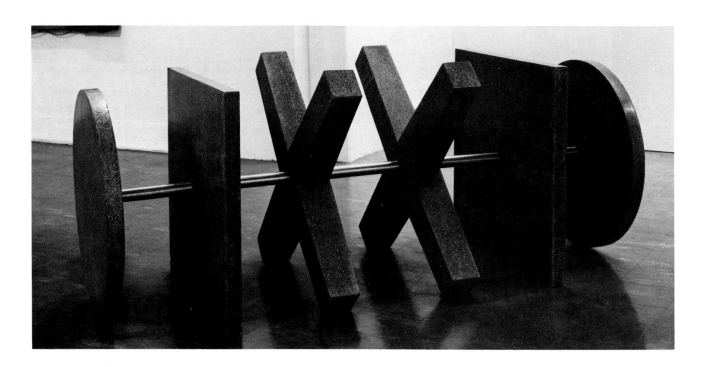

Phillip King: **Declaration**, 1961. Leicestershire Education Authority.

Early One Morning. ◖ Despite their abstract syntax these works must not be viewed in formal terms alone, as Michael Fried has persuasively argued; their content is 'the construction of expressive gestures'.[11]

Caro's influence was seminal to a number of younger sculptors at St. Martin's School of Art, but it was the enquiring attitudes and rigorous self-questioning that he brought to the discipline of sculpture rather than his work itself which proved most challenging for Scott, Tucker and King.[12] These three, the most gifted of those around Caro, accepted the need to return to fundamentals, to affirm the object-status of the sculptural piece devoid of all illusionistic, literary or subjective references.[13] The example of Brancusi was crucial for all of them, although Tucker initially owed more to Picasso and Gonzalez, as may be seen in a comparison of King's **Declaration**, Scott's **Umber** and Tucker's **Tunnel**. As in **Twenty Four Hours** these works use neutral components, simple geometric shapes linked together into clearly legible forms. All are placed directly on the ground, and thus firmly located in the spectator's space. They also share with **Twenty Four Hours** a neutral mood: their taciturn stance renders the archetypal images of the other developments almost loquacious.

A close proximity developed between these sculptors and certain contemporary British abstract painters who showed in the 'Situation' exhibitions of 1960 and 1961. American abstract painting was profoundly important to these artists in England for it provided a model of a new kind of art, one that was concerned with its fundamental qualities, that was imbued with a mood of optimism and vitality, and that dealt with the issue of making art with a new seriousness and daring. From its example the sculptors acquired a proclivity for questioning and examining the very nature of their activity which instilled a conceptual or at least theoretical basis to their undertaking. This quality clearly differentiated their approach from that of the sculptors concerned with archetypal imagery.[14]

Declaration was King's first major abstract sculpture: it was 'a sort of manifesto piece for me'.[15] ◖ Earlier he had experimented with expressively distorted figuration before adopting a gestural improvisatory manner as found in **Untitled** of 1960, now destroyed along with many other works from this period in his career. Made after a drawing influenced by Kline's calligraphy it reflected his interest in contemporary American painting. Yet the encour-

agement afforded him by American painting was tangential; more crucial for King was his awareness of belonging to a sculptural tradition. He was preoccupied by the need to explore issues intrinsic to it, as he stated in 1961: 'Traditional but modern. Today's concerns are a clearer but purer expression of old ideas'.[16]

Declaration was followed by works like **Drift** which employ a kind of biomorphic abstraction that now recalls the example of Arp as well as Brancusi.[17] By 1962 he felt that the biomorphic forms of **Split** and **Drift** were too subjectively associative and sought once again a more neutral, quasi-geometric form. ◖ The cone, first used in **Rosebud**, provided the answer. **Rosebud** marks a new stage in King's work; it has a cheeky originality, a display of wit and exuberance and an animate presence that distinguished it from his earlier work. ◖ Its signals his move from a concern with affirming the literal physical presence of the sculpture to a greater complexity of issues, of which this is only one ingredient, and a new multivalent meaning.

During these years similar developments occurred in the work of Scott, also engaged in an investigation of basic precepts. He too affirmed his allegiance with traditional sculptural concerns when he stated in 1961: 'The problem of monolithic closed volume sculpture is the one that has to be faced above all'.[18]

[11]Michael Fried, **Anthony Caro**, Whitechapel Art Gallery, London, 1963, n. p.
[12]Unlike Caro, all three not only rejected Cubism as the basis for the new direction but also many of Greenberg's beliefs. Greenberg regarded Brancusi as the 'ultimate extreme' of the monolithic tradition and thus concluded that the only viable direction for sculpture was one descended from Cubism: by contrast Brancusi was a source of great stimulus for these three. (See C. Greenberg, 'Modernist Sculpture, Its Pictorial Past', 1952, reprinted in *Art and Culture*, Boston 1961, p. 162)
[13]By contrast the premises on which Caro's work was based proved almost irresistible to others around him, many of whom like Annesley and Bolus had worked as assistants to him.
[14]Scott, for example, argued that American Painting 'opened up for most artists, myself included, an enormous extension to one's concept of art.' **Tim Scott**, Whitechapel Art Gallery, London, 1967: for Tucker, see footnote 16; for King, footnotes 2 & 16; see also N. Lynton, 'Painting, Situation and Extensions', **Arte Inglese Oggi, 1960-76**, British Council, Milan 1976, p. 24.
[15]Phillip King, interview with Charles Harrison 1968, tape, Whitechapel Art Gallery.
[16]Ibid.
[17]The Arp exhibition held at the Tate Gallery in 1962 was too late to have influenced this work directly, or sculpture by Tucker, but a general interest in this form of biomorphic abstraction is evidenced by Alan Bowness' statement of January 1960: (*Arts Magazine*, January 1960, p. 17) 'it seems to me the wrong moment for the Tate to be showing Lipchitz at all; if I judge the feeling in the country correctly, what we need more than anything is a large Arp exhibition.'
[18]**Tim Scott**, Whitechapel Art Gallery, London, 1967; see also **Tim Scott**, Edmonton Art Gallery, Edmonton, 1976.

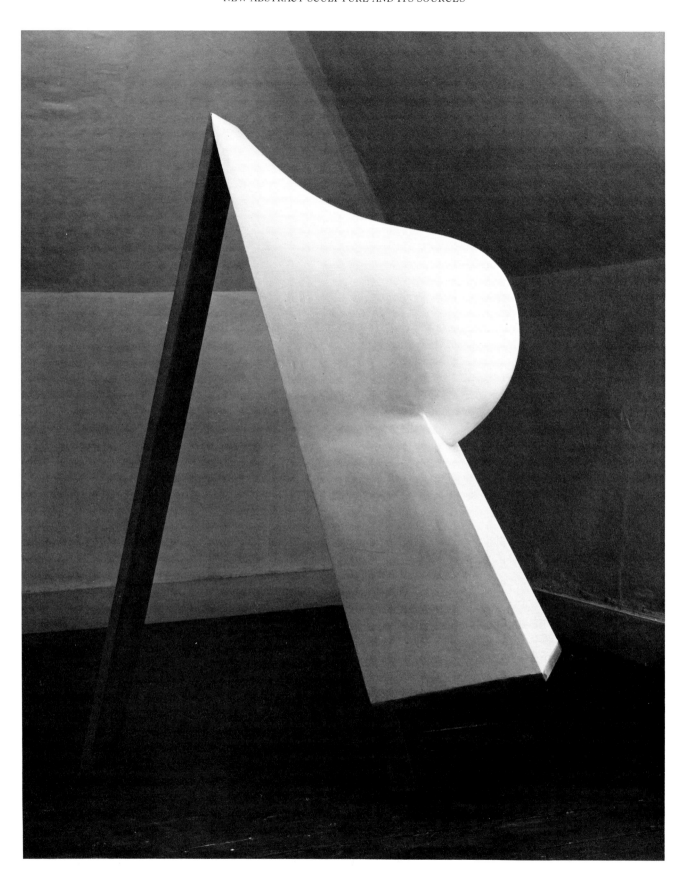

Phillip King: **Drift**, 1961.

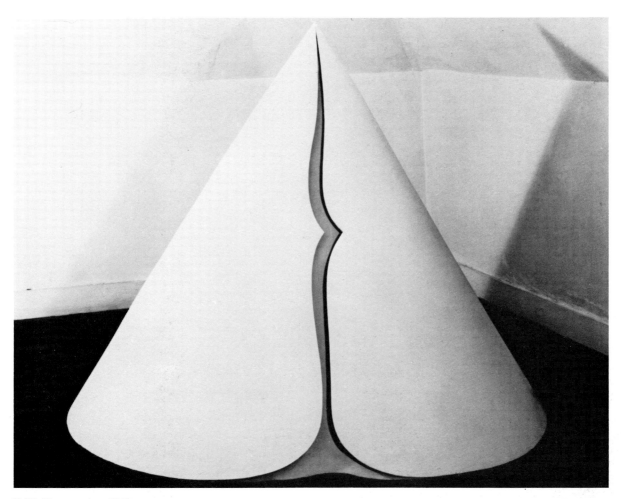

Phillip King: **Rosebud**, 1962.

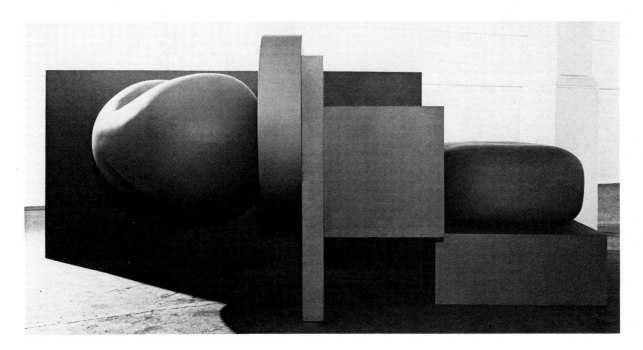

Tim Scott: **Umber**, 1961.

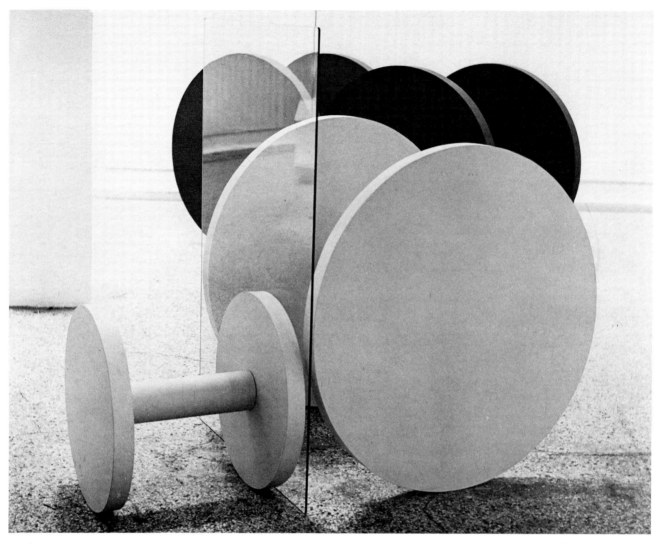

Tim Scott: **Peach Wheels**, 1961-62. Tate Gallery, London.

In works like **Umber** Scott saw himself extending the principles of Brancusi, whom he regarded as an abstract sculptor, by suspending hollow forms in a miraculous defiance of gravity. 🖝 New materials and processes, not available to the Rumanian artist, made this possible. Other early works such as **Shadows, Dulcimer** and **Peach Wheels** also employ simple forms composed in an unaccustomed manner, creating a kind of dialogue amongst the elements through contrast, asymmetry and reflection. 🖝 In these works Scott eliminates subjective expression, for he sought through the interplay of shape, volume and space to elicit from the spectator a heightened awareness of the unfamiliar object in front of him. From 1963 a more whimsical note entered Scott's work together with a greater play of wit and formal complexity, as found in **Agrippa**. 🖝 This exuberant mood reflects not only a changing ethos – shades of

'swinging London' – but a responsiveness to colour and shape that have counterparts in contemporary British painting.

Together with Scott and King, Tucker affirmed his indebtedness to tradition, in particular 'the pioneering sculptors of the early twentieth century, and to Abstract Expressionist painting.[19] Although Tucker initially used metal offcuts and a technique of controlled improvisation, his work, like Caro's, remained unambiguously abstract, far removed from the recent wave of junk sculpture as found in the allusive personnages of Colla and Stankiewicz, for example.[20] For Tucker, the cardinal qualities of sculpture were 'physicality' and 'visibility'. He stressed

[19]N. Lynton, 'Latest Developments in British Sculpture', *Art and Literature*, no. 2, 1964, p. 210.
[20]See Alloway's introduction, 'Junk Culture as a Tradition', in **New Forms, New Media**, Martha Jackson Gallery, New York, 1960. Colla's work was shown at the I.C.A. in 1959.

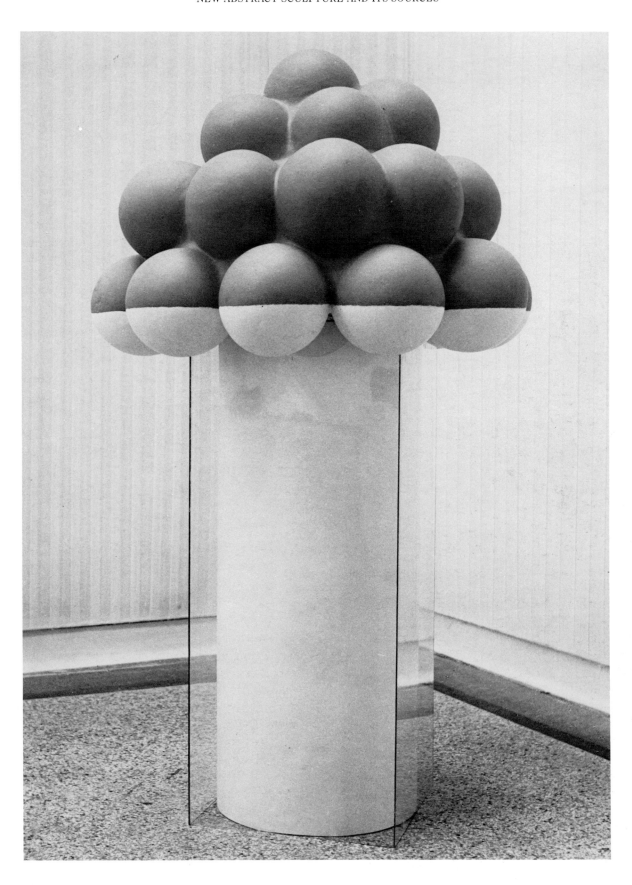

Tim Scott: **Agrippa**, 1964. Tate Gallery, London.

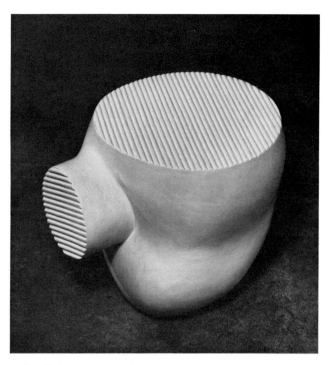

William Tucker: **Prayer**, 1962.

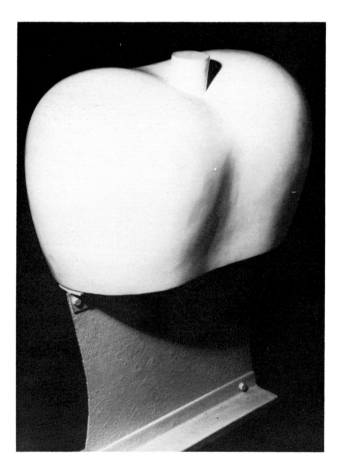

William Tucker: **Florida**, 1962.

that making sculpture was making things, things whose existence as such had to be their full justification: 'I use the words *visible*, *visibility*, here not as synonymous with *perceptible*, that is simply open to perception in the manner of the perceptibility of all objects, but to designate an active quality of the work – it goes out to meet, is made to attract and hold our sight'. [21]

In **37** of 1960 he collages mutually interfering shapes in a complex arrangement that requires careful scrutiny, but by 1962 he had adopted biomorphic forms as seen in **Prayer**, which suggest various associations which never quite reveal themselves: ◤ **Florida** is another intriguing piece that upsets conventional notions of how forms behave. ◤ By 1963 such ambiguous or mutually conflicting signals were occluded in favour of a more rigorous assertion of a single problem, as seen in **Meru II**. ◤ If Tucker's work was not always the most imaginatively or formally striking of this group, his keen concern with theoretical issues was very influential amongst this St. Martin's nexus and contributed significantly to the intellectual or conceptual basis underlying their approach.

By 1963 a different spirit (more lyrical and playful) and a wider range of concerns (no longer centred primarily on the issues of abstraction and the nature of sculpture) had entered their work. This shift of emphasis may be studied, for example, in the changing role of colour in sculpture over these years. Since it permitted a greater anonymity in material and form, colour was introduced by Caro as part of his reaction against the expressive surfaces and textures congruent with expressionism. By 1963 however, its role had become not only functional, but its expressive qualities were now being mined unashamedly. For these artists 1960-62 were crucial years in which they established the fundamental premises of their aesthetic. Although the work of the succeeding years is perhaps better known and more idiosyncratic, the sculpture of this period shows an untrammelled exploration and an uninhibited diversity that was not to be repeated. Above all, a new mode of sculpture was established which provided the basis for much subsequent work in the 60s. Outside St. Martin's few sculptors were exploring abstraction in this manner: often, as in the case of Brian Wall, they were direct descendents of continuing traditions, such as Constructivism.

[21]**William Tucker Sculptures**, Arts Council, 1977, n.p.

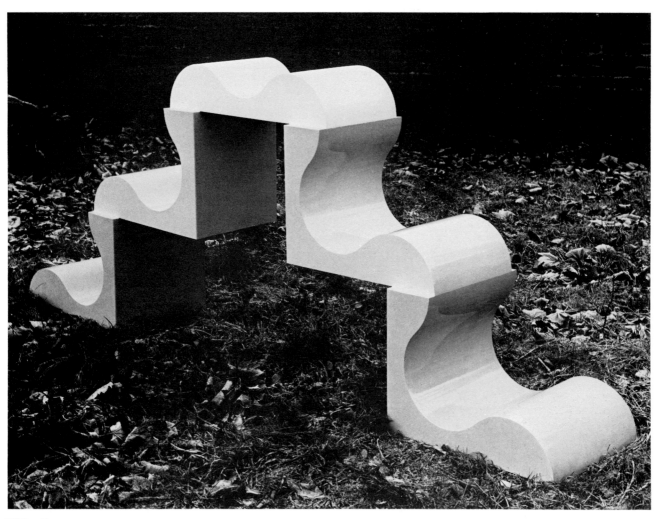

William Tucker: **Meru 2**, 1964. Tate Gallery, London.

Quite separate from these two main approaches to abstraction were a number of artists, many of whom did not necessarily consider themselves sculptors, who began in the late 50s making objects which circumvented traditional definitions of sculpture. These artists were generally preoccupied with realising a new kind of subject matter, and the three-dimensional and abstract nature of the resulting work was merely a logical outcome rather than an end in itself. Basic sculptural issues were of minimal concern to them and their relation to sculptural traditions was marginal. The work of Schwitters, shown in a large retrospective in London in 1958[22], was formative for several, like Mark Boyle who began making constructions at this time. Joe Tilson also turned to wooden structures around 1960; initially they were plain in form, though overlaid with allusive titles, but by 1962 they had become emblematic images infused with an urban iconography.[23]

Divorced even from this context was the highly individual work of John Latham, for whom an artwork, to use his terminology, is an 'attention magnet'. Latham is not concerned with making art-objects per se, but regards his works as didactic statements embodying aspects of his changing ideas. **Shem**, 1960, uses a favourite leitmotif, the book. ◢ Latham views books in multiple ways, on many levels, but above all they are repositories of knowledge which he deemed the 'burnt offerings of the verbal western

[22]In November 1958 the Lord's Gallery, London, held a large Schwitters retrospective with over one hundred works, including collages and constructions. As the first large scale exhibition of his work in England since his death it was highly acclaimed (see, for example, Robert Melville review in *Arts Magazine*, December 1958, p. 22) and marked a revival of interest in the artist in Britain. Schwitters was given a place of honour, with Brancusi, at the Venice Biennale in 1960. Boyle's works were shown in his first one-man exhibition, 'Erections, Constructions and Assemblages', at the Woodstock Gallery, London in 1963.
[23]See 'Joe Tilson', in C. Finch, **Image as Language: Aspects of British Art, 1950-68**, Harmondsworth 1969.

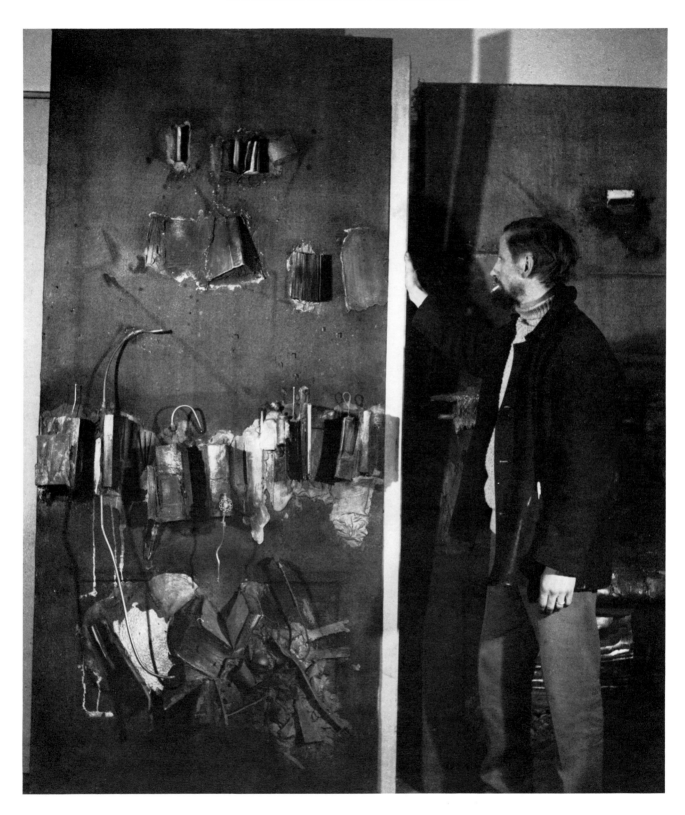

John Latham: **Shem**, 1960.

Detail of **Shem**.

tradition'. Our literate civilisation, devoid of transcendental values, is for him a decadent one, and through such works he attempts to accelerate its destruction and create a new phase out of the ashes of the past: 'Latham's destructive gesture turns into an act of creation, as non-verbal art appears out of the wreckage of 'the printed word.'[24]

The years between 1956-63 were a transitional period for these artists, but in their search for new directions or a personal idiom of abstraction was a fundamental consideration. The euphoric appraisals of British sculpture in the late 50s can be seen, retrospectively, to be insular and narrow: not only do such accounts ignore contemporary developments in America as well as outside the European main stream, but they gloss over internal divisions and nascent idioms. Yet by 1963 public taste had at last begun to acknowledge the innovations then occurring in sculpture, as may be seen by a comparison of two exhibitions both entitled 'Sculpture in the Open Air'. The first held in Holland Park in 1954, showed only figurative sculpture, with the exception of Chadwick's spikey **Inner Eye**.[25] Its intention was to affirm the pedigree of modern sculpture by tracing its lineage from the past: to this end it juxtaposed casts from classical Greek and medieval Indian sculpture with modern works ranging from Rodin to Butler. This historicizing approach was abandoned in the 1963 exhibition at Battersea Park where the selection was strictly contemporary.[26] For the first time the focus shifted from European and British sculpture to British

and American sculpture. Although expressionistic figuration still dominated, quantitively at least, in works by Nimptsch, Meadows, Lipton, Frink, Clatworthy, Brown, Baskin and Armitage among others, intimations of the advent of new modes, and of an international scope, are hinted at with the inclusion of Caro, Chamberlain, Smith and Stankiewicz. Nonetheless, in his catalogue introduction Norman Read continued both to champion the monolithic tradition of sculpture and to locate its continued existence within a unified national school of British sculpture.

The changing socio-economic climate was of paramount importance to the growth, as well as the gradual recognition, of the new modes. With less insular horizons and a generally increased prosperity these years witnessed a flourishing of international shows, travel grants, government-sponsored exhibitions and a stimulated art market. Embraced tentatively at the beginning of the decade, by the mid-60s abstract sculpture had almost attained the position of a new orthodoxy.

[24]L. Alloway, **Theo Crosby, Sculptures; Peter Blake, Objects; John Latham, Libraries**, I.C.A., London, n.p. See also **John Latham: States of Mind**, Städtische Kunsthalle, Dusseldorf, 1975.
[25]'Sculpture in the Open Air', Holland Park 1954, London County Council.
[26]'Sculpture in the Open Air', Battersea Park 1963, London County Council.

Timothy Hyman:

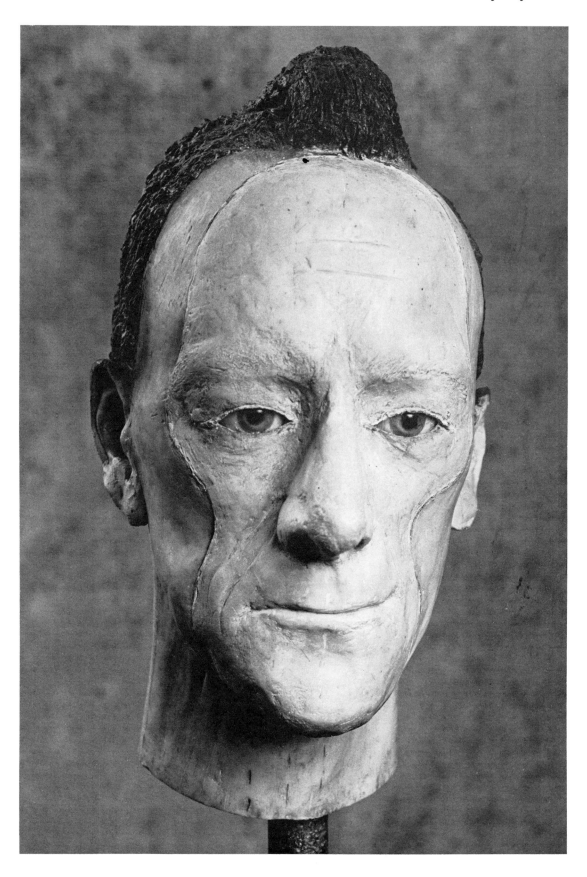

John Davies: **Uplees Man**, 1971-72. Private collection.

XIV. Figurative Sculpture since 1960.

Any visitor to such large recent surveys as 'The Condition of Sculpture' (Hayward Gallery, 1975), or the Jubilee Exhibition at Battersea in 1977, might well have assumed the virtual demise of figurative sculpture in Britain. While preparing this essay, and talking to art students, or to exhibition-goers fairly well informed about contemporary art, I found none able even to call to mind more than two or three likely names. This eclipse of the figure in serious sculpture – or at least, this failure to achieve any prominence – has left the whole terrain in shadow; but I think the cause of neglect goes beyond fashion. What it amounts to, is that no figurative sculptor of recent years has been able to create a consistent vision in which successive generations could recognise themselves, their needs and their concerns.

THE INHERITANCE
'The truth is that abstraction after 1945 did not, as its opponents in the figurative camp hoped, find an antipode of equal quality and power... The occasional appearance of representation, hailed by critics as the beginning of a new trend, resulted simply from a reduction of conflict between abstraction and representation.'

Professor A. M. Hammacher
The Evolution of Modern Sculpture, 1969

The tradition of the figure inherited by British sculptors after the war was (often all too literally) amorphous; academic practices might be buried, yet no-one since Rodin seemed to offer an alternative of real authority. Artists like Manzu, Nadelman and Gutfreund remained in the wings, while the centre stage was occupied by Brancusi, Gonzalez and Lipchitz, whose figures were already more than half-abstracted. From this perspective, the influence of Moore especially was away from any decisive figuration, and towards an art of shape-making, of 'suggestive forms'. He had invested the expressive forms of Picasso and de Chirico – the anguished bestial heads and the Disquieting Muses – with values that were the opposite of disquieting, a kind of primitivistic humanism; forms that had once conveyed stranded absurdity were now asked instead to stand for the fusion of man and the natural order, a permanence.

The result was a blurring of emotional resonance, spawning from lesser artists a lumber of dumb presences rising from institutional lawns. Later, sculptors like Meadows, Chadwick, Armitage, would regularly abandon exactly those elements in the figure that were distinctively human; heads were shrunk to featureless appendages, and hands lopped off. These kinds of distortion and stylisation carried no conviction for a subsequent generation; and yet, at this distance, the 'metaphorical' totems and robots of the 60s seem equally dated, equally an evasion. Has any sculptor in these twenty years been able to confront the figure directly, without being just plain dull?

The question is begged because of the enormous international acclaim enjoyed by English abstract sculpture in this same period. The early figures of Anthony Caro – the pitted bronze, saurian head, and grotesque violently wrenched limbs of **Woman waking up**, 1955 (Tate Gallery) – had been the monsters of their era. But after visiting America in 1959, and impressed by the hard-edge paintings of Kenneth Noland, Caro had developed his own highly formal art, equally cool and affirmative in flavour. Teaching at St. Martin's, he assembled a group of young sculptors whose painted steel idiom entirely dominated the next decade. Such bright clear-cut pieces as **Early One Morning**, 1962, (Tate Gallery) attest to Caro's own born-again sense of liberation; but at St. Martin's an ideology of form seems to have taken hold, proscribing all sentiment, all complex emotion. The figure was widely supposed to have been 'superceded'; in the words of one influential American critic, 'Not only is the radical abstractness of Caro's art not a denial of our bodies and the world, it is the only way in which they can be saved for high art today, in which they can be made present to us other than as theatre'. [1]

The *only* way?... It is against this stylistic orthodoxy that most artists working with the figure – humourously like Nicholas Monro (Low Art?) or tragically like John Davies (Theatre?) – have had partly to define themselves.

SOME HERETICS
'My sculpture is the result of my relationship to Nature, with man being central... Whilst I took a keen interest in the work of the St. Martin's School, it seemed to me – and this is a personal view only – that their "linear adventures in the material" lacked body. My work may be seen as a compensation for this'. [2]

A sculptor six years younger than Caro was Leonard McComb, the son of a Marxist shipyard worker, but himself almost defiantly quietist in temperament. He destroyed nearly all his early work, but by 1965 he had

[1]Michael Fried, **Anthony Caro**, Arts Council Catalogue 1969.
[2]Leonard McComb, letter to the author, 1980.

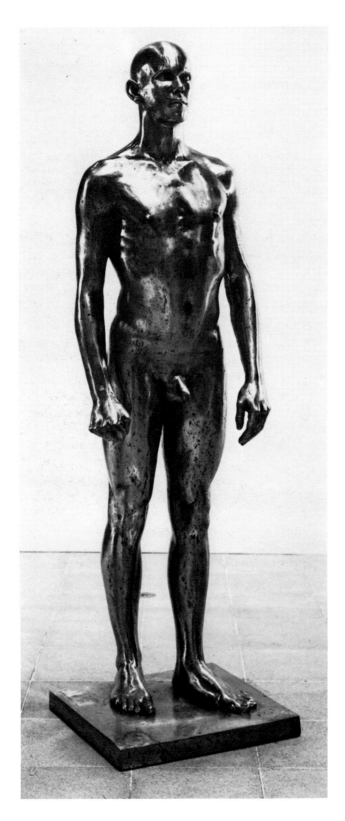

Leonard McComb: **Portrait of a Young Man Standing**, 1963-77, bronze.
Arts Council of Great Britain.

completed the first version of his **Portrait of a Young Man Standing**, bronze version 1963-77 (Arts Council Collection). ◼ 'I tried to create an image of a whole person, his physical and spiritual life being inseparably fused... The embedded capacity for powerful and gentle action, both physical and intellectual.'[3] At first sight a late child of neo-classicism, this is indeed a 'canonical' figure, but one whose dimensions deliberately assert the uniqueness of each individual; the measurements are based on the *asymmetries* of the particular model (visible especially in the chest), in tension, with one hand open, the other clenched. He saw his figure partly as a statement of faith in man's future (the background was the Cuba crisis and the first Kennedy murder); it harked back to Egypt – (the earliest word we have for sculptor is in Egyptian, 'one who keeps alive') – and yet its polished almost sci-fi smoothness betrays also his admiration for Arp and Brancusi.

Although the **Portrait** now seems a significant step towards the humane pantheism of McComb's mature art, it proved unshowable. A major artist was lost to British sculpture; over the following ten years McComb painfully developed his extraordinarily refined practice as a water-colourist, on an increasingly monumental scale, yet his patient building-up of accumulated strokes obviously suggests the sculptor he might have been.

In much of the best-known painting of the 1960s and 1970s, figures have been energized by a story-telling action (I'm thinking of Kitaj, Hockney, Green and so on); it's strange there's been no parallel sculpture. One factor may be the virtual outlawing in Britain of the relief – which has served from Greece to India, from Giselbertus to Donatello and della Quercia, as the greatest medium for story telling in art – yet which has come to be regarded by most contemporaries as a hybrid, as something 'less than fully sculptural.' A striking exception, but one whose reputation has had to be made outside Britain, is Raymond Mason. He arrived in Paris in 1946, and having nowhere else to work, the street became his subject. His cityscape reliefs were shown twice in London at the Beaux-Arts Gallery in the early 1960s (where they impressed Frank Auerbach among others). But Mason moved from the discreet window-space of **Carrefour de L'Odeon**, 1958-9, where the image is gouged into plaster or clay as a kind of drawing, to create a much more elaborate and monumental kind of art, a microcosm.

[3]Op.cit.

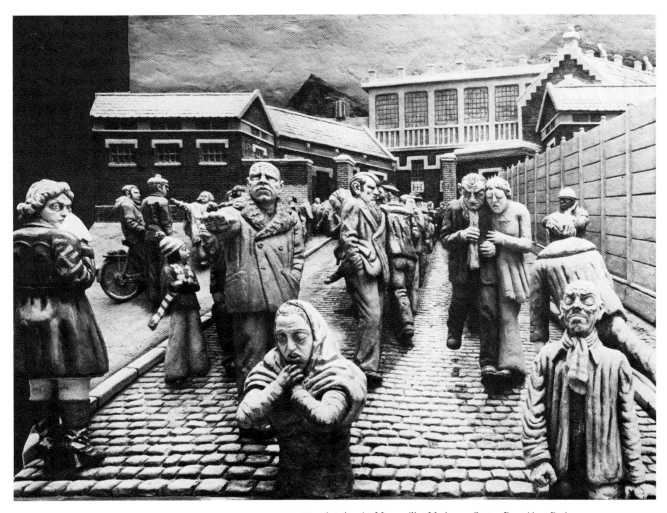

Raymond Mason: **A Tragedy in the North: Winter, Rain, Tears**, 1975-77, painted resin. Musee d'Art Moderne, Centre Pompidou, Paris.

A Tragedy in the North: Winter, Rain, Tears, 1975-77 (Centre Pompidou) is almost ten foot wide; the architectural setting is built up rather as the slanting terraces of a stadium, and the figures, separately cast in resin, slotted in. ☛ If his earlier generalised crowds recalled Giacometti, these bulging-eyed characters, strident in colour and gesture, populist in flavour, are reminiscent of nothing in past art so much as Daumier's polychrome busts of deputies, and beyond that to Gillray and the English humourists: the mining accident seems to have triggered memories from Mason's own Black Country childhood, and the scene perhaps suggests England as much as Northern France. The whole thrust of this art is to eliminate any aesthetic distance. Mason uses colour both to 'animate the space', and, he says, to 'humanise the figures.'[4] These tableaux sometimes seem to teeter between Red Grooms' **Manhattan** and the Lyons Corner House windows I remember from my childhood, yet they are fascinating in suggesting all

the untapped possibilities and resources that still remain open to sculpture.

GRASS ROOTS AND PUBLIC PLACES

Just as the conventional, more or less impressionistic landscape and portrait still accounts for ninety per cent of all painting's patronage, so Rodin is still the key to the vast bulk of contemporary sculpture in Board Room and High Street and Market Place. Sufficient to outline the astonishing career of David Wynne, who stands to sculpture much as Colonel Seifert to London's architecture. He never went to art school but at 21, encouraged by Epstein, made the portrait of Beecham now in the Royal Festival Hall; major commissions followed, such as the **Christ and Mary Magdalene** in Ely Cathedral in 1963 and the same year the two and a half ton marble **Gorilla** at Crystal Palace. In 1966 the Tate acquired his head of Kokoschka; in 1971 he completed the **Dancers** in Cadogan Place,

[4]Interview with Raymond Mason, Galerie Claude Bernard, 1977.

as well as a bust of **Virginia Wade**. After arduous research (he played with the dolphins in their tank, as he'd sat in the orchestra under Sir Thomas) he embarked on the 17 foot **Girl with a Dolphin**, 1973, in Cheyne Walk. He designed the linked hands on the 50p piece, and the Jubilee medal; also a twelve foot stainless steel **Horse and Naked Rider** for Sheffield. [5]

But are such works any more unconvincing than, for example, the Hepworth **Winged Figure**, 1962, on the side of John Lewis? Public sculpture seems to be a gap that no one is able to fill. Elisabeth Frink has tried, in her **Horse and Rider**, 1975, outside the Aeroflot offices in Piccadilly, but it seems meagre, insubstantial and sadly without symbolic power – inevitably the comparison is with Marini's much more memorable **Horseman**, 1947 (Tate Gallery) with its dreamlike tapering head. At the Royal Academy Summer Show in 1980 the figure sculpture seemed almost uniformly meretricious and anomalous; dull busts, including Frink's **Viscount Eccles**, stand as gateposts while overall a kind of salon figurine (**Nude on a Hammock**) is still the prevailing mode. Against this patinated soft-porn, one extraordinary blanched head stood out, mainly for its intensity, but also perhaps because the grey-white resin with its delicate traces of polychrome immediately renders it more present. It turned out to be a **Head of Rilke** by John Wragg. 🖙

I had known Wragg's work in the 1960s as he moved from a primal, mythic figuration akin to Ayrton and Frink (see the **Romulus and Remus** now at Charter-house School) through to a kind of abstraction, which he exhibited at the Hanover Gallery. What strange conversion had taken place? This new art, it transpired, came out of personal troubles, from a moment when he had, in effect, nothing more to lose; he left London, and the Rilke bust (the last of three, from 1975) is almost the only work he's exhibited since. He quotes Schopenhauer: 'Take note, young man, that the portrait must be a lyric poem, through which a whole personality with all its thoughts, feelings and desires, speaks.'

Gentler than John Davies, (whom he has known and admired since 1963) Wragg's summoning up of Rilke's phantom has the same psychological penetration. When, teaching at Chelsea, Wragg walks past the hunk of metal outside Sainsbury's in the King's Road, he finds it hard to believe he could have made it; his recent **Bathers**, with their air of emerging so vulnerably out of memory, speak of a new and altogether different beginning.

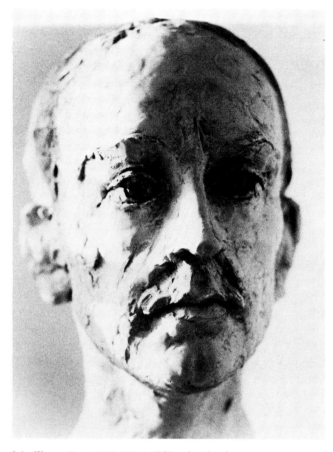

John Wragg: **Head of Rilke No. 3**, 1975, painted resin.

TOTEM AND YAHOO

'Figurative work . . . recognises the fact of art and life as parallel but separate realities and the requirement is not for intentional resemblance to life, but the phenomenon of coincidental significance.'[6]
At 24 George Fullard, visiting the Rodin Museum in Paris, was so impressed and unsettled as to be unable to make any sculpture for a year. To model the figure seemed no longer possible, yet for the next decade he struggled with a broken-formed expressionistic idiom, (as in **Mother and Child**, 1958, Arts Council Collection); until there appeared as a solution 'assemblage', an *oblique* way of creating figures out of ready-made elements. But inherent in assemblage is a certain playful opportunism and a distancing irony; eschewing the materials of traditional high art, it shades into the anti-art aesthetic, the short-cut collaged jokiness of Pop.

Fullard's early wooden figures were often simple,

[5]Most of this, and much else, is documented in **The Sculpture of David Wynne**, Phaidon 1974.
[6]George Fullard in **Painter and Sculptor** Vol 2, No. 2, 1958-9.

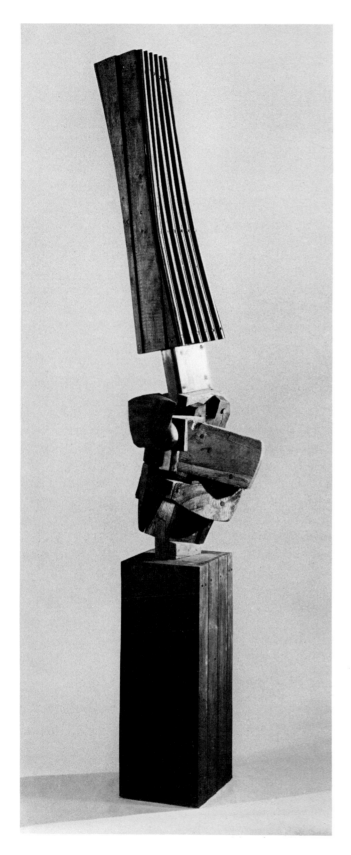

Peter Startup: **Up-ended Figure**, 1961, wood. Tate Gallery, London.

and paralleled the denser, starker totems of his near contemporary Peter Startup, whose 8 foot **Up-ended Figure**, 1961 (Tate Gallery) is similarly put together from 'the discarded junk of an urban life'.[7]

Their shared idiom was what's been called 'Esperanto-Picasso'; but where Startup always remained close to structural abstraction, and became more so, for Fullard the sawing-up of Edwardian domestic panelling and furniture seemed to lead inevitably to a historical subject-matter. His attitude to the First World War, mingling nostalgia, gentle satire, and protest can be seen as very much a parallel to Joan Littlewood's 'Oh What a Lovely War'! of roughly the same period. In **The Patriot**, 1960, the painted mother and child with flag are only elements within an elaborate encompassing structure; while **The Second War Dream**, 1964, is a chariot of whimsical menace, constructed out of model engine parts, with the tiny figure almost invisible inside. In the Tate's large **Death or Glory**, 1963-4, a table has been placed on its side, legs sticking out aggressively; above, a circular table top does service as a torso, its central knob standing as peg-leg, penis and rifle-barrel; while behind to the right, poking through a picture-frame, we glimpse the mouth of a cannon. ☛ By 1969 he had embarked on the poetic and lyrical reliefs of the **Sea Series**, with their sharper idiom, where the figure disappears altogether; but like Startup, Fullard died early, and it remains an incomplete development.

In the mid 1960s, an energetic intervention was made by Bruce Lacey when he created a substantial tribe of robots and automata. Leaving school at 13, he'd worked variously in an explosives factory, a bank, and the Navy, until a breakdown put him in hospital for 18 months; in 1954, after six years as an art student, he left the Royal College. 'Within a year of leaving it had all gone . . . All I could do was sit in my little attic studio and play with the sun light . . . I was left just like a silly bugger playing with all these silly bugger things instead.'[8] He made comic props for some of the Goons, he was a tap-dancer, musician and knife-thrower, he appeared in **An Evening of British Rubbish**. And so, when the sculpture began, it was partly a reproach from outside – even a revenge on Fine Art: 'The objects I make are hate-objects, fear-objects and love-objects. They are my totems and my fetishes . . . They may be what we know as art, they may not be, but if they are not, they are what art should be.'[9]

[7]Peter Startup, Statement for ICA exhibition, 1963.
[8]Bruce Lacey, interviewed in *Artscribe*, December 1978.
[9]Bruce Lacey, **Automata and Humanoids**, Gallery One, 1963.

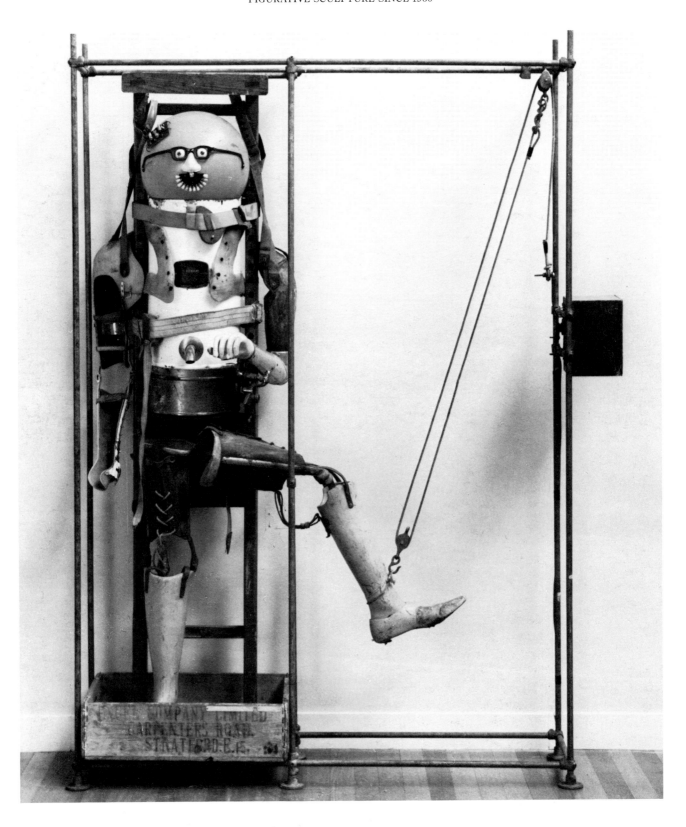

Bruce Lacey: **Boy Oh Boy, Am I Living**, 1964, mixed media. Tate Gallery, London.

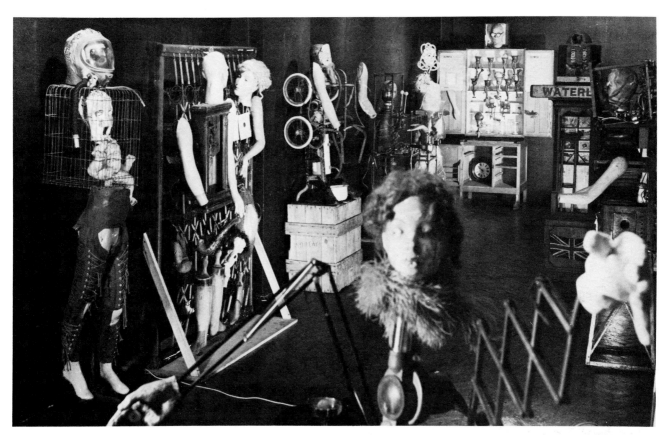

Bruce Lacey: **Exhibition of Humanoids**, Gallery One, 1963.

In the figure of 1964 now in the Tate, the torso is a bathroom geyser, with surgical limbs strapped on; inside his scaffold, unable to do more than lift one leg and lower it, he's entitled **Boy Oh Boy am I Living!** But Lacey's explosive creativity was shortlived. After his hilarious show at the Marlborough Gallery in 1965, he gradually moved away from sculpture, becoming a performer of rituals at Avebury and elsewhere; as with Spike Milligan, inspired humorist is, often tediously, entwined with homespun sage.

The 1960s found Eduardo Paolozzi in full career. His sculpture had always been based on assemblage, on the idea that 'all human experience is just one big collage,' but now, perhaps reflecting Britain's transition away from the bomb-blasted aftermath of war, his art became cooler. In works like **The Last of the Idols** 1963 (Wallraf-Richartz Museum, Cologne), manufactured out of standard machine-parts, a new immaculateness, and the reference to juke-box and one-armed bandit, brought him fully within the ironic compass of Pop. **Diana as an Engine** (1963) takes the multiple-breasted cult-image of the Ephesians and fuses it with the many-nozzled radial engine. Such works help distinguish Paolozzi from his contemporaries at St. Martin's; quite untouched by

George Fullard: **Death or Glory**, 1963-64, mixed media. Tate Gallery, London.

Eduardo Paolozzi: **Diana as an Engine 1**, 1963, painted aluminium.

to printmaking; he was, he said, concerned with 'the relationship between kitsch and technology.' But this involved him in the double-think of so much Pop; was he celebrating or condemning, cataloguing or exploiting, his patently meretricious source-material? In his 1971 Tate Gallery retrospective, Paolozzi vented a whole playground-full of splenetic novelties and bath-toys, such as **Friendly Neighbourhood Dog** and **Florida Snail**, as well as a battery of very realistic bombs. This kind of one-off conceit had been common in America throughout the 1960s in the cast objects of Johns and Westermann, and later, in England, in the chromium plated coca-cola bottles and art parodies of Clive Barker; as Harold Rosenberg wrote of Warhol's soup-cans, they are 'like a joke without humour told over and over again until it begins to sound like a threat.' But, finally, in the course of the 70s, Paolozzi adopted a mandarin abstract vocabulary whose esoteric permutations – in such works as the ceiling of Cleish Castle, or the doors of the Hunterian Museum, Glasgow – could hardly be further from the 'sublime of everyday life.'

ROADS TO THE ABSURD

'Ladies and gentlemen, allow me to introduce this lady on my right. I'm afraid you can't see her because she is a Fairy, and she has very kindly come along here tonight to grant one wish... Now we must agree, that within us all there is, has been, and always will be, a deep desire to, what we call, fly... The Fairy of course will demand that we be more specific. How would we like to fly, like a bird?... But here we make our first distinction. No, not like a bird, I would like to fly like a fish...'

From Nicholas Monro
Classical Newtonian
Physics and the Flying Saucer, 1980

Probably the most formally-realised figures of the past decade, modelled in plaster and cast in fibreglass, are those of Nicholas Monro. His sources are revealing; for example, he recently created a life-size group from a photo of the 1930s music-hall act **Cleopatra's Nightmare**, where the statuesque 'Betty' was flanked by the tiny eunuch-like figures of 'Wilson' and 'Kepple' in their outrageous 'sand-dance'. The act may have begun as a satire on the orientalism of the middle-classes, but through years of repetition all expressive meaning bled away, until their performance became entirely rigid, fossilised. 'If one wants to find

the doctrine of truth to materials, by the quest for pure or contemplative forms, he was 'trying to get away from the idea in sculpture of trying to make a Thing – in a way, going beyond the Thing, and trying to make a presence.'[10]

Yet in his masterly Wittgenstein prints (his first silkscreen portfolio, 1965-66), we watch the steady transition to an abstracted imagery; and in the 14 foot long **Hamlet in a Japanese Manner**, 1966 ☛ (on loan to Fitzwilliam Museum, Cambridge) the shifting presences are only vestigial, though there is a residue from Paolozzi's fascination with the **Laocöon**, and we sense a stylised drama, however fugitive, in progress. Colour is now an essential element; the camouflage patterns confer a sense of frenetic or manic, possibly futile, activity. In the following years the focus of Paolozzi's creativity would shift away from sculpture

[10]Eduardo Paolozzi interviewed by Richard Hamilton, **Arts Yearbook 8**, 1965.

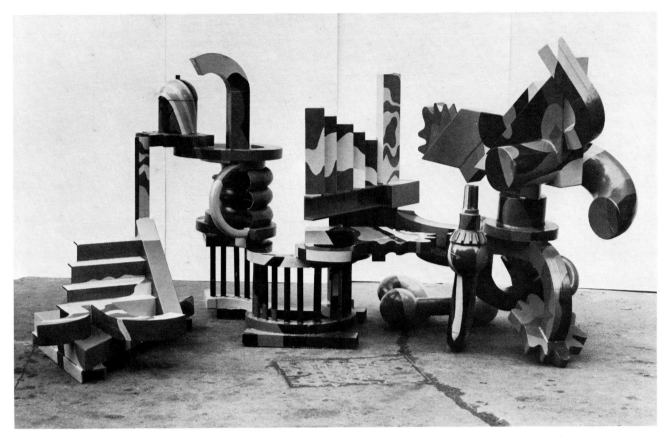

Eduardo Paolozzi: **Hamlet in a Japanese Manner**, 1966, painted aluminium.

meaning in the world' says Monro, 'one way is through absolute *perfection*.' In this sense his own art is a search for 'perfection', and his finest work has a quality of gratuitous, completely self-contained and unquestionable existence.

The 22 foot **Waiter's Race**, 1975, is probably his masterpiece so far, the six pea-green flunkeys enacting a whole typology of human character; his peculiar kind of form, both bland and tough, is evident through every fluttering napkin and coat-tail and tea-tray. ☛ In some heads one might see echoes of **Mlle. Pogany**, and Brancusi is the twentieth-century sculptor he admires most, 'for the universality of his images and the humour in his work';[11] and there's also in its cinematic progression, its speeding-up, a touch of Boccioni. (Further back I feel his kinship to the **Pleurants** and the **Well of Moses** of Claus Sluter in Dijon). This group is so full of childlike delight and inventive power that all reservations seem a cavil; at his best Monro reminds us of the wonders of the toy-box, of model soldiers, of the 'ideas' we all had as children of a **Samurai**, a **Cowboy**, and so on. His cast of mind runs to speculative fantasy, fairy-tale; what if a group of **African warriors** suddenly appeared before

us, or **Martians** like garden gnomes, or **Douglas Fairbanks**, or six apparitions of **Max Wall** or a 27 foot **King Kong** – or a fairy who let us all fly like a fish? Yet there is also, somewhere at the heart, a negation; Monro's closest friend among artists is Patrick Caulfield, and I find in both their work the same deadly irony, a bitter barren flatness that makes the bubbling laughter suddenly break off uneasily.

In the work of John Davies negation is far more explicit. On the one hand, he creates simulacra: 'There is always a conflict for me between the qualities of made sculpture figures and what one sees in the street, but I strive to make the figures display the qualities of human beings, rather than those of sculpture.'[12]

So in a group like **The Lesson**, 1973-75, (Sainsbury Centre, University of East Anglia, along with other works by Davies) face and heads are cast from life, clothes and shoes are real, glass eyes and human hair complete the waxwork. ☛ But this verisimilitude is only a first step towards conjuring up an emotional *unreality*; sleeves are cut away, whitewash poured,

[11]Nicholas Monro, *Art and Artists*, January 1975.
[12]John Davies, Statement for **Documenta**, Kassel, 1977.

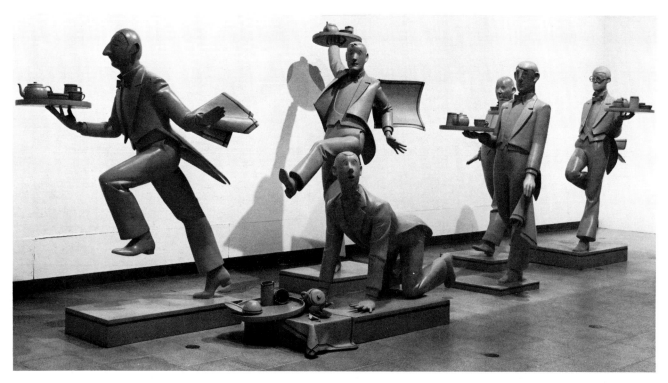

Nicholas Monro: **Waiter's Race**, 1975, fibreglass.

the figures festooned with a rope-ladder and made
to stand too close for comfort. (It's a kind of inhibited
embrace, without energy or hope). The effect is as
though we've been made to *dream* them, figures seen
through rain or tears, and to take on their burden of
grief.

All Davies' groups seem to emerge out of self
scrutiny, and all the figures are youngish men; in **The
Lesson** self seems to confront self. In his single heads
(often, like traitors, stuck on a pole) the eyes, staring
out, are blind to us. These hands are sometimes fitted
with a 'device', a shell, a piece of wire, a carrot-like
excrescence; they seem attributes, rather as the
Vices and Virtues once carried in the mediaeval world
– except that here their significance is unknown, even
one suspects, to Davies himself, who frequently
substitutes them. This creation of an allegoric
resonance brings him close to the mystifications of
surrealism; these devices resemble the obsessional
arbitrary objects that hover directly in front of some
of Magritte's figures. They are what cuts each of us
off from all the rest.[13]

Both Monro and Davies have shaped figures of an
uncompromised immediacy; at the same time, each
might be seen as wearing a mask, one comic, the other
tragic. Their admirable clarity and simplicity is bought
at the cost of narrowing the problem. They have
created not speaking human souls, but only half-

beings; cartoon-figures and ghouls. And in either
mode – (one feels this in Ionesco and Beckett) the
absurd may be a vein that comes a little too easily to us
today. There's a reclusive element in both, Monro on a
Berkshire farm, Davies in a Kent village; their work
bears all the marks of isolation (Monro had never
heard of Davies) and neither seems very likely to
provide any starting point from which future artists
will find help.

In doggerel from the mid 70s, Monro vented his
irritation at the hegemony of St. Martin's: 'When
people start to assess today's art/And contemporary
myths are exploded/There won't be a thing/By
Tucker or King/And the work that Caro did, Tucker
corroded.'[14] But today a new climate is shaping, in
which figurative artists of all kinds are no longer
assumed to be the backward children. At St. Martin's
for example, the new Professor, Tim Scott, initiated
in 1980 an entirely different kind of training, with
students obliged to work from the live model, and
much attention paid to Indian temple-figures; a note
of muted hope on which to conclude a chapter of
disappointments.

[13]When I first saw Davies' work I was reminded also of the heads
created by F. Messerschmidt in isolation in Bratislava. (See Ernst
Kris, **Psychoanalytic Explorations in Art: A Psychotic Sculptor of the
18th Century**). Messerschmidt was quite talked-about when I was at
the Slade, shortly before Davies; one of his beak-heads appears in an
early picture by Patrick Proctor.
[14]Nicholas Monro, in *Art and Artists*, January 1975.

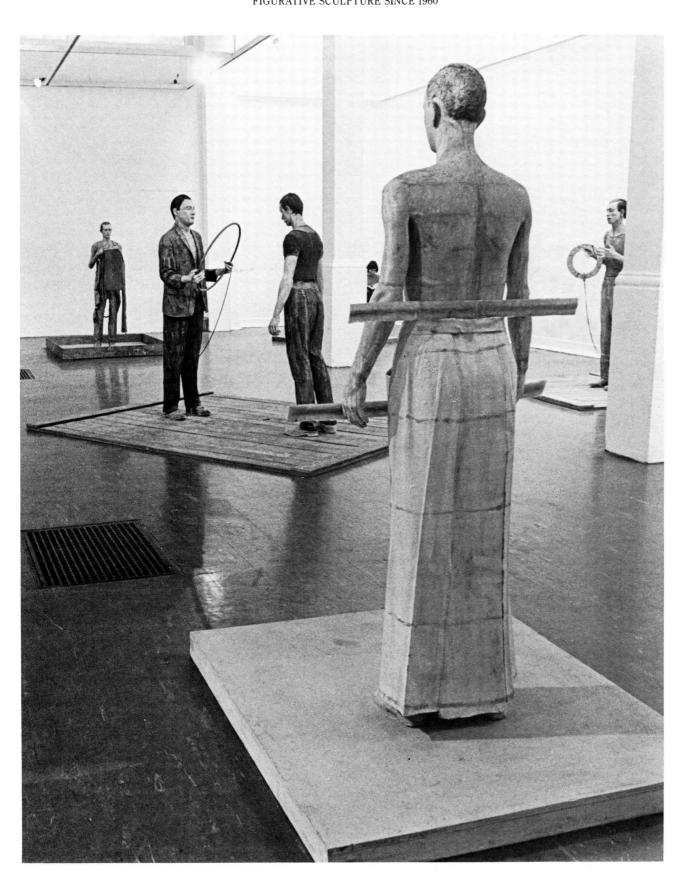

John Davies exhibition, Whitechapel Art Gallery, 1975, includes **The Lesson**, 1973-75.

Stuart Morgan: **XV. A Rhetoric of Silence:**

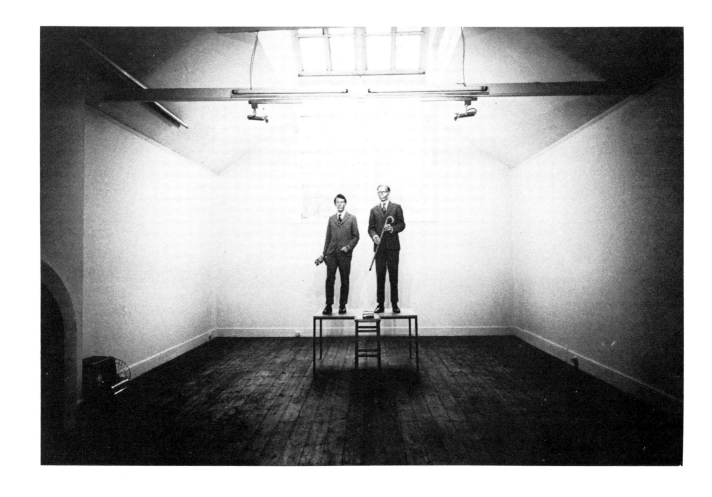

Gilbert & George: **Singing Sculpture**, 1969, at Nigel Greenwood Gallery, London 1970.

Redefinitions of Sculpture in the 1960s and 1970s.

Between Bryan Robertson's 'New Generation' in 1965 and Anne Seymour's 'The New Art' seven years later 'new' sculpture in Britain changed beyond all recognition. ☛ That much, at least, is certain. Whether it *remained* sculpture, whether it destroyed the possibility of ever defining sculpture again, whether an orgy of rule-breaking was halted once and for all by a conservative backlash in the mid-seventies are all contentious. So contentious, indeed, that although by the end of the sixties, thanks to Germano Celant's book **Arte Povera**, published in 1969, and Harald Szeeman's exhibition 'When Attitudes Become Form', (1969) Britain was a recognised participant in an experimental community spanning America, Germany, Italy and Holland, no detailed art-historical model for the art of this period has yet been proposed.

Perhaps there are good reasons for this omission. Flavio Caroli can maintain that in order to defeat consumerism the Italian avant-garde committed tactical hara-kiri in 1968.[1] Similarly, Robert Pincus-Witten can defend 1968 as the year which rivalled any in early modernism.[2] In Britain no comparable *annus mirabilis* can be found. Perhaps the battles were fought elsewhere. Already in Kynaston McShine's 'Primary Structures' exhibition at the Jewish Museum, New York in 1966, for example, Caro, King, Tucker and other St Martin's sculptors had met decisive opposition. Decorative elegance influenced by hard-edge abstract painting, in which modernity was interpreted as novelty of form or colour, proved no match for the leaner approach of Carl Andre, Sol LeWitt, Robert Morris and Don Judd, in whose work craftsmanship and composition played little part, and neither modernist reductivism nor constructivist theory had served as precedent.[3] Research on the British equivalent to Robert Pincus-Witten's 'post-minimalism', the only soundly argued historical explanation of turn-of-the-decade art, would begin with a paradox.[4] Is it possible to identify a *post-minimalism* without an initial minimalism? One's first reaction is to look for opposition to Caro and his disciples. Predictably, it came from their students at St Martin's School of Art.

On the vocational course there through the sixties were David Bainbridge, Jan Dibbets, Braco Dimitrijević, David Dye, Benni Efrat, Barry Flanagan, Hamish Fulton, Gilbert & George, Tim Head, Gerard Hemsworth, John Hilliard, David Lamelas, Roelof Louw, Richard Long, Bruce McLean and others. They were taught by Tim Scott, David Annesley, and Michael Bolus, writers such as Alexander Trocchi and

'The New Generation', Whitechapel Art Gallery, 1965.

Barry Flanagan, **Hayward II**, 'The New Art', Hayward Gallery, 1972.

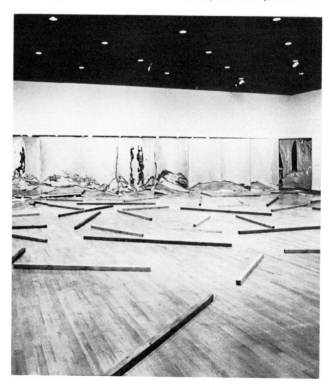

[1]Flavio Caroli, 'Before the Flood', **Nuova Immagine**, Milan 1980, p.12.
[2]'I think 1968 and 1912 are parallel moments in the twentieth century.' Robert Pincus-Witten, unpublished interview with the author, 14 August 1978.
[3]Cf. Arts Council's 'Pier and Ocean' Exhibition at the Hayward Gallery, 1980.
[4]Robert Pincus-Witten, **Post-Minimalism**, New York, 1977.

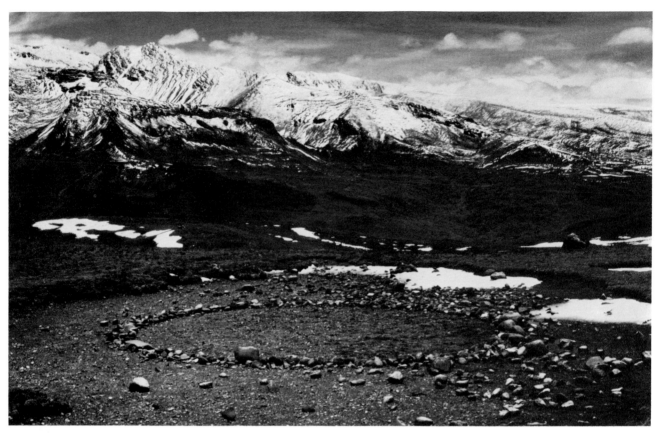

Richard Long: **Circle in the Andes**, 1972.

Raymond Durgnat and visitors including Clement Greenberg, Max Kozloff, Barbara Reise, William Burroughs and Kenneth Noland.[5] It has been said that Caro's students learned 'not a style, not a dogma, but a discipline of doubt and enquiry.'[6] Traditions deteriorate. 'The St Martin's sculpture forum would avoid every broader issue, discussing for hours the position of one piece of metal in relation to another', Bruce McLean remembered, 'Twelve adult men with pipes would walk for hours around sculpture and mumble.'[7] Characteristically terse, Gilbert & George said 'We were not in favour of groups of people standing around talking about sculpture.'[8] Something of the prescriptive tone of senior staff, most of them trained by Caro himself, can be gauged from the writings of William Tucker. In 1975, he defined sculpture as 'subject to gravity and revealed by light.' Freestanding, 'its constancy, in time and space, springs from its fundamental availability to perception.'[9] Reviewing his book **The Language of Sculpture** Albert Elsen suggested that Tucker was becoming 'the Charles Blanc or Adolf Hildebrand of his era, spokesman for an academic abstract art.'[10]

Every one of Tucker's precepts had been violated

long before. Constancy in time and space had been denied by Bruce McLean's photographs from 1967 – **Vertical Ice Sculpture** (a sheet of ice standing upright on a frozen pond) or **Splash Sculpture** (a stone hitting the surface of water). Richard Long's records of travel challenged fundamental availability to perception, showing temporary arrangements of on-site materials as sole reminder of some transient human presence.
☛ After stressing the aggressive potential of sculpture with a set of obstacles blocking the St. Martin's corridors, John Hilliard constructed a luminous line around the perimeter of his ceiling at home, a

[5]See *Studio International*, January 1969 special St Martin's issue and Charles Harrison, 'Some Recent Sculpture in Britain' *Studio International*, 26 January 1969. (Dibbets, a Dutch student researching coloured sculpture in Britain, only used the library.)
[6]Norbert Lynton, 'Latest Developments in British Sculpture', *Art & Literature* no. 2, Summer 1964, p.196.
[7]Nena Dimitrijevic, **Bruce McLean**, Whitechapel Art Gallery, London 1981, p.7.
[8]Anne Seymour, 'Gilbert & George', in **The New Art**, Arts Council of Great Britain, London 1972, p.92
[9]William Tucker, 'Introduction' in **The Condition of Sculpture**, Arts Council of Great Britain, London 1975, p.7.
[10]Albert Elsen, 'A Review of William Tucker's **Early Modern Sculpture: Rodin, Degas, Matisse, Brancusi, Picasso, Gonzalez** (the title of the American edition), in *Art Journal*, Winter 1975-6, p.138.

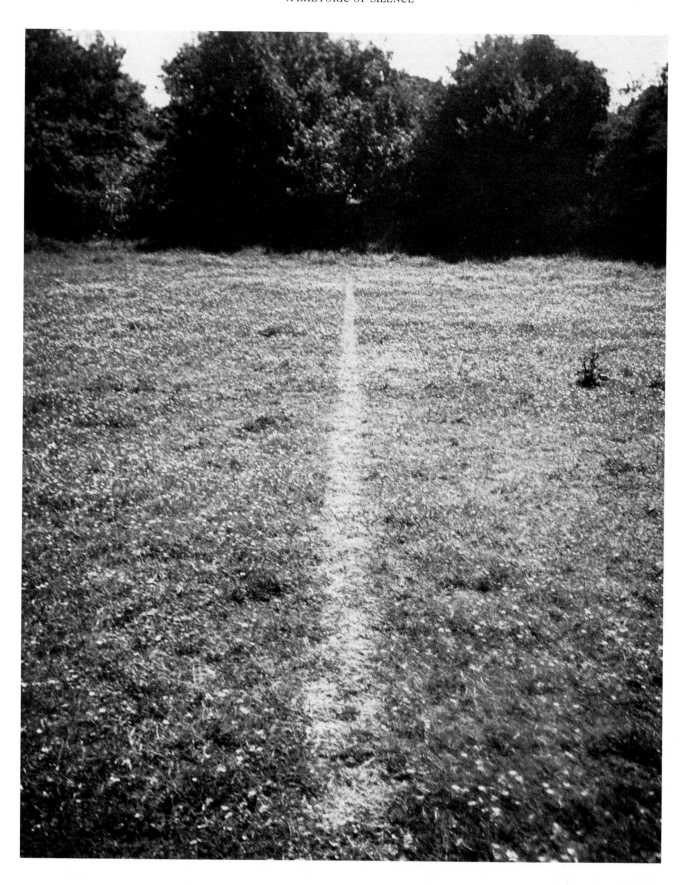

Richard Long: **A Line made by Walking**, England 1967.

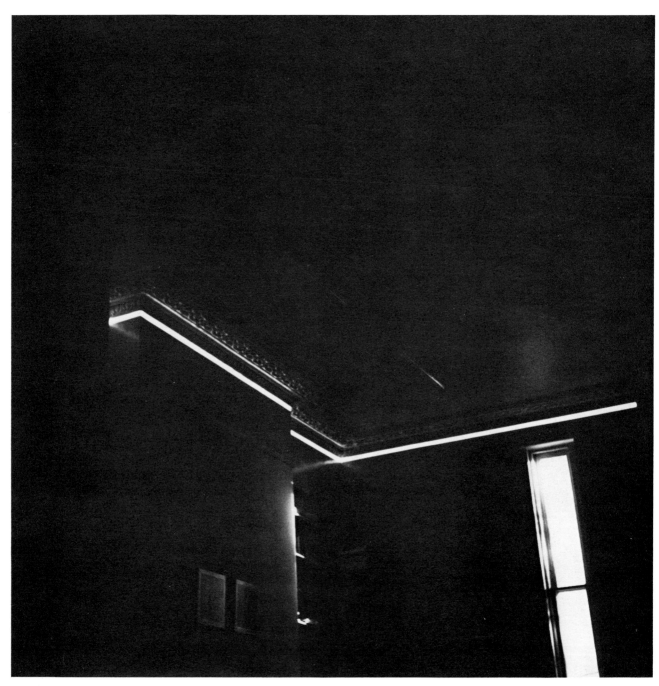

John Hilliard: **Peripheral Illumination**, 1970. Photo-luminescent tape.

work revealed only by darkness. ☛ Certainly floorbound installations by Long or Flanagan could be seen as extending the Caro innovation of abolishing the base. Perhaps in other media ex-students' concerns were persistently sculpturesque. The very fact that McLean, Long and Gilbert & George clung to the term 'sculpture' to describe their activities, however, suggests that no theory of head-on confrontation at St Martin's can ever apply. The likeliest rationale for student reaction is provided by a letter from Barry Flanagan to Anthony Caro dated June 1963, published in *Silence*, a student magazine he co-edited: 'Rejection has been a motivation for me . . . Am I deluded . . . or is it that in these times positive human assertion, directed in the channels that be, leads up to the clouds, perhaps a mushroom cloud. Is it that the only useful thing a sculptor can do, being a three-dimensional thinker and therefore one hopes a responsible thinker, is to assert himself twice as hard in a negative way . . .

John Latham: **Art and Culture**, 1966. Museum of Modern Art, New York.

'I might claim to be a sculptor and do everything else but sculpture. This is my dilemma.'[11] To be or not to be a sculptor was not the question. Rather, how to conduct a career during a time of elected silence. 'Since the artist can't embrace silence literally and remain an artist', wrote Susan Sontag, 'what the rhetoric of silence indicates is a determination to pursue his activity more deviously than before.'[12]

In 1966 John Latham reduced Greenberg's **Art and Culture** to a test-tube of goo and was fired from St. Martin's as a result. Image The same year the Tate mounted their 'Almost Complete Works of Marcel Duchamp' retrospective. A year later in America Michael Fried published his essay 'Art and Objecthood.'[13] Possibly the three events are not as unrelated as they seem. Dissatisfaction with formalism was increasing. In what Victor Burgin later called a 'pseudo-debate' inside the formalist camp Fried distinguished between 'literalism' (Donald Judd) and 'modernism' (Anthony Caro), favouring the latter.[14] His division, seen in terms of life versus art, exposed the very issue which had exasperated Flanagan. To want to make 'sculpture' without accepting the 'rules' laid down to ensure that an object constituted an *art*-object – in other words, to behave as Latham did and call it art – was impossible given existing terms. Duchamp was the necessary catalyst for *new* terms. In particular the readymade – which Octavio Paz described as '*an*-artistic' – became crucial.[15] Michael Craig Martin's *tour de force*, **An Oak Tree**, 1973, a single glass of

water on a shelf in a vast gallery with a leaflet purporting to be an interview with the artist, later summarised the pro's and cons of a belief that 'it's art if I say it is,' hinting that nomination was the infinitely thin knife-edge separating Flanagan's 'sculpture'/'not sculpture' paradox. Image Similarly, Art & Language, a collective working in Coventry, and John Stezaker published lengthy deliberations on the readymade, successfully resisting a Duchampian initiation their American contemporaries had taken more lightly. In 1970 Greenberg, who regarded Duchamp as a phenomenon rather than an artist, sounded the alarm, denouncing the audience for his works in a lecture called 'Counter Avant-Garde'. By that time it was too late.[16]

The flirtation with use implicit in Duchamp was shared by some of the new art. Invited by Cedric Price (who was under the mistaken impression that they were an offshoot of Pop design) David Bainbridge and Harold Hurrell staged an exhibition called 'Hardware' at the Architectural Association. Later Bainbridge found that his 'sculptures' – such as a design for a crane for a children's playground in Camden – made useful topics of analysis for the Art & Language group.[17] Both James Collins, who taught basic design in England before moving to New York in 1970, and Stephen Willats focussed on an art of social behaviour, Collins with his **Introduction Pieces** of 1970 and Willats with his shift from a preoccupation with audience response to sociological field-work.[18] Image Accompanied by a lengthy text, *Beyond Art for Art's Sake*, John Stezaker's **Mundus** 1973, a perspex and wood construction, contained an electronic apparatus by means of which the participant played a game. By answering questions and pressing two control buttons

[11]Barry Flanagan, 'A letter and some submissions', *Silence* no. 6, January 1965, 2-3.
[12]Susan Sontag, **Styles of Radical Will**, London 1969, p.12.
[13]Lucy Lippard, **Six Years**, London 1973, pp.15-16; **The Almost Complete Works of Marcel Duchamp**, London 1966; Michael Fried, 'Art and Objecthood', *Artforum*, June 1967, reprinted in Gregory Battcock (ed.) **Minimal Art**, New York 1968, pp.116-147.
[14]Victor Burgin, **Work and Commentary**, London 1973, n.p.
[15]Octavio Paz, 'Marcel Duchamp or the Castle of Purity', tr. D. Gardner, London 1970, reprinted in J. Masheck (ed.) **Marcel Duchamp in Perspective**, Englewood Cliffs, N.J. 1975, p.84.
[16]Clement Greenberg, 'Counter Avant-Garde', *Art International*, vol. XV, no. 5 1971, pp.16-19. (Adolph Ullman lecture, Brandeis University May 13, 1970).
[17]For Art-Language see Lynda Morris, 'Do You See What They Mean?', in Martin Attwood (ed.), **Artist's Bookworks** British Council, London 1975, pp.88-97; *Studio International* October 1973, Art Theory Supplement; **Art & Language 1966-1975**, Museum of Modern Art Oxford, 1975.
[18]Sarah Kent, **James Collins**, I.C.A. London 1978, pp.13-14; Stephen Willats, **Concerning our Present Way of Living**, Whitechapel Art Gallery, London 1979, pp.13-17.

Michael Craig-Martin: **An Oak Tree**, 1973.

Stephen Willats: **Meta Filter**, 1973-75, at Southampton Art Gallery, 1979.

The Ting: Theatre of Mistakes, **The Street**, London 1975.

it was possible to illuminate panels containing diagrams of four ideas – Action, Custom, Learning and Law. The status of **Mundus** ('world') was that of a diagram, summarizing Stezaker's theories.[19] In **Robin Redbreast's Territory** (1969) Jan Dibbets altered a robin's territory to correspond to 'a form that pleased me,' laying out the new domain with poles like a drawing. 'The sculpture was comprised by the movements of the bird between the erected poles.'[20] From street theatre in which the movements of the 'audience' directed the 'actors', the Theatre of Mistakes proceeded to impose complex artificial codes of behaviour on comparatively simple activities like pouring water (**The Waterfall**, 1977) or saying goodbye (**Going**, 1977). ☛ Interplay of behavioural patterns regarded as taxonomic systems provided tension as well as lyricism, later a mannerist repression of high emotion.[21] The behavioural model could be seen as one side of Pincus-Witten's American post-minimalist dichotomy – 'epistemological activity . . . engaged in the study of knowledge as its own end.'[22]

His other pole, 'ontological activity', which 'tends

. . . to emphasize the self-referential and the theatrical gesture' is certainly paralleled in British art.[23] In **Lecture Sculpture**, a collaboration at the Royal College of Art in 1969, for instance, Gilbert & George sat on the stage applauding politely while Bruce McLean acted out the work of famous sculptors. McLean repeated some of these imitations in **King for a Day**, his thousand-piece, one-day, book-form Tate Gallery retrospective in 1972.[24] 'Theatre' was a term used already by Michael Fried, who defined it as the area between traditional modes. The concluding section of 'Art and Objecthood' described the impression given by 'literalism' and 'theatre', both to be avoided. The experience was that of 'an object in a

[19]John A. Walker, 'John Stezaker at the Nigel Greenwood Gallery' *Studio International*, December 1973, p.248.
[20]Jan Dibbets, **Robin Redbreast's Territory: Sculpture**, Cologne/New York 1969, n.p.
[21]Nick Wood, 'The Theatre of Mistakes: Anthony Howell Interviewed', *Artscribe* no.10, pp.11-14.
[22]Robert Pincus-Witten, op.cit, p.89.
[23]Ibid.
[24]**Gilbert & George: 1968 to 1980**, Van Abbemuseum, Eindhoven, 1980, p.47 and **Bruce McLean**, op.cit, p.21.
[25]Fried, op.cit, p.125.

Stuart Brisley: **And for today…Nothing**, 1972.

situation – one that, virtually by definition, includes the beholder,' extorting some special complicity as another person did.[25] It conveys perfectly the impression given by certain works of Stuart Brisley, notably **ZL 65 63 95 C** or the celebrated **And for today . . . nothing**, both 1972, in which the artist himself was discovered in a filthy room, motionless in a wheelchair or sitting in a bath full of cold water and rotting meat.[26] Here 'situation' was equal in importance to 'object', a person functioning as one element in a totality.

Duchamp's influence served to deflect attention from the internal properties of works of art to their context; what had previously been considered support systems for art rather than the art itself were now emphasized. One major innovation, and the most common British replacement for object-making, was the marriage of language and photography, particularly in books. By the mid-sixties concrete poetry had become a thriving international movement. 'Conceptual' phototexts or titled drawings opposed the concrete poets' belief – dating, perhaps, from the

publication by Pound of Fenellosa's **The Chinese Written Character as a Medium for Poetry** – that words in Western languages can function happily as visual configurations and denotative tools. Like illustration titles, the words in a Long photograph or a Tremlett book do not trespass into a visual medium, but function as in magazine layout or advertisements. Later Stezaker, Burgin and Hilliard were to embark on analyses of exactly these subtexts, Burgin becoming a major critic of photography.[27] Yet despite increasingly scholarly examinations of words and images, the relationship between space on a page and space on a wall, between those two-dimensional spaces and the 'white cube' of the gallery, was seldom if ever mentioned by critics. Without requiring theoretical supports, such as Oppenheim's for his 'removals' or Smithson's for his 'non-sites', the viewer needs to feel some balance between the possibilities of each, and reassurance that in the work of given artists not only general principles but specific manipulations of space are connecting different media. In future commentators may connect the reading process with the duration which characterises performance, and appreciate contrasts between the two. Gilbert & George's page by page, line by line rehearsal of 'Underneath the Arches' in their book **Side by Side** (1971) evokes not only the measured precision of one of their performances but functions as a reminder of the self-perpetuating, endless devotion they proclaim to Art. Long's use of folksongs ('John Barleycorn') or Country and Western music ('Corinna, Corinna') indicate a reliance on regular rhythms and unpretentious content. It also relates to travel and to the relaxed perception David Tremlett has claimed that his pieces demand. Tremlett's own graceful calligraphy in **Some Places to Visit** (1974) or his sign-language in **On the Border** (1979) are the nearest that this schizophrenic medium gets to the concrete poetry of (say) Ian Hamilton Finlay. In Hamish Fulton an entire Arapahoe legend reprinted at the conclusion of **Hollow Lane** (1971) offers no direct key to the photographs. Paradoxically, as his journeys become more picturesque, in **Nepal 1975** or the title piece of **Skyline Ridge**, words diminish. The suggestion is of a loss of identity in the face of alien experience. Like an epigraph in a novel by Sir Walter Scott, the Indian legend acts as a key or talisman while adrift in strange places, among other ways of life. At the other extreme

[26]'Chronology' in **Stuart Brisley**, I.C.A. London, 1981, nos. 57 and 59.
[27]See, for example, his 'Two Essays on Art Photography and Semiotics' London 1976.

Bruce McLean: **Mirror Work**, 1969.

from such loose evocation is the methodical testing of language against picture in John Hilliard, intent on discovering whether his chosen medium can be a vehicle for truth.

Uncertain of how to find terms to cope with the new art, critics isolated its most obvious property. Alarmist phraseology such as 'dematerialization' or 'deobjectification' hinted at some apocalyptic exhaustion of forms.[28] The term 'conceptual art', unveiled before an English audience in the first edition of *Art-Language* in 1969 in an article by Sol LeWitt as well as in the magazine's subtitle, 'A Journal of Conceptual Art,' (but later discarded) stressed that art's concern was change of consciousness, an approach supported by Charles Harrison in his new essay for the London showing of 'When Attitudes

[28]Lucy L. Lippard and John Chandler, 'The Dematerialization of Art', *Art International*, February 1968, edited version included in L.Lippard, **Six Years: The Dematerialization of the Object**, London 1973, pp.42-43. Ursula Meyer, 'De-objectification of the Object', *Arts Magazine*, Summer 1969, pp.20-22.

Keith Arnatt: **Invisible Hole**, 1968 (revealed by the shadow of the artist).

Become Form' at the I.C.A. in the same year. Yet since 'object' can be regarded as the opposite of 'concept' the danger always existed that one side of a false division would banish the other. (Harrison and Barbara Reise, the most sensitive critics of the time, avoided such black and white dichotomies.) Characteristic of artists' preoccupations was the desire to exploit an 'object's' potential to ricochet interminably between fixed systems. One entire *trompe l'oeil* sub-genre demonstrates this well. Jan Dibbets's **Perspective Corrections** (1967-9), Bruce McLean's **Mirror Work** (1969), Richard Long's **England** (1967) and Keith Arnatt's **Invisible Hole** (1968) all provided 'proof' of imagined edges separating levels of reality. ☛ Claes Oldenburg's contribution to a 1967 Sculpture in Environment exhibition was a hole dug by grave-diggers and then refilled. He called it an underground

sculpture and 'a conceptual thing.' Arnatt said 'Although the idea of a sculpture that you couldn't see intrigued me considerably, I was sceptical about the notion of a sculpture being a "conceptual thing". There is at least a clear distinction to be made between the concept of a filled-in hole and an actual filled-in hole and it did worry me at the time that one had to take someone's word for it that such a hole had been dug and filled in.'[29]

His hole, mirrored on the sides and with the turf removed from the surface of the ground replaced on the bottom, isolates his own confusion, states the paradox he perceived and does nothing more. Yet he notes the paradox that Flanagan had already described

[29]Quoted in Richard Cork, 'Sculpture Now: Dissolution or Redefinition?', Lethaby Lectures, Royal College of Art, 11 and 12 November 1974, *Audio Arts Supplement* 1975.

Braco Dimitrijević: **Monument to David Harper, the casual Passer-by I met at 1.10pm**, London 1972.

to Caro; 'sculpture' defined in the terms they both inherited, was unworkable unless definitions of all kind could be shelved or altered or confused.

As a typical 'sculpture' of the period Arnatt's **Invisible Hole** exemplifies one especially appealing quality – an underlying desire for anonymity. Similarly, Braco Dimitrijević, in a funny, Warholian series, made monuments to the 'casual passer-by' he met in the street at a given time and place. They could be in any medium from hoardings to public sculptures. Finished and installed, they proved indistinguishable from other hoardings or monuments to allegedly 'famous' people, a situation which permitted the artist to claim that works *could* have been made by him. In an urban setting, he was making his own human parallel to the activities of Long, disturbing the landscape then passing on. Gilbert & George's

assumed personae, identically clad gentlemen from an earlier age, finally led to charges of snobbery and insincerity. *Art-Language* magazine proposed a continuing dialectic by which guidelines could be established for an art not yet in existence. Unlike Stezaker, who claimed his essays as his art, they offered only inconclusive dialogue, the record of a search. Fulton and Long avoided publicity. Such apparent modesty befits an art *povera*, stripped to the bone as a protest against the economic system. Yet humility too can satisfy the media. Richard Cork noted the movement's 'abject failure' to bypass the art market.[30] Anne Seymour wrote that 'instead of being quite unusable within the sinister structure of the art market an enormous amount of money has been made out of Conceptual art.'[31]

Sadly, ten years later the explosion of activity which post-Caro sculpture represented has been all but forgotten, the product of an episode in which criticism may have outrun original creation. Permission has been granted for a certain type of performance and a precedent has been set for artists to fluctuate between media. The almost Georgian naïveté of approach to nature may continue to charm, but grotesqueries of jargon and ill-informed borrowing from other disciplines have worn badly and exerted little influence. Vicarious experience of other people's emotions through 'documentation' was also a feature of the time, it seems. It has not persisted. Yet the virtues of a 'moratorium on objects' were undoubted and in future may seem a moral, if Pyrrhic, victory.[32] Above all, it dented formalist doctrines once and for all, as well as warning against a surplus of objects in the world. What terms art employs to describe its manifestations is of no concern to me. But my lack of concern was fortified, if not engendered, by this period. It seems inconceivable that sculptors cannot use its findings to enrich their practice in future, finding time amid the din to listen to a rhetoric of silence.

[30] Richard Cork, **Arte Inglese Oggi 1960-1976**, vol. 2, British Council Milan, 1976, p.314.
[31] Anne Seymour, 'Introduction', op.cit, p.6.
[32] Victor Burgin, 'Thanks for the Memory', *Architectural Design*, August 1970, p.388.

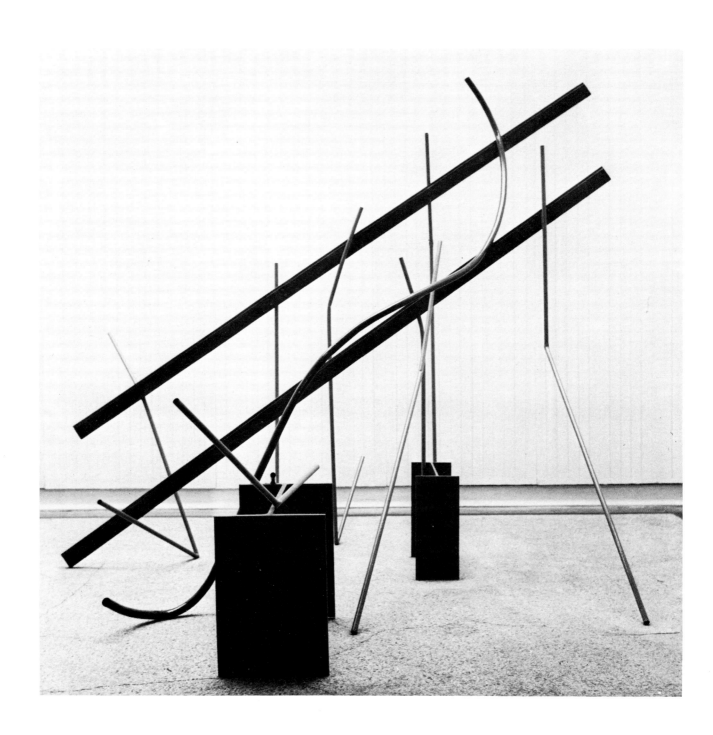

Anthony Caro: **Month of May**, 1963. T. M. and P. G. Caro.

XVI. Constructed Sculpture.

Bold innovation is not a familiar feature of British art: it usually reflects a foreign influence, and so it has been in the case of the constructed sculpture which began to appear in Britain in the 1960s, for Anthony Caro, who initiated this new wave of work with his welded steel sculpture, drew inspiration from the American David Smith. The broad American influence on British art, which was so much a feature of the 1960s, ultimately prompted a reaction. Sculpture has not been an exception. As this essay will show, the very sculptors who have most recognisably extended a tradition established by Caro's sculpture, in a strictly technical sense, have in some cases been those most concerned to question his work. In fact there has been a shift in taste, the light, openly-articulated sculpture of the 1960s now being regarded by some as anti-sculpture. My aim in this essay is to analyse the reaction against Caro's earlier sculpture, to define the characteristics of the new sculpture which has emerged and, finally, to argue that there is, in spite of everything, an underlying affinity with Caro's work of the 1960s.

In fact, the reaction itself began in the 1960s, because of Caro's very strong influence on the sculptors who were closest to him. Caro released creative energy in others and they, quite naturally, took pains to distance themselves and find their own ground. The fact that the generation of King, Scott and Tucker was normally prepared to construct in any material *except* steel speaks eloquently enough.

St. Martin's School of Art, where Caro and the others all taught in the 1960s, provided a forum and indeed 'sculpture forums', in which individual works were discussed, became a well-known feature of the teaching there. Sculptors would bring their own creative problems directly to bear upon their teaching. Caro's example encouraged this: he has always valued mutual criticism in sculpture. Phillip King says that it was precisely this 'openness', the sense of a forum, that attracted him to St. Martin's, as it must have attracted many others.

In terms of the reaction to Caro, King's work is a case in point. His 1960s sculpture, although physically relatively insubstantial (he frequently used fibreglass), had a very concentrated presence which can be attributed to his characteristic use of centralised, symmetrical form. King's powers of visualisation and his strong feeling for the expressiveness of colour worked to reinforce this presence. His sculptures generally had a more enclosed, object-like character than Caro's and this formal difference was bound up with the difference between their respective ways of

working. Whereas Caro would begin with an open space and let the chosen materials impose a form as he worked with them, King usually established the basic form of his sculpture at the outset. Enclosed form, then, and figure-like presence were characteristic of King's work from the beginning. In different guise, these came to be predominant features of the constructed sculpture of the 1970s and of the work of the succeeding generation.

Peter Hide was one of the first younger British sculptors to adopt Caro's methods and his sculptures could be seen as conducting an argument with Caro's, on the same ground. For example, **High and Over**, of 1976, clearly resembles Caro's work of the 1960s in a technical sense, but its organisation is dissimilar, its parts being joined one to another so as to make a simple continuous construction: with Caro, the parts of a sculpture had often (in the 1960s) been physically divorced from each other. ☛ Caro made sculpture *elastic*, in the sense that separate or strung-out parts were held in a sculptural tension across space (American field painting had been an influence here). In Hide's work, physical structure, rather than spatial arrangement, had come to be the unifying principle.

On the other hand, some younger sculptors drew on the very qualities of Caro's work that Hide rejected: for example, David Evison, who had been a contemporary of Peter Hide at St. Martin's. In pieces like **Sculpture IV**, of 1976, he balanced physical factors such as flexibility and weight with visual ones such as shape and reflectiveness, yielding a spatial experience which was a union or interplay of these contrasted terms. ☛

This distinction between the physical and the visual is somewhat artificial, but it has a pragmatic justification, since to test flexibility we must have direct contact with a material, whereas we apprehend reflectiveness in detachment, at a distance. These sculptors could thus be seen as appealing to our experience in quite different ways. Broadly, Hide appeals to tactile experience, by placing the unifying principle within the object (it is continuous), while Caro and Evison appeal to both sight and touch, wholeness here being more in the eye of the beholder.

Underlying these differences of approach are differences of expressive purpose and these persist, in spite of stylistic change. In purely stylistic terms all constructed sculpture has moved, in the 1970s, towards greater physical assertiveness. Caro's **Surprise Flat**, of 1974, for example, up-ends massive pieces of unpainted steel waste and has a relatively

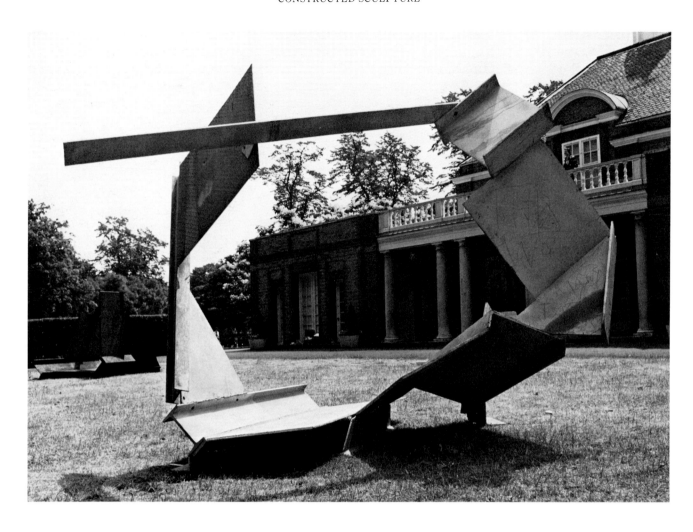

Peter Hide: **High and Over**, 1976.

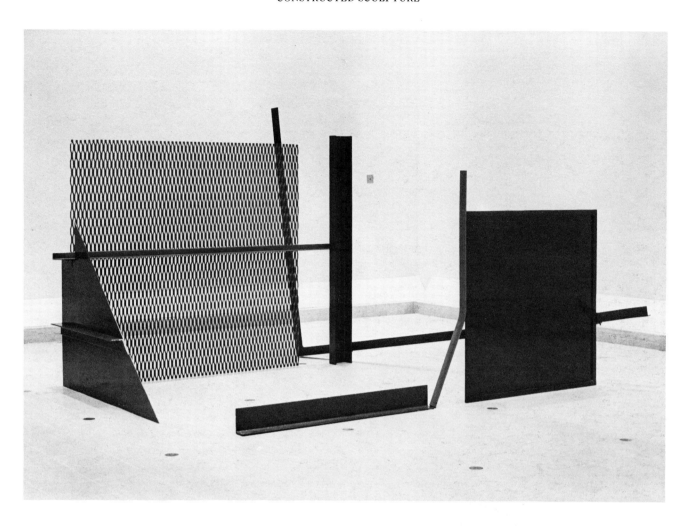

Anthony Caro: **The Window**, 1966-67. S.M. Caro.

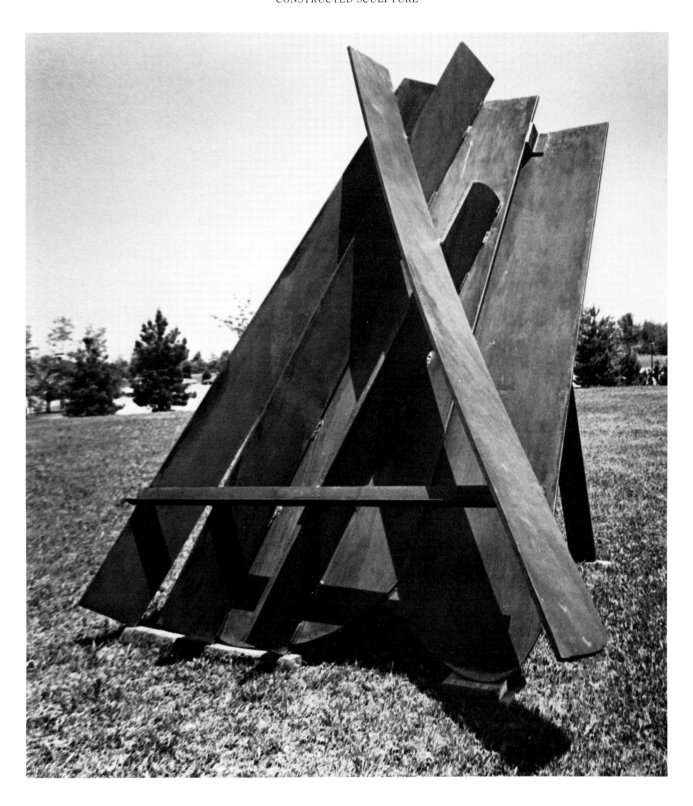

Anthony Caro: **Surprise Flat**, 1974.

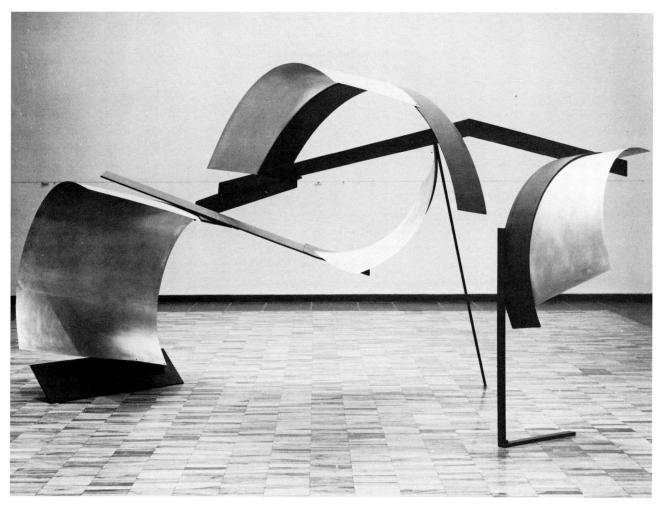

David Evison: **Sculpture IV**, 1976. Whitworth Art Gallery, University of Manchester.

closed overall form. ☛ However, the ordering of the parts gives a lightening effect: as in relief, the different parts refer to a single ground-plane, the overall formation being sign-like, even gestural, a letter A with a bold crossing-stroke. We are encouraged to bring to the sculpture the sense of a unifying pictorial screen and see the material parts in terms of it.

This is an example of what is known as the pictoriality of Caro's sculpture. In the 1970s, pictoriality became a contentious issue and the fact that it did so was due, amongst other things, to an increasing concern with the definition of sculpture. William Tucker played a leading part in this discussion, through his book **The Language of Sculpture**, 1974, the ultimate concern of which was to relate present practice to sculpture of the past. Constructed sculpture was now coming to be seen against a European background and in terms of a long sculptural tradition, rather than in terms of an American aesthetic whose bias was pictorial. In 1975, Tucker organised an

exhibition, 'The Condition of Sculpture', at the Hayward Gallery. He tackled the problem of definition in his catalogue introduction, placing special emphasis on what he termed 'the condition of gravity'.

Tucker helped to focus debate, but Tim Scott, another sculptor of the same generation, was influential in a more direct way. In about 1975, Scott, who had until that time chiefly used plastics, began to use steel. Caro's sculpting had always been a matter of welding given elements together. Scott felt a need to work the material more and to let this sense of manipulation be present in the sculpture. Steel is rigid and dense, but also malleable. It can be bent without breaking. Its inner strength is such that a heavy piece can support its own weight and that of other pieces while being itself supported from one small part of its surface. Looked at prosaically, Scott's steel sculptures – typically, clusters or tripod-like formations of thick, machined pieces – express these properties, and speak of gravity. Scott's way of working with steel was

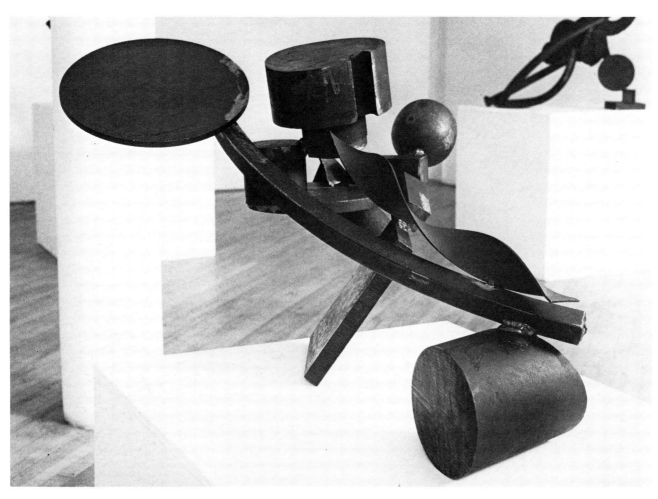

Tim Scott: **Rupavali II**, 1976-77.

radically different from Caro's. It provided an import-
ant alternative for younger sculptors, and it was at the
Stockwell studios that his influence was eventually
felt, though in fact the sculptors working there had
already been moving in a similar direction.

Peter Hide had been working in a studio at the
Stockwell Depot since 1967. The younger sculptors
most closely associated with him there – they all
showed work in yearly exhibitions at the Depot from
1974 onwards – were John Foster, Katherine Gili and
Tony Smart, the last two having been students at St.
Martin's. All four were making welded steel sculpture
and were well acquainted with each other's work. In
effect, a craft tradition was being developed. Although
this craft had its material beginnings in Caro's work, it
was informed by a rather different aesthetic, one in
which the experience of painting no longer had a
positive role to play.

Peter Hide's work dominated the first of the yearly
exhibitions in 1974: he showed the large enclosure-like
sculptures **Shaft** and **Advance**. Foster's **Blue Drum**

was similar in formation, but far smaller and different
in working, while his other piece, **Small Drum**,
showed a fluency and warmth, a feeling for the
material, which was matched only by Gili at this time.
A relatively small scale clearly suited these sculptors
and it is worth pointing out that Scott too was
frequently making quite small pieces (Caro's **Table**
series should also be remembered here). In Hide's
work, by contrast, there has always been a sense of
architecture or engineering.

Gili was able, by 1977, (in her Serpentine Gallery
exhibition) to show sculptures as distinctive as
Roundalay. ☛ It was, and is, surprising to see steel
used in so sensuous a way, and the connotation of
dance movement accords well with the sculpture's
form. The movements of the dancer define the body's
extremes, hence the continuing fascination of the
subject for sculptors: the objective integrity of the
sculpture can be braced against its expressed
expansion, to give an equivalent for the restrained,
graceful vitality of dance. Gili had always tended to

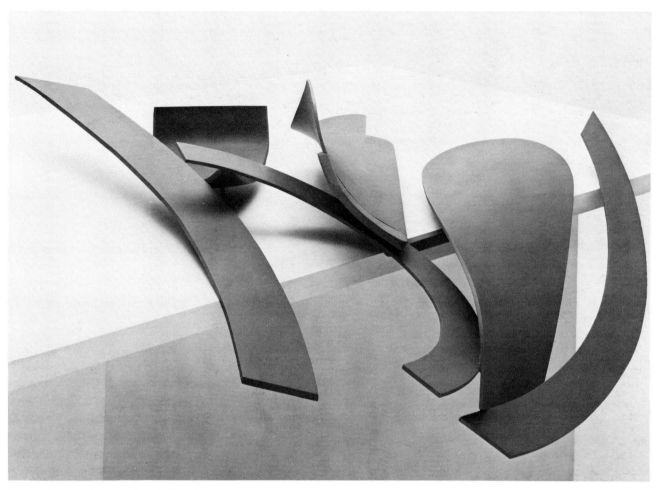

Anthony Caro: **LXXXII**, 1969. Tate Gallery, London.

make abstract formal reference to the human figure in her sculptures, but only in the Serpentine pieces did she give the figure-theme a positively expressive role, and this pointed to later developments.

These sculptures make a strong contrast with Smart's **Tamarind** series of the same year. Smart was trying to engage directly with mass and weight, in a way which partly related to Scott's work. But whereas Scott's sculpture was additive, one part held out from another, Smart's was closed, dense, lump-like. The other Stockwell sculptors had also used closed form, but not in this compressive way. Where Gili had exploited the expansiveness of surface, Smart was seeking to reduce the sense of surface in his sculptures to a minimum. In his untitled metre-high sculpture of 1978, he came closer to achieving his aim. The sculpture is relatively small and the disposition of weight within it is clearly expressed. There are no broad expanses of surface, the whole being made up of relatively small pieces welded (but not melted) into interconnecting masses. This is an effort to sculpt

from the core, from the inside: at its simplest, the sculpture comprises a loop which emerges from a base mass and returns into it, this being also a movement from jagged to rounded form.

Smart, Gili and Scott are all making sculptures which, although they do not resemble bodies, can be seen as body-analogues. In 1980, when Scott became Head of Sculpture at St. Martin's, sculpting from the model (constructing with rolled, reinforced clay) was made the basis of the curriculum. Studio practice at St. Martin's therefore closely follows the work which these three sculptors do in their own studios. Their present concern with the human figure is an abstract one, having to do with structural principle. It has resulted from stylistic change, which is informed by an increasingly apparent preoccupation with sculpture of the past and of other cultures.

This apparently steady development from bold innovation to conscious traditionalism has not gone uncontested. Although both Peter Hide and John Foster have been strongly affected by Smart's work,

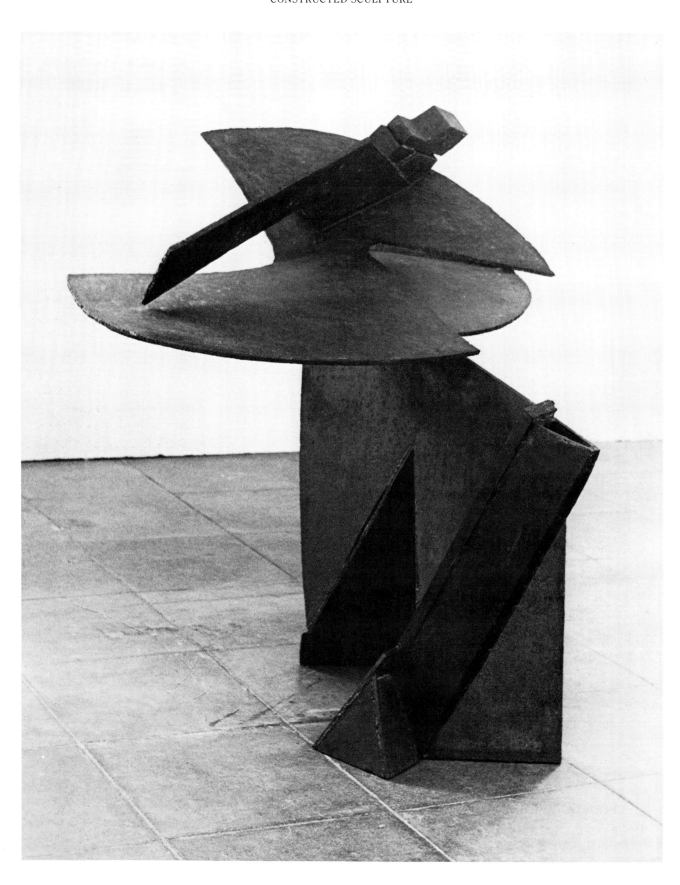

Katherine Gili: **Roundalay**, 1977. Private collection.

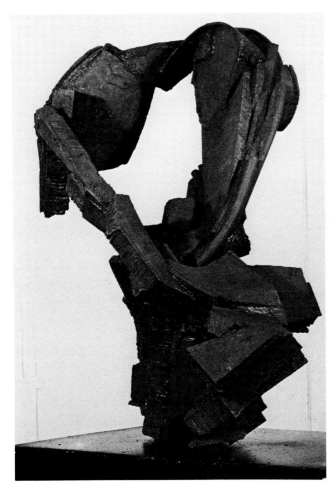

Anthony Smart: **Untitled**, 1978.

means. The sculptor's imagination is the depth, so to speak, from which the work arises. Hewlings begins with a shaping image or idea to which he must then give form; it could also be said to be the goal which he hopes to arrive at, for his sculpting is direct and exploratory.

He generally works through polar oppositions (open and closed, dark and light, above and below etc.), and it is by virtue of this that his sculptures gain their meaning, rather than through overt symbolism. He does not depend upon specific physical means, having in the past used mixed materials. Recent sculptures, like **Interiors**, 1979, are made of welded steel, in order that the differentiated forms should arise within a structural continuity. ☞ A consciousness of structure, and of structural equivalence, is central to Hewlings' concern with the archetypal. It enables him to fuse disparate images, ideas and associations into a synthesis whose pattern can be found again in the sculpture.

Hewlings' disagreement with Stockwell sculpture, then, is fundamentally a conceptual one: in formal or technical terms he has much in common with it. However, his work also has formal affinities with that of Phillip King. King was mentioned earlier as having anticipated the move towards closed sculptural form, but he did not participate in the developments described above. In the last few years he has made frequent and inventive use of heavy materials, slate slabs and wooden logs as well as steel, the steel generally setting fixed bounds with which, and within which, the other materials interact, as in **Open Place**, 1977, in slate and steel. ☞ King has moved from synthetic materials to natural ones, from applied colour to the colour of the given materials. Like David Evison, he makes expressive use of material differences, but there is a marked contrast of character between the work of these two sculptors. Evison's recent oak-block sculptures are characteristically calm and contemplative; King brings out the harsh and rough aspects of his materials and pushes structural tensions to an almost expressionistic extreme.

These sculptors do not form a group in an ideological sense, but they can be seen in opposition, as it were, to the Scott-Gili-Smart axis. These groupings are of course unfair to individuals: Gili's work remains quite distinct from Smart's, for example. However the aim here has been to trace the pattern of innovation and to bring out broad differences of approach. Hewlings, King and Evison all work in different ways, but, like Hide and Foster, they all want to retain

they have subsequently pulled away from it, returning to more open ways of working; Hide says that he wants 'to regain a sense of steel parts and relations between them'. Foster's recent sculptures (shown at Richard James' studio in October 1980) are shell-like in form and make plastic use of surface as well as substance. However, the sculptor whose work has differed most clearly in *principle* from that of much recent Stockwell sculpture is Charles Hewlings. Hewlings was a student at St. Martin's with Katherine Gili and Anthony Smart; but a full account of his approach makes its divergence from theirs apparent.

Like other sculptors, Hewlings finds inspiration in ancient and non-European sculptures, but not simply in terms of form. His reading of Coomaraswamy showed him how Indian sculpture finds its form within a cultural and religious context: the sculpture is, like the tip of an iceberg, the outward sign of an unseen depth. For Hewlings, the challenge is to make sculpture which has at least something equivalent to this depth of meaning, though with present-day sculptural

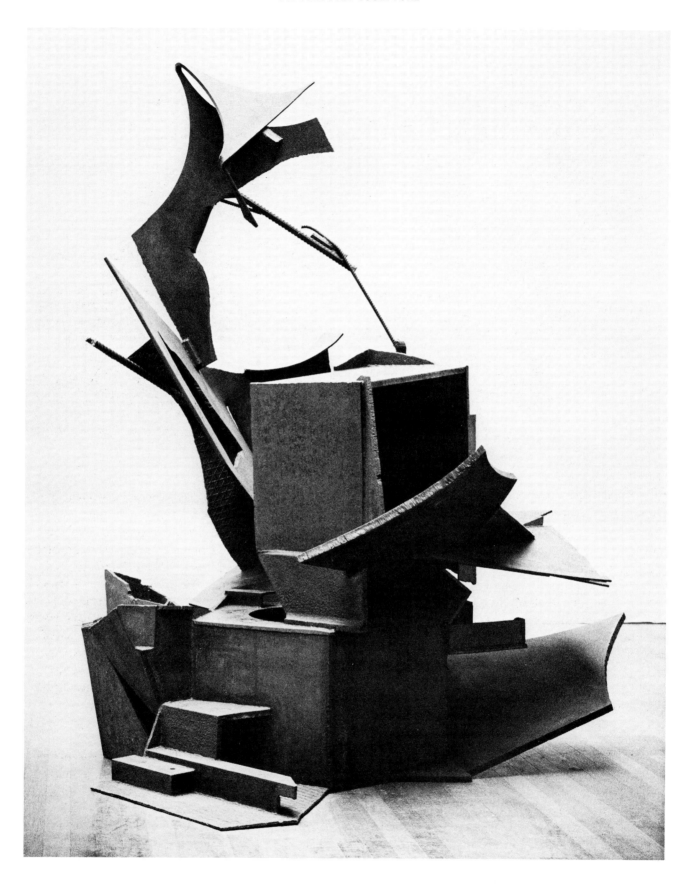

Charles Hewlings: **Interiors**, 1979.

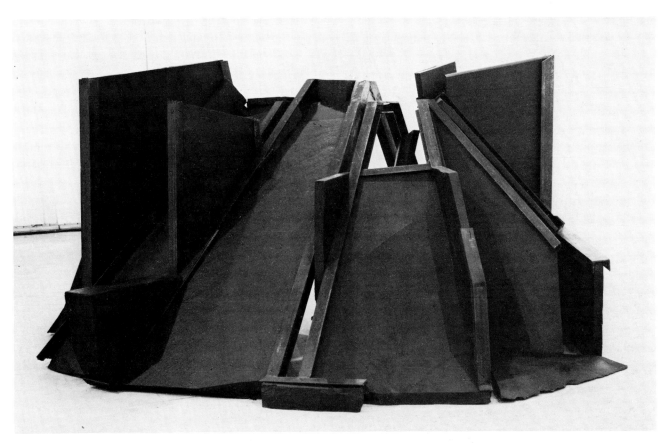

Phillip King: **Open Place**, 1977.

something of that openness of form which Caro had brought to sculpture. To put it crudely, the divisive question is: to qualify as real sculpture, must a work be solid through and through?

This leads us to the subject of carving, and to a third grouping of sculptors. The key figure here is Glynn Williams. Williams is Head of Sculpture at Wimbledon art school, and during the 1970s there has been a certain convergence of views between Wimbledon and St. Martin's, in terms of the issues outlined above. Williams had, as he now puts it, been 'seduced' by the dematerialized style of sixties sculpture, but he changed direction by the mid-seventies, when he started to construct in wood. This led to a combined process of constructing and carving and, in terms of style, to a Moore-like organicism. Williams is consciously reviving a practice of sculpture evident, for example, in Moore's early stone carvings. He has himself now begun carving in stone, taking ancient sculpture as a starting-point, as in his **Sea Rider (from the Etruscan)**, of 1980. ☛ His present treatment of a mother and child theme reflects his feeling that sculpture should frankly express human subjects.

Another sculptor who takes this view is Lee Grandjean; Grandjean draws inspiration from Roger Fry's writings (as do some of the other sculptors mentioned) and quotes Fry's works on sculpture as portraying 'the vital essence of man, that energy of the inner life which manifests itself in certain forms and rhythms.'[1] Like Williams, Grandjean has turned from combined carving and constructing to carving proper; he chiefly uses wood. Williams' and Grandjean's use of representation distinguishes their work from that of Smart, Gili and Scott, but the difference of medium should be borne in mind: carving, with its integral mass and continuous surface can present physiognomy in a way that steel construction cannot.

A further sculptor to add to this third grouping is Bob Russell, who works in wood, carving and constructing. Russell is particularly conscious of the effects of environment on sculptural work: a sculpture is, after all, in the world in a way that a painting is not. Recently, under the stimulus of work which he did with schoolchildren[2] Russell has been making abstract

[1] Roger Fry, **Last Lectures**, Boston 1962 (reprint) p.76. The actual subject of the sentence is 'Negro Art', but Fry's general argument concerns sculpture.
[2] In a year-long project at the Woolmore School, Poplar, under the auspices of the Whitechapel Art Gallery.

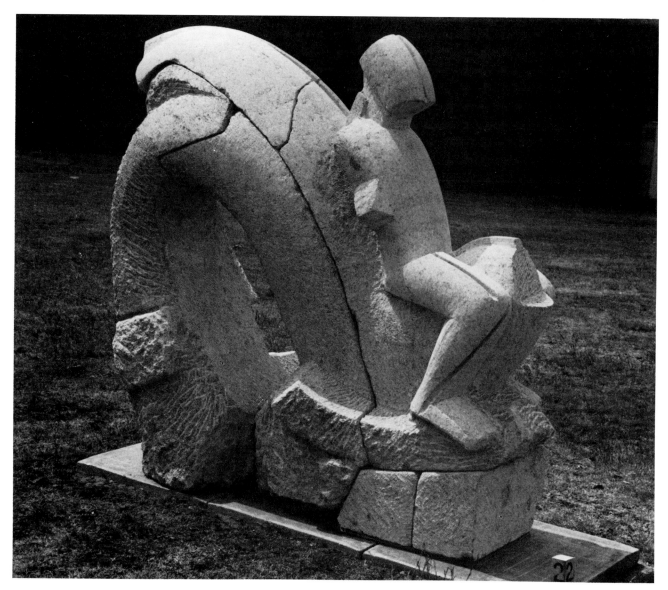

Glynn Williams: **Sea Rider (from the Etruscan)**, 1980.

sculptures based on the human figure in movement. **The Tumbler** and **The Hurdler**, both 1980, are typical: they combine a sense of dynamic rotation with a dramatisation of balance. ☛ If there are risks involved in this sculptural kineticism, they are taken for a purpose, since Russell is engaged in making work in which some aspects of human experience can be clearly recognised, and in this he shares common ground with Grandjean and Williams.

The differences of approach described here are real, but they are set within very tight limits. Ultimately, these limits reflect the empiricist bias of English culture, and that love of the intimate and the immediate which accompanies it. This is evident in the contrast between Caro and the American David Smith, in their differing conceptions of sculptural

openness. Smith sets presence-as-image against presence-as-thing (there, even when unseen), summoning to individual perception an intimation of the world which exists independently of it: there is a casualness or ease to his sculpture which encourages in the viewer a distanced, circumspect contemplation, and in this lies Smith's monumentality. Against this, Caro's 1960s sculpture was a formal dialogue of the open and the closed which stressed the object and its internal relationships. Where Smith had opened to the world, Caro presented an internal openness: aesthetic wholeness was paramount. In this, Caro's work was latently figure-like. St. Martin's practice took this to its logical conclusion. In studio criticisms, people would speak of 'focussing in' on a sculpture so as to judge its rightness. The notion of a focus or centre –

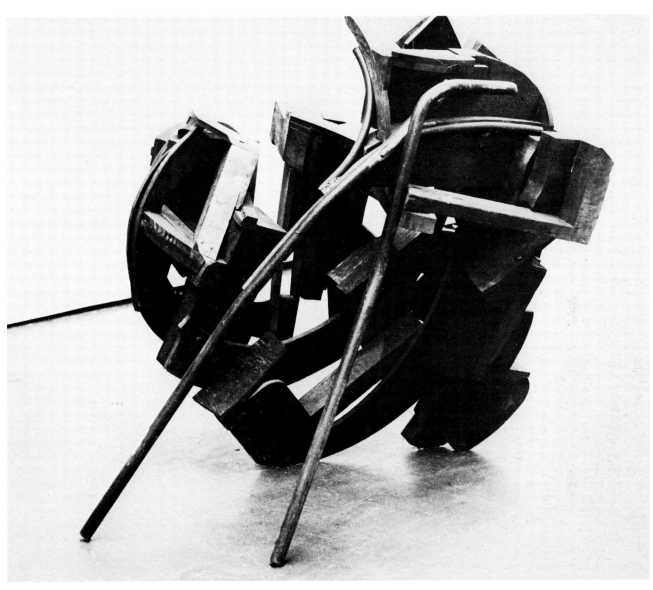

Robert Russell: **The Tumbler**, 1979.

the stage for individual artistic actions – was there at the outset: the present concern with the sculptural core is simply a more emphatic development of the established theme.

The bold innovation referred to at the beginning of this essay can now be presented in a different light: what Caro found in America he transformed in terms of his own European background and experience, and by virtue of this succeeded in making genuinely original work. In the seventies, the sense amongst younger sculptors of coming home, returning to European roots in terms both of style and subject, has been very strong and much of the most original work has sprung from it. This is not mere retrogression: there is creative purpose in approaching the familiar through the unfamiliar, the unfamiliar being, in this

case, the particular sculptural practice that Caro introduced. This theme of return or homecoming highlights that love of intimacy referred to earlier, for what constructed sculpture has gained in the seventies has been an enhanced sense of contact: this is both in terms of the sculptor's immediate physical rapport with the work in hand, and in terms of his or her sense of the sculpture's resonance within experience. 'Making new' has been as much a concern in the seventies as it was in the previous decade, but there is now a particularly strong insistence that innovation be well founded. This probity is discernible in the best work and the best work, these days, proceeds slowly.

Fenella Crichton:

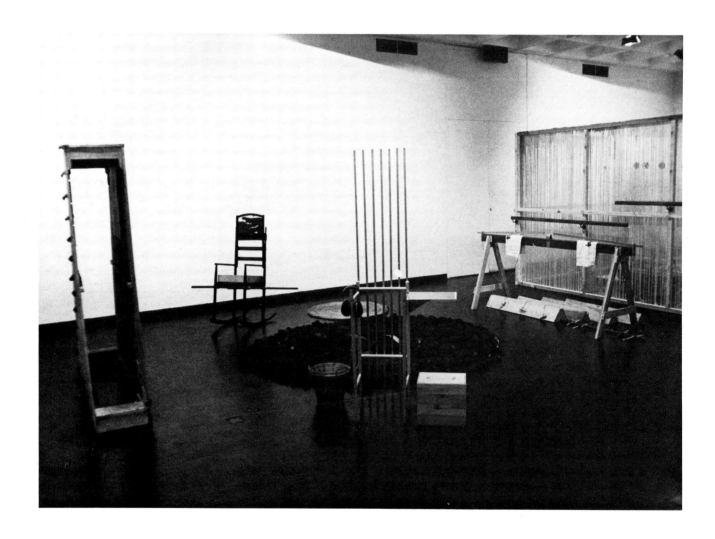

Carl Plackman: **Raft**, 1977-78.

XVII. Symbols, Presences and Poetry.

Poetry and symbolism are two of the qualities which strongly characterise a new strain of sculpture which has emerged in Britain since the late 1960s. The factors which underline this tendency can in many ways be regarded as a resurgence of a Romantic tradition. Baudelaire's famous non-definition 'Romanticism is precisely situated neither in choice of subject matter, nor in exact truth, but in a way of feeling' paradoxically remains the best definition of that kind of art which depends upon the expression of an artist's personal truth. In the early nineteenth century a sense of emotional authenticity became for the first time the most important criterion for evaluating art. This gave rise not only to the introduction of autobiography in a specific sense, but also to a growing belief that the artist had an obligation to be faithful to a contemporary reality. But at the same time the notion of a norm, or universal standard, became anathema and the nineteenth century Romantics 'were, and still are, identified because they differed'.[1] What these British sculptors have in common, distinguishing them from their contemporaries, is that their personal experience of the world is brought to bear directly on the meaning of their work. It is a conscious decision and, unlike many artists whose search for originality is centred on the invention of new forms, these sculptors use forms which above all have a degree of personal meaning. This means that their work relates directly to their personalities, ensuring that there is always an important dimension which is private, whatever the scale. It is of course no accident that many of them were at one time students at the Royal College of Art. But they are not a group, nor does their work constitute a movement, even in the imprecise sense of common aspirations. And so although I believe that their work does amount to a kind of revival of romanticism, some of it supports this view more strongly than that of others.

One of the most memorable images of nineteenth century Romanticism is Géricault's **The Raft of the Medusa,** and it so happens that the imagery of this painting occurs in work by two of the most different of these sculptors. It is a painting which is psychologically ambiguous: at first sight it may seem to suggest that rescue is imminent, but in fact Géricault chose to paint the moment of dawning despair when the men began to realise that the ship on the horizon is actually sailing away. In Carl Plackman's **Raft,** 1977-78, the raft serves as a metaphor for a state of the artist's own mind. ☛ Divided into two sections, the whole represents a moment in his life when he felt himself

simultaneously able to look back at childhood and forward to old age. But in Michael Sandle's mind the image is so intimately connected with death in a universal sense that in a series of recent projects for a tomb he uses a raft-like structure containing hollows where two bodies might be laid side by side.

If any artist can be said to have anticipated the new direction, which later took root at the Royal College, it is Michael Sandle. In 1964 he said that he wanted to find 'symbols for that which I fear or hold in awe . . . ghosts, War, Death, dissolution . . . to invest my work with magic, to make a talisman to render myself proof from whatever I feel could interfere with the continuation of my personality or volition.'[2] Sandle is a perfectionist, which is a useful neurosis for an artist, and he believes not only that doubt is an essential part of the working process but also in what he calls 'that indispensable quality of psychic pain'. To date he has completed only three major sculptures: **Oranges and Lemons,** 1966, **Monumentum pro Gesualdo,** 1966-69, and **A Twentieth Century Memorial,** 1971-78. ☛ All three are fantastic and surreal constructions, though the last is probably the clearest expression of his obsession with destruction. Ostensibly a memorial to the Vietnam war, and a condemnation of the horrors perpetrated in its name, it is nevertheless in one sense an exaltation of the purity and potency of death. The rotting figure manning the machine gun may demonstrate Sandle's gothic fascination with decay, but the weapon itself is gleaming and looks serviceable. Sandle's work instils an awareness that the cult of heroism is the stuff of Fascism and, although he has many admirers in this country, it comes as no surprise to discover that some English people find his work hard to stomach. In 1973 he moved to Germany but he had already had a significant influence on the development of a certain strain of British sculpture. Both Graham Ashton and John Cobb were at Coventry when he taught there in the 60s but, more important in the light of subsequent events, is the fact that Martin Naylor worked very briefly as his assistant.

In 1960 Bernard Meadows became Professor of Sculpture at the Royal College. By the end of the decade it was widely recognised that something new was happening within his department. Not all the work produced falls within the scope of this essay and in fact there was a strong feeling among the students that they were distinguished precisely by their indepen-

[1]Hugh Honour, **Romanticism,** London 1979.
[2]Robert Kenedy, 'Death as Speech: Michael Sandle's Universals' *Art International*, Vol. XIV/6, Summer 1970.

Michael Sandle: **Funereal Raft**, 1978.

dence and freedom from ideological constraint. But at the same time they did see themselves as providing an alternative to what they regarded as the uniformity of the St. Martin's style. Of course a different kind of revolt was itself taking place at St. Martin's but its ethos was equally alien to the students at the Royal College. Students there were quite clear that they were working in a School of Sculpture, no matter how unconventional a route they followed.

One of the first intimations of this new spirit was given by a piece called **Three Frames** made by Kenneth Draper during his final year in 1967. ☛ What was curious about this work was that although it was a large abstract sculpture in the New Generation mould it had sprouted box-like details in aluminium which contradicted a formal reading of its structure. Any impulse to close these 'drawers' was frustrated by the rows of pegs which studded every surface: a ploy to aggravate the reading of a simple object, and a neat updating of early Giacometti. That same year Martin Naylor and Carl Plackman arrived at the college. Naylor was stimulated by his brief meeting with Sandle and by his second year had started making original and overtly sinister environmental pieces. As the spec-

tator approached the steel and concrete wall of **Another Place**, 1968, he could see the edges of a curtain being regularly lifted from a hidden source, and as he stepped unknowingly past the boundaries of its 'precinct' he activated an unpleasant whining feed-back. ☛ Plackman's means of heightening the viewer's awareness of their own responses were more gently persuasive. In **Broken Promise**, 1968, the audience was required to negotiate three barriers across a corridor to find only a blank card index waiting: a journey of expectation with a disconcerting end. At this time the sculpture department was running at an extraordinarily high pitch. There was a great deal of aggression but it was also an extremely productive period. Shortly afterwards John Cobb arrived from Coventry, where he had been reading about behaviourism and making pieces which utilised the erratic movements of live chickens. Simultane-ously, Malcolm Poynter was making life-like tableaux with sadistic overtones, such as a middle-aged blonde sprawling in a pile of sand littered with razor blades. ☛

Much of this student work was theatrical and the devices employed blatant, particularly in the case of

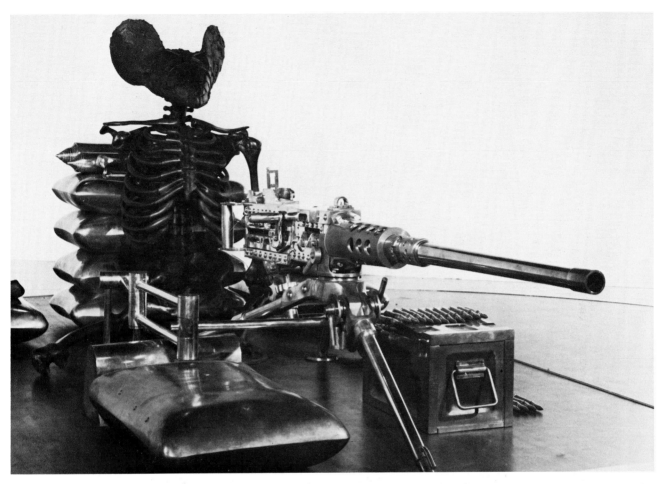

Michael Sandle: **A Twentieth Century Memorial**, 1971-78.

Martin Naylor. But in his first one-man show, at the Rowan gallery in 1974, Naylor moved right away from visual histrionics into an area which was more subtle and emotionally ambiguous. The sculptures in his series **A young girl seated at her window** were composite arrays of bits and pieces which evoked with great tenderness his own fleeting moods and memories. A broken cup balanced on a tripod and coils of spindly wire casting insubstantial shadows: everything depended on the exact placing of each frail and delicately allusive part. In the same show his **Discarded Sweater**, one of his most memorable images, read almost like a dramatic notation splashed across the pages of a diary. ☛ Even though the roots of this kind of assemblage are familiar, Naylor's work had an intense, personal mood which can really only be described as a kind of 'visual poetics'. In 1976 he wrote 'this mental time with its peculiarities and its gaps, its obsession and its obscure area is the one that fascinates'. The words were scrawled across a photograph which showed a film crew in the action of recording the passage of a woman through a room. This found image

(a Bergman film still) recurred throughout the exhibition and in several instances it had been subjected to various kinds of aesthetic despoliation. This manifestation of destructive impulses draws attention to the conflict between reason and passion, or male and female, which is invariably expressed in his work.

It may seem strange in writing about sculpture to dwell on the role played by a photographic image in directing our responses to the work. But a photograph can in itself be turned into an object and yet retain its identity. This point was well illustrated in a piece by Tony Carter. **Arc – the mould and the cast of a warp implied by the strain of a drawn bow**, shown at his one-man exhibition at Garage in 1974, consists of a photograph of a Japanese archer and, laid out beside it on a separate plinth, a crumbling and partial replica. Carter had covered the original with an opaque paste, centimetre by centimetre, and had then reproduced in paint that portion of the original which he had just obliterated. The photographic paper began to curl backwards, and he therefore eased apart his own

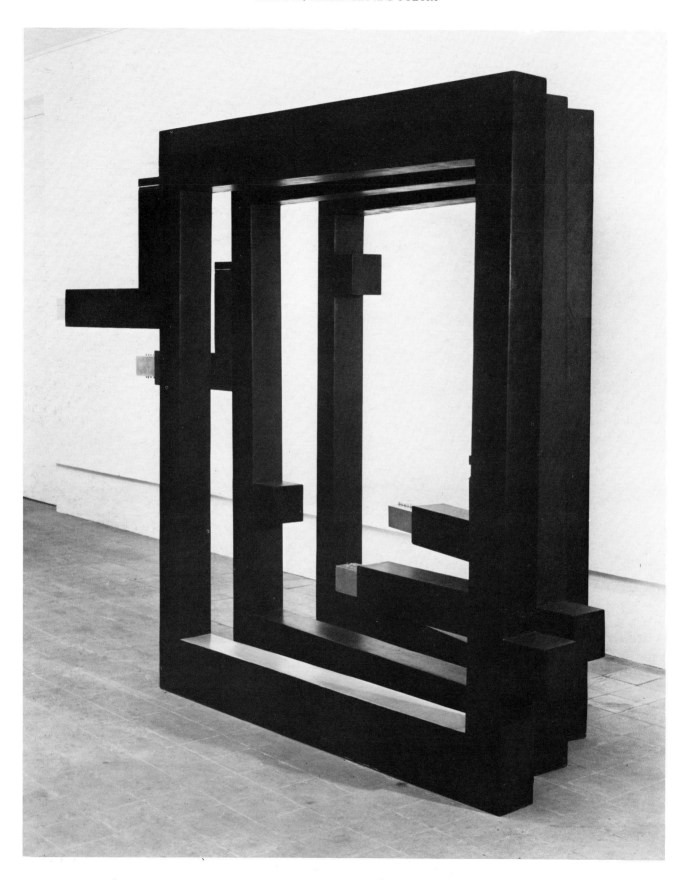

Kenneth Draper: **Three Frames**, 1967. Arts Council of Great Britain.

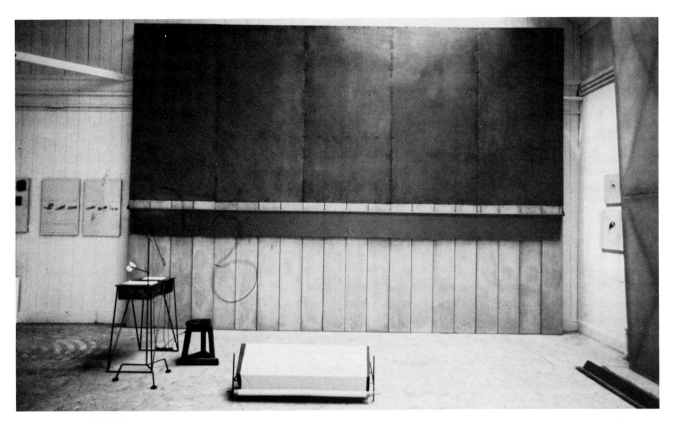

Martin Naylor: **Another Place**, 1968.

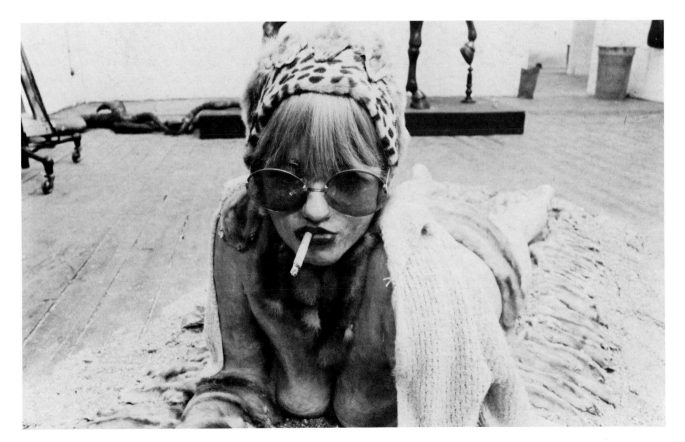

Malcolm Poynter: **Doris on the Beach**, 1973.

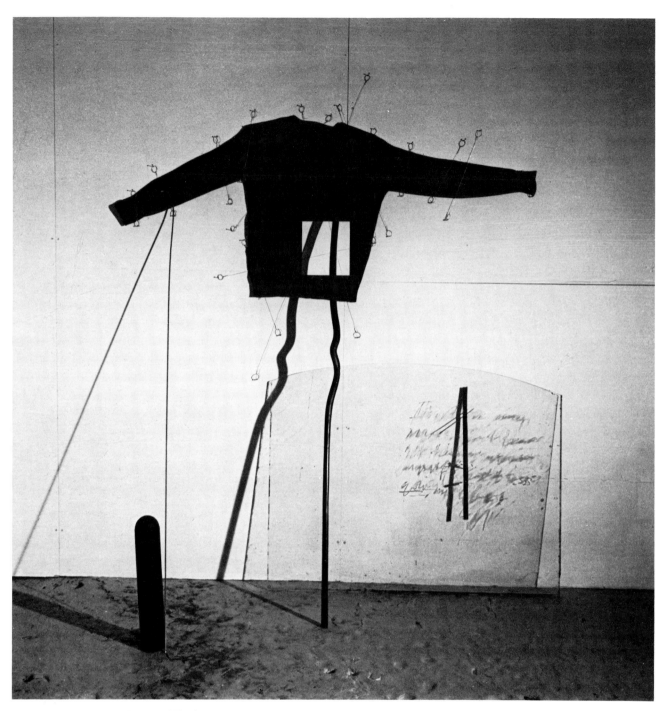

Martin Naylor: **Discarded Sweater**, 1973.

surface in an action which anticipated the release of tension which was imminent in the image of the drawn bow. All Tony Carter's work consists of such objects, the majority of them 'found', and it is only when these objects have 'given up their meaning' that he can tap that poetic area which sets his work in motion.

By bread only – for the demise of icons, 1978, is in some ways an even more extreme work. ◣ An old saucepan has been elegantly mounted on a clean white surface supported by a battered easel. Inside the pan there is an engraving of an angel's head by Leonardo and, issuing diagonally from its side, is an odd reflection of light which is shaped like an angel's wing. Once glimpsed this resemblance hardens in the spectator's mind and he begins to understand the meaning of the title.

The use of found objects is often associated with Surrealism, but there is a difference in some of this

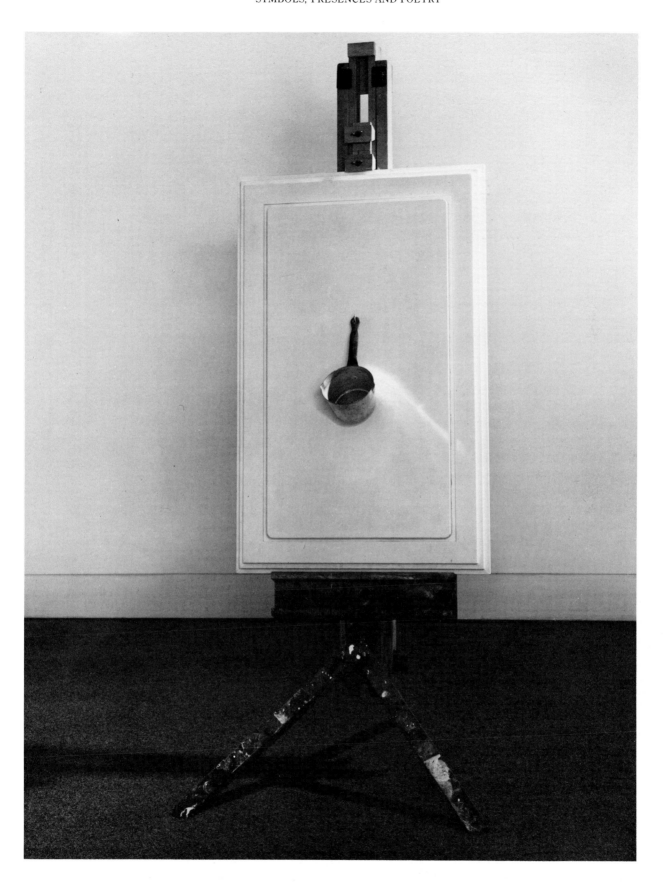

Tony Carter: **By bread only — for the demise of icons**, 1978.

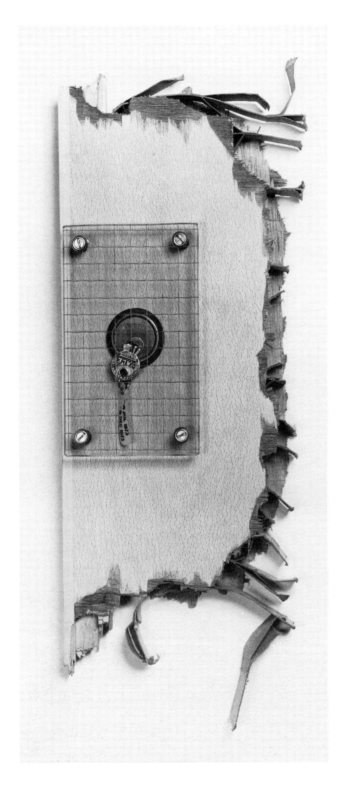

Richard Wentworth: **Momentary Memento (Protected Accident)**, 1974.

recent sculpture, which is explained by the roles that chance and reason play. In the piece by Tony Carter described above it was the accidental discovery that a certain kind of lighting could produce the illusion of an angel's wing which justified the engraving of the head. But of course there are connections with Surrealism and these are often associated with the creation of an atmosphere of cruelty and frustration of the kind found particularly in the early work of Giacometti. In the early 1970s there was a proliferation of work directly concerned with expressing frustration, much of it was by students or ex-students of the Royal College. Richard Wentworth's **Momentary Memento**, 1974, consisted of a part of a door, apparently wrenched from its context, with a twisted key in the lock, and Carl Plackman's **Archaeology of Love** included a set of plaster bottles incarcerated in wire netting.

Plackman makes constant use of symbolism in his work. It may be thought that artists have only recently discarded the conventional meanings of symbols and evolved a language of private signs, but in fact this kind of insistence on subjective freedom can be traced at least as far back as the Romantics, who completely rejected the notion that symbols had codified meanings. Plackman is constantly reinventing his language to express his feelings about the contemporary human condition. He makes extensive use of objects drawn from ordinary life, reconstructing them so that their own identity is heightened and they take on a new symbolic function. All his work involves the bringing together of 'real' and abstract elements, each of which alludes to a particular state of mind. In the environmental works the spectator has to pick his way through pieces scattered on the floor so that a claustrophobic sensation will be a powerful factor in the operation of the whole ensemble. In **Relationships and the way in which the world defeats us**, 1977, a complex and hostile scenario is played out around a bed with two pillows roped separately to either side. This central object is so dominant that it takes time to sense the subtler suggestions about sexuality which he is making through the surrounding parts. In a much simpler wall piece **Bachelor of Arts**, 1977, the idea of growth often symbolised by trees is reversed. Roots sprout out of the top, like the Tree of Life which sometimes flowers in medieval crucifixions, but as the piece grows downwards so the elements become harder: at the lowest level there is a platform carrying leaden relics which seals off flowerpots beneath.

While many of these artists can cull part of their vocabulary from the surrounding world there are also

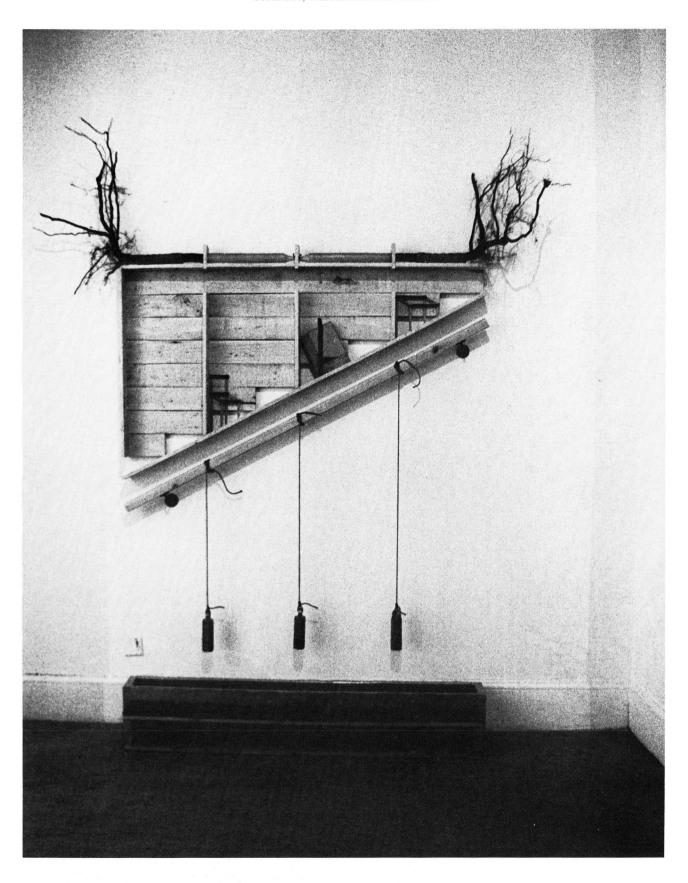

Carl Plackman: **Bachelor of Arts**, 1977.

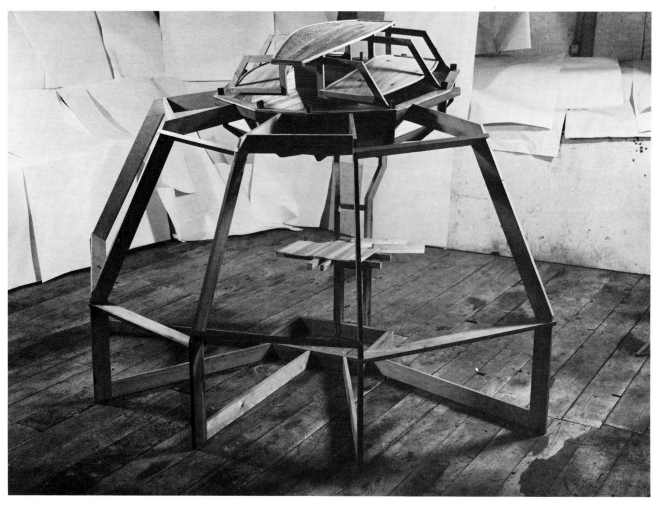

John Cobb: **Cover II**, 1975.

artists making work which still retains some kind of reference to the human factor, though used in a much more abstract way. In Rachel Fenner's **Sculptural Complex**, 1973-77, she used two intricate and complex thrones to signify different kinds of human presence. In Michael Kenny's sculpture the human presence is usually alluded to but never fully described, whereas in John Cobb's work it is only ever implied by its absence. Cobb has always worked with wood in its natural state, using it with a craftsman's skill and relish, so that a jointed strut may describe a curve or angle with a fluency almost like pencil on paper. But the often cage-like structures are put together in a manner which is essentially concerned with the experience of shifting volumes. There may be an inner and an outer shell, but the relationship between the two is ambiguous and thus provocative. The fact that things are never quite what they seem sharpens our responses. In several pieces it is as if the figurative references have been exploded, and we

have been left instead with a complex series of traces or indentations. Kenneth Draper's series of wall pieces, 1974-77, provide an obvious contrast. They are small, solid and densely coloured with strange accretions clinging to their sides. When he began making these mysterious objects they represented a decision to break away from the fashionable concerns of the time, but their secretive aura is a natural development from the subtlety of his earlier large-scale pieces. **Oriental Gateway**, 1980, is an erratic assembly of shapes which change in form and colour from one side to another. ☛ Despite its playful and human quality, however, it represents a serious response to the extremism and illogical aspects of Indian architecture and landscape.

The work of Fenner, Kenny, Cobb and Draper needs to be read on a level which is only partly formal. The same is true of Tony Cragg's arrangements of urban flotsam which doesn't lend itself easily to aesthetic transformation. Most of his material is plastic

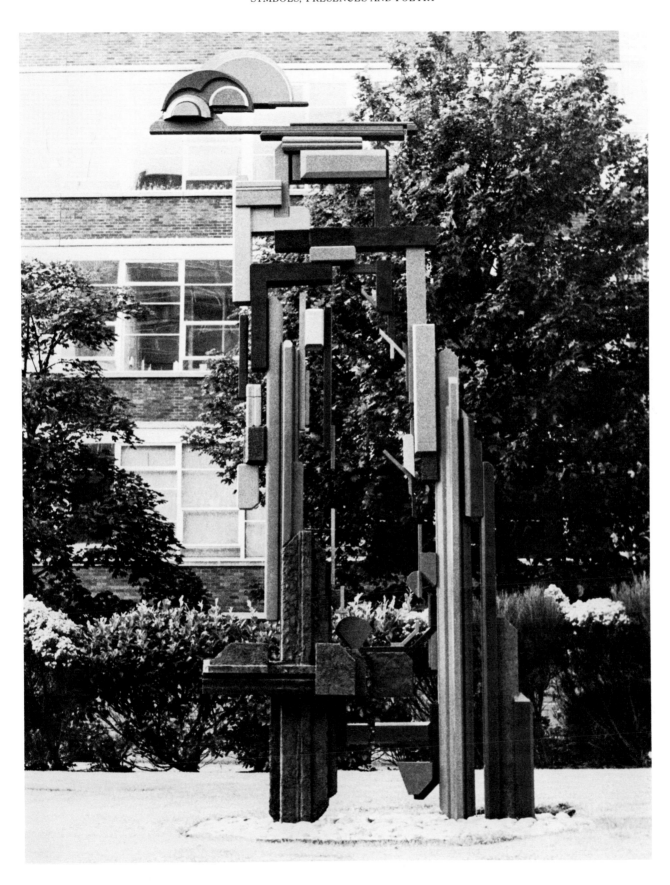

Kenneth Draper: **Oriental Gateway**, 1980.

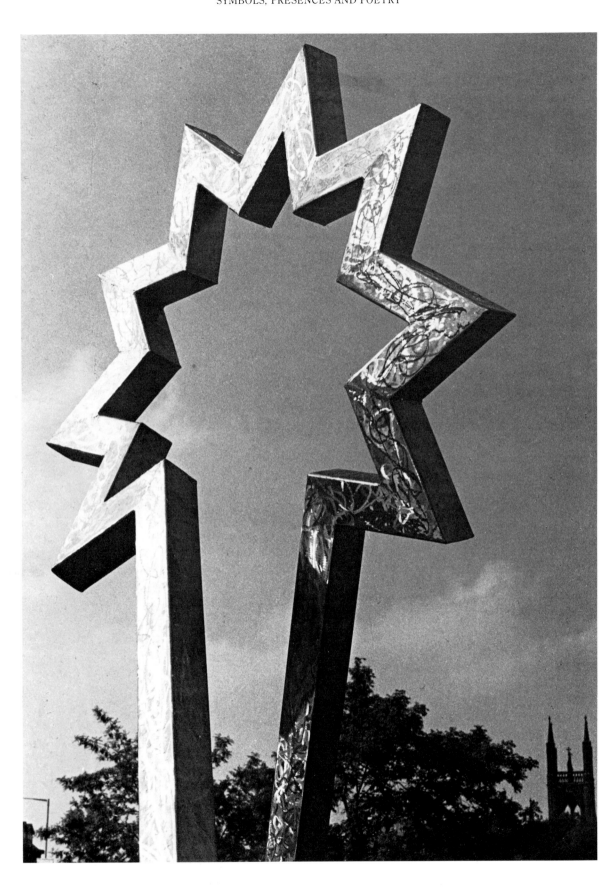

Paul Neagu: **Starhead**, 1980.

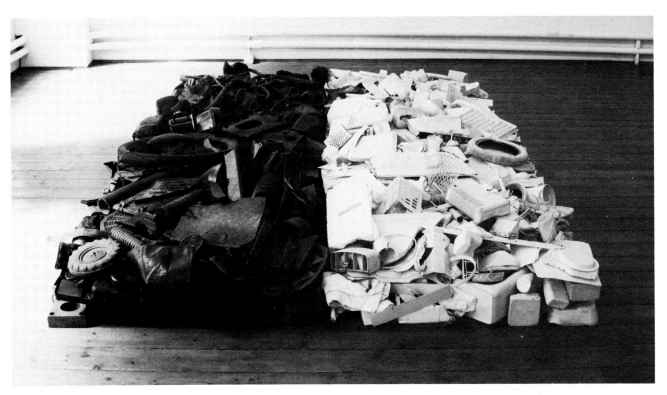

Tony Cragg: **Black and White Mixed Materials**, 1980.

and much of it is virtually unrecognisable: often bits of rims and containers. These unattractive scraps are codified only in terms of colour and then arranged in various ways. We are made aware of the discrepancy between their significance as entities (or fragments) and the fact that they have been conscripted as part of a sculptural strategy. But it is also possible to see his work as a tongue-in-cheek comment on the way we live today.

There is nothing light-hearted about Paul Neagu's work, however. He sees it as the vehicle for the expression of philosophical notions and he condenses complex ideas into simple sculptural form. His first important series, the **Anthropocosmos**, begun before he left Rumania in 1968, was based on the figure of a man, but since 1975 he has used more abstract shapes to express his metaphysical theories: firstly the **Hyphens**, which resemble utilitarian objects and demonstrate his theory of connections, and more recently the **Fusions**, open star-shapes which represent a new state of understanding. But the fact that Neagu puts forward his ideas as 'universal propositions' should not disguise the fact that he is presenting us with those subjective insights which are usually part of a mystical view of the world.

Paul Neagu notwithstanding, it is very important to point out that the kind of work discussed in this essay is specifically British. One of the outstanding characteristics of recent art has been the progressive erosion of national traits and the emergence of an international faction, which corresponded for the most part to the modernist notion of an avant garde. None of these sculptors belongs to this category and it is doubtful whether many of them would wish to do so. This comparative isolation cuts both ways, but it does not mean that they are incapable of being set in any kind of context. One consequence of the Romantic movement was that it encouraged the belief that works of art could give insight into metaphysics and, as a result, aesthetics again became an important part of philosophy. It could be argued that some of this work demonstrates a resurfacing of Victorian qualities: a neurotic tension, a sense of drama and implied narrative, and an obsessional accumulation of detail. But none of these characteristics could be applied to all of the work and only some can be distinguished in the work of others. Each of these sculptors is a deliberate individualist – and it is this shared condition which not only heightens their separateness, but also paradoxically provides the strongest link between them. Most of them are still in their thirties and we have not yet seen the full implications of the course which they have taken.

Selected Bibliography

Compiled by Sheena Wagstaff, with additional research by Hilary Gresty and Susan Ferleger Brades.
Note: The place of publication or exhibition is London unless otherwise stated.

BOOKS: THEORY AND HISTORY OF BRITISH SCULPTURE IN THE TWENTIETH CENTURY

I. British Sculpture

a. General

Arthur T. Broadbent, **Sculpture Today in Great Britain 1940–1943**, London, John Tiranti Ltd, May 1944, (reprinted November).

Dennis Farr, **British Sculpture since 1945**, London, Tate Gallery by Order of the Trustees, 1965.

Warren Forma, **5 British Sculptors**, New York, Crossman Publishers Inc., 1964.

Colonel Maurice Harold Grant, **A Dictionary of British Sculptors from the XIIIth Century to the XXth Century**, London, Rockliff Publishing Corporation Ltd, 1953.

A. M. Hammacher, **Modern English Sculpture**, London, Thames and Hudson, 1967.

Eric Newton, **British Sculpture 1944–1946/La Sculpture Britannique 1944–1946**, London, John Tiranti Ltd, 1947. English followed by French text.

Royal Society of British Sculptors, **Modern British Sculpture: An Official Record of some of the Works by Members of the Royal Society of British Sculptors**, London, Academy Architecture, 1921.

Royal Society of British Sculptors, **Modern British Sculpture**, London, Country Life Ltd, 1939.

M. H. Spielmann, **British Sculpture and Sculptors of To-day**, London, Paris, New York & Melbourne, Cassell & Co. Ltd, 1901.

Eric G. Underwood, **A Short History of English Sculpture**, London, Faber & Faber Ltd, 1933.

b. Public Sculpture

Walter Raymond Agard, **The New Architectural Sculpture**, London, New York, Oxford University Press, 1935.

Tancred Borenius, **Forty London Statues and Public Monuments**, London, Methuen & Co. Ltd, 1926.

British Institute of Industrial Art, **The Art of Graveyard Monuments, being a report by a special committee of the Institute on the present position of monumental art in Great Britain and the best means of raising the standard of the simpler graveyard monuments**, London,

His Majesty's Stationery Office, 1924.

Frank P. Brown, **London Sculpture**, volume III of English Art Series: Influences and Developments in the Progress of Art in Britain (1933–34), London, Sir Isaac Pitman & Sons Ltd, 1934.

Arthur Byron, **London's Statues: A Guide to London's outdoor Statues and Sculpture**, London, Constable & Co. Ltd, 1981.

C. S. Cooper, **The Outdoor Monuments of London: Statues, Memorial Buildings, Tablets and War Memorials**, London, The Homeland Association Ltd, 1928.

Sir Frederick Gibberd, **Sculpture in Harlow**, Harlow, The Harlow Development Corporation, 1973. Preface by Henry Moore.

Lord Edward Gleichen, **London's Open-Air Statuary**, London, Longmans Green & Co. Ltd, 1928.

G. L. Gomme, **Return of Outdoor Memorials in London, other than Statues on the Exterior of Buildings, Memorials in the nature of Tombstones, Memorial Buildings and Memorial Trees**, London, London County Council, 1910.

Modern Architectural Sculpture, (ed.) W. Aumonier, London, The Architectural Press. New York, Charles Scribner's Sons, June 1980.

Sculptured Memorials and Headstones carved in British Stones, London, 12 Lower Regent Street, 1934, revised third edition September 1938.

Osbert Sitwell, **The People's Album of London Statues**, London, Duckworth, 1928, with drawings by Nina Hamnett.

Lawrence Weaver, **Memorials and Monuments, Old and New: Two hundred subjects chosen from seven countries** London, published at the office of *Country Life* and by George Newnes Ltd, New York, Charles Scribner's Sons, 1915.

Westminster Abbey, **Official Guide**, new and revised edition, London, 1965.

Paul William White, with photographs by Richard Gloucester, **On Public View: A Selection of London's Open-Air Sculptures**, London, Hutchinson & Co. (Publishers) Ltd, 1971.

c. Material and Technique

Mark Batten, **Stone Sculpture by direct carving**, London, The Studio Ltd, New York, The Studio Publications, 1957.

Gilbert Bayes, **Modelling for Sculpture: A Book for the Beginner**, London, Winsor & Newton Ltd, 1930.

Geoffrey Clarke and Stroud Cornock, **A Sculptor's Manual**, London, Studio Vista. New York, Reinhold Book Corporation, 1968.

Bainbridge Copnall, **A Sculptor's Manual**, Oxford, New York, Toronto,

Sydney, Braunschweig, Pergamon Press, 1971.

Henry F. W. Ganz, **Practical Hints on Modelling Design and Mural Decoration**, London, Gibbings & Co. Philadelphia, J. B. Lippincott Co., 1908. Foreword by Alfred Gilbert.

T. B. Huxley-Jones, **Modelled Portrait Heads**, London, The Studio Ltd, 1955. Preface by Charles Wheeler.

Sargeant Jagger, **Modelling & Sculpture In The Making**, London, The Studio Ltd, New York, The Studio Publications Inc., 1933.

Ed. Lanteri, **Modelling: a Guide for Teachers and Students**, London, Chapman & Hall Ltd, 1902. Preface by E. Onslow Ford London, Chapman & Hall Ltd, 1907, Vol II. Preface by Sir W. B. Richmond London, Chapman & Hall Ltd, 1911, Vol III.

Alec Miller, **Stone and Marble Carving: a Manual for the Student Sculptor**, London, Alec Tiranti Ltd, 1948.

John Panting, **Sculpture in glass-fibre: the use of polyester resin and glass-fibre in sculpture**, Studies in art and design 1, London, Lund Humphries in association with the Royal College of Art, 1972.

G. Wooliscroft Rhead, **The Treatment of Drapery in Art**, London, George Bell & Sons, 1907.

Jack C. Rich, **Sculpture in Wood**, a Da Capo Paperback republication. First edition, New York, 1970. (Reprinted by arrangement with Oxford University Press Inc., 1977).

Thomas C. Simmonds, **The Art of Modelling in Clay and Wax**, First edition, London, Bemrose & Sons Ltd, 1892. Second edition, London, George Allen & Sons, 1910.

Albert Toft, **Modelling and Sculpture: a full account of the various methods and processes employed in these arts**, London, Seeley & Co. Ltd, 1911.

II. British Art

Lawrence Alloway, **Nine Abstract Artists: their work and theory**, London, Alec Tiranti Ltd, 1954.

A Tonic to the Nation: The Festival of Britain 1951, (ed.) Mary Banham and Bevis Hillier. Prologue by Roy Strong, London, Thames and Hudson, 1976.

Frank P. Brown, **South Kensington and its Art Training**, London, Longman's, Green & Co., 1912.

Contemporary British Artists with photographs by Walia, (ed.) by Charlotte Parry-Crooke, London, Bergstrom + Boyle Books Ltd, 1979. Introduction by Norbert Lynton.

Mary Chamot, Dennis Farr and Martin Butlin, **Tate Gallery Catalogues: the**

modern British paintings, drawings and sculpture, London, The Oldbourne Press, By order of the Trustees of the Tate Gallery, 1964, 2 Volumes.

Chantrey and His Bequest: a Complete Illustrated Record of the Purchases of the Trustees, with a Biographical Note, Text of the Will etc., London, Paris, New York and Melbourne, Cassell and Co. Ltd, 1904.

Richard Cork, Vorticism and Abstract Art in the First Machine Age, Vol I, Origins and Development, Vol II, Synthesis and Decline, London, Gordon Fraser, 1976.

Dennis Farr, English Art 1870–1940, Oxford at the Clarendon Press, Oxford University Press, 1978.

Christopher Finch, Image as Language: Aspects of British Art 1950–1968, Harmondsworth, Middlesex, Penguin Books Ltd, 1969.

Algernon Graves, The Royal Academy of Arts: a Complete Dictionary of Contributors and their work from its foundation in 1769 to 1904, London, Henry Graves and Co. Ltd and George Bell & Sons, 1905, 8 volumes; re-published by S. R. Publishers Ltd and Kingsmead Reprints, 1970, 4 volumes.

Geoffrey Grigson, 'Painting and Sculpture Today' in The Arts Today edited with an Introduction by Geoffrey Grigson, London, John Lane The Bodley Head, 1935, pp. 71-109.

Charles Harrison, English Art & Modernism Vol I 1900–1939, London, Allen Lane, 1981, Vol II 1940–1980 projected 1982.

The Dictionary of British Artists, 1880–1940, J. Johnson and A. Gruetzner (compilers), Woodbridge, Suffolk, Antique Collectors' Club, 1976.

William Johnstone, Creative Art in England: From the Earliest Times to the Present, London, Stanley Nott Ltd, 1936, revised and reprinted as Creative Art in Britain: from the Earliest Times to the Present, London, Macmillan & Co. Ltd. 1950.

Edward Lucie-Smith and Patricia White, Art in Britain 1969–70, London, J. M. Dent & Sons Ltd, 1970.

The Painter's Object, (ed.) Myfanwy Evans, London, Gerald Howe Ltd, 1937.

Herbert Read, Contemporary British Art, Harmondsworth, Middlesex, Penguin Books, revised edition 1964, (originally published 1951).

John Rothenstein, British Art Since 1900: An Anthology, London, Phaidon Press Ltd, 1962.

Royal Academy Exhibitors 1905–1970: A dictionary of artists and their work in the Summer Exhibitions of the Royal Academy of Arts, Wakefield, E. P. Publishing Ltd, 1973–79. 4 volumes (through 'Lawl') to date, of 8 projected volumes.

Towards Another Picture: an anthology of writings by artists working in Britain 1945–1977, (ed.) Andrew Brighton and Lynda Morris, Nottingham, Midland Group Nottingham, 1977.

Unit 1: the modern movement in English architecture, painting and sculpture (ed.) Herbert Read, London, Toronto, Melbourne, Sydney, Cassell & Co. Ltd, 1934.

Grant M. Waters, Dictionary of British Artists working 1900–1950, Eastbourne, Eastbourne Fine Art, 1975. 2 volumes.

William C. Wees, Vorticism and the English Avant-Garde, Manchester, University Press, University of Toronto Press, 1972.

Who's Who in Art, Havant, Hants. The Art Trade Press Ltd, 1980, nineteenth edition, (first published 1927).

Simon Wilson, British Art from Holbein to the present day, London, The Tate Gallery Publications Department & The Bodley Head Ltd, 1979.

III. Western Sculpture

Arnold Auerbach, Sculpture: a History in Brief, London, Elek Books, 1952.

Alan Bowness, Modern Sculpture, London, Studio Vista Ltd, 1965.

Jack Burnham, Beyond Modern Sculpture: the Effects of Science and Technology on the Sculpture of this Century, New York, George Braziller Inc., 1968. London, Allen Lane, The Penguin Press, 1968.

Stanley Casson, Some Modern Sculptors, London, Oxford University Press (Humphrey Milford), 1928.

Stanley Casson, XXth Century Sculptors, London, Oxford University Press (Humphrey Milford), 1930 sequel to Some Modern Sculptors.

Sheldon Cheney, Sculpture of the World: a History, London, Thames and Hudson Ltd, 1968.

Jane Clapp, Sculpture Index, Metuchen, New Jersey, The Scarecrow Press Inc., 1970, volume I: Sculpture of Europe and the Contemporary Middle East.

Albert E. Elsen, The Partial Figure in Modern Sculpture from Rodin to 1969, The Baltimore Museum of Art, 1969.

Albert E. Elsen, Origins of Modern Sculpture: Pioneers and Premises, London, Phaidon Press Ltd, 1974; separate issue New York, George Braziller Inc., 1974.

Albert E. Elsen, Modern European Sculpture 1981–1945: Unknown Beings and Other Realities, New York, George Braziller Inc. in association with Albright-Knox Art Gallery, Buffalo, 1979.

Harold North Fowler, A History of Sculpture, London, Macmillan & Co. Ltd, 1916. New York, Macmillan & Co. Ltd, 1916.

William Gaunt, Teach Yourself to Study Sculpture, London, The English Universities Press Ltd, 1957.

Carola Giedion-Welcker, Modern Plastik: Elemente der Wirklichkeit, Masse und Auflockerung, Zurich, Verlag Dr. H. Girsberger, 1937 and translated by P. Morton Shand as Modern Plastic Art: Elements of Reality, Volume and Disintegration, Zurich, Verlag Dr. H. Girsberger, 1937.

Carola Giedion-Welcker, Contemporary Sculpture: an Evolution in Volume and Space, London, Faber & Faber Ltd, 1961. New York, George Wittenborn Inc. Stuttgart, Verlag Gerd Hatje (as Plastik des XX Jahrhunderts) original: H. Girsberger, Switzerland, 1937, (revised and enlarged edition, New York, George Wittenborn Inc., 1960).

Robert Goldwater, What Is Modern Sculpture?, New York, The Museum of Modern Art distributed by New York Graphic Society Ltd, Connecticut, 1969.

Douglas Hall, 'The Human Form in Modern Sculpture' lecture delivered at opening of and printed in catalogue of exhibition, Twelve Views of Mankind, MacRobert Centre Art Gallery, University of Stirling, March 1974, pp. 11 (pamphlet).

A. M. Hammacher, The Evolution of Modern Sculpture: tradition and innovation, London, Thames and Hudson Ltd, 1969.

Joseph Hudnut, 'Modern Sculpture' in The New Arts, (ed.) Philip N. Youtz, Port Washington, Kennikat Press, 1970. (Hudnut article originally published by W. W. Norton & Co. Inc., 1929).

James J. Kelly, The Sculptural Idea, second edition Minneapolis, Minnesota, Burgess Publishing Co., 1974, (originally published 1970, same company).

Rosalind E. Krauss, Passages in Modern Sculpture, London, Thames and Hudson Ltd, 1977.

Fred Licht, Sculpture 19th & 20th Centuries, London, Michael Joseph (George Rainbird Ltd), 1967.

James Mackay, The Dictionary of Western Sculptors in Bronze, Antique Collectors' Club, 1977, (printed in England).

Herbert Maryon, Modern Sculpture: Its Methods and Ideals, London, Sir Isaac Pitman & Sons Ltd, 1933.

Alec Miller, Tradition in Sculpture, London and New York, The Studio Publications, 1949.

New Dictionary of Modern Sculpture, (ed.) Robert Maillard, New York, Tudor, 1971, originally compiled by Fernand Hazan as Dictionnaire de la Sculpture Moderne, Paris, 1960, translated by Bettina Wadia for

SELECTED BIBLIOGRAPHY

A Dictionary of Modern Sculpture, (ed.) Robert Maillard, London, Methuen & Co.Ltd, 1962.

Kineton Parkes, Sculpture of Today, London, Chapman and Hall Ltd, 1921. Vol I. America, Great Britain, Japan, (Vol II, Continent of Europe).

Kineton Parkes, The Art of Carved Sculpture, London, Chapman Hall Ltd, 1931. Vol I, Western Europe, America and Japan.

Chandlèr Rathfon Post, A History of European and American Sculpture from the Early Christian Period to the Present Day, Cambridge, Harvard University Press, London, Humphrey Milford, Oxford University Press, 1921. Vol II Baroque to Modern.

E.H.Ramsden, Sculpture: Theme and Variations – Towards a Contemporary Aesthetic, London, Lund Humphries, 1953.

E.H.Ramsden, Twentieth Century Sculpture, London, Pleiades Books, 1949.

Herbert Read, The Art of Sculpture, Faber & Faber Ltd, 1956. (The A.W.Mellon Lectures in the Fine Arts, 1954, National Gallery of Art Washington, D.C.).

Herbert Read, A Concise History of Modern Sculpture, London, Thames and Hudson, 1964.

Andrew Carnuff Ritchie, Sculpture of the Twentieth Century, New York, The Museum of Modern Art, London, Thames and Hudson Ltd, 1952.

L.R.Rogers, Sculpture, London, Oxford University Press, 1969. The Appreciation of the Arts, volume 2.

L.R.Rogers, Relief Sculpture, volume 8 of The Appreciation of the Arts series, London, Oxford University Press, 1974.

Henry Schaefer-Simmern, Sculpture in Europe Today, Berkeley and Los Angeles, University of California Press, 1955.

Paul Waldo Schwartz, The Hand and Eye of the Sculptor, London, Pall Mall Press, 1969.

Jean Selz, Modern Sculpture: Origins and Evolution, London, Melbourne, Toronto, Cape Town, Auckland, William Heinemann Ltd by arrangement with, New York, George Braziller Inc., 1963; translated from the French by Annette Michelson.

Michel Seuphor, The Sculpture of this Century: Dictionary of Modern Sculpture, London, A.Zwemmer Ltd, 1959; translated from French by Haakon Chevalier (editions du Griffon, Neuchatel, Switzerland – reprinted 1961).

Charles Seymour Jr., Tradition and Experiment in Modern Sculpture, Washington D.C. The American University Press, 1949.

W.J.Strachan, Towards Sculpture: Maquettes and Sketches from Rodin to Oldenburg, London, Thames and Hudson, 1976.

Eduard Trier, Form and Space: The Sculpture of the Twentieth Century, Lonson, Thames and Hudson Ltd, (orig. 1961, translated by C.Ligota from 1960 German edition, Berlin, Gebr. Mann Verlag Gmbh), revised and enlarged edition, 1968.

William Tucker, The Language of Sculpture, London, Thames and Hudson Ltd, 1974.

W.R.Valentiner, Origins of Modern Sculpture, New York, Wittenborn & Co., 1946.

R.H.Wilenski, The Meaning of Modern Sculpture. London, Faber & Faber Ltd. 1932.

Rudolf Wittkower, Sculpture: Processes and Principles, London, Allen Lane, Penguin Books Ltd, 1977.

IV. Western Art

Allgemeines Lexikon der Bildenden Kunstler von der Antike bis zur Gegenwart
Volumes I–IV (1907–10) (ed.) Dr Ulrich Thieme and Dr Felix Becker, Leipzig, Verlag von Wilhelm Elgelmann
Volumes V–XIII (1911–Volumes XIV–XV 1952) (ed.) Dr Ulrich Thieme, Leipzig, Verlag von E.A.Seeman. (eds.) Dr Ulrich Thieme and Fred C.Willis Leipzig, Verlag von E.A.Seeman.
Volumes XVI–XXXVII (1953–1962)
Allegemeines Lexikon der Bildenden Kunstler des XX Jahrhunderts (ed.) Hans Vollmer, Leipzig, Verlag von E.A.Seeman.

Etta Arntzen and Robert Rainwater, Guide to the Literature of Art History. Chicago, American Library Association. London, The Art Book Co., 1980.

Art Since 1945, London, Thames and Hudson Ltd, 1959. Essays include Herbert Read, 'Great Britain' pp.221–50.

E. Benezit, Dictionnaire (critique et documentaire) des Peintres, Sculpteurs, Dessinateurs et Graveurs (de tous les temps et de tous les pays).. Paris, Librarie Grund, 1976, (editions precendentes 1911–1923), 10 volumes.

Charles Biederman, Art as the Evolution of Visual Knowledge, Minnesota, Charles Biederman, 1948.

Mary W.Chamberlain, Guide to Art Reference Books, Chicago, American Library Association, 1959; sculpture, nos. 942–1089.

Herschel B.Chipp, Theories of Modern Art: a Source Book by Artists and Critics, Berkeley, Los Angeles, London, University of California Press, 1968.

Circle International Survey of Constructive Art, (ed.) J.L.Martin, Ben Nicholson & N.Gabo, London, Faber & Faber Ltd, 1937. (Reprinted 1971, Northampton, John Dickens & Co.Ltd).

Michael Compton, Pop Art, London, New York, Sydney, Toronto, Hamlyn Publishing Group Ltd, 1970.

Contemporary Art and Artists: an Index to Reproductions, compiled by Pamela Jeffcott Parry, London and Westport, Connecticut, Greenwood Press, 1978.

Contemporary Artists, (ed.) Colin Naylor and Genesis P-Orridge, London, St James Press. New York, St Martin's Press, 1977.

Data: Directions in Art Theory & Aesthetics, An anthology edited by Anthony Hill, London, Faber & Faber Ltd, 1968.

Edouard-Joseph, Dictionnaire Biographique des Artistes Contemporains 1910–1930 (avec nombreux portraits, signatures et reproductions), Paris, Art & Edition, 1930, (Vol I), 1931 (Vol II), 1934 (Vol III by Paris, Libraire Grund).

Roger Fry, Transformations, Critical and Speculative Essays on Art, London, Chatto and Windus, 1926.

Eric Gill, Art-Nonsense and Other Essays, London, Cassell & Co.Ltd & Francis Walterson, 1929.

Robert Goldwater, Primitivism in Modern Art, revised edition New York, Vintage Books, February 1967, (originally published 1938 as Primitivism in Modern Painting).

George Heard Hamilton, Painting and Sculpture in Europe 1880 to 1940, Harmondsworth, Middlesex, Penguin Books Ltd, (the Pelican History of Art), 1967. Revised and corrected, 1972.

George Heard Hamilton, 19th and 20th Century Art: Painting, Sculpture, Architecture, New York, Harry N.Abrams Inc. Publishers, 1972.

Patrick Heron, The Changing Forms of Art, London, Routledge & Kegan Paul, 1955.

Hilton Kramer, The Age of the Avant-Garde: an Art Chronicle of 1956–1972, London, Martin Secker & Warburg Ltd, 1974.

Edward Lucie-Smith, Art in the Seventies, Oxford, Phaidon Press Ltd, 1980.

Norbert Lynton, The Modern World, London, Paul Hamlyn Ltd, 1965.

Norbert Lynton, The Story of Modern Art, Oxford, Phaidon Press Ltd, 1980.

Daniel Trowbridge Mallett, Mallett's Index of Artists: International-Biographical including Painters, Sculptors, Illustrators, Engravers and Etchers of the Past and the Present, Bath, Kingsmead Reprint, 1976, (first published 1935).

Daniel Trowbridge Mallett, Supplement

to Mallett's Index of Artists . . . not in the first volume, Bath, Kingsmead Press, 1977, (first published 1940).

Metro; International Directory of Contemporary Art, Milan, Editoriale Metro, 1964.

Peter and Linda Murray, **A Dictionary of Art and Artists**, fourth edition, Harmondsworth, Middlesex, Penguin Books, 1976, (first published 1959).

Obituaries From The Times, including an Index to all Obituaries and Tributes appearing in The Times, Frank C. Roberts compiler, Reading, Newspaper Archive Developments Ltd, 1975–79, 3 volumes (including 1951–75) to date.

Phaidon Dictionary of Twentieth Century Art, Phaidon, London and New York, 1973, (second edition 1977).

Herbert Read, **The Meaning of Art**, London, Faber & Faber Ltd, 1931. New revised edition, 1968.

Herbert Read, **Art Now: An Introduction to the Theory of Modern Painting and Sculpture**, London, Faber & Faber Ltd, 1933. New revised edition, October 1936.

George Rickey, **Constructivism: Origins and Evolution**, New York, George Braziller Inc., 1967.

Edouard Roditi, **Dialogues on Art**, London, Martin Secker & Warburg Ltd, 1960.

John Russell and Suzi Gablik, **Pop Art Redefined**, London, Thames & Hudson, 1969.

Frank Rutter, **Art in my Time**, London, Rich & Cowan Ltd, 1933.

Frank Rutter, **Modern Masterpieces: An Outline of Modern Art**, London, George Newnes Ltd, 1940.

Karin Thomas and Gerd de Vries, **DuMont's Kunstler Lexikon von 1945 bis zur Gegenwart**, Cologne, DuMont Bucherverlag, 1977.

John Walker, **Glossary of Art, Architecture and Design since 1945**, London, Bingley, 1973.

The World of Abstract Art, (ed.) The American Abstract Artists, London, Alec Tiranti Ltd, 1957.

PERIODICALS

Edmund Gosse, 'The future of sculpture in London', *Magazine of Art*, 1881, vol IV pp. 281–284.

Walter Armstrong, 'Sculpture', *Art Journal*, June 1887, vol X pp. 177–180.

Claude Phillips, 'Sculpture at the Royal Academy', *Magazine of Art*, 1888, vol XI pp. 366–371.

'The Sculpture of the Year', *Magazine of Art*, 1889, vol XII pp. 369–374.

'The Sculpture of the Year, *Magazine of Art*, 1890, vol XIII pp. 361–366.

Claude Phillips, 'The Sculpture of the Year', *Magazine of Art*, 1891 vol XIV pp. 402–407.

Claude Phillips, 'Sculpture of the Year: British sculpture', *Magazine of Art*, 1892, vol XV pp. 378–384.

Claude Phillips, 'Sculpture of the Year: Royal Academy', *Magazine of Art*, 1893 vol XVI pp. 397–402.

Edmund Goose, 'The New Sculpture 1879–1894', *Art Journal*, 1894, pp. 138–142, 199–203, 277–282, 306–311.

Claude Phillips, 'Sculpture of the Year', *Magazine of Art*, 1895, vol XVIII pp. 67–72, 441–447.

Edmund Gosse, 'The place of sculpture in daily life: certain fallacies', pp. 326–329; 'Monuments', pp. 407–410; 'Sculpture in the home', pp. 368–371, *Magazine of Art*, 1895, vol XVIII.

A. L. Baldry, 'Sculpture in 1897', *Magazine of Art*, 1898, vol XXI pp. 65–72.

'The Cult of the Statuette', *The Studio*, May 1902, vol XXV pp. 275–282.

'British sculpture in 1903 technically considered', *Magazine of Art*, 1903, n.s. vol 1 pp. 436–440.

M. H. Spielmann, 'Sculpture at the Royal Academy', *Magazine of Art*, 1904, n.s. vol II pp. 409–412.

T. Stirling Lee and W. Reynolds-Stephens, 'Sculpture in its relation to architecture', *The Architectural Journal* (RIBA), 10 June 1905, vol XII no. 15 pp. 497–514.

Marion H. Spielmann, 'British sculpture of today', Journal of the Royal Society of British Architects, 3 April 1909, pp. 373–394.

T. W. Hill 'Open-air Statues in London', *The Home Counties Magazine*, 1910, vol XII pp. 28–35, 122–131, 189–199, 305–317.

J. R. Tranthim-Fryer, 'Modern Sculpture', (Part II British school), *The Building News*, 9 October 1914, vol CVII no. 3118, pp. 455–457.

Blast: Review of the Great English Vortex, (ed.) Wyndham Lewis, London, John Lane, The Bodley Head. New York, John Lane Co. Toronto, Bell & Cockburn (reprinted New York, Kraus Reprint Corp. 1967). No. 1, 20 June 1914. No. 2, July 1915.

H. Heathcote-Statham, 'The subject-matter of sculpture', *Architectural Review*, January 1916, pp. 1–3.

W. H. Godfrey, 'Examples of Modern Memorials', *Architectural Review*, 1920, vol XLVII, January, pp. 13–16, February pp. 38–41.

D. H. Banner, 'The decline of modern sculpture', The Nineteenth Century and After, December 1926, vol C, no. 595, pp. 885–896.

Kineton Parkes, 'Rights and Wrongs of Academy Sculpture', *Apollo*, June 1929, vol IX no. 54, pp. 341–345.

G. A. Jellicoe, 'Modern British Sculpture', *The Studio*, January 1930, vol XCIX no. 442, pp. 26–31.

S. Casson, 'Modernism', *Architectural Review*, September 1930, vol XLVIII, pp. 121–126.

John Grierson, 'The New Generation in Sculpture', *Apollo*, November 1930, vol XII no. 71, pp. 347–351.

R. P. Bedford, 'Modern Architectural Sculpture', *Architectural Design & Construction*, February 1931, vol 1 no. 4, pp. 130–134.

'The Royal Academy, for the cultivation and improvement of the Arts of Design: the opinions of contemporary painters', *The Architectural Review*, June 1931, vol LXIX, pp. 188–190.

Kineton Parkes, 'Sculpture at the Royal Academy', *Apollo*, June 1931, vol XIII, no. 78, pp. 378–380.

Kineton Parkes, 'Animal Sculpture', *Apollo*, December 1932, vol XVI no. 96, pp. 270–275.

Abstraction création art non figuratif, no. 1 1932, no. 2 1933, no. 3 1934, no. 4 1935, no. 5 1936.

Kineton Parkes, 'This Matter of Form', *Apollo*, January 1933 vol XVII no. 97, pp. 14–19.

Reginald Blomfield, 'Modern Sculpture and the Greeks', *The Quarterly Review*, January 1933, vol 260 no. 515, pp. 34–50.

Kineton Parkes, 'Sculpture at the Royal Academy', *Apollo*, June 1933, vol XVII no. 102, pp. 246–247.

Dorothy Grafly, 'Gill and Epstein', *The American Magazine of Art*, June 1934, vol XXVII no. 6, pp. 325–333.

Kineton Parkes, 'Royal Academy Sculpture', *Apollo*, June 1934, vol XIX no114, pp. 298–299.

'Contemporary Sculpture Number: Brancusi, Moore, Hepworth, Calder', *Axis*, July 1935, no. 3.

R. H. Wilenski, 'The place of sculpture today and tomorrow', *The Studio*, October 1935, vol CX no. 511, pp. 216–223.

Axis: A quarterly review of contemporary abstract painting and sculpture, January 1935–Early Winter 1937, 8 issues.

Anthony Blunt, 'The New Realism in Sculpture', *Cambridge Review*, 23 April 1937, pp. 335–336.

Herbert Read, 'l'Art contemporain en Angleterre', *Cahiers d'art*, 1938, 13e année no. 1–2, pp. 29–42.

Stanley Casson, 'The Role of Sculpture in Contemporary Life', *The Studio*, June 1938, vol CXV no. 543, pp. 296–311.

'Sculpture of Today', commentary by Stanley Casson, special spring number of *The Studio*, 1939.

Herbert Read, 'Three English Sculptors', *XXe Siècle*, 1939, 2e année no. 1, pp. 45, (reprinted in French, *XXe Siècle*,

noel 1959, n. s. 21e année no.13 pp.42–43).

Stanley Casson, 'Sculpture in the Post-war World', *The Studio*, December 1943, vol CXXVI no.609, pp.169–177.

Charles Wheeler, 'The Royal Society of British Sculptors', *The Studio*, September 1946, vol CXXXII no.642, pp.78–87.

Wyndham Lewis, 'Contemporary Art at the Tate', *The Listener*, 6 April 1950, vol XLIII no.1106, pp.610–611.

Patrick Heron, 'Trends in Contemporary British Painting', *The Listener*, 11 May 1950, vol XLIII no.1111, pp.836–838.

A. Durst, 'Sculpture Can Survive', *The Studio*, December 1950, vol CXL, pp.177–184.

Sir Philip Hendy, 'The Festival Exhibitions of Sculpture', *Britain Today*, August 1951, no.184 pp.19–23.

A.D.B. Sylvester, 'Contemporary Sculpture', *The Listener*, 23 August 1951, vol XLVI no.1173, pp.295–297.

A.D.B. Sylvester, 'Festival Sculpture', *The Studio*, September 1951, vol CXLII no.702, pp.72–77.

Hugh Casson, 'South Bank Sculpture', *Image*, Spring 1952, no.7, pp.48–60.

John Anthony Thwaites, 'Notes on some young English sculptors', *The Art Quarterly*, Autumn 1952, vol XV no.3, pp.234–241.

Michael Middleton, 'Huit sculpteurs brittaniques', *Art d'aujourd'hui*, March 1953, série 4 no.2, pp.6–9.

Léon Degand, 'Note d'un critique d'art "continental" sur la peinture et la sculpture d'aujourd'hui en Grande-Bretagne',' *Art d'aujourd'hui*, March 1953, serie 4 no.2, pp.16–17.

G.S. Whittet, 'London Commentary: Sculpture Competition', *The Studio*, April 1953, vol CXLV no.721, pp.142.

'Editorial: A Modern 'Ecce Homo'', *The Burlington Magazine*, June 1953, vol XCV no.603, pp.179–180.

Lawrence Alloway, 'Britain's New Iron Age', *Art News*, Summer 1953, vol LII, pp.19, 20, 68–70.

J.P. Hodin, 'Testimonianza sulla scultura Inglese attuale', *Selle Arte*, November/December 1953, anno II no.9, pp.57–64.

Lawrence Alloway and Basil Taylor, 'The Siting of Sculpture', *The Listener*, 17 June 1954, vol LI, pp.1044–1046.

Eric Newton, 'Some British Sculptors', *Britain Today*, July 1954, no.219, pp.24–27.

John Skeaping, 'A Return to Individuality', *ARK*; The Journal of the Royal College of Art, 1955, no.14, pp.30–33.

Robert Melville, 'British Portrait Sculpture Today', *The Studio*, May 1955, vol CXLIX no.746, pp.138–143.

Udo Kultermann, 'Englishe Plastik der Gegenwart', *Das Kunstwerk*, January 1959, heft 7/XII pp.5–20.

G.S. Sandilands, 'London County Council as Art Patron: II', *The Studio*, February 1960, vol CXLIX no.802, pp.42–47.

J.P. Hodin, 'Artist and Architect: Recent Monumental Works Produced in England', *Quadrum*, 1961, vol X, pp.11–26.

J.P. Hodin, 'La sculpture Anglaise depuis Moore', *XXe Siècle*, May 1961, supplément au no.16, XXIIIe année, pp.73–76.

Alastair Gordon, 'The British Council – International Impresario of British Art', *The Connoisseur*, June 1961, pp.18–21.

'Sculpture: Brave New Patrons', *The Architectural Review*, September 1961, vol CXXX no.775, pp.206–207.

Edwin Mullins, 'The Open-air Vision: A Survey of Sculpture in London since 1945', *Apollo*, August 1962, vol LXXVI no.6 (n.s.), pp.455–63.

L.R. Rogers, 'Sculptural Thinking', *British Journal of Aesthetics*, October 1962, vol II, pp.291–300.

G.S. Whittet, 'Battersea Power Sculpture', *Studio*, August 1963, vol CLXVI no.844, pp.48–53.

Dennis Farr, 'Sculpture in London since the War', *Country Life*, 14 November 1963, vol CXXXIV no.3480, pp.1240–1241.

'Modern Art in Britain', (ed.) Michael Peppiatt in *Cambridge Opinion*, 1964.

'Contemporary Sculpture', *Arts Yearbook 8*, New York, The Art Digest Inc, 1965.

Charles S. Spencer, 'The Phenomenon of British Sculpture', *Studio International*, March 1965, vol CLXIX no.863, pp.98–105.

James Burr, 'Without a Style', *Apollo*, March 1965, vol LXXXI no.37 (n.s.), pp.236–238.

Gene Baro, 'Britain's New Sculpture', *Art International*, June 1965, vol 9, pp.26–31.

Sculpture International, January 1966–September 1970, 10 issues.

Bainbridge Copnall, 'Sculpture in Industry', *Royal Society of Arts Journal*, January 1966, vol CXIV, pp.92–109.

Alastair Gordon, 'Art in the Modern Manner', *The Connoisseur*, May 1966, vol CLXII, pp.40–41.

Gene Baro, 'British Sculpture: the developing scene', *Studio International*, October 1966, vol CLXXII no.882, pp.171–181.

William C. Wees, 'England's Avant-Garde: The Futurist-Vorticist Phase', *The Western Humanities Review*, Spring 1967, vol XXI no.2, pp.117–128.

Christopher Finch, 'British Sculpture Now', *Art and Artists*, May 1967, vol II no.2, pp.20–23.

Charles Harrison, 'London Commentary: British Critics and British Sculpture', *Studio International*, February 1968, vol CLXXV no.897, pp.86–89.

'Gallery: Sculpture on the Streets', *The Architectural Review*, March 1968, vol CXLIII no.853, pp.209–212.

'Some Aspects of Contemporary British Sculpture', Special issue of *Studio International*, January 1969, vol CLXXVII no.907, including Charles Harrison, 'Some recent sculpture in Britain', pp.26–33.

Garth Evans, 'Sculpture and Reality', *Studio International*, February 1969, vol CLXXVII no.908, pp.61–62.

Charles Spencer, 'London Exhibitions: The Whole Experience', *Sculpture International*, April 1969, vol II, no.4, pp.12–27.

Bruce McLean, 'Not even crimble crumble', *Studio International*, October 1970, vol CLXXX no.926, pp.156–159.

P. McCaughey, 'The Monolith and Modernist Sculpture', *Art International*, November 1970, vol XIV/9, pp.19–24.

Barry Martin, 'The Problem of British Sculpture', *Studio International*, May 1972, vol CLXXXIII no.944, pp.186–188.

Jeremy Rees, 'Public Sculpture', *Studio International*, July/August 1972, vol CLXXXIV no.946, pp.9–15.

Peter Ferriday, 'Free Standing and Civic', *Studio International*, July/August 1972, vol CLXXXIV no.946, pp.41–44.

Theo Crosby, 'A Kind of Urban Furniture', *Studio International*, July/August 1972, vol CLXXXIV no.946, pp.45–47.

Lawrence Alloway, 'The Public Sculpture Problem', *Studio International*, October 1972, vol CLXXXIV no.948, pp.122–125.

B. Martin, 'British Sculpture', *One*, October 1973, no.1, pp.17–20.

Dolores Mitchell, 'Parts of British buildings as sculpture by architects', *Leonardo*, Winter 1974, vol VII no.1, pp.49–52.

H. Chapman, 'The Condition of Sculpture 1975', *Arts Magazine*, November 1975, vol L pt.3, pp.67–69

Artscribe no.3, summer 1976, *Sculpture Issue*.

Hilary Chapman, 'New British Sculpture', *Arts Review*, February 1977, vol XXIX part 3, pp.82–6.

Peter Fuller, 'Troubles With British Art Now', *Artforum*, April 1977, vol XV no.8, pp.42–47.

Ben Jones, 'A New Wave in Sculpture: a survey of recent works by ten younger sculptors', *Artscribe*, September 1977, no.8, pp.14–19.

William Tucker, 'Modernism, Freedom, Sculpture', *Art Journal*, Winter 1977/78, vol XXXVII/2, pp.153–156.

John McEwen, 'Aspects of British Sculpture', *Artforum*, April 1978, vol XVI no.8, pp.27–31.

W.J. Strachan, 'The Hand as Object', *Art and Artists*, June 1978, vol XIII no.2, pp.8–13.

Glynn Williams, 'Defining Sculpture', *Art Monthly*, 1979, no.29, pp.4–7.

241

SELECTED BIBLIOGRAPHY

David Sweet, 'Serious Sculpture: Some Problems', *Artscribe*, February 1979, no.16, pp.125–9.

'Grizedale Forest Sculpture', *Aspects*, Summer 1979, no.7 n.p.

Dave King, 'Recent Developments in Wood Sculpture', *Aspects*, Spring 1981, no.14 n.p.

'Grizedale Forest Sculpture', *Aspects*, Spring 1981, no.14 n.p.

EXHIBITIONS OF SCULPTURE IN BRITAIN AND ABROAD

Catalogues
The exhibitions selected are those which contain a significant number of works made by British sculptors.
All venues in London unless otherwise stated.

The Fine Art Society, 'First Exhibition of Statuettes by The Sculptors of Today, British and French', March 1902. Checklist with essay, 'Sculpture for the Home', by M.H.Spielmann.

The Fine Art Society, 'Statuettes and other Sculpture', January 1913. Checklist.

The Fine Art Society, 'Statuettes by the Royal Society of British Sculpture', December 1920. Checklist.

Selfridge & Co.Ltd, The Roof Gardens, 'The London Group: Exhibition of Open-Air Sculpture', 2 June–30 August 1930. Checklist.

The Zwemmer Gallery, 'Drawings and Sculpture by some Contemporary Sculptors: Jacob Epstein, Frank Dobson, Henry Moore, Henri Gaudier-Brzeska (1891–1915)', 26 November–13 December 1930. Checklist with foreword by R.H.Wilenski.

Sydney Burney, 'Sculpture – Considered Apart from Time and Place', 9–30 November 1932. Catalogue by Leon Underwood.

Portsmouth, Cumberland House Museum and Art Gallery, 'Exhibition of Modern British Sculpture', 16 January–13 March 1937. Leaflet.

The Arts Council of Great Britain, 'Sculpture in the Home' 1946. Selected by Frank Dobson. Travelled. Catalogue.

Battersea Park, 'Open Air Exhibition of Sculpture', May–September 1948. Organised by the London County Council in association with the Arts Council of Great Britain. Catalogue with essay, 'Sculpture', by Eric Newton.

New Burlington Galleries, 'Sculpture in the Home', (Second Exhibition) 30 August–23 September 1950, organised by the Arts Council of Great Britain. Toured Newcastle, Leicester, Hull, Bristol, Southampton, Eastbourne, Scarborough,

Falmouth, Stoke, Glasgow, through 18 August 1951. Catalogue.

Battersea Park 'Sculpture: an open air Exhibition', 8 May–mid-September. Organised by the London County Council in association with the Arts Council of Great Britain. Catalogue with essay, 'The Sculptor's Problems', by Nikolaus Pevsner.

Institute of Contemporary Art, 'Young Sculptors', 3 January–3 February 1952. Checklist.

Philadelphia Museum of Art, 'Sculpture of the Twentieth Century', 11 October–7 December 1952. Toured Chicago, New York through 7 September 1953. Organised by The Museum of Modern Art, New York. Catalogue.

New Burlington Galleries, 'The Unknown Political Prisoner: British Preliminary Exhibition', 15–30 January 1953. Checklist.

Tate Gallery, 'International Sculpture Competition: The Unknown Political Prisoner', 14 March–30 April 1930. Sponsored by the Institute of Contemporary Art. Catalogue.

Gloucester College of Art, 'Sculpture in the Home', (third exhibition) 8 May–23 May 1953. Organised by the Arts Council of Great Britain. Toured Manchester, Coventry, Leeds, Warwick, Glasgow, Aberdeen, Newcastle, London New Burlington, through 8 May 1954. Catalogue.

Holland Park, 'Sculpture in the Open Air', May–September 1954. London County Council Third International Exhibition of Sculpture. Catalogue with essay, 'Open Air Sculpture' by Sir Kenneth Clark.

Institute of Contemporary Art, 'New Sculptors/Painter-Sculptors', 1955. Checklist with essay, 'New Sculptors and Painter-Sculptors', by L(awrence) A(lloway).

The Arts Club of Chicago, 'Sculpture and Drawings by Young British Sculptors', 2–29 March 1955. Organised by the Arts Club of Chicago in collaboration with the British Council. Toured Minneapolis, Cincinnati, Buffalo, Toronto through 13 February 1956. Pamphlet with essay, 'New Aspects of British Sculpture', by Herbert Read, (re-printed from 1952 Venice Biennale catalogue).

'Junge Englische Bildhauer 1955–56: Plastiken und Zeichnungen'. Organised by the British Council. Travelled Munich, Stuttgart, Freiburg, Karlsruhe, Recklinghausen, Dusseldorf. Catalogue.

Aldeburgh, Red House, 'Some Contemporary British Sculpture', 16–24 June 1956. Organised by The Arts Council of Great Britain and arranged by the Norwich 1956 Exhibition Committee in conjunction with the Aldeburgh Festival. Toured Bedford, Cirencester, Huddersfield through

3 November 1956. Leaflet.

Hanover Gallery, 'Contemporary Sculpture', 24 July–14 September 1956. Catalogue.

'Yngre Brittiska Skulptörer 1956–57'. Organised by Riksförbundet för Bildande Konst and the British Council. Travelled to Göteborg, Sandviken, Linköping, Tranås, Lund, Hälsingborg, Halmstad, Falkenberg, Örebro, Stockholm. Catalogue with essay, 'Yngre Brittiska Skulptorer', by Robert Melville.

Nottingham, Castle Museum, 'Contemporary British Sculpture: An Open Air Exhibition', 25 May–15 June 1957. Arranged by the Arts Council of Great Britain. Toured Southampton, Cardiff, Penzance, Cheltenham, through 12 October 1957. Catalogue.

Holland Park, 'Sculpture 1850 and 1950', May–September 1957. Organised by the London County Council. Catalogue with essay, 'Sculpture 1850 and 1950', by Charles Wheeler.

Leamington Spa, The Jephson Gardens, 'Contemporary British Sculpture: An Open Air Exhibition', 31 May–22 June 1958. Arranged by the Arts Council of Great Britain. Toured Shrewsbury, Cardiff, through 30 August 1958. Catalogue.

Leeds City Art Gallery, 'Modern Sculpture', 8 October–5 November 1958. Catalogue.

Cambridge, Arts Council Gallery, 'Sculpture in the Home'. (Fourth Exhibition) 15 November–6 December 1958. Organised by the Arts Council of Great Britain. Toured Cambridge, Cardiff, Salisbury, Nottingham, Edinburgh, Aberdeen, Newcastle-upon-Tyne, Huddersfield, Harrogate, through 26 July 1959. Catalogue.

Battersea Park, 'Sculpture in the Open Air', May–September 1960. Organised by London County Council. Catalogue with essay, 'Sculpture Today', by Philip James.

Birmingham, Cannon Hill Park, 'Contemporary British Sculpture', 30 April–14 May 1960. Organised by the Arts Council of Great Britain. Toured Barnsley, Manchester, Stratford on Avon, Edinburgh, Cheltenham through 8 October 1960. Catalogue.

Birmingham, Cannon Hill Park, 'Contemporary British Sculpture: An Open Air Exhibition', 22 April–13 May 1961. Arranged by the Arts Council of Great Britain. Toured Eastbourne, Cirencester, Nottingham, Edinburgh, Bradford, through 30 September 1961. Catalogue.

Cardiff, The National Museum of Wales, 'Sculpture 1961', 15 July–2 September 1961. Organised by the Arts Council Welsh Committee. Toured Swansea, Aberystwyth, Bangor, through 26 November 1961. Catalogues.

Welsh Arts Council, 'Background II – Sculpture: The Artist and his Environment – Kenneth Armitage, Reg Butler, Stephen Gilbert'. 1961. Leaflet.

British Council, 'Recent British Sculpture', 1961–3. Circulated in Canada by the National Gallery of Canada; in New Zealand by the Auckland City Art Gallery; in Australia by the State Galleries of Australia. Catalogue.

Wales, Caerphilly Castle, 'Contemporary Sculpture: An Open Air Exhibition', 28 April–12 May 1962. Organised by the Arts Council of Great Britain. Toured Stevenage, Chester, Edinburgh, through 8 September 1962. Catalogue.

Nottingham, Midland Group Gallery, 'Sculptors Today', 18 August–8 September 1962. Checklist.

Battersea Park, 'Sculpture: An Open Air Exhibition of Contemporary British and American Works', May–September 1963. Organised by the London County Council. Catalogue.

Washington Gallery of Modern Art, 'Sculptors of our Time', 17 September–31 October 1963. Catalogue with essay, 'Sculptors of our Time', by Andrew S. Keck.

Birmingham, Cannon Hill Park, 'Contemporary British Sculpture: An Open Air Exhibition', 25 April–9 May 1964. Organised by the Arts Council of Great Britain. Toured Accrington, Wollaston, Cheltenham, Middlesbrough, Bradford, through 12 September 1964. Catalogue.

'Sculpture from the Arts Council Collection', March 1965. Organised by the Arts Council of Great Britain. Toured. Catalogue with essay 'Post-war Sculpture in Britain', by David Thompson.

The Tate Gallery, 'British Sculpture in the Sixties', 25 February–4 April 1965. Organised by the Contemporary Art Society in association with the Peter Stuyvesant Foundation.

Arts Council Gallery, 'Towards Art II: Sculptors from the Royal College of Art', 26 February–27 March 1965. Organised by the Arts Council of Great Britain. Toured Torquay, Southampton, Leeds, Nottingham, Bolton, Norwich, through 18 September 1965. Catalogue by David Sylvester.

Whitechapel Art Gallery, 'The New Generation: 1965', March–April 1965. Sponsored by the Peter Stuyvesant Foundation. Catalogue.

Birmingham, Cannon Hill Park, 'Contemporary British Sculpture: An Open Air Exhibition' 17 April–May 1965. Organised by the Arts Council of Great Britain. Toured Brighton, Northampton, Nottingham, Barnard Castle, Gloucester, through 25 September 1965. Catalogue.

Spalding, Springfields, 'Contemporary

British Sculpture: An Open Air Exhibition', 23 April–15 May 1966. Organised by the Arts Council of Great Britain. Toured Oxford, York, Middlesbrough, through 31 July 1966. Catalogue.

New York, The Jewish Museum, 'Primary Structures: Younger American and British Sculptors', 27 April–12 June 1966. Catalogue.

Battersea Park, 'Sculpture in the Open Air: An Exhibition of Contemporary British Sculpture', 20 May–end September 1966. Catalogue.

Cardiff, National Museum of Wales and Cardiff Castle, 'Structure 1966: The First Open Exhibition exclusively for Sculpture and Construction', 16 June–30 July 1966. Organised by the Welsh Committee of the Arts Council and the National Museum of Wales. Toured in part to Swansea, Bangor, London, St. Ives, Leicester, Manchester, Newcastle-upon-Tyne, Sheffield, Glasgow, through 22 April 1967. Catalogue.

Cambridge, The Arts Council Gallery, 'Chromatic Sculpture', 9–30 July 1966. Organised by the Arts Council of Great Britain. Toured Harrogate, Bolton, Portsmouth, through 15 October 1966. Catalogue.

Camden Arts Centre, 'New Dimensions', 9–30 October 1966. Catalogue with essay by Eddie Wolfram.

Hampstead Artists Council, 'Sculpture in a Civic Setting', 1966–7. In association with the Libraries and Arts Committee of the London Borough of Camden. Catalogue with essay by Charles Spencer.

Portsmouth, Cumberland House Museum, 'Sculpture 60–66 from the Arts Council Collection', 8–29 April 1967. Organised by the Arts Council of Great Britain. Toured Worcester, Colchester, Blackburn, Salford, Kettering, Swindon, Hull, Walsall, through 6 January 1968. Catalogue. (Revised and updated version circulated as 'Sculpture 60–67 from the Arts Council Collection': separate catalogue).

Amsterdam, Stedelijk Museum, 'Jonge Engelse Beeldhouwers', 21 April–4 June 1967. Catalogue, in English and Dutch.

Birmingham, Cannon Hill Park, 'Outdoor Sculpture 1967', 22 April–6 May 1967. Organised by the Arts Council of Great Britain. Toured Norwich, Northampton, Salisbury, Liverpool, through 2 September 1967. Catalogue.

New York, The Solomon R. Guggenheim Museum, 'Guggenheim International Exhibition 1967: Sculpture from Twenty Nations', 20 October 1967–4 February 1968. Toured Toronto, Ottawa, Montreal, through 18 August 1968. Catalogue.

Whitechapel Art Gallery, (in collaboration with the Loughborough University of Technology) 'British Sculpture and Painting from the Collection of the Leicester-

shire Education Authority', sculpture section exhibited December 1967–January 1968. Catalogue.

Bristol, Arnolfini Gallery, Bristol & West Building Society, and five open air venues in Bristol, 'New British Sculpture/Bristol', 20 May–29 June 1968. Organised by Arnolfini in co-operation with the Bristol Corporation and Bath Festival Society. Toured in part to Totnes through 10 August 1968. Catalogue. Complementary exhibition at Bristol City Art Gallery, 'British Sculpture/Bristol', 1–29 June 1968. Catalogue.

Stockwell Depot, 'Sculpture Exhibition', 24 May–10 June 1968. Leaflet with text by Michael Compton.

Birmingham, Post and Mail Building, 'Sculpture in a city: Anthony Caro, David Hall, Kim Lim, Ron Robertson-Swann, Bernard Schottlander, William Turnbull, Brian Wall, Derrick Woodham', 24 May–16 June 1968. Organised by the Arts Council of Great Britain, (arranged by the Midlands Arts Centre for Young People). Toured Liverpool, Southampton, through 10 August 1968. Catalogue.

Toulouse Musées des Augustins, 'Sculpture Anglaise Contemporaine', 4 June–1 July 1968. Organised by the British Council. Travelled Forcalquier, Lille, through 11 November 1968. Catalogue with essay, 'La Sculpture Anglaise Contemporaine', by Denis Milhau.

Coventry, Coventry Cathedral, 'British Sculpture', June–August 1968. Catalogue with essays 'Climate of Freedom', by Mario Amaya; 'Towards an Understanding of new British Sculpture', by Anthony Fawcett, 'Coventry Cathedral as a setting for sculpture' by Fabio Barraclough.

Camden Arts Centre, 'Survey '68: Abstract Sculpture', 20 June–21 July 1968. Catalogue.

City of London Festival, 'Sculpture Exhibition', 8–20 July 1968. Checklist with maps of sculpture venues.

The Fine Art Society Ltd, 'British Sculpture 1850–1914', 30 September–30 October 1968. Sponsored by the Victorian Society. Catalogue.

Southampton City Art College, '7 Sculptors', 9 August–20 September 1969. Organised by the Arts Council of Great Britain. Toured Oxford, Brighton, Norwich, Newcastle, Birkenhead, Leeds, Gateshead, Liverpool, through 12 December 1970. Catalogue with 'An Essay on sculpture' by William Tucker (reprinted from Studio International, January 1969).

Nottingham, Midland Group Gallery, 'Sculpture in Nottingham', 21 June–8 July 1969. Catalogue.

Stockwell Depot, 'Sculpture: Stockwell Depot 2: Alan Barkley, Roland Brener, David Evison, Roger Fagin, John Fowler,

Gerard Hemsworth, Peter Hide, Roelof Louw', 26 September–18 October 1969. Catalogue with texts by Anne Seymour.

Oslo, Kunsternes Museum, 'Stockwell Depot: atta engelska skulptörer fråan London', 24 January–15 February 1970. Toured Göteborg through 22 March 1970. Catalogue with text (in Swedish) by Nigel Greenwood.

Hayward Gallery, 'Continuum: Bob Janz, Dante Leonelli, Michael McKinnon', 7 June–7 July 1970. Extended from smaller exhibition at Axiom Gallery 11 June–13 July 1968, then in part with additions to Sheffield, summer 1969, and touring Hull, Oxford, and Manchester. Organised by the Arts Council of Great Britain. Catalogue with statements by the artists dated 1 May 1970.

Winchester, Winchester Cathedral Close, 'Ten Sculptors/Two Cathedrals', 6 July–9 August 1970. Travelled to Salisbury Cathedral Close, through 27 September 1970.

Institute of Contemporary Arts 'British Sculpture out of the Sixties', 6 August–27 September 1970. Catalogue.

The Tate Gallery, 'The Alistair McAlpine Gift', 30 June–22 August 1971. Catalogue with texts by Anne Seymour, Richard Morphet, Michael Compton.

Derby, Museum and Art Gallery, 'Eight Individuals: Sculpture and drawings chosen by Bryan Robertson for the Arts Council Collection', 4 December 1971–15 January 1972. Organised by the Arts Council of Great Britain. Toured Southampton, Folkstone, Billingham, Sheffield, through 26 August 1972. Catalogue.

The Royal Academy of Arts, 'British Sculptors '72', 8 January–5 March 1972. Catalogue.

Holland Park, 'Sculpture in Holland Park', 1–25 June 1972. Organised by Kensington and Chelsea Arts Council in association with the Greater London Council. Poster with text. Checklist. Separate catalogue including statements and work by Cain, Coyne, Head, Plackman, Saray.

Institute of Contemporary Arts, 'City Sculpture', 13–30 April 1972. Touring exhibition arranged with the support of the Arts Council of Great Britain in collaboration with the Peter Stuyvesant Foundation City Sculpture Project, to Newcastle-upon-Tyne, Sheffield, Liverpool, Birmingham, Cardiff, Plymouth, Southampton, through 24 November 1972. Catalogue with text by Jeremy Rees and statements by the artists. (Selected by Stewart Mason and Phillip King.)

Leigh, Public Library & Art Gallery, 'Eleven Sculptors, One Decade: Sculpture Bought by Hubert Dalwood for the Arts Council Collection', 23 September–15 October 1972. Organised by the Arts Council of Great Britain. Toured Keighley, Hull, Colchester, Leeds, Newcastle through 12 May 1973. Catalogue.

Serpentine Gallery, 'Serpentine Sculpture 73: Roger Dainton, Peter Grieve, John Harper, Paul Neagu, Ainslie Yule', 2–24 June 1973. Organised by the Arts Council of Great Britain. Exhibition literature includes envelope with card on each artist.

Hayward Gallery, 'Pioneers of Modern Sculpture', 20 July–23 September 1973. Organised by the Arts Council of Great Britain. Catalogue with essay, 'Pioneers and Premises of Modern Sculpture', by Albert E. Elsen.

Bracknell, South Hill Park, 'Sculpture at South Hill Park', 29 October 1973–29 October 1974. Loose leaves and catalogue information for each sculptor.

St. Matthews Gardens, 'Sculpture in the Open Air', 7–22 September 1974. Sponsored by the Lambeth Arts and Recreations Association. Checklist.

Stockwell Depot, 'New Sculpture: Peter Hide, John Foster, Katherine Gili, Anthony Smart', 10 September–5 October 1974. Pamphlet.

Bracknell, South Hill Park, 'Sculpture at the Park 2', March 1975–March 1976. Catalogue with 'Introduction' by William Packer, including statements by the artists.

Holland Park, 'Sculpture in Holland Park 1975: Figurative Sculpture', 22 May–9 July 1975. Presented by the *Illustrated London News* in conjunction with the Greater London Council. Catalogue.

Hayward Gallery, 'The Condition of Sculpture: a Selection of recent Sculpture by younger British and foreign Artists', 29 May–13 July 1975. Organised by the Arts Council of Great Britain. Catalogue with Introduction by William Tucker.

Burnley, Towneley Hall Art Gallery and Museums, '20th Century British Sculpture from Northern Public Collections', 10 April–26 September 1976. Checklist with anonymous '20th Century British Sculpture' text.

Worksop, Worksop Priory and Churchyard, 'Sculpture at Worksop: An Exhibition of Contemporary Sculpture and Drawings', 10 July–11 September 1976. Arranged by East Midlands Arts and the Midland Group, Nottingham. Catalogue with essay, 'Sculpture at Worksop Priory', by Tim Threlfall.

Nottingham Castle Museum and Art Gallery, 'Sculpture for the Collection/ Purchases by Bryan Kneale', 10 January–1 February 1976. Organised by the Arts Council of Great Britain. Toured Huddersfield, Chester, Derby, Edinburgh, Cambridge, Cheltenham, Portsmouth, through 7 November 1976. Catalogue including statements by the artists.

Battersea Park, 'A Silver Jubilee Exhibition of Contemporary British Sculpture 1977', 2 June–4 September 1977. Organised by the Greater London Council with Bryan Kneale as selector. Catalogue with essays: 'The Post-War Phase' by William Packer; 'Notes on British Sculpture 1952–77' by Bryan Robertson; 'Developments in the Sixties and Seventies' by Barry Martin. Complementary exhibition at Redfern Gallery, 'Silver Jubilee Exhibition of Contemporary British Sculpture in Microcosm: maquettes, drawings and related material', 14 June–6 July 1977. Card.

Tate Gallery, 'Carved, Modelled, Constructed: Three Aspects of British 20th Century Sculpture', 1 December 1977–28 February 1978. Leaflet with text by Sandy Nairne.

Camden Arts Centre, (organised by the Arkwright Arts Trust with the support of the London Borough of Camden). '3 Garden Exhibitions: Part I.: Brian Catling, Robert Russell', 18 August–3 September 1978. 'Part II: Esmond Bingham, Lee Grandjean, Gilbert Holmes, Michael Johnson', 9–28 September. 'Part III: Gerry Judah, Richard Layzell', 4 October–5 November. Poster with texts and checklist.

Amsterdam, Stedelijk Museum, 'Door Beeldhouwers Gemaakt', 14 September–5 November 1978. Catalogue with essay 'Door Beeldhouwers Gemaakt' by Rini Dippel and Geert van Beyeren in English and Dutch.

Serpentine Gallery, 'Scale for Sculpture: New Works by Shirley Cameron and Roland Miller, David Dye, Garth Evans, Nicholas Monro, Carl Plackman', 2 October–November 1978. Organised by the Arts Council of Great Britain. Toured Birmingham, Liverpool, Southampton, through 10 March 1979. Catalogue.

Buffalo, Albright Knox Art Gallery, 'Modern European Sculpture 1918–1945: Unknown Beings and Other Realities', 12 May–24 June 1979. Toured Minneapolis and San Francisco through 18 November 1979. Catalogue with text by Albert E. Elsen.

Birmingham, Ikon Gallery, 'Furniture/ Sculpture '79', 17 February–24 March 1979. Catalogue.

Birmingham, Ikon Gallery, 'New Sculpture: a selection', 10 November–8 December 1979. Catalogue.

Sunderland, Museum and Art Gallery, 'The Human Factor, Sculptures made by artists during the 1970's', 2 July–3 August 1980. Organised by the Arts Council of Great Britain. Toured Camarthen, Leigh, Bradford, Bangor, Hull, Lincoln, Newcastle, Southport, Barnsley and Carlisle

through 12 September 1981.

Bristol, Arnolfini Gallery and Institute of Contemporary Arts, 'Objects and Sculpture'. Two parts shown simultaneously at both venues 23 May–9 August 1981. Catalogue with statements by the artists.

SURVEYS OF WESTERN PAINTING AND SCULPTURE

Whitechapel Art Gallery, 'Animals in Art', 10 October–4 December 1907. Leaflet.

Paris, Fine Art Palace, 'Franco-British Exhibition', 14 May–31 October 1908. Catalogue with essay by Marion H. Spielmann.

New York, Armory Show, 'International Exhibition of Modern Art', 17 February–15 March 1913. Toured Chicago, Boston through 19 May 1913. Catalogue and exhibition documentation reprinted 1972, New York, Arno (3 volumes).

Whitechapel Art Gallery, 'Twentieth Century Art: A Review of Modern Movements', 8 May–20 June 1914. Leaflet.

New Chenil Galleries, 'The Exhibition of Tri-National Art: French, British, American', October 1925. Leaflet with 'Foreword' by Roger Fry.

The New Chenil Galleries, 'The Multi-National Exhibition of Works by French, British, American, German, Swiss and Mexican Artists', 1926. First shown in Paris, toured London, New York. Leaflet with 'Foreword' by Clive Bell.

Alex Reid & Lefevre Ltd, 'Abstract & Concrete: an international exhibition of abstract painting & sculpture to-day', 1936. Organised by Nicolete Gray in conjunction with *AXIS*. Toured Oxford, 41 St Giles February 1936, Liverpool, Newcastle, Cambridge through June 1936. Catalogue.

New York, Museum of Modern Art, 'Cubism and Abstract Art', 2 March–19 April 1936. Catalogue.

New Burlington Galleries, 'International Surrealist Exhibition', 11 June–4 July 1936.

Duncan Miller Ltd, 'Modern Pictures for Modern Rooms: an Exhibition of Abstract Art in Contemporary Settings', April 1936. Leaflet.

London Gallery, 'Surrealist Objects & Poems', 24 November–24 December 1937. Catalogue.

London Gallery, 'Constructive Art', 12–31 July 1937. Leaflet with 'Art as the Key to Reality' by Dr Siegfried Giedion.

Gloucester, Guildhall, 'Realism and Surrealism: an Exhibition of Several Phases of Contemporary Art', 28 May–26 June 1938. Catalogue.

Guggenheim Jeune, 'Abstract and Concrete Art', 10–27 May 1939. Catalogue

in 'London Bulletin' no.14, 1 May 1939, pp.2–4, 21–22.

New York, New York World's Fair, 'British Pavilion, Exhibition of Contemporary British Art', 1939. Organised by the British Council. Catalogue.

New York, Museum of Modern Art, 'Art In Our Time: an Exhibition to celebrate the Tenth Anniversary of the Museum of Modern Art and the Opening of its New Building', 10 May–30 September 1939. Catalogue.

Zwemmer Gallery, 'Surrealism Today', 12 June–3 July 1940. Organised by The Surrealist Group in England. Checklist.

New York, The American-British Art Center Inc., 'Paintings and Sculpture from England, Canada & America', January–February 1941. Catalogue.

The Tate Gallery, 'An Exhibition of a Selection from the Acquisitions of the Contemporary Art Society from its Foundation in 1910 up to the Present Day', 27 September–31 October 1946. Pamphlet.

Institute of Contemporary Art (Academy Hall, Oxford Street), 'Forty Years of Modern Art: 1907–1947 – A selection from British Collections', 10 February–6 March 1948. Pamphlet and separate checklist.

Institute of Contemporary Art (Academy Hall, Oxford Street), '40,000 Years of Modern Art: A Comparison of Primitive and Modern', 20 December 1948–29 January 1949. Catalogue with essay 'Primitive Influences on Modern Art' by G. Archer and Robert Melville.

Institute of Contemporary Arts (New Burlington Galleries), 'London/Paris: New Trends in Painting and Sculpture', 7 March–4 April 1950. Pamphlet including essay 'Painting and Sculpture in London' by Benedict Nicholson.

Institute of Contemporary Art, 'Collages and Objects', 13 October–20 November 1954. Pamphlet.

New York, Museum of Modern Art, 'The New Decade: 22 European Painters and Sculptors', 10 May–7 August 1955. Toured Minneapolis, Los Angeles, San Francisco through 15 March 1956. Catalogue.

The Tate Gallery, 'The Seasons: an Exhibition of painting and sculpture organised by the Contemporary Art Society', 1 March–15 April 1956. Leaflet.

Whitechapel Art Gallery, 'This is Tomorrow', 9 August–9 September 1956. Catalogue including essays 'Design as a Human Activity' by Lawrence Alloway and 'Marriage of Two Minds' by Reyner Banham.

Minneapolis, Institute of Arts, 'European Art Today: 35 Painters and Sculptors', 23 September–25 October 1959. Toured

Los Angeles, San Francisco, North Carolina, Ottawa, New York, Baltimore through 16 October 1960. Catalogue including 'Great Britain' by Lawrence Alloway.

New York, Museum of Modern Art in collaboration with Baltimore Museum of Art, 'New Images of Man', 30 September–29 November 1959. Catalogue by Peter Selz with statements by the artists.

New York, Museum of Modern Art, 'The Art of Assemblage', 2 October–12 November 1961. Toured Dallas, San Francisco through 15 April 1962. Catalogue by William C. Seitz.

Amsterdam, Stedelijk Museum, 'Experiment in Constructie', 18 May–16 June 1962. Catalogue in Dutch and English with 'The New Plastic Expression' by Joost Baljeu.

The Tate Gallery, 'Painting & Sculpture of a Decade 54–64', 22 April–28 June 1964. Organised by the Calouste Gulbenkian Foundation. Catalogue.

Oxford, Bear Lane Gallery, 'In Motion: an Arts Council Exhibition of Kinetic Art', 3–28 October 1966. Organised by the Arts Council of Great Britain. Toured with additions to Cambridge, Oldham, Leeds, Leicester through 18 February 1967. Catalogue.

Chicago, Museum of Contemporary Art, 'Relief/Construction/Relief', 26 October–1 December 1968. Toured Indianapolis, Bloomfield Hills, Atlanta through 30 March 1969. Catalogue with 'Relief Sculpture: From Tradition to Utopia' by Jan van der Marck.

Amsterdam, Stedelijk Museum, 'Op Losse Schroeven: Situaties en Cryptostructuren', 15 March–27 April 1969. Catalogue with 'De Tentoonstelling' by Wim A. L. Beeren and 'Politics and the Avant-Garde' by Piero Gilardi. Toured Essen, Museum Folkwang as 'Verborgene Strukturen', May–June 1969.

Bern, Kunsthalle, 'Live in your Head: When Attitudes Become Form – Works, Concepts, Processes, Situations, Information', 22 March–27 April 1969. Toured Krefeld, in part and with additions to London, Institute of Contemporary Art, 28 August–27 September 1969. Catalogue with essays 'Zur Ausstellung' by Harald Szeeman; 'Notes on the New' by Scott Burton/Gregoire Muller; 'Nuovo alfabeto per corpo e materia' by Tommaso Trini.

New York, The Museum of Modern Art, 'Information', 2 July–20 September 1970. Under the auspices of the International Council of the Museum of Modern Art. Catalogue by Kynaston McShine.

Hayward Gallery, 'Kinetics', 25 September–22 November 1970. Organised by the Arts Council of Great Britain. Catalogue with essays 'Kinetics' by Frank Popper and 'Articulate Energy – Kinetic

Art in Transformation' by Jonathan Benthall.

New York, The Solomon R. Guggenheim Museum, 'Guggenheim International Exhibition 1971', 12 February–11 April 1971. Catalogue.

Münster, Westfalisches Landesmuseum, 'Skulptur', 3 July–13 November 1977. Catalogue in two parts.

Hayward Gallery, 'Dada and Surrealism Reviewed', 11 January–27 March 1978. Organised by the Arts Council of Great Britain. Catalogue by Dawn Ades.

Hayward Gallery, 'Pier and Ocean', 8 May–2 June 1980. Toured Rijksmuseum Kröller-Müller, Otterlo 13 July–8 September 1980. Catalogue with texts by the artists.

SURVEYS OF BRITISH PAINTING AND SCULPTURE

Whitechapel Art Gallery, 'Twenty Years of British Art (1890–1910)', 10 May–19 June 1910. Leaflet.

The Grafton Galleries, 'Art & Artists at the Grafton: An Exhibition of Modern Art', April–May 1913. Checklist.

Doré Galleries, 'Vorticist Exhibition', opened 10 June 1915. Catalogue with 'Note for Catalogue' by Wyndham Lewis.

Mansard Gallery, 'Group X', 26 March–24 April 1920. Catalogue with 'Foreword: Group X' by Wyndham Lewis.

London, Walker's Galleries, 'Exhibition of Painting and Sculpture by the 'Seven and Five', 12 April–1 May 1920. Checklist with manifesto. (Annual exhibitions in other London galleries with differing participants – 1921–24, 1926–29, 1931–35, see 1935 below).

Whitechapel Art Gallery, 'Modern British Art', 21 March–22 April 1922. Checklist.

The New Chenil Galleries, 'The Inaugural Exhibition of Present-Day British Art', June–July 1925. Organised by the Chelsea Arts Club. Checklist with 'The Story of Chenil's' by H. Granville Fell.

Whitechapel Art Gallery, 'Exhibition of Contemporary British Art', 24 October–1 December 1929. Checklist.

The Mayor Gallery, 'Unit 1', April 1934. Checklist. Toured in part and with additions to Liverpool, Manchester and Hanley through 8 September 1934. Separate leaflets. Zwemmer Gallery, '7 & 5', 2–22 October 1935. Checklist.

Hampstead, Everyman Cinema Theatre, 'Abstract Art: Sculpture, Painting, Reliefs', 11–24 November 1936. Leaflet by S. John Woods.

The London Gallery Ltd, 'Living Art in England', 18 January–11 February 1939. Catalogue published in *London Bulletin* no. 8–9, January–February 1939, with essay 'In What Sense "Living"?' by Herbert Read.

Whitechapel Art Gallery, '1939 Exhibition: Work by Members of the Artists International Association exhibited as a Demonstration of the Unity of Artists for Peace, Democracy and Cultural Development', 9 February–7 March 1939. Leaflet.

London Museum, 'New Movements in Art: Contemporary Work in England – An Exhibition of Recent Painting and Sculpture', 18 March–9 May 1942. Leaflet.

Institute of Contemporary Arts, '1950: Aspects of British Art', 13 December 1950–12 January 1951. Leaflet with text '1950, Aspects of British Art' by Peter Watson.

Gimpel Fils, 'British Abstract Art', August 1951. Checklist.

Institute of Contemporary Arts (RBA Galleries), 'A British Festival Exhibition – Ten Decades: a review of British Taste 1851–1951', August–September 1951. Leaflet with 'Decade commentaries' by Robin Ironside (1881–1910), and Benedict Nicolson (1910–1951).

A. I. A. (New Burlington Galleries), 'The Mirror and the Square: An Exhibition of Art ranging from Realism to Abstraction', 2–20 December 1952. Leaflet.

Whitechapel Art Gallery, '20th Century Form: Painting, Sculpture and Architecture', 9 April–31 May 1953. Catalogue including essay 'The Pictures and Sculpture' by Bryan Robertson.

Whitechapel Art Gallery, 'British Painting & Sculpture 1954', 23 September–31 October 1954. Catalogue.

Institute of Contemporary Art, 'Statements: a review of British abstract art in 1956', 16 January–16 February 1957. Pamphlet with 'Introductory Notes' by Lawrence Alloway.

Liverpool, The Walker Art Gallery, 'The John Moores Liverpool Exhibition', 10 November 1957–11 January 1958. Illustrated checklist. (Annual exhibitions to the present including a sculpture section from 1958–1961/62).

London, O'Hana Gallery, 'Dimensions: British Abstract Art 1948–1957', December 1957. Leaflet.

RBA Galleries, 'A. I. A. 25: An Exhibition to celebrate the Twenty-fifth Anniversary of the Foundation in 1933 of the Artists International Association', 28 March–23 April 1958. Pamphlet with essay 'The First Twelve Years' by A. F(orge).

The Tate Gallery, 'The Religious Theme', 10 July–21 August 1958. Organised by the Contemporary Art Society. Leaflet.

Institute of Contemporary Arts, 'The Gregory Fellowship Exhibition', 14 August–20 September 1958. Leaflet.

Washington D.C., Smithsonian Institution, 'British Artist Craftsmen: an exhibition of contemporary work'. Circulated in the United States 1959–60. Catalogue.

Leeds City Art Gallery, 'Gregory Memorial Exhibition', 9 March–10 April 1960. Catalogue.

Drian Galleries, 'Construction: England 1950–1960', 11 January–4 February 1961. Pamphlet.

A. I. A. Gallery, 'Directions Connections: Architecture, Painting, Sculpture', 20 June–12 July 1961. Broadsheet with essay by Bernard Myers.

A. I. A. Gallery, 'The Geometric Environment', 10–31 May 1962. Leaflet.

'Construction England', Organised by the Arts Council of Great Britain. Toured Manchester, Whitworth Art Gallery 2–20 April 1963; Liverpool, Penarth, Swansea, Middlesbrough, Lincoln, Kingston upon Hull, Southampton, Newcastle upon Tyne through 30 November 1963. Catalogue.

'The Gregory Fellows, University of Leeds'. Organised by the Arts Council of Great Britain. Toured Cambridge, Arts Council Gallery, 8–29 February 1964. Bolton, Liverpool, Nottingham, Southampton, Cardiff through 18 July 1964. Catalogue.

The Tate Gallery, 'London Group 1914–64: Jubilee Exhibition – Fifty Years of British Art', 15 July–16 August 1964. Catalogue.

'London: The New Scene', Organised by the Walker Art Centre, Minneapolis. Toured Minneapolis, Walker Art Centre, 6 February–14 March 1965. Toured Washington, Boston, Seattle, Vancouver, Toronto, Ottawa through 20 March 1966. Catalogue with essays 'London: The New Scene' by Martin Friedman and 'Some Recent History' by Alan Bowness.

Marlborough Fine Art Ltd, 'Art in Britain 1930–40 centered around Axis, Circle, Unit One', March–April 1965. Catalogue with essay 'British Art 1930–40' and 'A Nest of Gentle Artists' by Herbert Read.

'Decade 1910–20'. Organised by the Arts Council of Great Britain. Toured Leeds, City Art Gallery 1–22 May 1965. Reading, Manchester, Glasgow, Leicester through 23 September 1965.

'Corsham Painters and Sculptors: an Exhibition of Paintings, Drawings and Sculpture by some Artists now teaching at Bath Academy of Art, Corsham'. Organised by the Arts Council of Great Britain. Toured Totnes, Dartington College of Art 17 July–7 August 1965. Sheffield, Walsall, Cambridge, Middlesbrough, through 6 December 1965. Catalogue.

Axiom Gallery, 'Constructions', 22 April–28 May 1966. Folder with loose leaves.

Whitechapel Art Gallery, 'The New Generation: 1966', 22 June–31 July 1966.

Catalogue.

Cambridge, The Arts Council Gallery, 'Unit Series Progression: an Exhibition of Constructions', 28 January–18 February 1967. Pamphlet.

Camden Arts Centre, 'From Life: English Art and the Model Today', 5–28 January 1968. Catalogue.

'New British Painting and Sculpture'. Organised by the Whitechapel Art Gallery for the University of California Art Galleries. Toured Berkeley, University Art Museum 8 January–11 February 1968, Portland, Vancouver, Seattle, Washington, Chicago, Houston through 1 June 1969.

Whitechapel Art Gallery, 'The New Generation: 1968 Interim', 25 April–26 May 1968. Catalogue with essay 'The Peter Stuyvesant Foundation'.

Hayward Gallery, '6 at the Hayward', 13 November–21 December 1969. Organised by the Arts Council of Great Britain. Poster/leaflet.

'Decade 1920–30: British Painting, Drawing and Sculpture'. Organised by the Arts Council of Great Britain. Toured Leicester, Museum and Art Gallery 21 February–15 March 1970. Newcastle upon Tyne, Doncaster, Manchester, Bristol, London through 30 August 1970. Catalogue.

Leeds City Art Gallery, 'Some Recent Art in Britain', 10 April–17 May 1970. Catalogue.

Washington D.C., National Gallery of Art, 'British Painting and Sculpture 1960–1970', 12 November 1970–3 January 1971. Organised by the Tate Gallery and the British Council. Catalogue.

The Fine Art Society Ltd, 'Aspects of Victorian Art', 30 March–23 April 1971. Catalogue.

New York, The New York Cultural Centre, 'The British Avant Garde', 19 May–29 August 1971. Organised in collaboration with *Studio International*. Catalogue with essays 'The British Avant Garde' by Donald Karshan and 'Virgin soils and old land' by Charles Harrison.

'Art Spectrum'. Organised by the Arts Council of Great Britain in collaboration with the Regional Arts Associations – South, Central and North England areas, Greater London, and the Arts Councils of Scotland, Wales and Ulster. Regional selections toured within respective areas simultaneously, June–October 1971.

Tate Gallery, 'Seven Exhibitions', 24 February–23 March 1972. Variable material provided by each artist.

'Systems'. Organised by the Arts Council of Great Britain. Toured Whitechapel Art Gallery 8 March–9 April 1972, Manchester, Sheffield, Billingham, Newcastle, Birmingham, Leicester, Leeds, Southampton, Newport and Oxford through 27 May 1973. Catalogue with statements by the artists.

Hayward Gallery, 'The New Art – the first of a series of contemporary British art exhibitions'. Organised by the Arts Council of Great Britain, 17 August–24 September 1972. Catalogue.

'Decade 40s: Painting, Sculpture and Drawing in Britain 1940–49'. Organised by the Arts Council of Great Britain. Toured Whitechapel Art Gallery 1–26 November 1972. Southampton, Carlisle, Durham, Manchester, Bradford, Aberdeen through 3 June 1973. Catalogue.

'Objects and Documents: Work bought by Richard Smith for the Arts Council Collection'. Organised by the Arts Council of Great Britain. Toured Manchester, Polytechnic 30 November–15 December 1972, Lancaster, Birmingham, Sheffield, Aberdeen, Newcastle, Oxford through 18 October 1973. Catalogue.

Liverpool, Walker Art Gallery, 'Peter Moores Liverpool Project 2: Magic and Strong Medicine', 27 July–28 October 1973. Catalogue.

The Fine Art Society Ltd, 'The Arts & Crafts Movement: Artists, Craftsmen & Designers 1890–1930', 2–27 October 1973. Catalogue with essay 'The Arts & Crafts Movement' by Lionel Lambourne.

Garage Gallery Ltd, 'Tables', 23 January–15 February 1974. Poster/broadsheet.

Camden Arts Centre, 'Hampstead in the Thirties: A Committed Decade', 29 November 1974–19 January 1975. Catalogue with essays including 'A study of the cultural history of Hampstead in the Thirties' by J.P. Hodin.

Stockwell Depot, 'Studio Exhibition: New Painting and Sculpture', 30 May–28 June 1975. Pamphlet. (Annual exhibitions, begun in 1967).

Liverpool, Walker Art Gallery, 'Peter Moores Liverpool Project 3: Body & Soul', 23 October 1975–4 January 1976. Catalogue.

Milan, Palazzo Reale, 'Arte Inglese Oggi 1960–76', February–May 1976. Organised by the British Council and the Comune de Milano. Two volume catalogue in Italian and English including essays 'Sculpture 1960–1976' by David Thompson and 'Alternative Developments' by Richard Cork.

Hayward Gallery, '1977 Hayward Annual: Current British Art selected by Michael Compton, Howard Hodgkin and William Turnbull'. Part One: 25 May–4 July 1977, Part Two: 20 July–4 September 1977. Organised by the Arts Council of Great Britain. Catalogue.

Liverpool, Walker Art Gallery, 'Peter Moores Liverpool Project 4: Real Life', 1977. Catalogue.

Portsmouth, City Museum and Art Gallery, 'Unit 1', 20 May–9 July 1978.

Catalogue including essays 'Barbara Hepworth' by Alan Bowness and 'Henry Moore' by Anna Gruetzner.

Hayward Gallery, 'Hayward Annual '78', 23 August–8 October 1978. Organised by the Arts Council of Great Britain. Catalogue with essay 'The Anatomy of an Annual' by Lucy Lippard.

'Style in the 70's: a touring Survey Show of new Painting and Sculpture of the Decade presented by *Artscribe*'. Toured Bristol, Arnolfini Gallery 7 July–25 August 1979. Cambridge, London, Aberdeen, Hull, Rochdale through 1980. Catalogue with essays 'Style in the Seventies' by Ben Jones; 'Relevance in Criticism' by James Faure Walker and 'Good Painting, Good Sculpture and Pluralism' by David Sweet.

'Hayward Annual 1979'. Organised by the Arts Council of Great Britain 19 July–27 August 1979. Catalogue including artist's statements.

Oxford, Museum of Modern Art, 'Open Attitudes', 1 July–5 August 1979. Broadsheet.

'The Seven and Five Society 1920–35'. Arranged by Michael Parkin Fine Art Ltd. Toured Southport, Atkinson Art Gallery 13 August–8 September 1979. Cardiff, Colchester, London, Penzance through 15 March 1980. Catalogue.

Liverpool, Walker Art Gallery, 'Peter Moores Liverpool Project 5: the Craft of Art', 3 November 1979–3 February 1980. Catalogue.

'The British Art Show: recent Paintings and Sculpture by 112 artists'. Organised by the Arts Council of Great Britain. Toured Sheffield, Mappin Art Gallery 1 December 1979–27 January 1980. Newcastle upon Tyne, Bristol through 24 May 1980.

New York, The Solomon R. Guggenheim Museum, 'British Art Now: an American Perspective 1980 Exxon International Exhibition'. Organised in association with The American Federation of Arts and the Royal Academy, London. Toured London, the Royal Academy 18 October–14 December 1980. Catalogue with essay 'British Art Now' by Diane Waldman.

'Nature as Material: An exhibition of sculpture and photographs selected for purchase for the Arts Council collection by Andrew Causey'. Organised by the Arts Council of Great Britain. Toured Southport, Atkinson Art Gallery 5 July–8 August 1980. Billingham, Sheffield, Carlisle, Coventry, Rochdale, Newcastle, Harrogate, Bath through 19 September 1981.

Biennials

Arnhem, Park Sonsbeek
Sonsbeek '49, Europese Beeldhouw kunst in de Open Lucht, 1 July–18 September 1949.

SELECTED BIBLIOGRAPHY

Catalogue
Sonsbeek '52 Internationale Tentoonstelling Beeldhouwkunst, 30 May–15 September 1952. Catalogue.
Sonsbeek '55 Internationale Beeldententoonstelling de Open Lucht, 28 May–15 September 1955. Catalogue.
Sonsbeek '58 International Beeldententoonstelling in de Open Lucht.
5e Internationale beeldenstentoonstelling Sonsbeek '66, 27 May–25 September 1966. Catalogue.
Sonsbeek '71, 19 June–15 August 1971. Catalogue (2 volumes).

Antwerp, Middelheimpark, Biennale voor Beeldouwkunst
May–September. From 2e Biennale (1953) every biennale to 1977 includes British sculptors. 1959 and 1969 exhibitions focus on British sculptors. Catalogues in Flemish, French, German and English.

Kassel, Museum Fridericianum, Documenta
documenta: kunst des XX. jahrhunderts – internationale ausstellung, 15 July–18 September 1955. Catalogue.
documenta II: Kunst nach 1945: Malerei, Skulptur, Druckgrafik. Internationale Ausstellung, 11 July–11 October 1959. Catalogue includes essay, 'Skulptur nach 1945' by Eduard Trier, and additional separate catalogue issued as 'documenta: Skulptur', Köln, Verlag M.Dumont Schauberg, 1959.
documenta III: Malerei, Skulptur, Druckgrafik Internationale Ausstellung, 27 June–5 October 1964. Catalogue; separate catalogue published by Verlag M.Dumont Schauberg, Cologne.
documenta 4: Internationale Ausstellung, 27 June–6 October 1968. Catalogue (2 volumes).
documenta 5: Befragung der Realität: Bildwelten heute, 30 June–8 October 1972. Catalogue.
documenta 6, 24 June–2 October, 1977. Catalogue (3 volumes) and general guide; volume I: *Malerei, plastik, environment, performance* includes essay, 'Kurze Thesen zur Plastik der 70er Jahre', by Manfred Schneckenburger.

Paris, Musee d'art moderne de la ville de Paris, Biennale de Paris
Première Biennale de Paris, 2–25 October 1959. Catalogue includes introduction to British section by Alan Bowness.
Deuxième Biennale de Paris, 29 September–5 November 1961. Catalogue includes introduction to British section by Lawrence Alloway.
Troisième Biennale de Paris, 28 September–3 November 1963. Catalogue includes introduction to British section by Norbert Lynton.

Quatrième Biennale de Paris, 29 September–3 November 1965. Catalogue includes introduction to British section by David Thompson.
Cinquième Biennale de Paris, 30 September–5 November 1967. Catalogue.
Sixième Biennale de Paris, 2 October–2 November 1969. Catalogue with introduction to British section by Richard Morphet.
8e biennale de Paris, 14 September–21 October 1973. Catalogue.
9e biennale de Paris, 19 September–2 November 1975. Catalogue.
Biennale de Paris — une anthologie: 1959—1967, 13 June–2 October 1977. Catalogue.
10e biennale de Paris, 17 September–1 November 1977. Catalogue, in French and English, includes essay by Michael Compton.
11e biennale de Paris, 20 September–2 November 1980. Catalogue in French.

Pittsburgh, Carnegie Institute
Department of Fine Arts, *The 1958 Pittsburgh Bicentennial International Exhibition of Contemporary Painting and Sculpture*, 5 December 1958–8 February 1959. Catalogue.
Department of Fine Arts, *The 1961 Pittsburgh International Exhibition of Contemporary Painting and Sculpture*, 27 October 1961–7 January 1962. Catalogue.
Museum of Art, *The 1964 Pittsburgh International Exhibition of Contemporary Painting and Sculpture*, 30 October 1964–10 January 1965. Catalogue.
Museum of Art, *The 1967 Pittsburgh International Exhibition of Contemporary Painting and Sculpture*, 27 October 1967–7 January 1968. Catalogue.
Museum of Art, *The 1970 Pittsburgh International Exhibition of Contemporary Art*, 30 October 1970–10 January 1971. Catalogue.

São Paulo, Bienal do Museu de Arte Moderna de São Paulo
II Bienal, December 1953–February 1954. General catalogue in Portuguese, with additional, separate catalogue for British section in English and Portuguese; introduction to British section by Herbert Read.
IV Bienal, 1957. General catalogue in Portuguese, with additional separate catalogue for British section in English, Portuguese and Spanish; introduction to British section by Herbert Read.
V Bienal, September–December 1959. Catalogue in Portuguese, with additional, separate catalogue for British section in English, Portuguese and Spanish.
VI Bienal, September–December 1961. Catalogue in Portuguese, with additional separate catalogue for British section in

English, Portuguese and Spanish.
VII Bienal, September–December 1963. Catalogue in Portuguese, with additional separate catalogue for British section in English, Portuguese and Spanish.
VIII Bienal, September–November 1965. Catalogue in Portuguese, with additional separate catalogue for British section in English, Portuguese and Spanish.
IX Bienal, September–January 1968. Catalogue in Portuguese, with additional separate catalogue for British section in English and Portuguese.
X Bienal, September–December 1969. Catalogue in Portuguese with additional separate catalogue for British section in English and Portuguese.
XI Bienal, September–November 1971. Catalogue in Portuguese, with additional, separate catalogue for British section in English and Portuguese issued as 'Road Show: New English Inquiry' with introduction by John Hulton.
XIV Bienal, 1 October–18 December 1977. Catalogue in Portuguese with additional separate catalogue in English and Portuguese.
XV Bienal, 3 October–9 December 1979. Catalogue in Portuguese with additional separate catalogue in English and Portuguese.

Venice, Biennale
From 1897 every biennale to 1980 includes British sculptors (except 1920, 1936, 1940, 1942).

Biographies

Sculptors working in Britain, born between 1845 and 1945. This selection excludes artists included in the exhibition or referred to in the book born after the terminal date.

Compiled by Sandy Nairne, assisted by Hilary Gresty.

These summary biographies give in order the date and place of birth and death; training; teaching appointments; prizes, awards and honours; public commissions, earliest one person exhibition, retrospective exhibitions and, where there is a period without such a retrospective, significant recent gallery exhibitions. Literature is necessarily selected and readers are directed to the important catalogues listed after the place and date of retrospective or one person exhibitions. The place of exhibitions is London, unless otherwise stated.

Abbreviations:

AIA: Artists International Association
ARA: Associate member of the Royal Academy (year)
ARBS: Associate of the Royal Society of British Sculptors (year)
ARIBA: Associates of the Royal Institute of British Architects (year)
CAS: Contemporary Art Society
FRBS: Fellow of the Royal Society of British Sculptors (year)
FRIBA: Fellow of the Royal Institute of British Architects (year)
ICA: Institute of Contemporary Arts
RA: Member of the Royal Academy (year)
RBS: Royal Society of British Sculptors
RCA: Royal College of Art

Ivor Abrahams.
Born: Wigan 1935.
Studied at St. Martin's School of Art, 1952–53, and Camberwell School of Art, 1953–57. Worked as an apprentice with Fiorini Bronze Foundry, 1954–55, and as a display artist, 1956–60. Making figurative sculptures in fibreglass and bronze, related to landscape themes, and printmaking.
Teaching: Birmingham, Coventry, Hull and Goldsmith's College, 1960–70.
Exhibitions: Gallery One, 1961. Retrospectives include Kunstverein, Cologne, 1973 (catalogue). City Museum and Art Gallery, Portsmouth, 1979 (catalogue).

Robert Adams.
Born: Northampton 1917.
Studied at Northampton School of Art, 1933. Worked at various jobs including engineering. Making carvings, and then from early 60s non-figurative constructed work made principally from steel.
Teaching: includes Central School of Art, 1949–60.
Commissions: include, sculpture for the Festival of Britain, 1951. Wall relief for the Municipal Theatre, Gelsenkirchen, Germany, 1959. Reliefs for the *Canberra*, 1961, and *Transvaal Castle*, 1961, (liners). Sculptures for the B.P.Building, London, 1966. Kingswell, Hampstead, 1972. William and Glyn's Bank, London, 1976.
Exhibitions: Gimpel fils, 1947, and subsequently. Retrospective, Northampton Art Gallery, 1971 (catalogue).
Literature: Ian Mayes, 'Robert Adams', *Sculpture International*, April 1969.

Eileen Agar.
Born: Buenos Aires 1904.
Came to England, 1911. Studied with Leon Underwood in 1924, at the Slade School of Fine Art, 1925–26, and in Paris, 1928–30. Member of the London Group since 1933. Painter of Surrealist works, who also made Surrealist sculptures and assemblages.
Exhibitions: 'International Surrealist Exhibition', New Burlington Galleries, 1936, and 'Fantastic Art, Dada and Surrealism', Museum of Modern Art, New York, 1937. Retrospectives, Brook Street Gallery, 1964 (catalogue). Commonwealth Art Gallery, 1971 (catalogue).
Literature: Eileen Agar, 'Religion and the Artistic Imagination', *The Island*, I.4. December 1931.

David Annesley.
Born: London 1936.
Studied at St. Martin's School of Art, 1958–61. Worked in Majorca, 1962. Making abstract sculptures, principally in metal. Also painting from 1972.
Teaching: Central School of Art and Design, 1963–69. St. Martin's School of Art from 1963.
Exhibitions: 'New Generation', Whitechapel Art Gallery, 1965. Waddington Gallery, 1966, and subsequently. 'The Alistair McAlpine Gift', Tate Gallery, 1971 (catalogue). Watters Gallery, Sydney, 1975.

Kenneth Armitage.
Born: Leeds 1916.
Studied at Leeds College of Art, 1934–37, and the Slade School of Fine Art, 1937–39. Served in the Army, 1939–46. First making stone carvings, then plaster modelling, changing to clay, 1955–57; recently utilising fibreglass.
Teaching: includes Bath Academy of Art, Corsham, 1946–56.
Awards: Gregory Fellow in Sculpture, Leeds, 1953–55. First prize in Krefeld War Memorial Competition 1956. David F. Bright Foundation Award, 1958. Artist-in-Residence in Berlin, 1967–69. C.B.E., 1969.

Exhibitions: Gimpel Fils, 1952, and subsequently. Bertha Schaefer Gallery, New York, 1954. Retrospectives, Whitechapel Art Gallery, 1959 (catalogue): Arts Council of Great Britain, 1972 (catalogue).
Literature: Roland Penrose **Kenneth Armitage**, Amriswil, 1960. Norbert Lynton, **Kenneth Armitage**, 1962. John Glaves-Smith, 'Kenneth Armitage', *Artscribe*, No 16, 1979.

Lawrence Atkinson.
Born: Chorlton upon Matlock, near Manchester 1873.
Died: Paris 1931.
Educated at Bowden College, Chester, and then studied singing and music in Berlin and Paris. Taught singing and music in Liverpool and London and gave concert performances. Self-taught as an artist. Worked first as a painter, and later concentrated on sculpture. Joined the Revel Art Centre, 1914, and was a signatory of the Vorticist Manifesto in **Blast No 1**, 1914. Moved to Paris after 1921.
Awards: Grand Prix for *L'Oiseau* at Milan Exhibition, 1921.
Exhibitions: Allied Artists Association, 1913, and with the London Group, 1916. 'Abstract Sculpture and Painting', Eldar Gallery, 1921 (catalogue).
Literature: Lawrence Atkinson, poems, **Aura**, 1915. Horace Shipp, **The New Art**, 1922. Horace Shipp, **Sculpture of Laurence** (sic) **Atkinson**, c.1922.

Arnold Auerbach.
Born: Liverpool 1898.
Studied at Liverpool School of Art and in Paris. Making modelled and carved sculptures, painting and etching.
Teaching: Regent Street Polytechnic and Chelsea School of Art.
Exhibitions: Royal Academy from 1923.
Literature: Arnold Auerbach, **Sculpture, a history in brief**, 1953.

Michael Ayrton.
Born: London 1921
Died: London 1975.
Born Michael Gould, adopted mother's maiden name. Attended various art schools, including Heatherley's, and in Vienna. Worked in Paris, sharing a studio with John Minton, 1938–39. Served in the R.A.F., 1939–42. Worked as a draughtsman, writer, critic, set designer and sculptor, modelling works cast in bronze. Travelled abroad frequently; and worked with the BBC as a broadcaster.
Teaching: Camberwell School of Art, 1942–44. Visiting professor at University of California, Santa Barbara, 1967–68; at Pennsylvania State University, Philadelphia, 1973.
Awards: Royal Society of Literature,

Heinemann Award, 1967. Honorary Doctorate, University of Essex, 1975.
Exhibitions: With John Minton, Leicester Galleries, 1942. Retrospectives, Birmingham City Museums and Art Gallery, 1977 (catalogue). Scottish Arts Council, 1981 (catalogue), Bruton Gallery, Somerset, 1981 (catalogue).
Literature: includes, Michael Ayrton, **The Rudiments of Paradise**, 1971, **Fabrications**, 1972, **The Midas Consequence** and **Archilochos**, both 1977. C.P. Snow **Michael Ayrton, Drawings and Sculpture**, 1966. Peter Cannon-Brookes **Michael Ayrton: An Illustrated Commentary**, Birmingham, 1978.

Clive Barker.
Born: Luton 1940.
Studied at Luton College of Technology and Art, 1957–59. Began to make objects, 1962, and making sculptures, modelled and cast, and often chromium plated. First visit to New York, 1966.
Exhibitions: Robert Fraser Gallery, 1968. Anthony D'Offay Gallery, 1974 (catalogue). '12 Studies of Francis Bacon by Clive Barker, 3 studies of Clive Barker by Francis Bacon', Felicity Samuel Gallery, 1978.
Literature: John Russell and Suzi Gablik, **Pop Art Redefined**, 1969.

Gilbert Bayes.
Born: London 1872.
Died: London 1953.
Son of painter and etcher, A.W. Bayes, and brother of painter, Walter Bayes. Studied part-time at the City and Guilds Technical College, Finsbury, and the Royal Academy Schools, 1896–99. Made reliefs, medals, statuettes and monuments, derived from mediaeval folklore and biblical subjects.
Awards: Gold Medal and Diploma of Honour, Paris Exhibition of Decorative Art, 1925. R.B.S. Silver Medal for the friese of the Saville Theatre, Shaftesbury Avenue, 1931. President of the R.B.S. 1939–44.
Literature: Gilbert Bayes, **Modelling for Sculpture: a Book for the Beginner**, 1930. Louise Irvine, 'The Architectural Sculpture of Gilbert Bayes', *Journal of the Decorative Arts Society* No 4, 1980.

Richard Bedford.
Born: Torquay 1883.
Died: Essex 1967.
Son of the artist, George Bedford. Studied part-time at Central School of Art and Design, and Chelsea School of Art. Carved works in marble, stone, and wood, often of abstracted animal forms. Joined Victoria and Albert Museum as technical assistant, 1903. Keeper of the Department of Sculpture, 1924–38, and of the Depart-

ment of Circulation, 1938–46. Curator of pictures, Ministry of Works, 1947–48.
Exhibitions: Lefevre Gallery, 1936. Royal Academy from 1947. The Minories, Colchester, 1960 and retrospective, 1968 (catalogue).
Literature: Kenneth Towndrow, 'Richard Bedford: Sculptor in Marble', *The Studio*, November 1947.

Franta Belsky.
Born: Brno, Czechoslovakia 1921.
Studied at the Prague Academy of Fine Arts, the Central School of Art and Design, 1939, the Royal College of Art, 1950. Served in the Army, 1940–45. Making portrait sculptures, figures and monuments.
Commissions: include, **Constellation**, Colchester, 1953. **Lesson**, GLC Housing, 1957–8. **Triga**, Knightsbridge, 1958. **Joy-Ride**, Stevenage New Town Centre, 1958. **Herschel Memorial**, Slough, 1969, **Fountains**, Shell Centre, South Bank, 1959–61. **Totem**, Arndale Centre, Manchester, 1975.
Awards: President of the Society of Portrait Sculptors, 1963–8. Jean Masson Davidson Award, 1978.
Exhibitions: Royal Academy from 1943.
Literature: G.S. Whittet, 'Franta Belsky, Sculptor', *The Studio*, July 1957, Mervyn Levy, 'The Shell Fountain by Franta Belsky', *The Studio*, June 1963.

Thomas Brock.
Born: Worcester 1847.
Died: London 1922.
Studied at the Royal Academy Schools, 1867. Made numerous portrait busts, funerary monuments and public statues.
Commissions: include, **Robert Raikes**, 1880, and **Sir Bartle Frere**, 1888, in the Victoria Embankment Gardens. **Black Prince**, Leeds, 1902. **Victoria Memorial**, Buckingham Palace, 1901–9. **Lord Lister**, Upper Portland Place, 1924.
Awards: A.R.A. 1883. R.A. 1891. First President R.B.S. 1905. Knighted 1911.
Exhibitions: Royal Academy from 1868.
Literature: Elizabeth and Michael Darby, 'The National Memorial to Victoria', *Country Life*, 16 November 1978.

Ralph Brown.
Born: Leeds 1928.
Studied at Leeds College of Art, 1948–51, Hammersmith School of Art, 1951–2 and the Royal College of Art, 1952–56. Studied in Paris with Zadkine, 1954. Making figurative sculpture, usually cast in bronze. Lived in France, 1973–76.
Teaching: Head of Sculpture, Bournemouth College of Art, 1956–8. Bristol College of Art, and the Royal College of Art 1958–72.
Commissions: include, **Sheep-shearer**,

1956, and **Meat Porters**, 1960 for Harlow New Town. **Swimmers** for Hatfield New Town.
Awards: Second Prize in the British Sculpture Section, John Moores Liverpool Exhibition, 1959. A.R.A. 1968. R.A. 1972.
Exhibitions: Leicester Galleries, 1961 and 1963. Taranman Gallery, 1976 (catalogue).
Literature: Bryan Robertson, 'Ralph Brown, Sculptor', *Motif*, no 8, Winter 1961.

Lawrence Burt.
Born: Leeds 1925.
Worked as an industrial metalworker, 1939–41 and 1946–49. Served in the Army, 1941–46. Studied part-time at Leeds College of Art, 1948–55. Making assemblage sculptures and reliefs. Lived and worked in Cyprus, 1971–74.
Teaching: Leeds College of Art, 1956–60; Leicester College of Art 1960–64; Cardiff College of Art 1964–66; Wolverhampton College of Art 1966–68; and Falmouth School of Art, 1974–79.
Exhibitions: Drian Gallery, 1961, 1966. Retrospective, Oriel Gallery, Cardiff, 1980 (catalogue).
Literature: Lawrence Burt, 'Statement', *Control*, No 5, 1970, 'Propaganda for Control', *Art and Artists*, June 1971. Charles Spencer, 'Lawrence Burt', *Studio International*, May 1966.

Reg Butler.
Born: Buntingford, Hertfordshire 1913.
Died: Hertfordshire 1981.
Trained as an architect; A.R.I.B.A. 1937. Practised as an architect and industrial technologist, 1936–50. Worked as a blacksmith, 1941–45. Started to make sculpture almost full-time during 1940's. Making figurative works in iron, and modelled and cast, in bronze and later in fibreglass.
Teaching: Slade School of Fine Art since 1950.
Commissions: include, Festival of Britain, 1951. **The Oracle**, 1952, for Hatfield Technical College.
Awards: Grand Prize in *The Unknown Political Prisoner* Sculpture Competition, 1953. Gregory Fellowship, Leeds University, 1950–53.
Exhibitions: Hanover Gallery, 1949. Retrospectives, Venice Biennale, 1954 (catalogue); Pierre Matisse Gallery, New York, 1959 (catalogue); and J.P. Speed Art Museum, Louisville, Kentucky, 1963 (catalogue). Pierre Matisse Gallery, New York, 1973 (catalogue).
Literature: Reg Butler, **Creative Development: Five Lectures to Students**, 1962.

Anthony Caro.
Born: London 1924.
Studied engineering at Christ's College, Cambridge, 1942–44; sculpture at the

Regent Street Polytechnic, 1946, and the Royal Academy Schools, 1947–52. Served in the Fleet Air Arm, 1944–45. Worked as an assistant to Henry Moore, 1951–53. Initially made figurative sculptures, cast in bronze or lead; since 1959 has been making non-figurative works in welded and bolted steel and aluminium, and more recently in brass and welded bronze.
Teaching: St. Martin's School of Art, 1952–53, and 1964–73. At Bennington College, Vermont, 1963–64.
Commissions: **London West**, Hammersmith, 1980.
Awards: Ford Foundation Travel Grant, 1959. Paris Biennale Sculpture Prize, 1959. David E. Bright Sculpture Prize, Venice Biennale, 1966. Sculpture Prize, 10th Biennale de São Paulo, 1969. C.B.E. 1971.
Exhibitions: Galleria del Naviglio, Milan, 1956, and Gimpel Fils, 1957. Retrospectives, Hayward Gallery, 1969 (catalogue). Museum of Modern Art, New York, 1975. Kunstverein Braunschweig, 1979, (catalogue).
Literature: Richard Whelan, **Anthony Caro**, 1974. William Rubin, **Anthony Caro**, 1975. Diane Waldman, **Anthony Caro**, New York, 1981 (projected).

Lynn Chadwick.
Born: London 1914.
Trained as a draughtsman in architectural practice. Served in the Fleet Air Arm, 1941–44. Worked in private practice until 1946. Began making metal mobiles, and from early 1950's, figure and animal forms made from iron and composition, and cast in bronze.
Commissions: include, three works for the Festival of Britain, 1951.
Awards: National Prize in *The Unknown Political Prisoner* Sculpture Competition, 1953. International Sculpture Prize, Venice Biennale, 1956. First prize at the Concorso Internazionale del Bronzetto, Padua, 1959. C.B.E. 1964.
Exhibitions: Gimpel Fils, 1950. Regularly with Marlborough Gallery from June 1961.
Literature: Lynn Chadwick, 'A Sculptor and his public', *The Listener*, 21 October 1954. Herbert Read, **Lynn Chadwick**, Amriswill, 1960. J.P. Hodin, **Lynn Chadwick**, 1961. Alan Bowness, **Lynn Chadwick**, 1962. W.J. Strachan, 'The Sculptor and his drawings: Lynn Chadwick', *The Connoisseur*, August 1974.

Geoffrey Clarke.
Born: Darley Dale, Derbyshire 1924.
Served in the R.A.F. 1943–47. Studied at the Royal College of Art, 1948–52. Working principally as a sculptor in metal, but also as an etcher, and a designer of stained glass.
Teaching: Royal College of Art, Light

Transmission and Projection Department, 1968–73.
Commissions: include, Coventry Cathedral, 1953–62. Time-Life Building, 1952. Thorn Electric Building, St. Martin's Lane, 1958. Physics Department, Newcastle-upon-Tyne, 1962.
Awards: A.R.A. 1970, R.A. 1976.
Exhibitions: Gimpel Fils, 1952. Redfern Gallery, 1965 (catalogue). Taranman Gallery, 1975 (catalogue) and 1976 (catalogue).
Literature: J.P. Hodin, 'Geoffrey Clarke, Maker of Art', *The Studio*, May 1963.

Robert Clatworthy.
Born: Bridgwater, Somerset 1928.
Studied at the West of England College of Art, 1944–46, Chelsea School of Art, 1949–51, and the Slade School of Fine Art, 1951–54. Working as a sculptor making modelled figurative works, and as a theatre designer.
Teaching: West of England College of Art, 1967–71. Head of Fine Art, Central School of Art and Design, 1971–75.
Awards: A.R.A. 1968. R.A. 1973.
Exhibitions: Hanover Gallery, 1954 and 1956. Basil Jacobs Gallery 1972. Royal Academy Diploma Galleries, with Phillip Sutton, 1977.

William Robert Colton.
Born: Paris 1867.
Died: London 1921.
Came to England, 1870. Studied at the City and Guilds School of Art and Royal Academy Schools. Made decorative sculpture and was associated with the revival of colouring, later his work became more romantic in character. Made figures and monuments.
Teaching: Professor of Sculpture at the Royal Academy Schools 1907–1910 and 1911–1912.
Commissions: **Boer War Memorial**, Worcester. **Royal Artillery Monument**, The Mall, 1910.
Awards: A.R.A. 1903. R.A. 1919. President of the R.B.S. 1921.
Exhibitions: Royal Academy and Paris Salon from 1889.
Literature: M.H. Spielman, 'W.R. Colton: the new associate of the Royal Academy', *The Magazine of Art*, 1903. A.L. Baldry, 'W. Robert Colton A.R.A.', *The Studio*, November 1915.

Edward Bainbridge Copnall.
Born: Cape Town 1903.
Died: Canterbury 1973.
Moved to England as a child. Studied painting at Goldsmith's College of Art, and at the Royal Academy Schools to 1924. Took up sculpture in 1929, making figures and architectural work, carved in stone and later in fibreglass, and mosaic and decora-

tive work.
Teaching: Head, Sir John Cass College, 1945–53.
Commissions: include, figures on RIBA building, 1931–34. **Aspiration**, Marks and Spencer, Edgware Road, 1959. **Swanman**, ICL Building, Putney Bridge, 1960.
Awards: M.B.E. 1946. President of the R.B.S. 1961–66.
Exhibitions: Royal Academy from 1925, and Paris Salon.
Literature: Bainbridge Copnall, **A Sculptor's Manual**, Oxford, 1971. Arnold Whittick, 'Bainbridge Copnall', *Commemorative Art*, July 1965.

Michael Craig-Martin.
Born: Dublin 1941.
Studied at Yale University, 1961–63, and Yale School of Arts and Architecture, 1964–66. Resident in Britain since 1966. Making works combining a number of materials and objects, earlier work using texts, and later work with large wall projections.
Teaching: includes, Bath Academy of Art, Corsham, and Canterbury College of Art, 1966–70. Goldsmith's College since 1973.
Commissions: **The Circular Book**, Margate Public Library, 1973–75.
Awards: Artist-in-Residence, King's College, Cambridge, 1970–72.
Exhibitions: Rowan Gallery, 1969, and subsequently. Retrospective, Turnpike Gallery, Leigh, 1976 (catalogue). '10 Works 1970–77', Institute of Modern Art, Brisbane, 1978.
Literature: Michael Craig-Martin, 'Taking things as pictures', *Artscribe*, 14, 1978.

Bill Culbert.
Born: Port Chalmers, New Zealand 1935.
Studied at Canterbury University, School of Art, New Zealand, 1954–57. Came to England, and studied painting at the Royal College of Art, 1957–60. Lived and worked in France, 1961–62 and 1972–73. Making paintings and from 1960's kinetic and illuminated sculptures, some in collaboration with Stuart Brisley.
Teaching: includes, Nottingham School of Art, 1966–72. Part-time, Reading University.
Commissions: include, stage set for Ashton's *Lament of the Waves*, Royal Ballet, Covent Garden.
Awards: Resident Artist, Nottingham University, 1962–65. First Prize Open Painting Competition, Belfast, 1964 and Prize, 1968. Canterbury Fellow, Canterbury University, New Zealand, 3 months, 1978.
Exhibitions: Commonwealth Institute, paintings, 1961. Kunst Forum, Rottweil, Germany, 1976. Serpentine Gallery, kinetic sculptures 1976 (catalogue). Sunderland Arts Centre (with Ron Haselden), 1980 (catalogue).

Hubert Dalwood.
Born: Bristol 1924.
Died: London 1976.
Apprenticed as an engineer to the British Aeroplane Company, 1940–44. Served in the Royal Navy, 1944–46. Studied at the Bath Academy, Corsham, 1946–49. Sculptures modelled and cast, and later constructed in metals and fibreglass.
Teaching: Leeds College of Art, Royal College of Art, Hornsey College of Art and Maidstone College of Art, 1956–64. Head of Sculpture Department, Hornsey College of Art, 1963–73. Head of Sculpture Department, Central School of Art, 1974–76.
Commissions: include, Liverpool University, 1960. Bodington Hall, Leeds University. Nuffield College, Oxford University. Wolverhampton Polytechnic, 1970. Initiated Arts Council *Art into Landscape* competition and exhibition while member of Serpentine Gallery Committee, 1972–74.
Awards: Gregory Fellowship at University of Leeds, 1955–58. First Prize for Sculpture, Venice Biennale, 1962. A.R.A. 1976.
Exhibitions: Gimpel Fils, 1954, and subsequently to 1970. Retrospective memorial exhibition, Hayward Gallery, 1979 (catalogue).

Sir William Reid Dick.
Born: Glasgow 1878.
Died: London 1961.
Studied at Glasgow School of Art to 1907, and the City and Guilds School of Art, Lambeth. Served in the Army, 1914–19. Sculpted portraits, figures and monuments. Trustee of the Tate Gallery, 1934–41.
Commissions: include, **Kitchener Chapel**, St. Paul's Cathedral, 1925. **Controlled Energy**, Unilever House, Blackfriars 1932. **Godiva**, City of Coventry 1944. **King George V**, Westminster, 1947. **F.D. Roosevelt**, Grosvenor Square, 1948.
Awards: A.R.A. 1921. R.A. 1928. Knighted, 1935. President of the R.B.S. 1935–38. Sculptor in Ordinary to his Majesty for Scotland, 1938.
Exhibitions: Royal Academy from 1908.
Literature: H. Granville Fell, **Sir William Reid Dick K.C.V.O., R.A.**, 1945.

Frank Dobson.
Born: London 1886.
Died: London 1963.
Son of an illustrator. Studied at Leyton School of Art, 1900–02. Worked in the studio of William Reynolds-Stephens, 1902–04. Studied at Hospitalfield Art Institute, Arbroath, 1906–10, and City and Guilds School of Art, Lambeth, 1910–12. Served in the Army, 1914–18. Early work was mainly painting; increasingly concen-

trated on sculpture after the war, both modelling and carving.
Teaching: Professor of Sculpture at the Royal College of Art, 1946–53.
Commissions: include, Facade of Hay's Wharf, Southwark, 1930. **London Pride**, for Festival of Britain, 1951.
Awards: President of the London Group, 1923–27. A.R.A. 1942. R.A. 1953. C.B.E. 1947.
Exhibitions: With Group X, 1920. Leicester Galleries, 1921–54. Royal Academy from 1933. Retrospective exhibitions: City Art Gallery, Bristol 1940 (catalogue), Graves Art Gallery, Sheffield, 1966. Arts Council of Great Britain, 1966 (catalogue). Kettle's Yard Gallery, Cambridge, 1981 (catalogue).
Literature: Raymond Mortimer, **Frank Dobson**, 1926. T.W. Earp, **Frank Dobson Sculptor**, 1945.

Kenneth Draper.
Born: Killamarsh, near Sheffield 1944. Studied at Chesterfield College of Art, 1959–62, Kingston College of Art, 1962–65, and Royal College of Art, 1965–68. Making abstract sculpture in a variety of materials, including wood, clay, latex, plaster and steel. Moved to Norfolk, 1978.
Teaching: Goldsmith's College and Camberwell School of Art.
Commissions: include, John Dalton Building, Manchester Polytechnic, 1973. **Oriental Gateway**, University of Bradford, 1977–78. Moat Community College, Leicestershire, 1980.
Awards: Prize for Sculpture, *Young Contemporaries*, 1965.
Exhibitions: Redfern Gallery, 1969 and 1978. Cartwright Hall, Bradford Art Galleries and Museums, 1978. Retrospective, Warwick Arts Trust, 1981 (catalogue).

Alfred Drury
Born: London 1856.
Died: London 1944.
Studied at Oxford School of Art, and the Royal College of Art. Worked with Dalou in Paris, 1881–85. Returned to London and worked as assistant to Boehm. Made portrait and figure sculptures, and monumental and memorial sculpture.
Commissions: include, statues for Leeds City Square, 1898. Architectural sculpture for the War Office, 1905; and for the facade of the Victoria and Albert Museum, 1908. Four figures for Vauxhall Bridge, 1909. **Joshua Reynolds**, courtyard of Burlington House, 1932.
Awards: A.R.A. 1900. R.A. 1913. Silver Medal of R.B.S. 1932.
Exhibitions: Royal Academy from 1885.
Literature: A.L. Baldry, 'A Notable Sculptor: Alfred Drury A.R.A.', *The Studio*, 37, February 1906.

Alan Durst.
Born: Alverstoke 1883.
Died: London 1970.
Served in the Royal Marines, 1902–13, and 1914–18. Studied at the Central School of Art and Design, 1913 and 1920. Curator of the Watts Museum, Compton, 1919–20. Carved figures and animals, and carried out ecclesiastical work.
Teaching: Wood carving at the Royal College of Art, 1925–40 and 1945–48.
Commissions: include, figures for the Royal Academy of Dramatic Art, 1931. West Front of Peterborough Cathedral.
Awards: A.R.A. 1953.
Exhibitions: Seven and Five Society, 1923–24. Leicester Galleries, 1930. Royal Academy from 1938.
Literature: Alan Durst, **Wood Carving**, 1938. 'Sculpture can Survive', *The Studio*, December 1950. Kineton Parkes, 'Alan Durst, Carver', *Apollo*, March 1929. Cora J. Gordon, 'Carvings of Alan Durst', *The Studio*, January 1950.

Jacob Epstein.
Born: New York 1880.
Died: London 1959.
Studied at the Art Students League, New York, and at night school, 1896–99. Travelled to Paris, and studied at the École des Beaux Arts, and at the Académie Julian, 1902–04. Settled in London, 1905, and became a British citizen, 1907. Worked in Paris, 1910–12, and met Picasso, Brancusi and Modigliani. Returned to England and was associated with the Vorticist Movement, and a founding member of the London Group, 1913. Carved architectural works, figures and monuments, many of which resulted in extensive public outcry, and modelled portraits and busts. Continued after the First War to model figures, and also made a number of large works on religious themes.
Commissions: include, British Medical Association Building, The Strand, 1907–08. **Oscar Wilde Memorial**. Père Lachaise Cemetery, Paris, 1909–12. **Rima**, W.H. Hudson Memorial, Hyde Park, 1924. **Night** and **Day**, St. James's Underground Headquarters, 1928–29. **Youth Advancing**, Festival of Britain, 1951. **Madonna and Child**, Cavendish Square Convent 1952. **Christ in Majesty**, Llandaff Cathedral, 1953–54. **St. Michael and the Devil**, Coventry Cathedral, 1955–56. **War Memorial**, T.U.C. Building, 1957. Bowater House Group, Knightsbridge, 1958–59.
Awards: Numerous honours and honorary degrees. Knighted, 1954.
Exhibitions: Twenty-One Gallery, 1913. Leicester Galleries, 1917 and subsequently. Retrospectives include, Temple Newsam, Leeds (with Matthew Smith), 1942. Arts Council of Great Britain, Tate

Gallery, 1952, and Edinburgh Festival, 1961 (catalogue). The Shinman Collection, New Jersey State Museum, 1968 (catalogue). 'The Rock Drill Period', Anthony D'Offay, 1973 (catalogue). 'Rebel Angel', Birmingham City Art Gallery and Museum, 1980 (catalogue). 'Epstein Centenary Exhibition', Ben Uri Gallery 1980 (catalogue).
Literature: Jacob Epstein, **Let there be Sculpture**, 1940; revised as **An Autobiography**, 1955. Bernard van Dieren, **Epstein**, 1920. Herbert Wellington, **Jacob Epstein**, 1925; and **Seventy five Drawings by Epstein**, 1921. Arnold Haskell, **The Sculptor Speaks**, 1931. L.P. Powell, **Jacob Epstein**, 1932. G. Ireland, **Jacob Epstein, Camera Study of the Artist at Work**, 1958. Richard Buckle, **Epstein Drawings**, 1962, and **Jacob Epstein, Sculptor**, 1963.

John Ernest.
Born: Philadelphia 1922.
Studied in New York and Philadelphia. Lived and worked in Sweden, 1946–49. Worked in Paris, 1949–51, and settled in London 1951. Making geometric constructions from 1956, and also making scientific models, 1956–59.
Teaching: Bath Academy of Art, Corsham, 1960–65. Chelsea School of Art from 1960.
Commissions: Relief mural and tower, International Union of Architects Congress, 1961.
Exhibitions: Institute of Contemporary Arts, 1964. 'Constructive Context', Arts Council of Great Britain, 1978 (catalogue).
Literature: John Ernest, 'Statement', *Gazette*, no 1, 1961.

Garth Evans.
Born: Cheadle, Cheshire 1934.
Studied at Manchester College of Art, 1955–57, and Slade School of Fine Art, 1957–60. Making abstract sculpture in polyester resins and metal.
Teaching: St. Martin's School of Art, 1965, and Camberwell School of Art, from 1971. Slade School of Fine Art and Royal College of Art from 1970.
Commissions: include, Ebbw Vale Urban District Council, Wigston College of Further Education. Peter Stuyvesant Sculpture Project, Cardiff, 1972.
Awards: Cruddas Park Sculpture Competition, Newcastle, 1961. Gulbenkian Award, 1964. Arts Council of Great Britain Award, 1966. British Steel Fellowship, 1969. Prize, Bradford Print Biennale, 1972.
Exhibitions: Rowan Gallery, 1962, and subsequently. Leeds Polytechnic, 1971 (catalogue). Oriel Gallery, Cardiff, 1976.
Literature: Fenella Crichton, 'Garth Evans', *Studio International*, May/June 1976.

J.D. Fergusson.
Born: Leith 1874.

Died: Glasgow 1961.
Studied medicine at Edinburgh University, took up art in 1894, inspired by painters of the Glasgow School. Travelled and settled in Paris, 1907–14. Worked in London, and in Paris between the Wars. Founded periodical, *Rhythm*, with Middleton Murry and Katherine Mansfield, 1911–13. Settled in Scotland 1939, and married the dancer, Margaret Morris. Founded the New Art Club, Glasgow, 1940; and the New Scottish Group, 1942. Worked as a painter and as a sculptor, carving in wood.
Exhibitions: Baillie Gallery, 1905. Scottish Arts Council Exhibition, paintings, 1954–56. Memorial Exhibition, Scottish Arts Council, 1961 (catalogue). Fine Art Society, 1974 (catalogue).
Literature: J.D. Fergusson, (ed) **Scottish Art and Letters; Modern Scottish Painters**, Glasgow 1943. M. Morris, **The Art of J.D. Fergusson**, Glasgow, 1974.

Ian Hamilton Finlay.
Born: Nassau, Bahamas 1925.
Studied at the School of Art, Glasgow. Short stories published from 1958. Founded Wild Hawthorn Press, 1960. Making concrete poetry from 1963; working as an artist, poet and writer, often collaborating with other artists or craftsmen in the production of works. Creating Stonypath garden from 1967.
Commissions: include, sun dial and approach to British Embassy, Bonn, 1979.
Awards: Scottish Arts Council Bursaries: 1966, 1967, 1968. Atlantic-Richfield Award, Boston, 1968.
Exhibitions: Axiom Galleries, 1968. Scottish National Gallery of Modern Art, Edinburgh, 1972 (catalogue). Kettle's Yard Gallery, Cambridge, 1977 (catalogue). Graeme Murray Gallery, Edinburgh, 1976, 1980, 1981. Serpentine Gallery 1977 (catalogue).
Literature: includes numerous publications by Finlay; and David Brown, 'Stonypath, an Island Garden', *Studio International*, January/February 1977.

Barry Flanagan.
Born: Prestatyn 1941.
Studied at St. Martin's School of Art, 1964–66. Making abstract sculptures in a variety of materials, including cloth, rope, sand and glass. Also making films, furniture and drawings, and since mid-1970's figurative works in clay, marble and stone.
Teaching: includes, St. Martin's School of Art, 1967–71. Newport School of Art, and Omaha Municipal University, Nebraska, 1970–75.
Commissions: Peter Stuyvesant Sculpture Project, Cambridge 1972. Lincolns Inn Fields, 1980. City Square, Ghent, 1980.
Awards: Institute of Contemporary Arts

Award, 1965. Gulbenkian Foundation Grant to work with dance company, Strider, 1972.
Exhibitions: Rowan Gallery, 1966 and subsequently to 1974. Waddington Galleries and Art and Project, Amsterdam. Retrospectives, Stedelijk Van Abbemuseum, Eindhoven, and Serpentine Gallery, London, 1978 (catalogue). New 57 Gallery, Edinburgh, 1980 (catalogue).

Edward Onslow Ford.
Born: London 1852.
Died: London 1901.
Studied at the Antwerp Academy, 1870–72, and in Munich, 1872–74. Made monuments, busts and allegorical subjects often incorporating precious stones and metals.
Commissions: include, **General Gordon**, Chatham, 1889–90. **Shelley Memorial**, University College, Oxford, 1892. **Queen Victoria**, Manchester, 1901.
Awards: A.R.A. 1888. R.A. 1895.
Exhibitions: Royal Academy from 1875. Grosvenor Gallery, Suffolk Street Gallery and New Gallery from 1879.
Literature: Walter Armstrong 'E. Onslow Ford A.R.A.', *Portfolio*, 1890. A.H. Dixon, 'Onslow Ford R.A.: an imaginative sculptor', *Architectural Review*, September, 1900. Francis Haskell, 'The Shelley Memorial', *Oxford Art Journal*, 1, 1978.

George Frampton.
Born: London 1850.
Died: London 1928.
Studied at the City and Guilds School of Art, Lambeth, and at the Royal Academy Schools, 1881–87. Studied sculpture in Paris under Antonin Mercié and painting under P.A.J. Dagnan-Bouveret. Sculpted portraits, memorials and reliefs; after 1893 interested in craft and decorative work and produced polychromatic sculpture with mixed materials.
Teaching: Joint Head, with Lethaby, of Central School of Arts and Crafts from 1894.
Commissions: include, **Mitchell Memorial**, Newcastle-upon-Tyne, 1898. **Peter Pan**, Kensington Gardens, 1912. **Edith Cavell Memorial**, St. Martin's Place, 1920.
Awards: A.R.A. 1894. R.A. 1912. Knighted 1908. President of the R.B.S. 1911–12.
Exhibitions: Royal Academy from 1884. With Munich and Vienna Secessions and Libres Esthetique, Brussels.
Literature: George Frampton, articles in *The Studio* including 'Colouring Sculpture', June 1894; 'Wood Carving', October 1897. Fred Miller, 'George Frampton A.R.A.: Art Worker', *Art Journal*, November 1897. W.K. West, 'Some recent Monumental Sculpture by Sir George Frampton R.A.', *The Studio*, October 1911.

Elisabeth Frink.
Born: Thurlow, Suffolk 1930.

Studied at Guildford School of Art, 1947–49, and Chelsea School of Art, 1949–53. Sculpting, modelled and cast, figurative works, predominantly of men and animals. Trustee of the British Museum, 1976.
Teaching: Chelsea School of Art, 1951–61; St. Martin's School of Art, 1954–62, and the Royal College of Art.
Commissions: include, **Wild Boar** for Harlow New Town, 1957. **Blind Beggar and Dog**, Bethnal Green, 1958. Lectern for Coventry Cathedral, 1962. Paternoster, St. Paul's Cathedral, 1975. **Horse and Rider**, Piccadilly, 1975.
Awards: C.B.E. 1969. A.R.A. 1972. R.A. 1977.
Exhibitions: St. George's Gallery, 1955. Waddington Galleries, 1959 and subsequently. Great Courtyard, Winchester, 1981 (catalogue).
Literature: Elisabeth Frink, **Aesop's Fables**, 1968; **Canterbury Tales**, prints, 1972. Edward Mullins, **The Art of Elisabeth Frink**, 1972.

George Fullard.
Born: Sheffield 1923.
Died: London 1973.
Studied at Sheffield College of Art, 1938–42, and the Royal College of Art, 1945–47. Served in the Army, 1942–44. Made figures and constructions in wood and clay.
Teaching: Chelsea School of Art, 1963–73.
Awards: A.R.A. 1973.
Exhibitions: Woodstock Gallery, 1958. Memorial retrospective exhibition, Serpentine Gallery, 1974 (catalogue).

Naum Gabo.
Born: Briansk, Russia 1890.
Died: Waterbury, Conneticut 1977.
Brother of Antoine Pevsner. Studied mathematics and engineering in Munich. Travelled to Italy and Paris, 1911–14. Lived in Copenhagen, 1914–18. Changed name from Pevsner to Gabo. Began to make constructions, 1915, and worked in metals, wood, perspex and kinetics to produce abstract constructivist works. Returned to Russia, 1917–22. Worked in Berlin 1922–32. Lived in Paris, and member of Abstraction-Creation, 1932–35. Moved to London, 1935–39. Lived St. Ives, Cornwall, 1939–46, where he was closely associated with Ben Nicholson and Barbara Hepworth. Worked in New York, 1946–77.
Commissions: include, Bijenkorf Monument, Rotterdam, 1955–57. Fountain for St. Thomas's Hospital, 1970–75.
Awards: include, Honorary K.B.E. 1971.
Exhibitions: With Pevsner, Galerie Percier, Paris, 1924. Kestner Gesellschaft, Hanover, 1930. Retrospectives include, Museum of Modern Art, New York,

1948 (catalogue) and 'Naum Gabo, The Constructive Process'. Tate Gallery, 1976 (catalogue).
Literature: Naum Gabo with Antoine Pevsner, **Realist Manifesto**, Moscow, 1920. Co-edited with J.L. Martin and Ben Nicholson, *Circle*, 1937. Herbert Read and J.L. Martin, **Gabo**, 1957. 'Naum Gabo and Constructivism' issue of *Studio International*, April 1966.

Louis Richard Garbe.
Born: London 1876.
Died: Westcott, Surrey 1957.
Apprenticed to his father's business producing small fancy goods in horn, ivory and hardwoods. Studied at the Central School of Art and at the Royal Academy Schools. Made figure and animal carvings in stones and ivory, and some monumental work. Worked with Doulton & Co. producing ceramic figures 1933–39.
Teaching: Central School of Art, 1901–29. Professor of Sculpture at the Royal College of Art, 1929–46.
Awards: A.R.A. 1929. R.A. 1936.
Exhibitions: Royal Academy from 1898.
Literature: 'Studio Talk', *The Studio*, May 1903, and July 1906.

Henri Gaudier-Brzeska.
Born: Saint-Jean-de-Braye 1891.
Died: Neuville-Saint-Vaast 1915.
Son of a carpenter and wood carver. Visited England, 1906, and on a scholarship to study business methods at University College, Bristol, 1908. Travelled to Nuremberg, and to Paris, 1910, and began work as a sculptor. Met Sophie Brzeska and added her name to his own. Returned to London in 1911, and met John Middleton Murry, Alfred Wolmark, Horace Brodzky and Jacob Epstein. Produced a number of portrait busts, bas-reliefs and allegorical groups, while also making works, both carved and modelled, in more radical abstract styles. Met Ezra Pound and T.E. Hulme, and was also briefly affiliated with Omega Workshops. Joined the Vorticist Group, and contributed to *Blast*, 1 and 2. Joined the French Army, 1915.
Exhibitions: Allied Artists' Association Salon, 1913. With Grafton Group, Alpine Gallery, 1914. Vorticist Exhibition, Doré Gallery, 1915. Retrospectives include, Leicester Galleries, 1918. Temple Newsam, Leeds (with Roy de Maistre), 1943. Beaux Arts Gallery, 1952 and 1954. Musée des Beaux Arts, Orléans, 1956 (catalogue). Arts Council of Great Britain, 1956 (catalogue). Kunsthalle Bielefeld, 1969 (catalogue). Scottish National Gallery of Modern Art, 1972 (catalogue). Mappin Art Gallery, Sheffield, 1977. Gruenebaum Gallery, New York, 1977 (catalogue). Mercury Gallery, 1970, 1975 and 1977.

Literature: Ezra Pound, **Gaudier Brzeska, A Memoir**, 1916. H.S. Ede, **A Life of Gaudier-Brzeska**, 1930, reprinted as **Savage Messiah**, 1931. Horace Brodzky, **Henri Gaudier-Brzeska 1891–1915**, 1933. **Gaudier-Brzeska, Drawings**, 1946. M. Levy, **Gaudier-Brzeska**, 1965. Roger Cole, **Burning to Speak, Life of Gaudier-Brzeska**, 1978. Roger Secrétain, **Gaudier-Brzeska**, Paris, 1979.

Mark Gertler.
Born: London 1891.
Died: London 1939.
Studied at the Regent Street Polytechnic, 1906–07, and at the Slade School of Fine Art, 1908–12. Painted portraits, figure subjects and still-lives, and modelled sculpture, 1916–17.
Exhibitions: Goupil Gallery, 1921. Memorial Exhibition, Whitechapel Art Gallery, 1949 (catalogue). The Minories, Colchester, 1971 (catalogue).
Literature: **Mark Gertler, Selected Letters**, edited N. Carrington, 1965. Hubert Wellington, **Mark Gertler**, 1925. John Woodeson, **Mark Gertler**, 1972.

Alfred Gilbert.
Born: London 1854.
Died: London 1934.
Studied at Heatherley's Art School, 1872–73, and at the Royal Academy Schools, 1873. Worked as an assistant to Boehm, 1874. Studied at the Ecole des Beaux Arts, Paris, 1875–78, and in Rome, 1878–84. Worked in a variety of metals for casting, making busts, classical statues, small compositions and monuments. Declared bankrupt in 1901, and moved to Bruges, 1904, returning to England in 1926.
Teaching: includes, Professor of Sculpture, Royal Academy of Schools, 1900–04.
Commissions: include, **Queen Victoria**, Winchester, 1887. **Eros**, Shaftesbury Memorial, Piccadilly Circus, 1893. **Clarence Tomb**, Windsor, completed 1926. **Queen Alexandra Memorial**, St. James's, 1932.
Awards: A.R.A. 1887. R.A. 1892, resigned 1908. Member of the Royal Victorian Order, 1897. Re-admitted to R.A. and Knighted, 1932.
Literature: Joseph Hatton, Special Easter Issue, *Art Journal*, 1903. Isabel McAllister, **Alfred Gilbert**, 1929. Henry Ganz, **Alfred Gilbert and his work**, 1934. Adrian Bury, **Shadow of Eros**, 1954. Lavinia Handley-Read, 'Alfred Gilbert, a new assessment', *The Connoisseur*, September – October, 1968.

Stephen Gilbert.
Born: Fife 1910.
Studied architecture at the Slade School of

Fine Art, 1929–32, and changed to painting, 1930. Lived in Paris, 1938–39, then Dublin, returning to Paris, 1945. Painting abstract works from 1948, and member of the Cobra Group, 1948–49. Worked on projects for metal houses, Huddersfield, 1955–56, and making constructed aluminium sculptures from 1958.
Commissions: London County Council Commission for Hampstead Heath, 1965. Chappell Building, Bond Street, 1966. British Steel Corporation, 1971.
Awards: Gulbenkian Foundation Award, 1962. First Award for Sculpture, Tokyo Biennale, 1965. Prize, *Structure 66* Welsh Arts Council, 1966.
Exhibitions: Painting, Wertheim Gallery, 1938. Sculpture, Drian Galleries from 1961. Retrospective, Graves Art Gallery, Sheffield, 1966 (catalogue).
Literature: Charles Spencer, 'Stephen Gilbert, Curvilinear Constructions', *Studio International*, October 1965.

Gilbert & George.
Gilbert, born Gilbert Proesch, Dolomite Mountains, Italy 1943.
George, born George Passmore, Totnes 1942.
Gilbert studied Wolkenstein School of Art, Hallein School of Art and Munich Academy of Art. George studied Dartington Hall College of Art and Oxford School of Art. Started working together at St. Martin's School of Art, 1967. From 1968, making living sculpture presentations, book works, videotapes, postal sculptures, magazine sculptures, and graphic and photographic works.
Exhibitions: Robert Fraser Gallery, 1968. Art and Project, Amsterdam, 1970, and subsequently. Konrad Fischer, Dusseldorf, 1970 and subsequently. Whitechapel Art Gallery, 1971. National Gallery of Victoria, Melbourne (catalogue), 1973. Retrospective, 'Photopieces 1971–80', Van Abbemuseum, Eindhoven, Kunsthalle Dusseldorf, Kunsthalle Berne, Musee d'Art Moderne, Centre Pompidou, Paris, Whitechapel Art Gallery, 1980–81.
Literature: Gilbert & George, **Side by Side**, Cologne, 1971. **Dark Shadow**, 1976. **Gilbert & George, 1968–80**, Van Abbemuseum Eindhoven, 1980.

Eric Gill.
Born: Brighton 1882.
Died: Uxbridge 1940.
Studied at Chichester Art School. Became an articled pupil to the architect, W. Caroe, 1900–3, and attended evening classes in masonry at the Westminster Technical Institute, and in lettering at the Central School of Art and Design. Began working as a letter cutter, 1903, and making carvings from 1910. Worked as a sculptor,

engraver, on inscription, type design, and wrote pamphlets. Became a Roman Catholic, 1913, and a tertiary of the order of St. Dominic, 1918. Ran the St. Dominic's Press at Ditchling, 1907–24, moved to Capel-y-Ffin, Wales, 1924, worked with the Golden Cockerel press, and subsequently settled near High Wycombe, 1928. Designed type for the Monotype Corporation.
Commissions: include, **Stations of the Cross**, Westminster Cathedral, 1913–18. War Memorials, Leeds University, and St. Cuthbert's Church, Bradford, 1920–24. St. James's Underground Headquarters, 1928. **Prospero and Ariel**, and other carvings on Broadcasting House, Langham Place, 1929–31. The Palestine Museum, Jerusalem, 1934; and the League of Nations Palace, Geneva, 1935–38.
Awards: A.R.A. 1937.
Exhibitions: Chenil Gallery, 1911. Royal Academy from 1938. Retrospectives include, Dartington Cider Press Centre, and Kettle's Yard, Cambridge, 1979 (catalogue). 'Strict Delight', Whitworth Art Gallery, Manchester, 1980 (catalogue).
Literature: Eric Gill, **Autobiography**, 1940. J.K.M. Rothenstein, **Eric Gill**, 1927. Joseph Thorp, **Eric Gill**, 1929. Walter Shewring, **Letters of Eric Gill**, 1947. Evan Gill, **Bibliography of Eric Gill**, 1953. Robert Speaight, **The Life of Eric Gill**, 1966. Donald Attwater, **A Cell of Good Living**, 1969.

Dora Gordine.
Born: St. Petersburg 1906.
Studied music in Paris until 1922, and then art, encouraged by Maillol. Travelled in the Far East 1929–35, and in Hollywood, 1947. Sculpting figures and portrait busts, modelled and cast.
Commissions: include, bronzes for the New Town Hall, Singapore, 1930–35. Milford Haven Oil Refinery, 1961.
Exhibitions: Leicester Galleries, 1928, and subsequently to 1949.
Literature: M. Sorrell, 'Dora Gordine', *Apollo*, May 1949. 'A Triumph of Sculptural Form: the work of Dora Gordine', *The Connoisseur*, December 1958.

Nigel Hall.
Born: Bristol 1943.
Studied at the West of England College of Art, Bristol, 1960–64, and the Royal College of Art, 1964–67. Making abstract sculpture, with metals and glass fibre, often attached to the walls.
Teaching: Royal College of Art, 1972–74, and Chelsea School of Art since 1974.
Commissions: Peter Stuyvesant Sculpture Project, Sheffield, 1972.
Awards: Harkness Fellowship, 1967–69. Prize, Bradford Print Biennale, 1974.

Exhibitions: Galerie Givaudan, Paris, 1967. Regularly with Felicity Samuel Gallery, and Annely Juda Fine Art. Retrospectives, Sunderland Art Centre, 1980 (catalogue). Warwick Arts Trust, 1980 (catalogue).

Anthony Hatwell.
Born: London 1931.
Studied with David Bomberg at the Borough Polytechnic, Bromley College of Art and Slade School of Art. Assistant to Henry Moore, 1958.
Teaching: Edinburgh College of Art from 1969.
Exhibitions: London Group from 1952, Borough Bottega 1953, 1954, 1955, Battersea Open Air exhibition, 1963, and *From Life*, Camden Arts Centre 1968.
Literature: Maurice de Sausmarez '4 British Sculptors', *Motif*, 12, 1964.

Barbara Hepworth.
Born: Wakefield 1903.
Died: St. Ives, Cornwall 1975.
Studied at Leeds School of Art, and the Royal College of Art, 1921–23. Worked in Rome with John Skeaping, 1924–26. Married Skeaping, 1925; divorced, 1931. Married Ben Nicholson, 1932. Made carved sculptures of figures and animals, and moved into abstract work in the 1930's, and from 1940's modelled and carved stone with lyrical landscape associations. Made drawings and prints, and stage designs, 1951–55. Co-founder of Penwith Society of Arts, St. Ives, 1948. Established Trewyn Studio, St. Ives, 1949. Trustee of the Tate Gallery, 1965.
Commissions: include, two sculptures for the Festival of Britain, 1951. Mullard House, 1956. **Winged Figure**, John Lewis, Oxford Street, 1962. **Single Form**, United Nations, New York, 1963. **Theme and Variations**, Cheltenham and Gloucester Building Society Headquarters, Cheltenham, 1970–1.
Awards: include, Second Prize, *Unknown Political Prisoner* Competition, 1953. C.B.E. 1958. Grand Prize, 5th Biennale, São Paolo, Brazil, 1959. D.B.E. 1965.
Exhibitions: Beaux Arts Gallery (with John Skeaping), 1928. Retrospectives include, Wakefield City Art Gallery, 1951 (catalogue). Whitechapel Art Gallery, 1954 and 1962 (catalogues). Tate Gallery, 1968 (catalogue). Yorkshire Sculpture Park, 1980.
Literature: Barbara Hepworth, **A Pictorial Autobiography**, Bradford-on-Avon, 1978. William Gibson, **Barbara Hepworth**, 1946. Herbert Read, **Carvings and Drawings**, 1952. A.M. Hammacher, **Barbara Hepworth**, 1958; and **Barbara Hepworth**, 1968. J.P. Hodin, **Barbara Hepworth, Life and Work**, 1961. Michael Shepherd, **Barbara**

Hepworth, 1963. Alan Bowness, **Drawings for a Sculptor's Landscape**, 1966; and **Barbara Hepworth, Complete Sculpture**, 1971.

Gertrude Hermes
Born: Bromley, 1901.
Studied at Beckenham School of Art, 1919–20, and at Leon Underwood's Brook Green School of Art, 1922–26. Making portrait sculptures, and working as an illustrator, lithographer and wood engraver.
Teaching: St. Martin's School of Art, and the Central School of Art and Design, 1945–46. The Royal Academy Schools, from 1966.
Commissions: Fountain and Mosaic floor, Shakespeare Memorial Theatre, Stratford-Upon-Avon, 1932. **Peacock**, Ordsall School, Salford, 1961.
Awards: A.R.A. 1963, R.A. 1971.
Exhibitions: Royal Academy from 1934. Whitechapel Art Gallery, 1967 (catalogue). Royal Academy, 1981 (catalogue).

Peter Hide.
Born: Surrey 1944.
Studied at Croydon College of Art, 1961–64, and at St. Martin's School of Art, 1964–67. Making welded and constructed steel sculptures.
Teaching: Norwich School of Art, 1968–71, St. Martin's School of Art 1971–77.
Commissions: Peter Stuyvesant Sculpture project, Southampton, 1972.
Awards: Visiting Sculptor, University of Alberta, Canada, 1977–79.
Exhibitions: Stockwell Depot from 1968. Serpentine Gallery, 1976 (catalogue). Arnolfini Gallery, Bristol, 1979.

Anthony Hill.
Born: London 1930.
Studied at St. Martin's School of Art, and Central School of Art and Design, 1947–51. Visited Paris, 1951–52. Started to make constructional reliefs from 1954, and abandoned painting, 1956. Organised the exhibition 'Construction: England 1950–1960', Drian Galleries, 1960. Editor, **Data, Directions in Art, Theory and Aesthetics**, 1968.
Teaching: Part-time, graphics and design, Polytechnic of Central London from 1957, and at Chelsea School of Art.
Commissions: Constructional screen, International Union of Architects Congress, 1961.
Awards: Leverhulme Fellowship, Department of Mathematics, University College, 1971–73.
Exhibitions: 'Aspects of British Art', Institute of Contemporary Arts, 1958 (catalogue). Kasmin Gallery, 1966, 1969. 'Constructive Context', Arts Council of Great Britain, 1978, catalogue.

Literature: Anthony Hill, 'A View of Non-figurative Art and Mathematics and an Analysis of a Structural Relief', *Leonardo*, 10, Winter 1977. R.C. Kenedy, 'Anthony Hill', *Art International*, October/November 1976.

Charles Sargeant Jagger.
Born: Kilnhurst, Yorkshire 1885.
Died: London 1934.
Brother of the painters David and Edith Jagger. Worked as a silver engraver in Sheffield and studied part-time at Sheffield School of Art. Studied at the Royal College of Art, and worked as an assistant to Lanteri, 1903–10. Served in the Army, 1914–18. Made figure sculpture and monuments.
Commissions: include, **Artillery Memorial**, Hyde Park Corner, 1925. Decorations for Imperial Chemicals House, Millbank, 1921. War Memorials at Paddington Station and West Kirby. **Shackleton**, Royal Geographical Society, 1932.
Awards: A.R.A. 1926. R.B.S. Gold Medal, 1926 and 1933.
Exhibitions: Royal Academy from 1913. Memorial exhibition, Royal Watercolour Society Galleries, 1935 (catalogue).
Literature: Charles Sergeant Jagger, 'The Sculptor's Point of View' *The Studio*, November 1933. **Modelling and Sculpture in the Making**, 1933. I.G. McAllister, 'Charles Sargeant Jagger', *The Studio*, November 1914.

William Goscombe John.
Born: Cardiff 1860.
Died: London 1952.
Studied at Cardiff School of Art, and worked, with his father, on the restoration of Cardiff Castle. Studied at the City and Guilds School of Art, Lambeth, and at the Royal Academy Schools, 1884. Sculpted monuments and statues, and worked as a medallist and lithographer. Worked in Paris under Rodin, 1890–91.
Commissions: include, equestrian statue of **Edward VII**, Liverpool, and **St. David**, Cardiff City Hall, 1916.
Awards: A.R.A. 1899. R.A. 1909. Gold Medal, Paris Salon, 1901. Knighted, 1911. R.B.S. Gold Medal, 1942.
Exhibitions: Royal Academy from 1884. Retrospective, National Museum of Wales, Cardiff, 1979 (catalogue).

Eric Kennington.
Born: London 1888.
Died: Reading 1960.
Son of the painter, T.B. Kennington. Studied at the City and Guilds School of Art, Lambeth. Served in the Army, 1914–19. Painter and draughtsman, sculpted in stone and modelled figures and busts from 1924. Visited Arabia to illustrate

T.E. Lawrence's **Seven Pillars of Wisdom**, 1920. Official War Artist, 1940–45.
Commissions: include, Monument to the 24th Division, Battersea Park, 1924. **Tomb of T.E. Lawrence**, Wareham, 1940. Carvings on Memorial Theatre, Stratford-on-Avon, 1930. **Coker Memorial**, Bicester Church, 1956.
Awards: A.R.A. 1951. R.A. 1959.
Exhibitions: Royal Academy from 1908. Leicester Galleries from 1918. 'Works on Paper', Maas Gallery, 1981 (catalogue).
Literature: 'In the Studio of Eric Kennington: the Man and his Work', *The Studio*, August 1930.

Michael Kenny.
Born: Liverpool 1941.
Studied at Liverpool College of Art, 1959–61, and Slade School of Fine Art, 1961–64. Making work principally in wood and plaster.
Teaching: Slade School of Fine Art, and Goldsmith's College.
Awards: Sculpture Prize, John Moores Liverpool Exhibition, 1964. Sainsbury Award, 1965. Arts Council Awards, 1975, 1977 and 1980. A.R.A. 1976.
Exhibitions: Bear Lane Gallery, Oxford, 1964. Serpentine Gallery, 1977 (catalogue). Bluecoat Gallery, Liverpool, 1981 (catalogue). Annely Juda Fine Art, 1978 and 1981.

Phillip King.
Born: Kheredine, Tunisia 1934.
Came to England, 1946. Studied modern languages at Christ's College, Cambridge, 1954–57, and sculpture at St. Martin's School of Art, 1957–58. Worked as an assistant to Henry Moore, 1958–59. Worked initially in clay and plaster, from 1960 making abstract work in fibreglass and metal, and from late 60's using metals with wood and slate. Trustee of the Tate Gallery, 1967–69.
Teaching: St. Martin's School of Art, 1959–80. Bennington College, Vermont, 1964, and at the Hochschule der Künste, Berlin, 1979–80. Professor of Sculpture, Royal College of Art, 1980.
Commissions: include, Expo '70, Tokyo. C & J Clark Ltd., Street, Somerset, 1972. European Patent Office, Munich, 1978. Romulus Construction Ltd., London, 1979.
Awards: First Prize, Socha Piestanskych, Czechoslovakia, 1969. C.B.E. 1974. A.R.A. 1977.
Exhibitions: Heffer's Gallery, Cambridge, 1957. Rowan Gallery, 1970, and subsequently. Retrospectives include, Whitechapel Gallery, 1968 (catalogue). Kröller-Müller National Museum, Otterlo, 1974 (catalogue). Hayward Gallery, 1981 (catalogue).

Bryan Kneale.
Born: Douglas 1930.
Studied at Douglas School of Art, 1947, and the Royal Academy Schools, 1948–52. Rome Scholar in painting, 1949–51. Began to make sculpture, 1959–60. Making abstract sculpture, constructed in metal. Organised 'British Sculptors '72', Royal Academy, 1972 and 'Silver Jubilee Exhibition of British Sculpture', Battersea Park, 1977.
Teaching: Royal College of Art from 1964.
Commissions: include, Leicestershire Education Authority. Peter Stuyvesant Sculpture Project, Southampton, 1972.
Awards: Prize, 'Structure 66', Welsh Arts Council, 1966. Arts Council Purchase Award, 1967. A.R.A. 1970. R.A. 1973.
Exhibitions: Redfern Gallery, paintings, 1954, and subsequently. Retrospectives, Whitechapel Art Gallery, 1966 (catalogue). Serpentine Gallery, 1978 (catalogue).
Literature: Bryan Robertson, 'Bryan Kneale's New Work', *Studio International*, October 1967.

Bruce Lacey.
Born: Catford 1927.
Service in the Royal Navy, 1945–46. Studied at Hornsey College of Art, 1948–51, and the Royal College of Art, 1951–54. Stopped painting after 1954, and concentrated on making special props for television, short films and performing as part of a comic cabaret act, 'The Alberts', 1956–60. Making first assemblages, environments and robots from 1962. Making performance works and environments with Jill Bruce from mid 1970's.
Exhibitions: Gallery One, 1963. Marlborough New London Gallery, 1964. Retrospective, Whitechapel Art Gallery, 1975 (catalogue). With Jill Bruce, Acme Gallery, 1978, 'Continuous Creation', Serpentine Gallery, 1980 (catalogue).
Literature: 'Bruce Lacey and Jill Bruce, Interview', *Artscribe*, 15, 1978.

Maurice Lambert.
Born: Paris 1902.
Died: London 1964.
Brother of the composer, Constant Lambert. Apprenticed to Derwent Wood, 1918–23. Served in the Army, 1939–45. Sculpted portraits, figures and animal subjects in stone and bronze.
Teaching: Master of Royal Academy Schools, 1950–58.
Commissions: include, **Viscount Nuffield,** Guy's Hospital, 1949. Carvings, Associated Electrical Industrial building, Grosvenor Place.
Awards: A.R.A. 1941. R.A. 1952.
Exhibitions: Claridge's Gallery, 1927. Seven and Five Society, 1928–31. Tooth's, 1929 and Lefevre Gallery, 1932, 1934.

Royal Academy from 1938.
Literature: P.G. Konody, 'The Art of Maurice Lambert', *Artwork*, September – November 1927. 'New Sculpture by Maurice Lambert', *The Studio*, June 1932.

Peter Lanyon.
Born: St. Ives, Cornwall 1918.
Died: Taunton 1964.
Studied at the Penzance School of Art, 1937, and at the Euston Road School, 1938. Met and taught by Ben Nicholson and Naum Gabo, who had moved to St. Ives at the outbreak of War. Served in the R.A.F., 1940–45. Made paintings, and occasionally constructions, some of which related to works on canvas.
Teaching: Bath Academy of Art, Corsham, 1950–57. West of England College of Art, Bristol, 1960–64.
Commissions: include, Ceramic mural for Liverpool University, 1960. Mural painting for Arts Building, University of Birmingham, 1963.
Awards: Second Prize, John Moores Liverpool Exhibition, 1959.
Exhibitions: Lefevre Gallery, 1949. Retrospectives, Arts Council of Great Britain, 1968 (catalogue). Whitworth Art Gallery, Manchester, 1978 (catalogue).
Literature: Peter Lanyon, 'A Sense of Place', *The Painter and the Sculptor*, Autumn 1962. Andrew Causey, **Peter Lanyon: his paintings,** 1971.

John Latham.
Born: Mozambique 1921.
Studied at Chelsea School of Art, 1946–50. Making paintings, assembled sculptures from 1958, and performances and films from 1960. Founder member of the *Artists' Placement Group,* 1967.
Teaching: part-time, St. Martin's School of Art, 1966–67.
Exhibitions: Kingly Gallery, 1948. Kunsthalle, Düsseldorf, 1975 (catalogue). Retrospective, Tate Gallery, 1976 (catalogue). **Government of the 1st and 13th Chair,** Event, Riverside Studios, 1978 (catalogue).

Gilbert Ledward.
Born: London 1888.
Died: London 1960.
Son of the sculptor, R.A. Ledward. Studied at the Chelsea Polytechnic, Goldsmith's College, the Royal College of Art and the Royal Academy Schools, 1903–14. Served in the Army, 1914–18. Sculpted portraits, and modelled and carved figures. Founded the organisation 'Sculptured Memorials and Headstones', 1934, to improve design and use of local stone in memorials.
Teaching: Professor of Sculpture at the Royal College of Art, 1926–29.
Commissions: include, **Guards Division**

Memorial, St. James's Park, 1926. **Venus Fountain,** Sloane Square, 1953.
Awards: 1st British School of Rome Scholarship in Sculpture, 1913. A.R.A. 1932. R.A. 1937. President of the R.B.S. 1954–56. O.B.E. 1956.
Exhibitions: Royal Academy from 1912. Memorial Exhibition, Stoke-on-Trent Museum and Art Gallery, 1961 (catalogue).
Literature: Gilbert Ledward in *Architects Journal,* August 1922.

Dante Leonelli.
Born: Chicago 1931.
Studied at the School of the Art Institute of Chicago, 1949–53. Served in the U.S. Army, 1953–55. Moved to London, and worked as a research student at the Courtauld Institute of Art, London University, 1955–59. Making collages and paintings, and subsequently kinetic and optical sculptures. Organised *Continuum Group* with Robert Janz and Michael McKinnon.
Teaching: Head of Plastics Research Unit, Royal College of Art, 1968. Director of Fourth Dimensional Studies, Middlesex Polytechnic, from 1969. Visiting U.S.A. and Japan, 1970–80.
Commissions: **Argon Ice Bridge,** Iowa City, 1978–79.
Awards: Prize, Holborn Station Competition, 1980.
Exhibitions: Matthieson Gallery, 1959 and 1961 (catalogue). 'Four Sculptors', University of East Anglia, 1981 (catalogue).

Liliane Lijn.
Born: New York 1939.
Came to Europe, 1955, and studied archeology and art history in Paris, 1958. Worked in New York, 1961–62, Paris, 1963–64, and in Athens, 1964–66. Settled in London, 1966. Making sculpture from plastics, metals and prisms, often kinetic and utilising reflection and refraction, also prints and drawings.
Commissions: include, Bebington Civic Centre, Liverpool, 1971. Peter Stuyvesant Sculpture Project, Plymouth, 1972. **Circle of Light,** Milton Keynes Shopping Arcade, 1979.
Exhibitions: La Libraire Anglaise, Paris, 1963. Hanover Gallery, 1970. Serpentine Gallery, 1977 (catalogue). Central Art Gallery, Wolverhampton, 1979 (catalogue). *What is the Sound of One Hand Clapping,* film, 1972–73.

Kim Lim.
Born: Singapore 1936.
Studied at St. Martin's School of Art, 1954–56, and the Slade School of Fine Art, 1956–59. Married William Turnbull, 1960. Making abstract sculptures with semi-geometric components in wood, stone and metals, also printmaking.

Exhibitions: Axiom Gallery, 1966. Alpha Gallery, Singapore, 1974. Round House Gallery, 1979.
Literature: Gene Baro, 'The Work of Kim Lim', *Studio International*, November 1968.

Richard Long.
Born: Bristol 1945.
Studied at Bristol School of Art, 1962–66, and St. Martin's School of Art, 1966–68. Began making works in the landscape, 1967, from 1969 travelling to Europe, U.S.A., Africa, South America and India.
Exhibitions: Konrad Fischer, Düsseldorf, 1968. British Pavilion, Venice Biennale, 1976. Whitechapel Art Gallery, 1977. Anthony D'Offay, 1979, 1980, 1981.
Literature: Numerous cards, books, and pamphlets. **Richard Long**, Van Abbemuseum, Eindhoven, 1979. Michael Compton, **Some Notes on the Work of Richard Long**, XXXVII Biennale Venice, 1976. N. Foote, 'Long Walks', *Artforum*, Summer 1980.

Andrea Carlo Lucchesi.
Born: London 1860.
Died: London 1925.
Son of a sculptor's moulder. Studied at the West London School of Art and the Royal Academy Schools, 1881–86. Assistant to A. H. Armstead and E. Onslow Ford. Made statuette figures, and portrait busts.
Commissions: include, **Memorial to E. Onslow Ford**, Abbey Road.
Awards: Gold Medal, Dresden, 1897. Exposition Universelle, 1900. Turin, 1911.
Exhibitions: Royal Academy from 1881.
Literature: C.C. Hutchinson, 'Mr. A.C. Lucchesi', *Magazine of Art*, 23, 1899.

Bertram McKennal.
Born: Melbourne, Australia 1863.
Died: Torquay 1931.
Studied under his father, the architectural sculptor, John McKennal, and then at Melbourne Art School. Came to London, 1882, studied at the Royal Academy Schools, 1883, and in Paris, 1884. Worked in Australia, 1889–92. Made figures, portraits and monuments.
Teaching: Head of the art department at a pottery, Coalport, Shropshire.
Commissions: include, decoration of Government House, Melbourne, 1889. First World War memorials at Eton and House of Commons. **Edward VII Memorial**, St. George's Chapel, Windsor.
Awards: A.R.A. 1909. R.A. 1922. Knighted, 1921.
Exhibitions: Royal Academy from 1886.
Literature: W.K. West, 'The Sculpture of Bertram MacKennal', *The Studio*, September 1908.

Bruce McLean.
Born: Glasgow 1944.
Studied at Glasgow School of Art 1961–63 and St. Martin's School of Art 1963–66. Made constructed sculptures and then works using performance, photographs and video. Formed *Nice Style: The World's First Pose Band*, 1971–75. Making large scale collaborative performances, and paintings.
Teaching: includes, Maidstone College of Art and Epsom School of Art.
Awards: Pratt Award 1965. Sainsbury Award 1966. Arts Council Major Award 1975. Arts Council Bursary 1978. Tolly Cobbold prizewinner 1981. D.A.A.D. Fellowship, Berlin 1981–82.
Exhibitions: Konrad Fischer, Düsseldorf, 1969. 'Objects no Concepts', Situation, 1971. 'King for a day', Tate Gallery 1972 (catalogue). Third Eye Centre, Glasgow, 1980 (catalogue). Kunsthalle Basel, Whitechapel Art Gallery, and Van Abbemuseum Eindhoven, 1981/2 (catalogue).

William McMillan.
Born: Aberdeen 1887.
Died: London 1977.
Studied at Gray's School of Art, Aberdeen, and the Royal College of Art, 1908–12. Sculpted figures and monuments, often carved in stone.
Teaching: Master of the Royal Academy Sculpture School, 1929–40.
Commissions: include, War Memorials, Aberdeen and Manchester, 1919. **Earl Haig**, Clifton College, Bristol, 1932. **Admiral Earl Beatty**, Trafalgar Square, 1948. **George VI**, Carlton House Terrace, 1955. **Sir Walter Raleigh**, Whitehall, 1959. **Alcock and Brown**, Heathrow Airport, 1966.
Awards: A.R.A. 1925. R.A. 1933. C.V.O. 1956.
Exhibitions: Royal Academy from 1917.

F.E. McWilliam.
Born: Banbridge, Ireland 1909.
Studied drawing at the Slade School of Fine Art, 1928–31. Worked in Paris, 1931–32. Started to make sculpture from 1933. Served in the R.A.F. 1940–45. Making surrealist and figure sculptures in stone, concrete and terracotta.
Teaching: Slade School of Fine Art, 1947–68.
Commissions: include, **The Four Seasons**, Festival of Britain, 1951. **Elizabeth Frink**, 1956, and **Help**, 1976, Harlow New Town. **Princess Macha**, Attnagelvin Hospital, Londonderry, 1957. **Father Courage**, Kent University, Canterbury (New Zealand) 1960. **Pay de Dome**, Southampton University, 1962. **Hampstead Figure**, Swiss Cottage, 1964.
Awards: A.R.A. 1959; resigned 1963.

C.B.E. 1966.
Exhibitions: London Gallery, 1939. Retrospective, Arts Council of Northern Ireland, 1981 (catalogue).
Literature: Roland Penrose, **F.E. McWilliam**, 1964.

Kenneth Martin.
Born: Sheffield 1905.
Studied at Sheffield School of Art, 1921–23, and 1927–29. Worked in Sheffield as a designer, 1923–29. Studied at the Royal College of Art, 1929–32. Married Mary Balmford, 1930. Making abstract paintings from 1948–49, and kinetic constructions from 1951. Continued making paintings, sculptures and drawings based on chance and order.
Teaching: St. John's Wood School of Art and Goldsmith's College of Art, 1946–68.
Commissions: include, **Twin Screw** for International Union of Architects, Congress Building, 1961. **Fountain**, Brixton College of Further Education, 1961. Engineering Laboratory, University of Cambridge, 1967. Peter Stuyvesant City Sculpture Project, Sheffield, 1972. **Fountain**, Gorinchem, Holland, 1974. **Kinetic Monument**, Swansea, 1977.
Awards: O.B.E. 1971.
Exhibitions: Heffer's Gallery, Cambridge (with Mary Martin) 1954. Institute of Contemporary Arts (with Mary Martin), 1960. Retrospectives, Arts Council of Great Britain (with Mary Martin), 1970–71 (catalogue). Tate Gallery, 1975 (catalogue). Yale Centre for British Art, New Haven, 1979 (catalogue).

Mary Martin.
Born: Folkestone 1907.
Died: London 1969.
Studied at Goldsmith's College of Art, 1925–29, and the Royal College of Art, 1929–32. Married Kenneth Martin, 1930. From 1951, making abstract reliefs, and free standing constructions from 1956.
Commissions: Musgrave Park Hospital, Belfast, 1957. Relief Panels for S.S. Oriana, 1960. Wall construction for International Union of Architects Congress, 1961. Construction for the University of Stirling, 1969.
Awards: Joint First Prize, John Moores Liverpool Exhibition, 1969.
Exhibitions: Heffer's Gallery, Cambridge (with Kenneth Martin), 1954. Institute of Contemporary Arts (with Kenneth Martin), 1960. Arts Council of Great Britain, 1970–71 (catalogue).
Literature: Alan Bowness, 'Mary Martin's Constructions', *Studio International*, March 1968.

Raymond Mason.
Born: Birmingham 1922.

Studied at the College of Arts and Crafts, Birmingham, 1937, Royal College of Art 1942–43, Ruskin School of Art, Oxford, 1943, Slade School of Art, 1943–46 and Ecole des Beaux Arts, Paris, 1946. Living in Paris from 1946. Making figurative sculpture in relief.
Commissions: Set and costumes for *Phèdre*, Théâtre du Gymnase, Paris, 1959.
Awards: William and Noma Copley Foundation award, 1961.
Exhibitions: Janine Hao Gallery, Paris, 1960. Pierre Matisse Gallery, New York, 1968 and subsequently (catalogues).
Literature: Michael Brenson, 'Urban Drama in High Relief, *Art in America*, July – August 1979.

Bernard Meadows.
Born: Norwich 1915.
Studied at the Norwich School of Art, 1934–36, and at the Royal College of Art, 1938–40, and 1946–48. Studio assistant to Henry Moore, 1936–40. Served in the R.A.F., 1941–46. Making works cast in bronze, often figures or abstracted animal forms.
Teaching: Chelsea School of Art, 1948–60. Professor of Sculpture at the Royal College of Art, 1960–80.
Commissions: include, Festival of Britain, 1951.
Awards: Italian State Scholarship, 1956.
Exhibitions: Gimpel Fils, 1957, and regularly to 1967. Taranman Gallery, 1975, and subsequently.
Literature: W.J. Strachan, 'The Sculptor and his drawings, 2: Bernard Meadows', *The Connoisseur*, April 1974.

Alec Miller.
Born: Glasgow 1879.
Died: Thanet 1961.
Studied at Glasgow School of Art, 1900–2, and in Florence, 1908. Made sculptures, mostly carved in stone, marble and wood. Lived in Gloucestershire and Monterey, California.
Teaching: Campden School of Arts and Crafts, 1902–14. City School of Arts, Oxford, 1919–23.
Exhibitions: Royal Academy from 1919.
Literature: Alec Miller, **Ruskin Reconsidered**, 1929. 'Sculpture in Wood', *American Magazine of Art*, June 1930. **Stone and Marble Carving**, 1948. **Tradition in Sculpture**, 1949.

Nicholas Monro.
Born: London 1936.
Studied at Chelsea School of Art, 1958–61. Making life-size figurative sculpture, modelled and cast in fibreglass.
Teaching: Swindon School of Art, 1963–68. Chelsea School of Art, from 1968.
Commissions: Peter Stuyvesant Sculpture

Project, Birmingham, 1972.
Awards: Arts Council Award, 1969.
Exhibitions: Robert Fraser Gallery, 1968. Galerie Thelen, Essen, 1969 (catalogue). City Art Gallery, Bristol, 1972 (catalogue). Felicity Samuel, 1978.
Literature: 'Nicholas Monro', *Ark*, 1965. Eddie Wolfram, 'Monro's Menagerie', *Art and Artists*, January 1975.

Henry Moore.
Born: Castleford 1898.
Taught at Castleford Grammar School, 1916. Served in the Army, 1917–19. Studied at Leeds School of Art, 1919–21, and at the Royal College of Art, 1921–24. Working in stone and wood, making abstracted figure works, and later casting in bronze, as well as continuing to carve. Official war artist, 1940–42. Trustee of the Tate Gallery, 1941–48, and the National Gallery, 1949–56. Started Henry Moore Foundation, 1977.
Teaching: Royal College of Art, 1925–32, and Chelsea School of Art, 1932–39.
Commissions: include, Work on St. James's Underground Headquarters, 1928–29. Northampton Church, 1946. UNESCO Headquarters, Paris, 1957–58. Lincoln Centre, New York, 1963; and numerous sites in London and other cities.
Awards: Numerous honours including, C.H. 1955, and O.M. 1963.
Exhibitions: Warren Gallery, 1928. Leicester Galleries, 1931 and subsequently. Marlborough Fine Art, 1959–73, and Fischer Fine Art from 1973. Retrospectives include, Temple Newsam, Leeds, 1941, (with John Piper and Graham Sutherland) and 1945 (with Ivon Hitchens). Museum of Modern Art, New York, 1946 (catalogue). Arts Council of Great Britain at the Tate Gallery, 1968 (catalogue). Forte di Belvedere, Florence, 1972 (catalogue). Orangerie de Tuilerie, 1977. Bradford City Art Gallery, 1978 (catalogue). Serpentine Gallery, 1978 (catalogue). Palacio de Velázquez, Madrid, 1981 (catalogue).
Literature: David Sylvester, Herbert Read and Alan Bowness, **Henry Moore, Sculpture and Drawings**, 1944 – 1977 in 4 volumes.

David Nash.
Born: Esher 1945.
Studied at Kingston College of Art, 1963–67, and Chelsea School of Art, 1968–70. Established studio in Blaenau Ffestiniog, 1967. Working mostly in wood, making objects and environmental works.
Commissions: Planting project commission, Southampton University, 1979.
Awards: Bursary, Welsh Arts Council, 1975. Resident Sculptor, Grizedale Forest, 1978.
Exhibitions: York Festival, 1973.

Serpentine Gallery, 1976. Arnolfini Gallery, Bristol, 1976 (catalogue). AIR Gallery, 1978 (catalogue). *Woodman*, film by Peter Francis Browne, Arts Council of Great Britain, 1979.
Literature: 'Interview with David Nash', *Artscribe*, No 12, June 1978. Hugh Adams, 'The Woodman', *Art and Artists*, April 1979.

Paul Nash.
Born: London 1889.
Died: Boscombe, Hampshire 1946.
Brother of painter John Nash. Studied at the Chelsea Polytechnic, 1906–8, at London County Council Evening Classes, 1908–10, and at the Slade School of Fine Art, 1910–11. Served in the Army, 1914–18. Worked as a landscape painter, book illustrator, photographer, writer, designer of applied art, and creator of surrealist collages and sculptures. Founded *Unit One*, 1933.
Exhibitions: International Surrealist exhibitions, London 1936, and Paris, 1938. Retrospectives include, Temple Newsam, Leeds, 1943, Cheltenham, 1945, and Tate Gallery, 1975 (catalogue).
Literature: Sir John Rothenstein, **Paul Nash**, 1961. Margot Eates, **Paul Nash, Paintings, Drawings and Illustrations**, 1973. Andrew Causey, **Paul Nash**, 1980.

Martin Naylor.
Born: Morley, Leeds 1944.
Studied at Dewsbury and Batley Technical and Art School, 1961–65, Leeds College of Art, 1965–66, and the Royal College of Art, 1967–70. Art Advisor, Psychology Department, University of Leeds, 1966–67. Making wall works and environmentally-scaled sculptures from a wide variety of materials and objects.
Teaching: Part-time teaching, and tutor at the Royal College of Art, 1974–77. Head of Sculpture, Middlesex Polytechnic from 1977.
Awards: Peter Stuyvesant Award, 1969. Arts Council Award, 1971. Gregory Fellowship at Leeds University, 1973–74. Joint First Prize, Art into Landscape, 1974. Prize Winner, John Moores Liverpool Exhibition, 1978. Arts Council Major Award, 1979.
Exhibitions: Lane Gallery, Bradford, 1966. Rowan Gallery, from 1974. Sunderland Arts Centre, 1976 (catalogue).

Paul Neagu.
Born: Bucharest 1938.
Studied at the Institute 'N. Grigorescu', Bucharest, 1959–65. Worked in various jobs, including mosaics and stage design. Immigrated to Britain, 1969, naturalised 1976. Working in several media, constructed wooden sculptures,

environments and performances. Founded
Generative Art Group, 1972.
Teaching: Chelsea School of Art and
Middlesex Polytechnic.
Awards: Centre Internationales de
Rencontres, Nice, 1972. Foundation
Michael Karolyi, Vence, France, 1973.
Arts Council Award, 1973 and 1978. Arts
Council Bursary, 1975. Prize, Tolly
Cobbold Exhibition, 1976. Northern Arts
Fellowship, 1979–81.
Exhibitions: Amphora Gallery, Bucharest,
1969. Richard Demarco Gallery,
Edinburgh, 1969. Institute of
Contemporary Arts, 1979 (catalogue).
Third Eye Centre, Glasgow, 1979
(catalogue).
Literature: Paul Neagu, **Guide to
Generative Arts**, 1977.

Victor Newsome.
Born: Leeds 1935.
Studied painting at Leeds College of Art,
1953–55, and 1957–60. Worked in Rome,
1960–62. Making sculpture and reliefs in
plastics and metals; gave up sculpture in
1969, working on paintings and drawings.
Teaching: Various colleges and Nottingham
School of Art, 1963–64, and Hull College of
Art, 1964–70, Goldsmith's College, and
Wimbledon School of Art.
Awards: Peter Stuyvesant Travel Bursary,
1966. Prize, 'Structure '66', Welsh Arts
Council, 1966. Arts Council Award, 1967.
Prize, 'Edinburgh Open 100', 1967.
Exhibitions: Grabowski Gallery, 1966.
'New Generation', Whitechapel Art
Gallery, 1966. '6 at the Hayward', Hayward
Gallery, 1969. Anne Berthoud Gallery,
1980.
Literature: M. Quantrill, 'The World of
Victor Newsome', *Art International*,
Summer 1979.

Uli Nimptsch.
Born: Berlin 1897.
Studied at the Applied Art School, Berlin,
1915–17, and the Academy, Berlin,
1919–26. Lived in Rome, 1931–38. Worked
in Paris 1938–39, and settled in London,
1939. Sculptor of modelled figures and
portraits.
Commissions: include, **Brendan Bracken**,
Times Building. **Neighbourly Encounter**,
Bermondsey. **Lloyd George**, House of
Commons, 1962–63.
Awards: A.R.A. 1958. R.A. 1967.
Exhibitions: Redfern Gallery, 1942. Royal
Academy from 1957. Walker Art Gallery,
Liverpool, 1957 (catalogue).
Retrospective, Diploma Galleries, Royal
Academy, 1973.

Alfred J. Oakley.
Born: High Wycombe 1878.
Died: Newbury 1959.

Son of an artist-craftsman and apprenticed
to the chair-making trade in High
Wycombe. Studied at the City and Guilds
School of Art, Lambeth, 1903–8 and 1910.
Served in the Royal Army Medical Corps,
1915–18. Made sculptures in wood and
bronze, and in later years working
principally on church commissions.
Commissions: include, panels on the liner,
Queen Mary, 1933–34. Daily Telegraph
Building, Fleet Street.
Exhibitions: Royal Academy from 1922.
7 and 5 Society 1920–26.

John Panting.
Born: New Zealand 1940.
Died: England 1974.
Studied at Canterbury University School of
Art, New Zealand, 1959–62, and Royal
College of Art, 1964–67. Made abstract
sculpture in glass fibre and steel.
Teaching: Royal College of Art and Central
School of Art and Design, 1967–74. Head
of Sculpture, Central School of Art and
Design, 1972–74.
Commissions: Peter Stuyvesant Sculpture
Project, Plymouth, 1972.
Awards: New Zealand Arts Council Award,
1963. Bickert and Widdowson Scholarship,
New Zealand, 1969.
Exhibitions: Galerie Swart, Amsterdam,
1967. Memorial retrospective, Serpentine
Gallery, 1975 (catalogue).
Literature: John Panting, **Sculpture in
glass-fibre: the use of polyester resin and
glass-fibre in Sculpture**, 1972. R.J. Rees,
'John Panting', *Studio International*,
September 1974.

Eduardo Paolozzi.
Born: Edinburgh 1924.
Studied at the Edinburgh College of Art,
1943, and the Slade School of Fine Art,
1944–47. Worked in Paris, 1947–50.
Working as a sculptor in metal, and a
ceramicist, and also as a draughtsman,
lithographer, designer and film-maker.
Teaching: Textile Design at the Central
School of Art and Design, 1949–55,
Sculpture at St. Martin's School of Art,
1955–58. Hochschule für Bildende Kunst,
Hamburg, 1960–62. Visiting lecturer,
University of California, 1968. Royal
College of Art, from 1968.
Commissions: include, fountains for the
Festival of Britain, 1951; and for a park in
Hamburg, 1953. Doors to the Hunterian
Library, Glasgow, 1978. Euston Station,
1981.
Awards: Critics Prize, 1953. Copley
Foundation Award, 1956. David Bright
Foundation Prize, 1960. Watson F. Blair,
Chicago, 1961. C.B.E. 1968. A.R.A. 1972.
D.A.A.D. Fellowship, Berlin, 1974–75.
R.A. 1979. Artist-in-Residence,
University of St. Andrews, 1979.

Exhibitions: Mayor Gallery, 1947.
Retrospectives include, Tate Gallery, 1971
(catalogue); Nationalgalerie, Berlin, 1975
(catalogue); Arts Council of Great Britain,
1976 (catalogue); prints, Victoria and
Albert Museum, 1977; Kölnischer
Kunstverein, Cologne, 1979 (catalogue).
Films include, 'A History of Nothing', 1962.
Literature: Eduardo Paolozzi writings
include, **Metafisikal Translations**, 1960;
Kex, Chicago, 1966; **Abba-Zaba**, 1970.
M. Middleton, **Eduardo Paolozzi**, 1963.
D. Kirkpatrick, **Eduardo Paolozzi**, 1970.
U.M. Schneede, **Paolozzi**, 1971.

Harold Parker.
Born: Aylesbury 1873.
Died: Brisbane, Australia 1962.
Lived in Brisbane, Australia from 1876.
Studied at Brisbane Technical College,
1889–93. Came to London, 1896. Studied
at the City and Guilds School of Art,
Lambeth, 1897–1902. Painted and
sculpted, figurative works modelled and
carved. Returned to Australia, 1930.
Commissions: include, Colossal groups for
Australia House, 1915–18.
Awards: Medallist, Paris Salon, 1928.
Exhibitions: Royal Academy, 1903–29.
Retrospectives, Sydney, 1930, and
Melbourne Fine Art Society, 1933.

Roland Penrose.
Born: London 1900.
Studied at Queens College, Cambridge
University, and then moved to France,
1922. Returned to England, 1935, and
organised the International Surrealist
Exhibition, New Burlington Galleries,
1936. Painter and collage maker, also
producing surrealist sculpture and
assemblages. Co-founded the Institute of
Contemporary Arts, 1947. Also working as
a critic and writer. Trustee of the Tate
Gallery, 1959–67.
Awards: C.B.E. 1960. Knighted, 1966.
Exhibitions: Galerie van Leer, Paris, 1928.
Retrospective, Arts Council of Great
Britain, 1980 (catalogue).

Glyn Warren Philpot.
Born: London 1884.
Died: London 1937.
Studied at the City and Guilds School of
Art, Lambeth, 1900–4, and at the
Académie Julian, Paris, 1905. Painter and
Sculptor, of portraits and figure subjects,
modelled and cast. Served in the Army,
1914–17. Trustee of the Tate Gallery, 1935.
Awards: Gold Medal, Pittsburgh
International Exhibition, 1911. A.R.A.
1915. R.A. 1923.
Exhibitions: Royal Academy from 1904.
Baillie Gallery, 1910. Grosvenor Galleries,
1923. Leicester Galleries, 1932 and 1934.
Memorial Exhibition, Tate Gallery, 1938.

Leighton House, 1959. Ashmolean
Museum, Oxford, 1976 (catalogue).
Literature: A.C. Sewter, **Glyn Philpot
R.A.,** 1951.

Roland Piché.
Born: London 1938.
Studied at Hornsey College of Art,
1956–60, and the Royal College of Art,
1960–64. Part-time assistant to Henry
Moore, 1962–63. Making sculpture from a
variety of materials, with organic and
geometric forms.
Teaching: Principal lecturer, Maidstone
College of Art, from 1964.
Commissions: Moorgate Sculpture
Competition, 1968.
Awards: Walter Neurath Prize, 1961. First
Prize, 'Structure '66', Welsh Arts Council,
1966.
Exhibitions: Marlborough Gallery, 1967.
The Minories, Colchester, 1980
(catalogue).

Carl Plackman.
Born: Huddersfield 1943.
Apprentice architect, 1959–60. Studied
mathematics and history, Bath, 1960–62,
West of England College of Art, Bristol,
1962–67, and Royal College of Art,
1967–70. Worked with Lynn Chadwick,
1967. Making assemblage sculptures and
environmentally scaled works, with a
variety of materials and objects.
Teaching: includes, Goldsmith's College.
Awards: Walter Neurath Drawing Prize,
1968. Sculpture Drawing Prize, Royal
College of Art, 1970.
Exhibitions: Serpentine Gallery, 1972.
Felicity Samuel Gallery, 1971 and 1980.
Arnolfini, Bristol, 1978.
Literature: Norbert Lynton, 'Carl
Plackman', *Arnolfini Review*, November
1978.

Frederick William Pomeroy.
Born: London 1856.
Died: Cliftonville 1924.
Articled to a firm of architectural sculptors
and studied part-time at the City and Guilds
School of Art, Lambeth, and the Royal
Academy Schools, 1881–85. Studied in
Paris under Mercié, and in Rome. Made
modelled sculptures of ideal figures,
portraits and monuments. Founding
member of the Society of Portrait
Sculptors, 1911.
Commissions: include, **Oliver Cromwell,**
St. Ives, 1901. **W.E. Gladstone,** Houses
of Parliament. **Agriculture,** figure on
Vauxhall Bridge, 1907.
Awards: Medallist at Chicago Exhibition
and the International Exhibition, Paris,
1900. A.R.A. 1907. R.A. 1917.
Exhibitions: Royal Academy from 1885.
Literature: A.L. Baldry, 'The Work of F.W.

Pomeroy', *The Studio*, November 1898.

William Pye.
Born: London 1938.
Studied at Wimbledon School of Art,
1958–61, and at Royal College of Art,
1961–65. Making abstract sculpture in
metal, often kinetic and with highly
reflective surfaces.
Teaching: Visiting Professor, California
State University, Northridge, 1976.
Commissions: include, Kings Cross
House, Pentonville Road, 1974. Peter
Stuyvesant Sculpture Project, Cardiff,
1972. **Aeolus,** City of Birmingham and
Joseph Lucas joint commission, 1973.
Fiesta Mall, Mesa, Arizona, 1976.
Eastgate Mall, Cincinnati, Ohio, 1978.
Awards: Prize, 'Structure '66', Welsh Arts
Council, 1966.
Exhibitions: Redfern Gallery, 1966, and
subsequently. 'Reflections', 1971, and
'Scrap to Sculpture', 1972, films. Great Hall
and City Museum, Winchester, 1979
(catalogue). University College,
Aberystwyth, 1980 (catalogue).

William Reynolds-Stephens.
Born: Detroit 1862.
Died: Tunbridge Wells 1943.
Educated in England and Germany, studied
at the Royal Academy Schools, 1884–87.
Assumed the additional name of Reynolds,
1890. Worked as a painter, goldsmith and
furniture designer, and from 1904 made
decorative sculpture in a variety of
materials.
Commissions: include, **Sir William Q.
Orchardson,** St. Paul's. **Archbishop Lord
Davidson,** courtyard of Lambeth Palace.
Awards: Gold Medal, R.B.S., 1904.
President, R.B.S., 1921–23. Knighted,
1931.
Exhibitions: Royal Academy from 1885.
Literature: M.H. Spielmann, 'Mr. W.
Reynolds-Stephens', *Magazine of Art*,
1897. A.L. Baldry, 'Recent Decorative
Work and Sculpture by Mr. W. Reynolds-
Stephens', *The Studio*, January 1911.

Charles Ricketts.
Born: Geneva 1886.
Died: London 1931.
Educated in France and Italy, and came to
London, 1879. Studied wood engraving at
the City and Guilds School of Art, Lambeth,
1872. Met Charles Shannon, and with him
founded *The Dial*, 1889–97, and The Vale
Press, 1896–1904. Continued writing and
took up painting and sculpture, 1904, and
designed theatre sets from 1910.
Awards: A.R.A. 1922, R.A. 1928.
Exhibitions: Royal Academy from 1923.
Charles Ricketts and Charles Shannon,
Orleans House, Twickenham, 1979.
Charles Ricketts and Charles Shannon,

FitzWilliam Museum, Cambridge, 1979
(catalogue).
Literature: Charles Ricketts, books with
Shannon, **The Prado and 18 Masterpieces,**
1903; **Titian,** 1910; **Pages on Art,** 1913;
Self-Portrait, 1939. T. Surge Moore,
**Charles Ricketts R.A., Sixty-five Illustra-
tions,** 1933. Stephen Calloway, **Charles
Ricketts,** 1979. Joseph Darracott, **The
World of Charles Ricketts,** 1980.

Ivor Roberts-Jones.
Born: Oswestry 1913.
Studied at Goldsmith's College, 1932–34,
and at the Royal Academy Schools, 1935.
Served in the Army, 1939–45. Making
portrait busts and monumental figures,
modelled and cast.
Teaching: Goldsmith's College since 1946.
Head of Sculpture, 1964.
Commissions: include, **Augustus John
Memorial,** Fordingbridge, 1967. **Winston
Churchill Memorial,** Parliament Square,
1973. **Clement Attlee,** House of
Commons, 1978.
Awards: A.R.A. 1969. R.A. 1973. C.B.E.
1975.
Exhibitions: Beaux Arts Gallery, 1957.
Royal Academy. Oriel Gallery, Cardiff,
1978 (catalogue).

Michael Sandle.
Born: Weymouth 1936.
Studied at Douglas School of Art, 1951–53,
and at the Slade School of Fine Art,
1956–59. Studied lithography in Paris,
1959–61. Making reliefs and figurative
sculptures, modelled and cast.
Teaching: Leicester College of Art,
1961–63. Coventry College of Art,
1964–68. University of Calgary, Canada,
1970–71. University of British Columbia,
1971–72. Professor of Sculpture, Pforz-
heim, Germany, 1973 and Kunstakademie,
Karlsruhe, 1981.
Awards: D.A.A.D. Fellowship, West Ber-
lin, 1974–75.
Exhibitions: Drian Gallery, 1963. Hayward
Annual, 1978 (catalogue). Fischer Fine
Art, 1981.
Literature: 'Vera Lindsay in discussion
with Michael Sandle', *Studio International*,
September 1969. R.C. Kenedy, 'Michael
Sandle', *Art and Artists*, August 1971.

Benno Schotz.
Born: Arensburg, Estonia 1891.
Studied engineering in Darmstadt, 1911,
and at the Royal Technical College, Glas-
gow. Part-time study in sculpture at
Glasgow High School, 1913–14, and at
Glasgow School of Art, 1914. Worked in the
drawing office of John Brown's shipbuilders;
and making sculptures, compositions and
portrait heads from 1923.
Teaching: Glasgow School of Art, Head of

Sculpture, 1938–61.
Commissions: include, Work for St. Charles's R.C. Church, Glasgow, 1958–61. Group for Town Centre, Glenrothes, 1962–65.
Awards: President, Society of Painters and Sculptors, Glasgow, 1920. Appointed H.M. the Queen's Sculptor in Ordinary for Scotland, 1963. Honorary President of the Royal Glasgow Institute of Arts, 1973.
Exhibitions: Royal Scottish Academy from 1918. Royal Academy from 1925. Alex Reid and Lefevre's, Glasgow, 1929. Retrospectives, Diploma Galleries, Royal Scottish Academy, Edinburgh, 1971 (catalogue). Glasgow Art Gallery and Museum, 1978 (catalogue).
Literature: Charles Spencer, 'Benno Schotz, his new religious work', *The Studio*, July 1959. S.G. South, 'Benno Schotz', *Scottish Art in Review*, 3, 1962.

Kurt Schwitters.
Born: Hanover, Germany 1887.
Died: Kendal 1948.
Studied at Kunstakademie, Dresden, 1909–14, Kunstakademie, Berlin, 1914, and architectural studios, Hanover, 1918. Made abstract works in collage and assemblage form, also painting, writings and poems from 1917. First **Merz** work, 1918, and built **Merzbau** in Hanover, 1920. Founder and editor of **Merz** magazine, 1923–32. Regularly visited Norway, 1929–37. Left Germany in 1937, and moved to Norway, and then to England in 1940. Interned, and then lived in London, 1941–45. Worked on **Merzbau**, Little Langdale, Cumbria, 1947–48.
Exhibitions: Galerie der Sturm, Berlin, 1920. Retrospectives include, Museum of Modern Art, New York, 1948. Kestner Gesellschaft, Hanover, 1956 (catalogue). University of California, Los Angeles, 1965 (catalogue). Kunsthalle, Düsseldorf, 1971 (catalogue). Marlborough Fine Art, 1972 (catalogue).
Literature: Kurt Schwitters, numerous poems and writings. Ronald Alley, 'Kurt Schwitters in England', *The Painter and Sculptor*, Autumn 1958. Kate Steinitz, **Kurt Schwitters: A Portrait from Life**, Los Angeles 1968. Werner Schmalenbach, **Kurt Schwitters**, 1970.

Tim Scott.
Born: Richmond, London 1937.
Studied at Tunbridge School of Art, 1954, the Architectural Association, 1954–59, and St. Martin's School of Art, 1955–59. Lived and worked in Paris at the Atelier Le Corbusier-Wegenscky, 1959–61. Making abstract sculptures in glass-fibre, steel and other materials including glass and perspex.
Teaching: St. Martin's School of Art from 1962. Head of Sculpture Department, 1980.
Commissions: Peter Stuyvesant Sculpture Project, Liverpool, 1972.
Awards: Peter Stuyvesant Foundation Bursary, 1965. Sculptor in Residence, North London Polytechnic, 1978–79.
Exhibitions: Waddington Galleries, 1966, and subsequently to 1977. Whitechapel Art Gallery, 1967 (catalogue). Museum of Modern Art, Oxford, 1969 (catalogue). Museum of Fine Arts, Boston, 1972 (catalogue). Retrospective, Kunsthalle Bielefeld, 1979 (catalogue).

William G. Simmonds.
Born: Pera, Istanbul 1876.
Died: Stroud 1968.
Son of an architect, came to England as a child. Studied at the Royal College of Art, 1893–99, and at the Royal Academy Schools, 1897–1904. Worked as an assistant to the painter, Edwin Austin Abbey, 1906–10. Made sculpture from 1913, carving wood, stone, ivory, often of animal subjects. Involved with arts and craft work in Chipping Camden during 1930's.
Exhibitions: Royal Academy from 1903. Retrospectives, Painswick 1966; Cheltenham Art Gallery, 1980 (catalogue).
Literature: J. Rothenstein, 'Marionettes by William Simmonds', *Creative Art*, December 1929.

John Skeaping.
Born: South Woodford 1901.
Died: London 1980.
Studied at Goldsmith's College, 1915–17, the Central School of Art and Design 1917–19 and the Royal Academy Schools, 1919–20. Worked in Florence, 1924 and married Barbara Hepworth, 1925; divorced 1931. Carved in stone and modelled, figures and animal subjects, later concentrating on equine sculptures. Official War Artist 1940–45. Worked in Mexico, 1949–50.
Teaching: Royal College of Art, from 1948; Professor of Sculpture, 1953–59.
Awards: A.R.A. 1950. R.A. 1960.
Exhibitions: Alex Reid and Lefevre, Glasgow (with Barbara Hepworth), 1928. Royal Academy from 1922.
Literature: John Skeaping, **Animal Drawing**, 1936; **How to Draw Horses**, 1941; **The Big Tree of Mexico**, 1952; **How to Draw Dogs**, 1961; **Les Animaux**, Paris 1969. **An Autobiography**, 1977. John Grierson, 'New Generation in Sculpture', *Apollo*, November 1930. Mary Sorrell, 'The Mexican Terracottas of John Skeaping', *The Studio*, March 1952.

Willi Soukop.
Born: Vienna 1907.
Apprenticed to an engraver, and studied at the Academy of Fine Art, Vienna. Came to England in 1934. Making figure and portrait sculptures, modelled and cast.
Teaching: Dartington Hall, 1934–40. Bromley School of Art, 1945–46. Guildford School of Art, 1945–47, and Chelsea School of Art, 1947–72. Master of Sculpture, Royal Academy Schools, 1969.
Commissions: Numerous Schools and Housing Estates.
Awards: A.R.A. 1963. R.A. 1969.
Exhibitions: Royal Academy from 1935.
Literature: Willi Soukop, 'Modelling for Beginners', *The Artist*, November 1953 – January 1954.

Peter Startup.
Born: London 1921.
Died: London 1976.
Studied at the Hammersmith School of Arts and Crafts, 1935–39, the Central School of Art and Design, 1943–44, Ruskin School of Drawing, 1944–45, and at the Slade School of Fine Art, 1945–48. Studied sculpture in Brussels, 1948–49. Made semi-abstract and abstract sculptures, often carved in wood.
Teaching: includes, Wimbledon School of Art, 1965–76. Visiting Artist to Minneapolis School of Art, 1968.
Awards: Second Prize, Littlewoods Sculpture Competition, 1964.
Exhibitions: Works on paper, Roland, Browse and Delbanco, 1952. Sculpture (with Malcolm Hughes and Raymond Moore) A.I.A. Gallery, 1963. Memorial retrospective, Serpentine Gallery, 1977 (catalogue).
Literature: Charles Spencer, 'Peter Startup; Multiple Image Sculpture', *Studio International*, September 1965.

Wendy Taylor.
Born: Stamford 1945.
Studied St. Martin's School of Art 1961–66. Making constructed sculpture, often incorporating illusions of weight or material.
Teaching: includes, Ealing School of Art 1967–75. Royal College of Art 1972–73.
Commissions: include, **Chevron**, City of London Festival, 1968. **Triad**, Somerville College, Oxford, 1971. **Time Piece**, Tower Hotel, St. Katherine's Dock, 1973.
Awards: Walter Neurath Award 1964. Pratt Award 1965. Sainsbury Award 1966. Arts Council Award 1977. Gold medal, Listowel Graphics Exhibition, 1977. First prize, Barcham Green Print competition 1978.
Exhibitions: Axiom Gallery, 1970. Oliver Dowling Gallery, Dublin 1976 and 1979.
Sculpture-Wendy Taylor, BBC Southern Television film, 1970.

James Harvard Thomas.
Born: Bristol 1854.
Died: London 1921.
Studied at Bristol Art School, the South Kensington Schools and the Ecole des Beaux Arts, Paris, 1881–84. Worked and lived near Naples, 1889–1906. Modelled classical figures and statues.
Teaching: Professor of Sculpture at the Slade School of Fine Arts, 1914.
Commissions: include, **Boadicea**, Cardiff Town Hall.
Exhibitions: International Society from 1898. Royal Academy from 1889. Carfax Galleries, 1909. Memorial Exhibition, Leicester Galleries, 1922. Beaux Arts Galerie, 1936.
Literature: F. Gibson, 'J.H. Thomas: his sculpture', *The Studio*, April 1919.

William Hamo Thornycroft.
Born: London 1850.
Died: Oxford 1925.
Studied under his father, Thomas Thornycroft, and then at the Royal Academy Schools, 1869. Made classical figures, statues and monuments.
Teaching: Royal Academy Schools, 1882–1914.
Commissions: include, **General Gordon**, Trafalgar Square, 1888. **Oliver Cromwell**, Westminster Hall, 1899. **Dean Colet Memorial**, St. Paul's School, 1902. **Gladstone**, The Strand, 1905.
Awards: A.R.A. 1881. R.A. 1888. Medal and Honour at the Exposition Universelle, 1900. Knighted, 1917. Gold Medal, R.B.S. 1923.
Exhibitions: Royal Academy from 1872. Joint Memorial Exhibition with Frances Derwent Wood, Royal Academy, 1927.
Literature: E.W. Gosse, 'Hamo Thornycroft', *The Magazine of Art*, 3, 1881. W. Armstrong, 'Mr. Hamo Thornycroft', *The Portfolio*, 1888.

Albert Toft.
Born: Birmingham 1862.
Died: Worthing 1949.
Studied at evening classes at Hanley School of Art and at Newcastle-under-Lyme School of Art. From family of craftsmen in silverwork and pottery. Apprenticed to Josiah Wedgwood. Studied at South Kensington Schools, 1880–85. Modelled figures and portrait busts.
Commissions: include, **Boer War Memorial**, Cannon Hill Park, Birmingham, 1905. **Queen Victoria**, Nottingham, 1907 and at Leamington and South Shields, 1908. **National War Memorial**, Cardiff, 1910. **Royal Fusiliers Memorial**, Holborn, 1922–24.
Exhibitions: Royal Academy from 1885.
Literature: Albert Toft, **Modelling and Sculpture**, 1911. J. Harper, 'Mr. Albert

Toft', *The Magazine of Art*, 1901, 26. A. Reddie, 'Albert Toft', *The Studio*, October 1915.

Stephen Tomlin.
Born: London 1901.
Died: London 1937.
Studied Classics at New College Oxford in 1919. Took up sculpture; worked with Frank Dobson c.1925–26. Made modelled and cast, and ceramic, portraits also carved in stone. Closely associated with the Bloomsbury Group.
Commissions: Designed wrought iron gates, New Square, Lincoln's Inn.
Exhibitions: London Group, 1924.

David Tremlett.
Born: St. Austell 1945.
Studied at Falmouth Art School, 1962–63, Birmingham College of Art, 1963–66, and the Royal College of Art, 1966–69. Making sculpture installations, and from 1971 travelling extensively and making wall works related to locations visited.
Exhibitions: Grabowski Gallery, 1970. Stedelijk Museum, Amsterdam, 1979 (book). John Hansard Gallery, University of Southampton, 1981.
Literature: publications include, **Some Places to Visit**, 1975; **On the Waterfront**, Newlyn, 1978; **On the Border**, Amsterdam, 1979. Willoughby Sharp, 'The Art of Searching. An interview with David Tremlett', *Avalanche*, Autumn 1972.

William Tucker.
Born: Cairo 1935.
Came to England, 1937. Studied history at Oxford University, 1955–58. Studied sculpture at Central School of Art and Design, and St. Martin's School of Art, 1959–60. Making abstract sculptures, in steel, and in fibre-glass, plastics and wood. Selected 'The Condition of Sculpture' at the Hayward Gallery, 1975.
Teaching: Goldsmith's College and St. Martin's School of Art, 1961–62. University of Western Ontario, Canada, 1976. Columbia University, New York, and New York School of Painting and Sculpture, 1978.
Commissions: include, Peter Stuyvesant Sculpture Project, Newcastle-upon-Tyne, 1972. Livingston Development Corporation, Lanark, 1976.
Awards: Gregory Fellowship in Sculpture, Leeds University, 1968–70.
Exhibitions: Grabowski Gallery, 1962. Kasmin Gallery, and Waddington Galleries since 1967. Kunstverein, Hamburg, 1973. Arts Council of Great Britain, 1973 (catalogue) and 1977 (catalogue).
Literature: William Tucker, numerous articles, and **The Language of Sculpture**, 1974. Interview with Caryn Faure Walker and Ben Jones, *Artscribe*, 3, Summer 1976.

William Turnbull.
Born: Dundee 1922.
Served in the R.A.F. 1941–45. Studied at the Slade School of Fine Arts, 1946–48. Living in Paris, 1948–50. Resident in London from 1950. Married sculptor Kim Lim, 1960. Making abstract paintings and sculpture. Sculpture mostly constructed from metal and wood parts, sometimes in serial form, also making modelled works.
Teaching: Central School of Art and Design, 1952–61, and 1964–72.
Commissions: include, Peter Stuyvesant Sculpture Project, Liverpool, 1972.
Exhibitions: Hanover Gallery, 1950 and 1952. Molton Gallery, 1960 and 1961. Waddington Galleries, 1967 and subsequently. Retrospective, Tate Gallery, 1973 (catalogue).

Leon Underwood.
Born: London 1901.
Died: London 1975.
Studied at the Regent Street Polytechnic, 1907–10, and at the Royal College of Art, 1910–13. Served in the Camouflage Section, 1914–18. Studied at the Slade School of Fine Art, 1919–20. Travelled to the USA, 1925–26, and first visit to Mexico, 1927. Founded the magazine *The Island*, 1931. Served in the Civil Defence Camouflage, 1939–42. Travelled to West Africa, 1945. Made paintings and wood engravings, and worked as sculptor in stone and wood.
Teaching: Royal College of Art, 1920–23. Ran the Brook Green School of Art, Hammersmith, 1921–38.
Commissions: include, Windows for Church at New Marston, Oxfordshire.
Exhibitions: Drawings and Etchings, Chenil Gallery, 1921. Retrospectives, Kaplan Gallery, 1961. The Minories, Colchester, 1969 (catalogue). 'Mexico and After', Cardiff, National Museum of Wales, 1979 (catalogue).
Literature: Leon Underwood, **Art for Heaven's Sake**, 1934; **Statuettes en bois de l'Afrique Occidentale**, 1947; **Masks of West Africa**, 1948; **Bronzes of West Africa**, 1949; **Cycles of style in Art, Religion and Science and Technology**, pamphlet. R.B.S. Annual Report, 1961. Christopher Neve, **Leon Underwood**, 1974.

Arthur Walker.
Born: London 1861.
Died: Parkstone, Dorset 1939.
Studied at the Royal Academy Schools from 1883. Worked as a painter, illuminator, mosaic designer and sculptor of figures and monuments.
Teaching: Goldsmith's College.
Commissions: include, **Bronze Christ**, Old Church, Limehouse. **Florence Nightingale**

Memorial, Waterloo Place, 1916. **Orlando Gibbons** in Westminster Abbey.
Awards: A.R.A. 1925. R.A. 1936.
Exhibitions: Royal Academy from 1884.
Literature: H.H. Bashford 'How Marble Statues are Carved. The Art of Mr. A. Walker' *London Magazine*, June 1911.

Brian Wall.
Born: London 1931.
Studied at Luton College of Art, 1949–50. Worked as an assistant to Barbara Hepworth, 1954–58. Making abstract sculptures in welded steel.
Teaching: Ealing College of Art, 1961–62. Central School of Art and Design, 1962–72. University of California, Berkeley, 1969–73; Assistant Professor since 1975.
Commissions: include, Thornaby-on-Tees Town Centre, 1968. University of Houston, Texas, 1978.
Awards: Prize, Bay Area Rapid Sculpture Competition, San Francisco, 1975.
Exhibitions: School of Architecture, Architectural Association, 1957. Braunston Quay Gallery, San Francisco from 1976.
Literature: Brian Wall, 'Statement', *Sculpture International*, October 1969.

Charles Wheeler.
Born: Codsall, Staffordshire 1892.
Died: Mayfield, Sussex 1974.
Studied at Wolverhampton School of Art, and at the Royal College of Art, 1912–17. Married the sculptor, Muriel Bourne, 1918. Sculpted figures in stone and modelled in clay, painted, and produced architectural sculptures. Trustee of the Tate Gallery, 1942–49.
Commissions: include, Figures for the Bank of England, 1932. Decorative motif for South Africa House, 1934. **Jellicoe Memorial** and fountains in Trafalgar Square, 1948. **Earth** and **Water**, Ministry of Defence, 1953.
Awards: A.R.A. 1934. R.A. 1940. C.B.E. 1948. President R.B.S. 1944–49. President of the Royal Academy, 1956–66. Gold Medal of the United States National Academy of Design, 1963.
Exhibitions: Royal Academy from 1914.
Literature: Charles Wheeler, **High Relief, Autobiography**, 1968. Thomas Bodkin, 'Charles Wheeler C.B.E., R.A.', *The Studio*, June 1956.

Glynn Williams.
Born: Shrewsbury 1939.
Studied at Wolverhampton College of Art, 1955–61. Lived and worked in Rome, 1961–63. Making abstract constructed sculptures using various media, and more recently carving stone.
Teaching: Various art colleges, and Head of Sculpture, Wimbledon School of Art.

Commissions: include, Wolverhampton Grammar School, 1963. Merrion Centre Sculpture Competition, Leeds, 1974. Leeds City Council, 1965. Welsh Arts Council, 1970.
Awards: Prize in Open Exhibition of Contemporary Painters and Sculptors in Wales, Welsh Arts Council, 1964 and 1967.
Exhibitions: Institute of Contemporary Arts, 1967. '11 Sculptors, 1 Decade', Arts Council of Great Britain, 1972 (catalogue). Oriel Gallery, Cardiff, 1978.

Gillian Wise-Ciobotaru.
Born: Ilford, Essex 1936.
Studied Wimbledon School of Art 1954–57 and Central School of Arts and Design 1959. Leningrad Art Academy 1969–70. Making constructed reliefs in mixed media and free-standing linear constructions.
Teaching: University of Illinois, Chicago, 1970–71 and Chelsea School of Art since 1971.
Commissions: International Union of Architects' Congress, 1961. Wall screen with Anthony Hill, for *Queen Elizabeth II*, 1968. Wall relief, Nottingham University Hospital 1973–75.
Awards: UNESCO Fellowship Prague, 1968. Arts Council Award 1976.
Exhibitions: Institute of Contemporary Arts (with Anthony Hill), 1963 (catalogue). 'Drawn from Structures', Polytechnic of Central London, 1976 (catalogue).
Literature: J. Bumpus, 'Gillian Wise-Ciobotaru and the Constructivist section at the Hayward', *Artscribe*, 13, 1978.

Isaac Witkin.
Born: Johannesburg 1936.
Came to England, 1957. Studied at St. Martin's School of Art, 1957–60. Worked as an assistant to Henry Moore, 1961–64. Making abstract sculpture constructed in steel.
Teaching: St. Martin's School of Art, 1963–64 and 1966–67. Bennington College, Vermont, 1965–66. Parsons School of Design, New York, from 1975.
Awards: Joint First Prize, Paris Biennale, 1965. Artist in Residence, Bennington College, Vermont, 1967.
Exhibitions: Rowan Gallery, 1963. Waddington Galleries, 1966 and 1968. Marlborough Gallery, New York, 1975. University of Vermont, Burlington, 1971 (catalogue).

Francis Derwent Wood.
Born: Keswick 1871.
Died: London 1926.
Studied in Switzerland and Karlsruhe. Returned to Britain 1887, and worked in Staffordshire potteries and foundries. Studied at the Royal College of Art, 1889; and as assistant to Legros, Slade School of

Fine Art, 1890–92. Royal Academy Schools, 1894, becoming assistant to Thomas Brock. Worked in Paris, 1896–97, and in Glasgow, 1897–1901. Making classical works, portraits and memorials. Served in R.A.M.C. 1914–18; and worked with remedial plastic surgery, Wandsworth Hospital.
Teaching: Glasgow School of Art, 1897–1901. Royal Academy Schools, and Professor of Sculpture, Royal College of Art, 1917–23.
Commissions: include, figures for Art Gallery, Kelvingrove, Mercantile Buildings, Bothwell Street, and the Caledonian Low Level Railway Station, Glasgow, 1897–1901. **William Pitt**, National Gallery of Art, Washington, 1920. **Machine Gun Corps Memorial**, Hyde Park Corner, 1925.
Awards: Honourable Mention, Paris Salon, 1897. A.R.A. 1910. R.A. 1920.
Exhibitions: Royal Academy from 1895. Memorial Exhibitions, Leicester Galleries, 1926 (catalogue), and Royal Academy (with Onslow Ford), 1927.
Literature: W.K. West, 'The Work of F. Derwent Wood', *The Studio*, January 1905. H. Granville Fell, 'A Sculptor's Drawings: a Consideration of some of the Projects and Decorative Studies of Francis Derwent Wood', *Apollo*, July 1925.

John Wragg.
Born: York 1937.
Studied at York School of Art, 1953–56, and the Royal College of Art, 1956–60. Making modelled abstract work, and recently, portraits and figure studies.
Teaching: Chelsea School of Art, 1961.
Awards: Sainsbury Award, 1960. Arts Council Major Award, 1977.
Commissions: Sainsbury's, Kings Road, 1966.
Exhibitions: Hanover Gallery, 1963, 1966, 1970. York Festival, 1969. Festival Gallery (with Graham Arnold), Bath, 1976.
Literature: Charles Spencer, 'John Wragg', *Studio International*, April 1966.

David Wynne.
Born: Lyndhurst 1926.
Studied at Trinity College, Cambridge, and served in the Royal Navy, 1944–47, completing degree in 1949. Worked with Georg Ehrlich, and then in Paris with Paul Landowski and Welles Bosworth. Sculpting figures and animals, some carved, mostly modelled and cast.
Commissions: include, **Teamwork**, Taylor Woodrow, 1958. **Guy the Gorilla**, for Greater London Council, 1961. **Flying Swans** and **Tyne God** for Civic Centre, Newcastle-upon-Tyne, 1968. **Boy with a Dolphin**, Cheyne Walk, 1974. **Girl with a Dolphin**, St. Katherine-by-the-Tower, 1975. **Five Swimmers Fountain**,

Photograph Sources

Elmsleigh Precinct, Staines, 1980.
Exhibitions: Leicester Galleries, 1950.
Retrospective, Cannizaro Park,
Wimbledon, 1980 (catalogue).
Literature: T. R. J. Boase, **Sculpture of David Wynne, 1949–1967**, 1968. Graham Hughes, **Sculpture of David Wynne, 1968–1974**, 1974.

Architectural Review 160
Kenneth Armitage 133
Keith Arnatt 206
Arts Council of Great Britain 133, 159, 162, 171, 180 (bottom), 186, 226
Humanities Research Center, University of Texas at Austin 78 (right)
BBC Hulton Picture Library 18, 62 (bottom), 64, 65 (top left and right), 66 (top, bottom left), 67 (top right), 69 (top) 70 (top right)
Corry Bevington 197 (bottom)
Bradford City Art Gallery 89 (left)
British Council 88 (top), 143, 144, 145
Rosemary Butler 134, 151
Arthur Byron 147
Cambridge, Mass., Fogg Art Museum 51
University of Cambridge, Kettle's Yard 57, 59 (right)
Tony Carter 229
John Cobb 232
Commonwealth War Graves Commission 65 (bottom left), 70 (bottom right)
Rose Coombs 66 (bottom right), 69 (Royston, Sledmere)
Courtauld Institute 8, 11 (right), 12, 13, 16, 22, 29, 30, 36, 38, 40, 42, 43, 44, 45, 46, 47 (right), 48, 65 (bottom middle & right), 67 (top left), 68, 117, 118, 121, 122, 123, 130, 194
Courtauld Institute Collection 72, 87 (bottom)
John Davies 184
Kenneth Draper 233
University of East Anglia 161
Edinburgh, Scottish National Gallery of Modern Art 158
Crispin Eurich 148
Tony Evans 191 (top)
Fischer Fine Art (photos Prudence Cuming) 81 (right), 224, 225
Floyd Picture Library 173 (bottom), 208, 210, 216
Grattan Freyer 61 (right)
Gilbert & George 196
Katherine Gili 217
Gimpel Fils Ltd. 170 (bottom)
Glasgow Museums and Art Gallery 142
John Goldblatt 177 (bottom), 178, 179, 181
Carlos Granger 213
Greater London Council 128 (right), 141, 144 (left)
Anna Gruetzner 115 (right)
A. J. Hepworth Estate 108 (bottom)
Charles Hewlings 218
Peter Hide 212
Anthony Hill 163
John Hilliard 200
University of Hull Art Collection 73
Imperial War Graves Commission 67 (bottom), 70 (top left, bottom left)
Imperial War Museum 62 (top), 67 (top right), 69 (Euston), 71
Keystone Press 141
Martin Koretz 197 (top)
John Latham 182, 183

Leeds City Art Gallery 88 (bottom)
Leicestershire Education Authority 169, 174 (bottom)
John Lewis Partnership 149
Lisson Gallery 234
Liverpool, Walker Art Gallery 47 (left)
London Transport Press Office 90, 92, 93, 94, 95, 96, 99, 100
Richard Long 198, 199, back cover
Manchester City Art Gallery 77, 79
University of Manchester, Whitworth Art Gallery, 215
Brian Marsh 204
Bruce McLean 205
The Henry Moore Foundation 14 (bottom), 21, 25, 26, 32, 33, 89 (right), 107 (left), 110, 150, 172
Raymond Mortimer Estate 86 (bottom)
Trustees of the Paul Nash Estate 112, 116, 119
National Monuments Record 129
Paul Neagu 235
New York, Museum of Modern Art 201
Anthony d'Offay Gallery 52 (top), 55, 76 (right)
Ottawa, National Gallery of Canada 102
Eduardo Paolozzi 34, 170 (top left), 192, 193
Paris, Musée National d'Art Moderne, Centre Pompidou 187
Paris, Musée Picasso, © SPADEM 61 (left), 82
Dr. S. Pasmore 154
Sir Roland Penrose 114
Photo Studios Ltd. 149
Carl Plackman 222, 231
Malcolm Poynter 227 (bottom)
Private Collections 156, 165
Punch 60, 74
William Pye 31, 35
C. S. Reddihough 107 (right)
Rowan Gallery 176, 177 (top), 219, 227 (top), 228
Robert Russell 221
Anthony Smart 214
Sport and General 140
Stromness, Pier Gallery 105
Tate Gallery 11, 14 (top), 39, 59 (left), 75, 76 (left), 78 (left), 80, 86 (top), 87 (top), 107 (bottom), 108 (top), 109, 111, 124, 125, 126, 127, 128 (left), 132, 157, 166, 170 (top right), 173 (top), 174 (top), 189, 190, 191 (bottom), 211
The Ting: Theatre of Mistakes 203
Trades Union Congress 19
Thorn EMI Ltd 148
William Turnbull 168
Waddington Galleries Ltd 202 (top), 207
John Webb 180 (top)
Richard Wentworth 230
Whitechapel Art Gallery front cover (photo David Ward), 10, 195, 197 (top)
Stephen Willats 202 (bottom)
Glynn Williams 220
Wolverhampton Art Gallery 81 (left)
John Wragg 188
Rodney Wright-Watson 115 (left)